BLACK VISUAL CULTURE

For Sean and Dave with love

BLACK VISUAL CULTURE

MODERNITY AND POSTMODERNITY

GEN DOY

I.B.Tauris *Publishers*
LONDON • NEW YORK

Published in 2000 by I.B.Tauris & Co Ltd
Victoria House, Bloomsbury Square, London WC1B 4DZ
175 Fifth Avenue, New York NY 10010
Website: http://www.ibtauris.com

In the United States and Canada distributed by St. Martin's Press
175 Fifth Avenue, New York NY 10010

ISBN 1-86064-382-5

A full CIP record for this book is available from the British Library
A full CIP record for this book is available from the Library of Congress

Library of Congress catalog card: available

Typeset in Melior by Wyvern 21 Ltd, Bristol
Printed and bound in Great Britain by CPD Wales, Ebbw Vale

CONTENTS

LIST OF PLATES

Plate 1 Frank Bowling, *Rule Britannia*, 1995, acrylic on canvas, 66 × 51 cms. Courtesy of the artist. Photograph Mike Simmons.

Plate 2 Rasheed Araeen, *Green Painting*, 1985–6, mixed media, nine panels, 173 × 226 cms overall, collection Arts Council of Great Britain. Photo Arts Council of Great Britain.

Plate 3 Chris Ofili, *Afrodizzia*, Second version, 1996, mixed media, acrylic, oil, resin, paper collage, glitter, map pins and elephant dung on canvas, 183 × 122 cms. Courtesy Victoria Miro Gallery, London.

Plate 4 Isaac Julien, still from *The Attendant*, 1993, Normal Films. Courtesy Victoria Miro Gallery, London and Isaac Julien.

Plate 5 Dave Lewis, *Allan Alexander. Merchant Navy Cook who served in the North Sea and the Middle East*, ca 1996, colour photograph. Courtesy of the artist.

Plate 6 Keith Piper, *Trade Winds*, 1992, colour video still from mixed media installation. Courtesy of the artist.

Plate 7 Roshini Kempadoo, *Sweetness and Light*, 1996–7, computer generated colour photographic montage for Website. Courtesy of the artist.

Plate 8 Roshini Kempadoo, *European Currency Unfolds. Spanish Banknote*, 1992, colour photographic panel. Courtesy of the artist.

Plate 9 Donald Rodney, *In the house of my father*, 1997, colour photograph by Andra Nelki, 153 × 122 cms. With permission.

Plate 10 Dave Lewis, *Haddon Photographic Collection, Cambridge University Museum of Anthropology and Ethnography*, 1995, sepia photograph.Courtesy of the artist.

Plate 11 Keith Piper, colour still from *The Fictions of Science*, 1996, computer generated image for CD Rom. Courtesy of the artist.

Plate 12 Ernest Dyche, *Busworker*, ca 1960?, black and white photograph, Dyche collection Birmingham Central Library.

Plate 13 Ernest Dyche, *The Kenth Family*, January 1958, black and white photograph, Dyche collection, Birmingham Central Library.

Plate 14 Maz Mashru, *Self Portrait*, 1987, colour photograph, 48 × 58 cms, The Portrait House, Leicester.

ACKNOWLEDGEMENTS

Many thanks to the library staff at De Montfort University Library, especially the staff in the inter-library loans section, who are always so helpful with all my requests. I am also grateful to secretarial staff at De Montfort University for doing my printing jobs for me. Thanks also to Philippa Brewster, my editor at I.B.Tauris for all her encouraging and helpful support. I am grateful to all the artists who answered my queries and who gave me permission to reproduce their work. I have made every attempt to contact copyright holders. If there are any omissions, I apologize, and please contact me.

I was given a period of study leave by De Montfort University in order to work on this book, as well as some money to visit various exhibitions essential for my research. I am happy to acknowledge this academic and financial support. I am also extremely grateful for a grant from the British Academy which helped cover some of the photographic reproduction fees. This money was most welcome.

Special thanks, in no particular order, to Dr. Eddie Chambers; Karun and Roy for help, friendship and sympathetic ears; Pete Challis for computer help; Ajamu, for taking the time to answer my questions; Frank Bowling; very many thanks to Isaac Julien; thanks to staff at Ralph Lauren; Mike at the photography centre at De Montfort University for his excellent work on the illustrations; Surjit Simplay; Nick Cornwall (thanks for the Brazilian kisses); Samina Khan; Sue Ward at *The Art Book* for getting me books I needed; Tim O'Sullivan for lending me books; Pete James and Urmi Merchant at Birmingham Central Library; Maz Mashru for taking the time to talk to me; Val Hill; Andy Medhurst; Richard Dyer; Hadyn Hansell at the Picture Library at the Victoria and Albert Museum; Kippa Mathews; Anthony Clement at The Brewery, Kendal, for help with Maud Sulter material; Dave Lewis; Keith Piper; Juginder Lamba; Roshini Kempadoo; South London Art Gallery and Jane Bilton; Nilesh Mistry at Cartwright Hall, Bradford; Anise Richey at The Robert Mapplethorpe Foundation; Roger Bradley at Picture House, Leicester; Chris Ofili and the Victoria Miro Gallery, London; Renée Stout

and the Dallas Museum of Art; inIVA; Panchayat; The African and Asian Visual Arts Archive at the University of East London; and especially Mark Sealy at Autograph. Without Mark's generous help, my task in locating artists and getting permission to reproduce their works would have been much more difficult. I want to take this opportunity to encourage everyone who finds this book useful to subscribe to Autograph, The Association of Black Photographers. For a modest amount of money you get monthly newsletters, monographs of photographers, and, in my case, friendly help and advice. Once again, many thanks. The address of Autograph and other useful organizations and resources is given before the bibliography at the end of the book.

Within quotations, any words which appear in square brackets are my explanatory additions.

INTRODUCTION

In this book, I want to look at issues surrounding black visual culture and to look back at recent developments and forward to possibilities for the twenty-first century. The somewhat arbitrary dating of a world historical shift in history, based on the birth of Jesus Christ, is being seen in Britain as both a cause of (controversial) celebration and commemoration and as an expensive nuisance to computer software. The planned Millenium Dome to be constructed at Greenwich, London, at a cost of £750 million has proved difficult to sell to a sceptical public. The year 2000, whatever its cultural significance real or manufactured, may not coincide, in fact, with any epoch-making changes in world history and culture. However, it may be that visual culture, both created by, and representing, black people, may be going through a qualitative change as we approach the end of the twentieth century, a century associated with the high point of modernist visual and material culture, advanced industrialisation and technological development, and rationalist critical thought. I want to look at various interconnecting themes and issues in black art and cultural history at this particular conjuncture of modernity and postmodernity.

In recent years, a majority of cultural critics, both black and white, have adopted and developed the theoretical approaches of postmodernist writers. This new orthodoxy holds that modernism, historically and culturally, is now discredited as a motor force of both historical understanding and cultural production. So-called 'grand' or 'master narratives' of historical and cultural progress, created and driven by individual or collective subjects (or, to put it crudely, people), have collapsed along with the faltering progress of Western capitalism and imperialism, and the disintegration of the former Soviet Union. In their place are fragmentation, flux, displacements of fixed certainties and identities, and the disintegration of the notion of a coherent individual subject.

However, for both theorists and practitioners of culture who are members of socially oppressed groups, some aspects of postmodern thought have not been accepted without question. For example, certain feminist

theorists have argued that without a 'grand' narrative, (perhaps a 'mistress' narrative to replace the 'master' one), how can the socially oppressed situate or understand their oppression historically, and therefore challenge it?[1] A similar question might be raised in relation to the history and cultural productions of the 'racially' oppressed. Nevertheless, many theorists and critics of black visual culture have located a significant change in the work of black artists and film-makers as we approach the end of the twentieth century. Speaking in a film made by Pratibha Parmar in 1994 for British television's Channel 4, *The Colour of Britain*, cultural critic Paul Gilroy locates an important shift in the late 1980s. Many black artists in the eighties sought to express the 'essential' nature of what it was to be black in a racist society, and felt that 'Black Art' was necessarily political and engaged with issues of social and cultural oppression. Now, in the 1990s, says Gilroy, black artists are licensed to play and question, not merely express what he terms a 'mechanistic' politics of anti-racism. Black artists, he claims, are no longer being forced to become 'pamphleteers'. Gilroy is not the only cultural theorist to locate this crucial shift in the late 1980s or to describe the qualitative differences in 'Black Culture', before and after it. Writer and curator David A.Bailey also identifies a move from the kind of work produced by black artists in Britain in the 1970s and 1980s, which sought to express an essentialized black subjectivity, to the work of the 1990s, where the agenda has changed to break a 'chain or set of relations that were fixed – essentialist, homogeneous'.[2] In some senses the shift is viewed from a more collective notion of 'Black Art' expressed by an individual artist (modernist) within that collectivity, to a more individualized, fragmented notion of the 'postblack' creator of cultural discourse (postmodernist). Kobena Mercer has argued that 'What differentiates artists of the 1990s – such as Steve McQueen, Chris Ofili, or Perminder Kaur – is that the shift away from the issue-based *gravitas* of the 1980s is a response to art world changes that have institutionalised the demand for difference.'[3] This may be one factor in the change Mercer identifies in black artists' work, but ever since the inception of modernism, with its valuation of formal novelty, change and the marketing of the individual authorial persona, art world institutions have projected and valued difference as an aesthetic commodity. Other factors are also involved, however.

Basically we seem to be encountering here an argument for a shift from modernism to postmodernism in black culture in the later 1980s, both in Britain and internationally. At that time, in 1988, Rasheed

Araeen's retrospective exhibition acknowledged this perception of a qualitative cultural break in its title.[4] Thus, it appears that postmodernism has been espoused by certain black cultural theorists and practitioners later than it has by white theorists such as Fredric Jameson or Jean Baudrillard, to name just two examples. In any case, not all theorists agree as to when postmodernism started. For some it is the 1960s, for others later. Of course locating the beginning of postmodernism depends on what criteria are being used to define it. For Jameson, for example, postmodernism is seen as the cultural embodiment of late capitalism, rather than defined primarily by visual qualities, so it needs to be located in relation to specific economic changes in the organization of the capitalist mode of production and consumption, such as the demise of traditional heavy industries, development of computer technology, increasing focus on service industries, 'just-in-time' production, and consumer- rather than production-led economic organization. So if postmodernism has more recently occurred in the theorization of black visual culture, then why is this? For reasons that will become clearer in the course of this book, many black artists and theorists have been more reluctant than their white counterparts to abandon notions of history, truth, reality and conscious subjectivity. Economic, cultural and social pressures on artists and theorists to align themselves with postmodern theories have been strong, however, and the tension this creates has perhaps proved fruitful for debate and creative production. In looking at these issues though, do we have to revise and question notions of postmodernism and/or the application of postmodern theory to cultural practice? Where writers on black cultural theory and practice have argued for the persistence of notions of modernism, we need to assess the validity of their arguments and their consequent implications.

One may object that in writing a book specifically on black artists and issues related to their work, I am reinforcing a ghettoization of black artists, many of whom want to be recognized as artists pure and simple, rather than as *black* artists. While this is a valid point, I think it should be borne in mind that there remain specific themes and issues which are embodied in the works of black artists and black visual culture more than they are in current practice by non-black artists – for example, history, memory, belonging and identity. While these themes are not exclusive to black artists, they seem to be more important in their work, and are given particular inflections. Also, I feel that for sixth form, further and higher education students, it is important to attend to the specificities of the theory and practice of black visual culture, which can too

often be ignored in teaching, curriculum development and library pro-
vision. From where I stand as a teacher and researcher in higher
education, the view is perhaps different from that of a relatively well-
established professional artist who may be more at home in the London
and international art world. Such questions clearly require more
discussion.

On this apparent cusp of the modern/postmodern/millenial in black
visual culture, I will be looking at selected examples of imagery in
relation to particular configurations of economic, political, social and
cultural factors in late twentieth century Britain, and to some extent,
parallel developments in examples of work by artists from North
America.

TERMS OF ABUSE

I want to discuss at this point some of the key terms I will be using in
this book, and attempt to clarify their meanings. Firstly, there is the term
'race'. In using this term I will refer to 'race', since, along with many
other writers I consider the concept of 'race' to have no genetic or sci-
entific validity as a means of differentiating between groups of human
beings.[5] The form 'race', therefore, indicates a historically, socially and
culturally constructed notion, not a fact of material existence. As such,
it is a notion powerfully charged with ideological significance, used in
both approving and disapproving ways to differentiate between human
beings and based on supposedly 'natural' qualities. Although I am aware
that in these postmodern times, my use of ideology in a Marxist sense is
likely to be dismissed, I believe its validity is justified. In Marxist theory,
ideological notions and concepts function to articulate perceptions of how
the world is and are believed by their users to be natural and obvious
facts. However, ultimately, these beliefs function to maintain and sup-
port a world view which underlines the social *status quo*, rather than
allowing it to be seriously questioned. Thus notions of 'race' functioned
in the past to justify the economic exploitation of black people as slaves.
In the present, they function, among other things, to justify giving jobs
to white people rather than black, or paying black workers less than white.
However if 'race' is a concept and a construct, the same cannot be said
of racism. As Colette Guillaumin forcefully argues:

'Whether race is or is not"a fact of nature", whether it is or is not a
"mental reality", it is today, in the twentieth century, a legal, political

and historical reality which plays a real and constraining role in a number of societies ... That is why simply rejecting the notion of race is not enough. Denying its existence as an empirically valid category, as the human, social and, ultimately, natural sciences are trying to do, can never, however correct the intention, take away that category's reality within society or the state, or change the fact that, while it may not be valid empirically, it certainly exerts an empirical effect ... while the reality of "race" is indeed neither natural and biological, nor psychological (some innate tendency of the human mind to designate the other as a natural entity), it does nevertheless exist'.[6]

One of the issues I want to consider, then, is the apparent contradiction between leading theorists and practitioners of black culture turning away from clearly social and political engagement in their art, towards a more ambiguous examination of identities and contextualisations, at a time when black people in Britain are reporting more racial incidents to the police than before and are still suffering from social and economic discrimination.[7] Of course, we should not expect developments in culture to flow mechanistically from economic and social factors. Nevertheless, this seeming divergence of cultural concerns and social realities deserves some attention. In a recent interview, Dr. Eddie Chambers, a black British artist and curator, explained how he thought the work of black artists had developed since the 1980s. Chambers has always advocated and supported art concerned with black issues, 'an art form that clearly addresses the black experience'. Chambers feels that a few black artists have become famous, a fact which masks the reality of the many more black artists who have never managed to gain financial backing or opportunities to exhibit. He maintains his belief that black artists should remain in touch with the day-to-day realities of the black community.'I don't think we could pursue a kind of Post-Modernist dream at the expense of what's happening to our people.'[8] Chambers describes the developments in black British visual culture in the later 1980s and 1990s as a 'dilution' and 'process of compromise', in comparison to critics such as Kobena Mercer or Paul Gilroy, who have approvingly hailed the more subtle and ambiguous recent developments in black visual culture as a progression from essentialist and restricting notions of black artists and black experiences.

The term 'black' and my use of it also requires some discussion. In the interview referred to above, Chambers states that his view of

black art is basically a continuation of his attitudes in the early 1980s.

> 'My working definition of black art was that it was art by black people
> for black people, about black people, and that it was art which
> specifically addressed the black experience, the political conditions
> and so on and so forth ... I've never really stopped believing that
> 'black' is really a term that belongs exclusively to us as African
> people.'[9]

Some critics now feel happier avoiding the term 'black' entirely, pre-
ferring to discuss works by black artists in terms of notions such as
hybridity, diasporas and ethnicities. Others want to continue to use the
term, but as a more expanded concept than Chambers' view. Mark Sealy,
director of Autograph, the Association of Black Photographers, founded
in 1988, states:

> 'It's an organisation that deals with people who have got a sense of
> imperialism, a sense of colonialism, that have somehow been margin-
> alized through their ideas and their practice, because they've been
> identified as dealing with issues that are not central to high art
> concerns ... We were always, since the early constitution, the
> association of Black photographers.This included work by and about
> Black issues, whatever they may be. We never used the term Black as
> an Afrocentric label. It's always been used really to describe, (what
> later became trendy in the late 1980s and early 1990s), as "people of
> colour". So the term Black is just a label to map out those named as
> "other", whatever "other" is. I'm very clear not to name a specific
> space that we occupy, because it's fluid and changing and I'm more
> concerned with working with the specific issues, than looking at the
> geographical location of where people come from. But it is really
> important to keep that geography in focus. It's about challenging the
> Eurocentric values that are dominant within artistic production. We
> are very interested in spaces like Bangladesh, spaces like the African
> continent, spaces like Latin America. For us, these are all Black
> people, these are people who don't normally get considered or are
> seen as flavoured by whatever scenario. It's about breaking up the
> mythologies that good practices don't exist in other spaces'.[10]

This use of the term black derives ultimately from an inclusive political
self-application of the term by conscious anti-racist and civil rights

activists in the USA in the 1960s, activists who replaced 'coloured' with 'black'. Many in Britain followed this, along with the assertion that 'black is beautiful', which challenged the aesthetic denigration of black people and their cultures. In the 1970s, it was not unusual to attend meetings where Chinese, Turkish, Iranian, Caribbean and South Asian people collaborated as 'blacks'. However Dilip Hiro, in the preface to his book on black Britain, *Black British, White British*, is reluctant to define black as the colour of the oppressed and disadvantaged, and specifically sees the designation of South Asians as black as problematic. In the end, he decides to use a variety of different terms to refer to Asian and Afro-Caribbean Britons.[11] Avtar Brah argues that the term 'black' was associated with 'new Left' politics in the 1970s and 1980s, and states that the demise of black as a 'political subject' 'is an indictment of certain forms of totalizing impulses, intolerance, élitism and vanguardisms of various kinds which became a significant tendency within all Left politics.'[12] Thus for Brah, the demise of black activism and politics is seen as more the result of 'the Left' (which is assumed to be white) and its undemocratic structures, rather than wider factors in economics, politics and culture.

Similar forms of this argument are to be found in the works of cultural critics, in particular Paul Gilroy and Kobena Mercer. Gilroy, in one of his many comments on the issue, writes that those who want to speak with a unified black voice are prisoners of outmoded forms of thought.

'For this tendency, the fracturing of black political subjectivity during the 1980s was rendered unthinkable or incomprehensible by a political language created during the 1970s and scarcely modified since. The arguments over the term 'black', specifically who it included and on what terms, were glossed over or ignored. Participants who retained older ideas of political unity between post-colonial people of African and Asian descent seemed to have become reticent or uncertain about the basis on which this contingent alliance might be maintained and whether the term' black' would be part of it.'[13]

This kind of antagonism to Left politics and socialist organizations of various sorts tends to lay the blame for lack of social change and political advance for black people on undemocratic, inflexible and theoretically unsubtle organisations and theories associated with the Left, socialism and Marxism. This strong dissatisfaction with 'modernist' notions of revolutionary politics, parties, and collective action informed by a

political programme is especially evident among writers most keen to articulate an adherence to postmodernist notions of fragmentation, hybridity, rejection of so-called 'master-narratives' and the demise of the conscious individual and collective subject. Later, I will examine these arguments in more detail and give a rather more detailed account of the relationship of black postmodernist theory to politics.

It is clear, however, that there is no consensus on the meaning and application of the term 'black' within the writings of black artists and critics. Writing in 1988, Kwesi Owusu stated:

> '"Black arts" refers to the creative expressions of the African and
> Asian communities in Britain, both continental and diasporic . . . a
> living, interminable challenge to imperialism in the metropolis. The
> state of consciousness which informs them articulates the dialectics of
> race, sex and class within the context of the exploitative and endemic
> racism of capitalist social relations'.[14]

Reviewing the ground-breaking exhibition *The Other Story*, shown at the Hayward Gallery, London in 1989, and successfully curated by Rasheed Araeen after many years of problems and delays, Lola Young confessed to feeling uncomfortable about using the term 'black' due to its persistent negative connotations. She added:'In any case, Black is increasingly difficult to locate: is it a skin colour, a 'race', a diaspora? Does the term 'Black art movement' still maintain its validity in Britain today? '[15] In a response to the question 'Is Black Art Dead?' put to artists who exhibited in the East Midlands during 1996, it was concluded that rumours of its death had been greatly exaggerated. However, the answers revealed, not surprisingly, a range of understandings and perceptions of what black art was/is. The sculptor Errol Morris, for instance, saw black art as anything created by black people:'As long as Black people are alive, our art forms will always exist.' Keith Piper, on the other hand, stressed the difficulties faced by artists competing in a declining capitalist economy:'The dispute is economic, it is very much a product industry. The future is bleak for Black artists, especially young artists. The public sector is contracting-out. All avenues that were available in the 1980s have now disappeared politically.'[16] This perceptive comment points to one of the key factors in the context of the rise of postmodernity in black art and cultural theory – increasing competition for academic jobs, arts funding, and commissions, accompanied by cuts in government funding on a local as well as a national scale.

In her foreword to the book of the *Mirage* exhibition, which brought together works by artists inspired by the writings of the psychiatrist Frantz Fanon, Gilane Tawadros, director of inIVA (The Institute of International Visual Arts), points to the difficulties in defining the term 'black' and its spelling:

'One contentious issue raised many times within this publication is the use of the word black and indeed its spelling. Many terms or expressions could have been used throughout this publication. The general editorial position has been to use the term 'black' (with a lower case *b*) as referring to peoples of African, Asian, South East Asian, Latino (Puerto Pican, Mexican, Cuban) or Native American descent'.[17]

Black with upper case *B* has tended to be used to refer to Black as a proudly chosen identity, history and culture associated with African roots, distinguishing the term from a simple adjective 'black' describing colour.

In general, I will be using the term 'black' rather than ethnic, diasporic, multicultural, international or any of the other alternatives, because I wish to preserve the resonances of collective perception and response to social oppression on the grounds of 'race' which the history of the term 'black' still incorporates. Where relevant, I will indicate more specific cultural locations of the chosen artists and photographers within the more general term 'black'. I am reluctant to refer to black artists as Black artists, since many would not accept a community of interests exists between all artists who are black, or see their work as being about Black issues. However when referring to generalizing movements, concepts and organizations which assume a collective Black identity, such as Black history, Black liberation, Black community, or Black art movement, rather than individual black artists, I will sometimes use a capital B, depending on the specific instance.

Most of the visual culture discussed and reproduced in this book is the work of artists of South Asian, African or Afro-Caribbean descent. The works of black artists do not necessarily always address 'black issues', nor should they, in my opinion. It seems unfair to burden black artists as a group with expectations and conditions which are not demanded of white artists. For example it is not expected that *all* white artists produce works concerned with social and political issues. I personally find such work more interesting, but this preference needs to be

distinguished from a theoretical definition of what constitutes black art in the late twentieth century.

MAPPING THE FIELD OF STUDY

I want to concentrate in the chapters that follow on examples of visual culture. Since this is a vast field, it is clear that certain limits are necessary.[18] I will not, for example, be discussing black representation on TV in any detail, or programmes made by black producers and directors except in a couple of cases concerning films commissioned specifically by TV channels. It is perhaps worth asking why there seems to be far less of a black presence in the production of TV material than in the visual arts, though as we have mentioned above, the emergence of some black artists who are now well-known, such as Sonia Boyce, Maud Sulter and Keith Piper, may mask the continuing under-representation of many more.[19] In an article welcoming the appointment of Yasmin Anwar as commissioning editor for Channel 4 TV, Trevor Phillips points to the need for her to commission far more programmes which reflect the interests and identities of a multicultural Britain. He cites as evidence the findings of a report published in 1997 by the European Media Forum which showed that Channel 4's multicultural output dropped from 163 to 64 hours a year between 1988 and 1995, a fall of 61 per cent. Multicultural programming fell from 3 per cent to 1 per cent of total output during the period.[20] It may be that the increasing numbers of black art students were able to benefit from the equal opportunities policies of local councils, which enabled exhibition organisers in council-funded venues to argue for exhibitions devoted to the work of both black and women artists in a way that worked rather differently from TV. I do not mean to say that local authority equal opportunities policies brought about a huge change, but I would argue that even a paper commitment allowed some progress when accompanied by determined lobbying and imaginative exhibition programming.[21]

Most of the examples of visual culture in this book are fine art works, photographs, film stills and advertisements. One of the aims in my discussion of these images will be to look at the different media and techniques used to produce them, reasons for the choice of medium, and, importantly, notions of high and popular culture in relation to black visual imagery. It is an important development of the last fifteen years or so that younger black artists are visible at the cutting edge of the fine arts, and it is interesting to examine in more detail how they have

modified our notion of high art, and the conventional association of black artist(e)s with popular cultural forms such as recorded music, dance and other performing arts.

AN 'OTHER' STORY?

The title of the 1989 exhibition *The Other Story* attracted some comment at the time. It is useful to look at its connotations once again, since they raise issues relevant to my own project here. The curator, Rasheed Araeen, did not intend the show to be a history of 'Black' or 'ethnic' art, but an attempt to illustrate the contribution and relationship to European modernist art by 'Afro-Asian' artists.[22] Obviously, the exhibition could not possibly make up for all the omissions, rejections, dismissals and other prejudicial treatment of black artists over many years, and it was wrong to expect it to do so, given the difficulties Araeen experienced in getting the exhibition accepted by the Arts Council.[23] It was criticized for a number of reasons, including the small number of women artists represented and its focus on what Araeen termed 'Afro-Asian' work.[24] Elsewhere, Araeen explained what he understood by Black and Afro-Asian culture:

"Black art", if this term must be used, is in fact a specific historical development within contemporary art practices and has emerged directly from the joint struggle of Asian, African, and Caribbean people against racism, and the artwork itself explicitly refers to that struggle. It specifically deals with and expresses a human condition, the condition of Afro-Asian people resulting from Western cultural imperialism. The condition of diaspora, the feeling of being uprooted and not belonging to the white/Western society [in which] one finds oneself living (by the fact of being placed outside the mainstream of contemporary culture) and subsequently one's commitments or participation in black struggle, are some of the determining factors of this development in art, which I describe as black consciousness and which emerged in the early 1970s. It is not an alternative to or a complete rupture from the mainstream. It represents, historically, a critical distance or radical position within its broad spectrum as a result of the entry and participation of Afro-Asian artists in Modernism'.[25]

Some invited artists refused to participate in a black art exhibition,

apparently seeing it as a kind of aesthetic ghetto.[26] Lola Young was also concerned about the use of the word 'Other' in the title, seeing it as reinforcing the notion of the artists as different, ethnic, black and marginalized – representatives of essential 'otherness' from white mainstream modernism and art institutions. While sympathetic to Young's concerns, I feel that the title of *The Other Story* has additional connotations which can be helpfully interrogated.

The exhibition and the catalogue do tell an/other story – a story largely hidden from the histories of European modernist art production, where black artists were made invisible and ignored. Many pioneering exhibitions and books on women's art started with the same aims – to tell and show what had been 'hidden from history', so to speak. It is arguable that this historical excavation is often a necessary first step before more ambitious questions concerning theoretical frameworks and interrogation of objects of study can be pursued in greater depth. By 1989, the awareness of women's art, publications devoted to it and an interest in women's issues in artistic and academic circles far outpaced comparable developments in black visual culture. We need to realize that Araeen was working in a particular cultural and historical situation which conditioned the result of his committed and dedicated work.

An additional meaning associated with the term 'Other' derives ultimately from Hegel via Jacques Lacan, the French philosopher and psychoanalyst. The term 'Other' (or other) has come to be used in rather a vague way, with both upper and lower case 'o', generally referring to everything that is different and opposite from the individual or group who is speaking. This has been linked to the structuralist notion of binary oppositions which, it is argued, are the building blocks of our existence and perceptions of ourselves and the world eg.male/female; white/black; culture/nature. We experience ourselves as different from the 'Other', and our very identity depends on him/her/it. Stuart Hall has argued that the origins of our notions of 'otherness' stem from Hegel's discussion of the master/slave relationship, which was obviously significant for black cultural critics. The master needs the slave to consciously experience his being as a master; the slave needs the master to experience his being as a slave. Their consciousness can exist only through being experienced through one-another in a process of mutual recognition and definition. This is Hegel's idealist dialectics at work. (In materialist dialectics, the master and slave interact, but the material conditions underpinning their relationship will ultimately have an effect on the slave's consciousness

which may result in something rather different from Hegel's model.) In recent years, Hall has increasingly rejected the term 'black', arguing that it suggests essentialized otherness:

'There's nothing that global post-modernism loves better than a certain
kind of difference, a touch of ethnicity, a taste of the exotic as we say
in England "a bit of the other"'.[27]

One of the problems with the use of the notion of otherness is that it is sometimes employed in a rather wooden, undialectical way. Notions of fixed opposites are conceptualized, for example black/white; female/male. Seen dialectically, these terms are necessarily interpenetrating and contradictory, not separate and unchanging. They should not be abstracted from the particular social totality in which they exist at different historical times. There is, for example, a vast difference between notions of blackness in Hegel's time and in the late twentieth century, which should not be obscured by ahistorical references to master narratives, the heritage of the Enlightenment and so on. Hall believes that, essentially, identity depends on the perceived construction of an opposite: 'Identity is always, in that sense, a structured representation which only achieves its positive through the narrow eye of the negative.'[28] I believe there are a number of problems with this view which will be addressed in more detail later. For the present, I will briefly ask whether this is a permanent trait of all human existence, whether it exists only in relations of power and domination in societies based on the ownership of private property, or, indeed whether black artists are, or will always be, seen as cultural 'others'?

The rather ahistorical nature of some of the writings on 'the Other' by black critics such as Hall, Kobena Mercer and Homi K.Bhabha appear to be influenced by their sources in the idealist philosophy of Hegel, structuralism and the somewhat obscure writings of Jacques Lacan. Lacan's concept of the 'Other' refers to the symbolic order of language and speech. The 'other' (small o) refers to the other who resembles the self, when seen in the mirror, for example, but who never quite becomes one with the self. In opposition to this small other and the ego, Lacan posited the Symbolic pair of Subject and Other, defined in 1955 as 'the place where is constituted the I who speaks with the one who hears'.[29] So here again the subject cannot exist without the Other, this time not an actual person, but the Symbolic place required by the speech of the subject who, for Lacan, is constituted by language. Since the subject is

constituted through language, the existence of an Other – a place from which you are heard and from which you are recognized – is necessary. This is how it is possible for the individual subject to be recognized and find some kind of identity in the symbolic order. When the subject asks 'What am I for the Other?' it is a question about existence and identification. Lacan says that the response to the question 'What am I, what place do I occupy for the Other?' is the fantasy, which involves assuming the identity of some object given a privileged value in relation to the mother eg. the breast, the voice, the look. In the fantasy the child finds a kind of stability by invoking one of these objects not as a circulating object in the chain of symbolic meanings available in the objects surrounding us, but as a reminder, a left-over scrap of the whole operation of entering the realm of the symbolic.[30]

It would appear that Lacan's terms have been taken over and used by many writers on culture in a somewhat loose manner and applied in a variety of ways, which is not surprising given the difficulty of Lacan's ideas. Many critics obviously feel that within Lacan's writings (inspiring or irritating according to one's preferences) is a kernel of interesting insights which can be usefully applied to questions of identity, location, and the construction of a subject who experiences the self as lacking and incomplete, unstable and even inferior. I will return to the notion of the Other/other later in relation to Frantz Fanon.

The more commonly encountered usage of 'Other' is seen in the following example from a book by Peter Rigby:

'Furthermore, in current discussions of multi-culturalism in the United States and Europe, the dominant white, male culture is never placed as "the Other", whose peculiar "differences" need to be explained to anyone. It is only "minorities" (Africans, African Americans, Black Englishmen, Asians, Native Americans) who constitute the Other.[31]

I want to bear this in mind as I write, as I do not want this book to be seen as the product of the relationship between the author and her Other – a white art historian, and black art practitioners seen as exotic and different. In choosing to write on black artists at this particular historical conjuncture, I do so because, in my opinion, much of their work is more interesting than that of their white counterparts, and also, as I hope to show, because I believe the intersection of modernism and postmodernism in the practice and theory of black visual culture has entered a

qualitatively new stage in relation to cultural politics. In an interesting article, A.deSouza shows how the international art market views 'diaspora' and 'ethnic' artists as more interesting, different and 'primitive'. He argues that this results in a contradictory situation for the artists, which can work both for and against them, in that their work is catogorized and stereotyped, but also marketable internationally.[32] However, this made me wonder whether this is similar to the way in which early modernism's interest in so-called 'tribal' and 'primitive' arts was seen as being used to revive the tired art of the imperialist countries? While this attitude has not entirely disappeared, I think the situation in the later twentieth century is very different. Black art is produced both within and beyond the borders of imperialist countries, and many artists can now construct their own artistic histories and identities as authorial subjects, not as producers of raw materials for white artists to use for 'real art works'.

AUTHORIAL VOICE(S)

Readers will have noticed that I am speaking/writing in the first person. This is neither accident nor oversight. I reject arguments which maintain that the individual conscious subject is now an outmoded modernist fiction, crudely conceptualized by the likes of Marx and Freud. I attempt as far as possible to speak/write consciously from a position informed by both subjective and objective factors ie. an art historian, a woman, a Marxist: living in late twentieth century Britain, working in Higher Education in a 'market' context, existing in a society where discrimination on the grounds of 'race' still exists. I could say that I was writing because I am interested in multiculturalism, and/or ethnicities, and in the richness of this pluralistic society and its cultures. However, I am tempted to approach these terms with some wariness. Multiculturalism, which has tended to replace anti-racism as a term, suggests that we live in a society where there are many cultures, and we should all know a bit about each one, value them all, and even consume a part of them all. This obscures the fact that some cultures are seen as cultures of the oppressed, and are not the dominant cultures with the same ideological values. Similarly, the term ethnicities, which Stuart Hall now prefers to 'black', makes me pause for thought.[33] Ethnicities are seen as more radical, challenging and contextual than the constricting essentialities of blackness. Many black artists and writers now speak of inventing their own ethnicities, and displacing previous certainties

of identity and difference. We are all seen as constructed by discourses of ethnicity, a view which reveals that none of us is ethnically pure, clean and white, as in the US artist Adrian Piper's work, where she argues that all North Americans probably have at least one black ancestor.[34] Lola Young sees the term 'ethnicity' as useful because everyone belongs to an ethnic group, including white people, though the latter are usually excluded from any discussion of this categorization.[35] Again, however, I am suspicious. I may choose to invent myself as positioned by a discourse of Celtic ethnicity, but where would this position my ethnicity in relation to national or social oppression within a society based on class exploitation? Ethnicities are not free-floating and of equal status. My (partly) Celtic ethnicity and culture may sound as if I am positioned as oppressed, but in fact the Scottish upper classes willingly joined a union with England and thereafter became partners in the exploitation of colonies, with many lower class 'Celts' participating in this process. On the other hand the Celtic ethnicity of the Republican Irish in both the North and south of Ireland means that despite the recent peace agreement, they still live in a divided nation of which the major part is arguably a semi-colony and the lesser is occupied by the British army. Thus ethnicity as a concept seen in isolation from other factors has serious limitations in understanding historical and cultural identities which are formed in relations of oppression and discrimination. Are we speaking of the ethnicity of the oppressor or of the oppressed?

There are other terms which need further interrogation. However, they are best discussed when encountered in the course of the remaining sections of this book. I want to outline briefly the contents of the chapters which follow, and the way they have been conceptualized. Many of the issues I discuss, and the artists I mention, will appear in more than one chapter. The chapters are not chronological, but based around the discussion of themes and issues which intersect and overlap with others in different chapters. Thus discussions of contexts, identities, sexuality and her/histories will appear in various places, not neatly parcelled up in discrete sections. I want to mention individual artists by name and select examples of their work because, although rumour has it that the author is dead and meanings are constituted by spectators and readers, I want to pay attention to individual agency in the creation of artworks. Also, many students find it very difficult to research the work of black artists because in many cases they do not know their names, and without this authorial name, research in databases can be difficult. I think this is a distinct problem for black artists in comparison to better-known

white ones whose works can be located in books, exhibitions or on an Internet website. Naming and identifying as part of the process of gaining knowledge is important, so the relation of named individuals to issues and themes in visual culture is part of the framework of this study. It is also the case, of course, that the art world is geared to the recognition, exhibition and marketing of the named individual artist as a commodity; the artist's authenticated authorial identity and signature sells the work and/or makes it desirable to seek. In the first chapter, I will be analysing the terms 'modernity' and 'postmodernity' in relation to examples of work by black painters, photographers and film-makers. It will become apparent that the distinctions between modernism and postmodernism are perhaps not so clear-cut nor as universally agreed as we might suppose.

Chapter Two examines why history, truth and the real are still important concerns in recent work by artists such as Dave Lewis, Keith Piper, Roshini Kempadoo, Donald Rodney and Maud Sulter. I argue that writings by such influential critics as Stuart Hall, for example, wrongly deprioritize material factors in crucially influencing the experience and production of visual culture by black artists. Once again notions of modernity and postmodernity in relation to history and subjectivity will be relevant in understanding the techniques and meanings of these photographic, installation and computer pieces.

Chapter Three will examine the themes of identities and contexts. I will be looking at some of the discussions around questions of identity and representations of identities in visual culture. These will be situated in particular contexts of production and consumption, as well as of historical and social specificity. Notions of display, exhibition and classification will be discussed in relation to works by artists who interrogate ethnic/anthropological imagery and its status as science and knowledge, including work by Dave Lewis and Keith Piper. I will also examine cross-overs between high and popular culture around the themes of hybrid cultures. What media, forms of representation and constituencies are involved in the photographic representations of black identities and public and private imagery? What factors are involved in the representation of black people as objects or as subjects? Examples of visual culture discussed here will include portrait photographs from public collections in Birmingham by the professional studio photographer Ernest Dyche, contemporary studio portraits by Asian photographers, and recent artworks using photography by young black women artists of South Asian descent.

The fourth chapter, entitled Black Beauties, will examine works representing the male body and questions of fetishization, sexuality and 'race' in photographs, looking at works by Ajamu, Rotimi Fani-Kayode and Robert Mapplethorpe. Different approaches to notions of fetishism will be examined by looking at the concept of 'performance' in relation to black male identity, advertising imagery, and art works by the US artist Renée Stout and Tam Joseph.

Finally, in Chapter Five I will critically examine theories of the postcolonial and the postmodern in relation to the recent revival of interest in Frantz Fanon in particular. Works by visual artists including Isaac Julien's film on Fanon, *Black Skin, White Mask* will be situated within the debates on the postcolonial, 'race' and class. Looking also at works related to partition and independence, the personal and the national, I also want to examine the relationship of postcolonial theory to the making and understanding of actual art works. I will conclude by assessing the achievements, significance and continuing possibilities for black visual culture as we approach the millenium.

NOTES

1 Janet Wolff, '*Postmodern Theory and Feminist Art Practice*', in R.Boyne and A.Rattansi eds, *Postmodernism and Society*, (Macmillan, Basingstoke, 1990), pp 187–208.

2 D.A.Bailey, '*Photographic Animateur. The photographs of Rotimi Fani-Kayode in relation to black photographic practices*', *Third Text*, Winter, (1991), pp 57–62, quote from p 60.

3 K.Mercer, '*Back to my routes. A postscript to the 80s*', followed by '*A footnote from the nineties*', p 3, CD Rom *Party-Line*, available from Autograph.

4 *From Modernism to Postmodernism: Rasheed Araeen a retrospective: 1959–1987*, Ikon Gallery, (Birmingham, 1988)

5 See for example K.Malik, *The Meaning of Race: Race, History and Culture in Western Society*, (Macmillan, Basingstoke, 1996), M.Kohn, *The Race Gallery. The Return of Racial Science*, (Vintage, London, 1996), and C.Guillaumin, *Racism, Sexism, Power and Ideology*, (Routledge, London and New York, 1995).

6 Guillaumin, p 106.

7 See *Guardian Education*, 4 February 1997, p 9. Another contradiction reported in this same feature was the documented ill-treatment of black people by the same police who receive the rising number of complaints of racial abuse and harassment, coupled with the increasing number of black Britons who felt things had improved over the last five years (over 60 per cent). This may indicate some improvement from a previously dreadful state of affairs, combined with the continuing structural racism of state bodies who deal with 'racial problems'.

8 '*Eddie Chambers. An interview with Petrine Archer-Straw*', *Art and Design*, vol.10, 3/4, March/April (1995) pp 49–57, quote from p 55. Chambers is a

significant figure in the history and development of black visual art practice and theory in Britain. He is an artist, writer and curator, and together with Tam Joseph and Juginda Lamba produced *The Artpack. A history of black artists in Britain*, (Haringey Arts Council, 1988) for use in schools as an introduction to the rich body of work produced by black artists, but seldom studied at the time.

9 Chambers in *Art and Design*, p 55.

10 Interview between Clémentine Deliss and Mark Sealy, from *Metronome*, Dakar, May (1996) available on the Autograph CD-rom *Party-Line*, texts and photographs by black practitioners, available from Autograph.

11 D.Hiro, *Black British White British. A History of Race Relations in Britain*, (Paladin, London, 1992 edition), pp viii-ix.

12 A.Brah, *Cartographies of Diaspora. Contesting Identities*, (Routledge, London and New York,1996) p 14.

13 P.Gilroy, '*Intervention for what? Black TV and the impossibility of Politics*', in J.Givanni ed., *Remote Control. Dilemmas of black intervention in British Film and TV*, (British Film Institute, London, 1995) p 37. In the same publication, Lola Young writes: 'Film-maker Isaac Julien pointed out that the use of 'black' as a term of political organisation has become increasingly contentious because of the recognition that identities are fragmented rather [sic] unitary' p 40.

14 K.Owusu, *Storms of the Heart. An Anthology of Black Arts and Culture*, (Camden Press, London, 1988) p 1.

15 Lola Young, '*Where do we go from here? Musings on "The Other Story"*', *The Oxford Art Journal*, vol. 13. no. 2, (1990) p 53.

16 '*Is Black Art Dead?*', *Flava Magazine*, vol. 2, Summer (1997) pp 8–9.

17 *Mirage: Enigmas of Race, Difference and Desire*, (ICA and inIVA, London, 1995) p 13.

18 John A.Walker and Sarah Chaplin define visual culture as 'those material artifacts, buildings and images, plus time-based media and performances produced by human labour and imagination, which serve aesthetic, symbolic, ritualistic or ideological-political ends, and/or practical functions, and which address the sense of sight to a significant extent'. J.A.Walker and S.Chaplin, *Visual Culture: An Introduction*, (Manchester University Press, Manchester, 1997) pp 1–2.

19 Concern has been expressed over the fact that black people may be 'left behind in the skills market' as financial constraints on TV companies lead to the curtailing of special training schemes, see L.Young, '*Questions of colour*' in J.Givanni ed. *Remote Control: Dilemmas of black intervention in British film and TV*, p 48.

20 T.Phillips, '*Let culture collide with culture*', *The Guardian*, 13 October 1997.See also the interview with the British newscaster Trevor McDonald; K.Ahmed, '*Big Mac bites back*', *The Guardian* (Media Supplement), 22 June, 1998, pp 6–7.

21 For example The City Gallery, Leicester has put on a significant number of shows devoted to the work of black artists, both as individuals and groups, over the past decade. This has meant that black artists' work appears as an integral part of the exhibition programme, not as one or two tokenistic events.

22 R.Araeen, *The Other Story. Afro-Asian Artists in post-war Britain*, (Hayward Gallery, Arts Council of Great Britain, London, 1989).

23 L.Young, '*Where do we go from here? Musings on "The Other Story"*', *The Oxford Art Journal*, vol. 13, no. 2, (1990) p 54.

24 Young, "*Where do we go from here?*", p 53.

25 R.Araeen, 'The Emergence of Black Consciousness in Contemporary Art in Britain: Seventeen Years of Neglected History" in The Essential Black Art (Chisenhale Gallery/Black Umbrella, London, 1988), quoted on p 60 of the exhibition catalogue Transforming the Crown: African, Asian and Caribbean Artists in Britain 1966–1996, (The Franklin H.Williams Caribbean Cultural Center/African Diaspora Institute, New York, 1997).

26 C.Enahoro, review article 'The Other Story – Afro-Asian artists in post-war Britain', Women Artists' Slide Library Journal, no. 31/32 Jan/Feb (1990) p 26.

27 Quoted from 'What is this "Black" in Black Popular Culture?' in J.Givanni ed. Remote Control, p 58.

28 Quoted by J.Gabriel, Racism, Culture, Markets, (Routledge, London and New York, 1994) p 16.

29 Quoted in the entry Other/other by Marie-Claire Boons-Grafé, in E.Wright ed., Feminism and Psychoanalysis. A Critical Dictionary, (Blackwell, Oxford and Cambridge, Mass., 1996) p 298.

30 Clearly this is only a very crude summary of Lacan's theories, which would take too long to study in detail here. For those who want a reasonably accessible outline of his work see D.Leader and J.Groves, Lacan for Beginners, (Icon Books, Cambridge, 1995).

31 P.Rigby, African Images. Racism and the end of anthropology, (Berg, Oxford and London, 1996) pp 1–2.

32 A.deSouza, 'The Flight of/from the Primitive', Third Text, 38, Spring (1997), p 66.

33 Hall, 'New Ethnicities', chapter 21 in D.Morley and K-H.Chen eds, Stuart Hall. Critical Dialogues in Cultural Studies, (Routledge, London and New York, 1996).

34 Piper was often taken to be white, so in 1986 produced My Calling (Card) No.2, which was designed to 'alert white people to my racial identity in advance'. The card is illustrated on p 190 of R.J.Powell, Black Art and Culture in the 20th Century, (Thames and Hudson, London, 1997). As Piper put it: 'If someone can look and sound like me and still be black, who is unimpeachably white?', Adrian Piper, (Ikon Gallery, Birmingham and Cornerhouse, Manchester, 1991) p 26.

35 Young, 'Where do we go from here?' p 53.

CHAPTER 1

QUESTIONING FRAMEWORKS

Rasheed Araeen trained as an engineer in Pakistan, but in the late 1950s embarked on a career as an artist. He decided to travel to Europe to experience modernism at first hand, rather than remain in a semi-colonial country where artists rarely felt their own traditions merited inclusion into global modernism. At this time, international modernism usually meant abstract or non-figurative work concerned with the meanings of materials and forms, rather than a concern with social issues which were seen as 'outside' the art works. Araeen arrived in Paris in 1964 and moved to London in 1969. Evolving through a critical engagement with non-figurative modernism, Araeen turned in the early 1970s to much more active and critical work, such as the performance *Paki Bastard* in 1977. His keenly felt critical admiration of European and North American modernism led him to question the modernist canon, and the ways in which histories of modernism included or excluded certain art practices and practitioners. As noted in the introduction, Araeen's critical engagement with modernism resulted in his curatorship of *The Other Story*, as well as his own art practice, an example of which I will discuss later in this chapter.

In motivating his selection of artists to be included in *The Other Story*, Araeen stated 'My main consideration has been that the work must engage with the idea of modernity (or post-modernity), with its historical formations as well as its socio-cultural constraints and contradictions.'[1] For Araeen, as well as for most other curators, critics, practitioners and theorists of culture in the late twentieth century, the terms of modernism and postmodernism constitute the conceptual and practical framework within which the production and consumption of visual culture takes place. However the terms are subject to critique and debate, and within the sphere of black cultural production and criticism, there are different positions on the nature and significance of modernity and postmodernity. While some critics have welcomed the demise of modernism as the ending of a Eurocentric master narrative which ignored, objectified and stereotyped black cultures, others are more

suspicious of the 'benefits' of the postmodernist theories which have
succeeded the supposedly outmoded narratives of European progress,
rationalism and historical/cultural development.

Adherents of post-modern theories have welcomed the notion of 'the
death of the author', proclaimed by the French cultural critics Michel
Foucault and Roland Barthes, which has undermined the concept of
identity, agency and intention on the part of the artistic producer in
favour of the production of shifting and multiple 'readings' of cultural
artifacts on the part of the spectator.[2] However for others, especially
women, black artists or art students trying to make a name for them-
selves, the benefits of authorial death (in theory) are not so apparent.
For the socially oppressed, who for many years saw themselves excluded
from histories of modernist culture, it is disheartening to find that
notions of history, authorship and creativity have now been changed out
of all recognition, and that the canon of modernist greatness is no longer
available for negotiation and appropriation, but, according to some, has
been totally obliterated. Debra P.Amory has written:

> 'Doesn't it seem funny that at the very point when women and people
> of colour are ready to sit down at the bargaining table with the White
> boys, the table disappears? That is, suddenly there are no grounds for
> claims to truth and knowledge any more, and here we are, standing in
> the conference room making all sorts of claims to knowledge and
> truth but suddenly without a table upon which to put our papers and
> coffee cups, let alone to bang our fists'.[3]

The argument that art works are not the product of individual
creators/workers, but effects of discourse, questions the notion of
individual agency and the ability to act on one's social and cultural
environment through conscious intention. Also, such an approach would
tend to denigrate the efforts made by individuals and organizations to
lobby, picket, protest and cajole in favour of the inclusion of black artists
and women artists in art institutions and exhibitions. If, as many post-
modernists claim, there are no coherent conscious individual or collec-
tive subjects, no historical or social truths – merely discourses which
constitute us as subjects, fragmented and unstable, and cultural signs of
advertising and TV which are more real than material reality – what
particular problems does this raise for black artists and cultural theorists?

One strategy has been to celebrate the demise of fixed identities as
signalling the end of stereotypes of black people and the so-called

'essential black subject'. Now black artists and writers can celebrate their lack of fixed identities: their indeterminacy, their hybridity, their 'in-betweenness'. Identity and knowledge are sources of play, not serious concerns related to situating oneself in the world or actually changing it. The play of images and signifiers, especially using computer technology, has become an important accompaniment of postmodern theoretical influences. So-called virtual reality takes the place of reality, especially in the theoretical approach of the French critic and philosopher Jean Baudrillard. However one major problem has faced black artists and academics interested in postmodernist theories. It is understandable that the dissolution of Eurocentric narratives of history is welcomed, especially when many of these narratives have marginalized black people and distorted their histories. However it is argued that it would be undesirable if black history, indeed *all* history, were to disappear along with Eurocentric history. Given the importance of excavating and preserving the history of slavery and the contribution of black people to world history and culture, there is an obvious reluctance to go along with all the consequences of the most extreme postmodern theory. Most black artists and theorists, then, have been careful about what they have taken from postmodern theory and how they have applied it. Postmodernism is not perceived as an unqualified benefit for the theorization and practice of contemporary black culture. The cultural theorist Manthia Diawara, of New York University, has pointed out that 'In fact, many black thinkers have a suspicious attitude to post-structuralism and postmodernism, in part because they interpret the emphasis that these theoretical projects put on decentering the subject politically – as a means to once again undermine the black subject.'[4] Where critics have welcomed postmodernism, it is perceived as having been modulated by an attention to black concerns, black consciousness, and transformed from the largely pessimistic cultural force – seen, for instance, in the writings of Jameson – to something more hopeful.[5] Richard J.Powell writes:

'Because of an omnipresent racial dimension in the works of these
artists and others working with similar concepts [Gary Simmons for
example], these postmodernist activities are seen as "different". This
ideological aligning of artworks with black history and culture [in
works by Lyle Ashton Harris and Alison Saar, for example] has
converted postmodernism into a far more lineage-conscious and,
therefore, intriguing approach. The role of black culture in this period

of ruin and reconfiguration has been to divest art of its current despair
and create in its place a new optimism, an alternative worldview, and
an unparalleled critical stance'.[6]

I now want to look in more detail at definitions of modernism and post-
modernism with reference to black visual culture, before examining
some examples of visual imagery to see to what extent they relate to the
theoretical terms, and whether in fact modernism and postmodernism
are completely antithetical. I also wish to look at whether modernism
and postmodernism have different meanings and histories for black
artists as compared to others.

MODERNISM

One of the important things accomplished by *The Other Story* was that
it made clear that for many years, black artists have made significant,
though often unacknowledged, contributions to modernist art. Young
writes:

> 'The notion that it is somehow new that black people are immersed in
> artistic production is still prevalent and must be a constant source of
> frustration to those who have been significant participants in the
> history of art without being credited.'[7]

As artists and as subjects of modernist art, black people have been largely
ignored. Thus, it is hardly surprising that the perceived demise of mod-
ernism has often been hailed by both women artists and black artists as
liberating and empowering.

Modernism has been associated with a number of developments in
modern European history and culture. There is debate as to when
modernism actually started. Some place modernism in the eighteenth
century with the rise of the Enlightenment and the beginnings of the
economic and ideological dominance of the bourgeoisie. Thus, the
philosophers Kant and Hegel are seen as modernists.

The beginnings of modernism in visual culture are usually said to
have developed later, in the mid-nineteenth century. The most influen-
tial theorist associated with this view was Clement Greenberg, whose
essay 'Modernist Painting' argues that Manet was the first modernist
painter. In Greenberg's view, Manet's paintings declared themselves to
be flat surfaces, not imitations of three-dimensional sculpture or

representations of literary narratives. Most importantly, modernist paint-
ing was self-critical (following Kant, the first self-critical philosopher,
according to Greenberg).[8] Thus, painting defined its being and develop-
ment primarily in formal terms, in relation to the art which had preceded
it. However, although Greenberg paid almost no attention to the social
and economic pre- and co-requisites of modernist art, these were
extremely significant both in understanding and developing different
types of modernism. Industrialization, urbanization, the development
of a market for commodified art works along with galleries, art critics,
critical literature and commodification of leisure activities were all
part and parcel of the development of modernism. In addition, the term
Modernism was developed, not to describe painting but rather as a term
to cover the approach associated with Greenberg, which sought to under-
stand the development of visual art by formal qualities peculiar to that
specific medium, not by economic, social or historical factors related to
artistic change. Thus, art existed in a world of form, composition, colour,
brushstrokes and other material qualities of the given art medium. The
sphere of existence of modernist art lay between the classical and the
conservative forms of fine art, and the mass-produced forms of what
Greenberg termed 'kitsch' – more popular, usually mass-produced
culture, which required no effort from the spectator or reader, and could
be passively consumed. Examples of this would be so-called pulp fiction,
pop music or comic books.

Modernism was also thought to centre on the individual as a coher-
ent, conscious entity. Freud, described as a modernist, sought to theo-
rize the unconscious mind, but one securely based within the notion on
each individual's particular psyche. Marx, seen as another key modernist
figure, studied how the individual could escape from social, economic
and psychic alienation, and achieve liberation as part of a new class,
the proletariat, which was conscious of its place in history. Whether
functioning as an isolated person or participating in a collective enter-
prise, the individual was an important focus for modernism.

The German cultural critic Georg Simmel wrote:

'The deepest problems of modern life derive from the claim of the
individual to preserve the autonomy and individuality of his existence
in the face of overwhelming social forces.' (1902) [9]

Thus modernism is now seen by postmodernists as hopelessly flawed
due to its construction of, and belief in, a coherent individual subject

endowed with conscious agency, rather than concentrating on the social and cultural discourses which are now said to construct the subject/s.

OLYMPIA

If we look briefly at discussions of one of the key examples of early modernist painting, we can see that black cultural theorists have been justified in complaining about the marginalization of black issues and concerns in 'white' Modernist theory. Manet's famous painting *Olympia*, 1863, (Musée d'Orsay, Paris), represents a nude white model on a bed. Widely thought to represent a prostitute, this was in fact posed by Victorine Meurend, a friend of Manet and herself an artist whose paintings also featured at the Paris Salon exhibitions. Both at the time and since, many critics have focussed their attention on the relationship between the white female nude and the posited spectator who walks into her room, and in doing so, have almost completely ignored the black servant, who offers the young white woman a large bunch of flowers.

Emile Zola, writing in the nineteenth century, had nothing much to say about the figure posed by the black model Laure. Zola mentions the black woman only as an aside along with the cat – someone who is included for her tonal value and nothing more. Addressing Manet he wrote:

'You needed some clear and luminous patches of colour, so you
added a bouquet of flowers; you found it necessary to have some dark
patches so you placed in a corner a Negress and a cat.'[10]

In 1988–89, Georgia Belfont exhibited a mixed media work, *Re-evaluating 'Olympia'*, in which she responded to the presence of the black maid in Manet's painting, and the way in which she had been ignored by critics and historians. Belfont's aim was to draw an analogy between the situation of the black woman Laure, her position in the painting, and the ways in which black women have been ignored or objectified in European culture. The artist substitutes a photograph of herself for the black maid, and the bouquet of flowers offered to Olympia is replaced by a photocopied photograph of Belfont's family. Thus, traces of the reality of black presence and history are inserted into the artist's own reinterpretation of the work. The imagined white male spectator, who is implied but not represented in Manet's painting, is shown in Belfont's work as a silhouette standing in the front centre of the image, a nameless cut-out found by the artist in a magazine.[11]

Two recent books by the American scholars Hugh Honour and Albert Boime have discussed the meanings of 'race' in the painting, and an article by Lorraine O'Grady has argued that the black servant is placed 'outside what can be conceived as woman' so that 'only the white body remains as the object of a voyeuristic, fetishizing male gaze'.[12] Manet himself made disparaging remarks about black women he saw in Brazil, so it is probably fair to conclude that the apparently radical subversion of the male gaze directed at Olympia (who looks straight back) does not extend to a radical representation of black femininity in the same key work of early modernist painting. As a sixteen year old sailor visiting Rio de Janeiro in 1848, Manet wrote:

'Three quarters of the population is Negro, or mulatto. In general, that
portion is hideous apart from a few exceptions among the negresses
and mulatto women; almost all of the later are pretty.'[13]

However, written and visual interpretations of Manet's painting which draw attention to the black woman are not necessarily postmodern by this fact alone. Indeed in the case of Belfont's work, another view of visual history and culture is inserted into the Manet image in order to displace some things and foreground others. This strategy implies a belief that some views of (art) history are more valid than others, and that some histories are emphasized for ideological and cultural reasons and some are not. This would be unacceptable to most postmodernists, who would argue that discourses of blackness, whiteness, gender and so on, all construct their own 'truths', none of them more real than any other.

WHITE MEN OF MODERNISM?

Certain black cultural theorists were glad to see the back of the modernist narratives such as those of Freud and Marx. Postmodern theorists emerged in the wake of the defeat of rioting workers and students in France at the end of May 1968, and so-called modernist projects like progress and socialism were thought to have failed. Rooted in economic and political developments surrounding the apparent survival of imperialism and the collapse in 1991 of the Soviet Union, postmodernism became a cultural movement espoused by many apparently radical cultural theorists. Some black theorists were among them. Kobena Mercer, in particular, welcomed the development of dialogues around hybridization and diaspora. Instead of the political language of

black radicalism – 'race', blackness, immigration and forced migration
for political and economic reasons, we are invited to explore the richer
and more subtle concepts of hybridity (in-betweenness and indetermi-
nacy rather than cross-bred or mongrel), and diaspora (interpreted as a
cultural dissemination and proliferation rather than a forced displace-
ment or exile). This more cultural and less political language was a relief
to Mercer, tired of 'the dialogue which previous generations sought in
the hyphenation of Freudo-Marxism (a word which today reeks of the
funky, musty, smell of hippy kinship arrangements)'. He added that 'con-
temporary hybridity, differentiated by the vocal and visible presence of
others, enriches such inheritance to seek new forms of dialogic *détente*
in a age of post-imperial *perestroika*'.[14] The collapse of the Soviet Union,
so the argument goes, proves that Marxism was fundamentally flawed,
and for Mercer, in particular, all Left politics are tainted with élitism,
hierarchical oppression and blindness to issues of 'race'. I will discuss
the economic, political and cultural contexts underpinning postmod-
ernism in more depth in a later chapter. For the present, however, I want
to look briefly at Hegel, Freud and Marx as modernists, relating their
position in cultural history to issues of 'race'.

The German philosopher Hegel has been criticized by black writers
on several occasions for his schematic views of cultural history. In his
early nineteenth century lectures and writings on art, he characterized
South Asian art as static, spiritual and subjective. Hegel viewed the art
of different countries and periods as various manifestations of the Spirit
– aspects of the self-revelation of God. Araeen rejects this kind of his-
tory of art written from a Hegelian historical framework, and argues that
it undervalued non-European and non-classical cultures.[15] It is certainly
true that a number of Enlightenment thinkers were not particularly
enlightened about 'race'. Another German philosopher, Kant, provides
an example. Discussing the oppressive treatment of women by black
men, Kant writes:

'A despairing man is always a strict master over anyone weaker, just
as with us that man is always a tyrant in the kitchen who outside his
own house hardly dares to look anyone in the face. Of course, Father
Labat reports that a Negro carpenter, whom he reproached for haughty
treatment toward his wives, answered:'
 "You whites are indeed fools, for first you make great concessions
to your wives, and afterward you complain when they drive you
mad." And it might be that there were (sic) something in this which

perhaps deserved to be considered; but in short, this fellow was quite
black from head to foot, a clear proof that what he said was stupid'.[16]

For Hegel, there was 'no subjectivity in Africa . . . but merely a series of
subjects who destroy one another'.[17] Asia is a land of antithesis: 'Here
the opposite principles receive their freest expression; they are the home
of light and darkness, of outward splendour and the abstraction of pure
contemplation – in short of what we call orientalism. This is particu-
larly true of Persia.'[18] Europe has a developed state which has harmo-
nized the equilibrium of these contradictions: 'Those distinct ways of
life which appear in Asia in a state of mutual conflict appear in Europe
rather as separate social classes within the concrete state.'[19] Hegel's is a
teleological view which sees world history as the expression of a Spirit
which has materialized itself in Europe as the highest form of human
civilisation, therefore he selects what he wants to see and believe so that
it shows this to be the 'correct' outcome.

Marx has also been rejected along with the remains of the master
narratives of modernism. Edward Said, in his influential book on
Orientalism, categorizes Marx along with all other Occidentals, in their
oppressive use of 'Orientalist discourse'. Said places a quotation from
Marx at the very beginning of his book: 'They cannot represent them-
selves; they must be represented.' This is accompanied by another from
Disraeli: 'The East is a career.' Thus, Said sets Marx up as an Orientalist,
along with a major ruling class politician. It is therefore implied that
class consciousness is no respecter of Orientalism – all Occidentals
treat Orientals the same way, even if they are revolutionaries. According
to Said, Marx did not sympathize with the sufferings of Indians and
other colonized peoples because they were 'only' Orientals: 'Marx is no
exception. The collective Orient was easier for him to use in illustration
of a theory than existential human identities.' Marx's sympathies were
censored: 'What the censor did was to stop and then chase away the
sympathy, and this was accompanied by a lapidary definition: those
people, it said, don't suffer – they are Orientals and hence have to be
treated in other ways than the ones you've just been using.'[20] Actually
the quotation from Marx at the beginning of Said's book refers to the
French peasantry in the early 1850s and has nothing to do with any
'Orientals'. However Said distorts Marx's views of India in order to
categorize Marx as an Occidental and so slot Marxism into the framework
of Said's understanding of the world as divided between Occidentals
and Orientals. Economics and class analysis have little to do with his

project, so Marx is well and truly damned by being stigmatized as an Occidental Orientalist.

In fact, Marx's analysis of India saw the development of capitalism there as contradictory. It ruined the agricultural and industrial base of village life, but since these villages were also the foundation of back-ward despotism and the caste system, the result, argued Marx, was parallel to the destruction of English village life in the Industrial Revolution. The cost was human suffering on a vast scale, but a prole-tariat emerged from these economic changes. Marx concludes that the Indian proletariat, created in its own interest by the British bourgeoisie, would join 'the most advanced peoples' in the struggle against oppres-sion, which could never have been done in the village system of agri-culture and small-scale industry.[21] It is surely no accident that by the time this argument arrives in an article on 'Black Art' by Kobena Mercer, the quote about 'representing themselves' is used to designate Marx and Marxism as oppressive, disempowering and implicitly Eurocentric. Mercer approvingly refers to the French writers Foucault and Deleuze, who reject Marxism, 'because they recognised the political and ethical violence implicit in Marx's statement "They cannot represent them-selves:they must be represented".'[22] Thus, Marx is stigmatized as an Orientalist and a tyrant, one who by definition cannot offer anything of theoretical or practical use to black people.[23]

I would, however, argue that this is a rather distorted view of Marx's position. For a start, it must be stated that for generations following Marx's death, and even in his lifetime, large sections of the Left in Europe and North America paid little attention to issues of 'race' and racial oppression, and many trade unions did nothing to attract black workers or fight racism on the part of their white members. Yet this needs to be seen historically and politically, and understood and changed, rather than imputed to a caricature of Marxism as Occidental and Eurocentric. Yet this is a view commonly encountered among writers on black culture. One of them has maintained: 'Useful as Karl Marx's theories on class and class dialectics might have been to twentieth-century politics, his attitudes on race and racial aptitudes were hardly more sophisticated than Le Gobineau's . . .'[24]

Gobineau, the so-called 'father of modern racism', published his *Essays on the Inequality of Races* in France in the 1850s. He viewed history as a struggle of three main races for supremacy. These were the nobility or conquering race; the bourgeoisie of mixed stock; and the lower classes who are a result of interbreeding with negroes in the South and Finns

in the North. In his view, all history revolved around whites. Where only black or 'yellow-skinned' peoples lived, 'no history is possible. They did not create anything, and no memory of them has survived ... History results only from the mutual contact of the white races.'[25]

Marx certainly disagreed with Gobineau's ideas on the inequality of human races. He condemned the Frenchman's 'spite' against the 'black race', writing: 'For such people, it is always a source of satisfaction to have somebody they think themselves entitled to *mépriser* [despise]'. However, Marx comments that in spite of the disparaging and racist content of the remainder of his four volume work, Gobineau attributes the source of the art and creativity of white people to the admixture of black blood.[26]

It would be mistaken, though, to say that Marx was entirely free from stereotypical views of black people. To late twentieth century readers, Marx's references to his daughter's fiancé, and later husband, Paul Lafargue, seem insensitive at best. Lafargue had been born in Cuba and had grandparents of black and Caribbean Indian descent. Marx came to refer to him as 'Creole' or 'nigger', and Marx and Lafargue had discussions about the latter's 'Creole temperament', which Marx felt was excessively impetuous. Marx laid down stringent conditions for the betrothal, fearing that his daughter would not be well provided for. Marx wrote to Engels in 1866 that 'yesterday I informed our Creole that if he cannot calm himself down to English manners, Laura will give him his *congé* without further ado ... He is an extremely good chap, but an *enfant gaté* (spoiled child) and too much a child of nature.'[27] Marx's concern for his child's future is apparent, but it is clear that he is not without stereotypical views of the 'nature' of Creoles, in spite of his condemnation of Gobineau's theories on the inequality of races. However it is a vast exaggeration and generalization to conclude from Marx's personal and public writings on 'race' that Marxism is inextricably bound up with a modernist discourse which is built upon foundations of racial oppression, and incapable of offering any critical perspectives on 'racial' subjugation.[28] Marx's writings always stressed the need to fight for the end of all social oppression, and with regard to Ireland, for example, argued that the British workers would never be liberated from their own fetters until they ceased to support the domination and vilification of the Irish by their own ruling class.

Freud, another key figure in the construction of so-called modernist master narratives, has little to say directly about 'race' in terms of black

and white.[29] However in *Totem and Taboo* (1913) Freud had argued that the 'primitive subject', often considered to be the radical opposite of civilized culture in Enlightenment thought,

> 'could function as a medium of understanding the irrational and the unconscious: the mental life of "those whom we describe as savages or half-savages", Freud argued, has "a peculiar interest for us if we are right in seeing it as a well-preserved picture of an early stage in our development"'.[30]

'Primitives', then, experienced the psychic life of an earlier stage of humanity which now lay deeply buried in the mental recesses of the 'civilized' mind. It seems that Freud accepted the hierarchical scheme of human development which saw black people at the bottom, and civilized white Europeans at the top. It is not therefore to the modernist Freud, but to the supposedly postmodernist Frantz Fanon, the radical psychiatrist, that black cultural practitioners and theorists have turned for insights into the psychic internalization of black experience in an oppressive social milieu. In the last chapter, I will discuss Fanon's significance for contemporary black culture and in particular Isaac Julien's homage to Fanon in his recent film *Black Skin White Mask*.

POSTMODERNIST LIBERATION?

For some writers on black culture, the demise of modernism was virtually equated with liberation from colonialism. The dawn of the postmodern era was seen as pregnant with possibilities for a radical re-valuation of cultural difference:

> 'Modernism – let's describe it loosely as the ideology behind European colonialism and imperialism – involved a conviction that all cultures would ultimately be united, because they would all be westernized . . . Postmodernism has a different vision of the relation between sameness and difference: the hope that instead of difference being submerged in sameness, sameness and difference can somehow contain and maintain one another.[31]

Difference, both cultural and artistic, could now flourish in a mutually enhancing relationship, rather than in a relationship based on dominance. This optimistic view of postmodernism articulated by some

writers in the 1980s and early 1990s tended to understate the considerable problems still facing black artists in terms of funding, inclusion in exhibitions and even support on degree level courses.

Several writers in the same collection of essays on postmodernism and black American art, from which the quote above is drawn, clearly welcome postmodernism, but are unsure as to how precisely it relates to black culture. S.Patton, for example, believes that Afro-American artists have a history which is part of American art history, and yet their history was never really included in an oppressive master narrative, so critics have problems analysing the work of Afro-American artists as postmodern.[32] This argument suggests than you cannot be postmodern without first having experienced modernism.

For some black cultural critics and historians, this raises problems. How can an understanding of black history be fully integrated into either modernist or postmodernist frameworks? This has led some black writers to criticize both modernism and postmodernism as failing to offer a conceptual framework for the understanding of black history and culture. Patton argues that successful black artists use 'monolithic propositions such as multiculturalism and feminism (and postfeminism), but deconstruct them at the same time, by claiming their sexuality, race, ethnicity and individuality.'[33] Ann Gibson points out that there is a problem in praising the empowering notion of postmodern difference and fragmentation, when difference has been forced on Afro-Americans and not consciously chosen from a historical position of social equality. She also feels that postmodernism is a totally 'white' construct; so much so that some black Americans would rather move towards some kind of Pan-Africanism.[34] Within the same volume it is argued that postmodernism is just as 'white' and useless for the black artist as modernism was, and also that black artists have been postmodernist since the 1920s, preserving postmodern themes and ways of working throughout the 1950s, 1960s and 1970s during the climax of high modernism: examples are the work of the American artists Faith Ringgold, David Hammons and Betye Saar.[35] Thus when postmodernism 'dawned', white critics finally gave black artists some recognition.[36] I think there is a problem with this view, especially if we see the emergence of postmodern theory as linked to particular economic, social and cultural developments, and specifically to the post 1968 crisis of the Left in Europe which led influential cultural critics Michel Foucault, Jacques Derrida and Jean Baudrillard, among others, to turn resolutely away from Left politics. Thus, postmodernism is not a selection of themes or modes of visual

representation, but a complex and contradictory cultural embodiment of particular material conditions. It follows that postmodernism could not have arisen in the nineteenth or the early twentieth centuries, when the material preconditions for modernism were still developing and maturing. Whether or not it is the culture of late capitalism, as Jameson argues, it needs to be situated in a concrete historical milieu in order to be understood.[37] I will return to this in the chapter on postmodernism and postcolonialism. For the present, however, we should note the genuine and understandable difficulties some black theorists feel exists with both modernism and postmodernism. (Of course many white theorists are also critical of these theoretical approaches, but not for entirely the same reasons.) Black theorists have several explanations for the fact that neither has provided an approach to culture, history and society which adequately relates to black cultures and experiences.

The British sociologist Ali Rattansi has recently argued that a shift towards cultural politics is characteristic of postmodernism.[38] As opposed to political activism in other spheres by artists, writers and others, for example, protesting, lobbying, striking or even voting (!) culture is now the domain in which political contestation occurs. Gone are the old-fashioned notions of strikes, rallies and demonstrations. Cultural theorist Paul Gilroy and others have argued that racism has moved from a scientific concept which was more clearly discriminatory and coercive, to one constructed around culture and identity.[39] Scientific racism developed in the nineteenth century and argued that 'races' were biologically different, with demonstrably different brains, measurements and, therefore, abilities.[40] It is no accident that this argument is paralleled by the trajectory of postmodernist thought which sees old-fashioned political activity as outmoded and dead along with modernism, while any deconstruction or contestation occurs at the level of the cultural sign or a rebellious retreat from politics altogether. Thus at the same time as black art is apparently a bygone product of the 1980s, postmodernist ethnic arts can be political in a new way, by contesting and proliferating identities and cultural constructs. In this way, black art and politics are now redefined for the postmodernist age.

However, as mentioned above, not all writers and artists are comfortable with this kind of re-formulation of the role and significance of culture, especially culture produced and theorized by members of socially oppressed groups. In a very useful article on modernism, postmodernism and black art, Gilane Tawadros, now the Director of the Institute of International Visual Arts, London, discusses some of the problems and

potential for both theory and practice opened up by the apparent demise
of modernism. She argues that the collapse of grand narratives (for
example Marxism, progressive capitalism, modernism and so on) makes
the articulation of black experience possible. But does this imply that
if we say grand narratives still exist, then are we silencing black
experience? Tawadros claims that black and diasporan experience is in
opposition to the 'false unities of Western thought which reach their
apogée in the "supreme fictions" of modernism'.[41] However, she sees
problems in any neat equation of blackness and postmodernity.
Tawadros' useful discussion is too long to summarize in any detail here,
but essentially she agrees with the German critical theorist Habermas
that postmodern and poststructuralist theories evacuate history from
their field of study. Thus, postmodernism allows elements of modernist
thought to exist within it since it has not understood their historical
grounding and has therefore replaced them. Also, postmodernism does
not criticize the continuing hegemony of 'the West', says Tawadros. She
argues that neither postmodernism nor feminism can serve to under-
stand the work of such black women artists as Lubaina Himid, Sonia
Boyce or Sutapa Biswas, since their work incorporates a number of
aspects largely ignored by both these theoretical positions. For example,
Boyce's work may look postmodern in its return to figurative
imagery, but it is not postmodern in its attention to the location of the
individual within a black culture which exists in time and place, for
example the black family in contemporary Britain. Similarly, aspects of
Boyce's work which revolve around the experiences of the black girl
child or black woman (for example *She ain't holding them up, She's
holding on [Some English Rose]*, Middlesborough Museums and
Galleries, 1986) have been marginalized within the concerns of
contemporary feminism, which have increasingly been concentrated on
career prospects for mainly white professional women, or 'difficult'
academic theory. Yet historical understanding needs to be preserved.
Thus, Tawadros suggests replacing grand narratives with small
narratives, in order to 'clarify the broader political and aesthetic project
which informs black women's creativity and from which it derives'.[42]
Black artists, she claims, need to occupy 'a radical position actually
within modernity.'[43] Tawadros concludes:

'In this context, the "populist modernism" of black cultural practice,
. . . . signals a critical reappropriation of modernity which stems from
an assertion of history and historical processes . . . In opposition to

the theoretical structures of postmodernism, black cultural politics
insists upon the ascendancy of a broader aesthetic and political
project which redefines the agenda of modernity through a critical
interrogation of the past and according to the political imperatives of
the present'.[44]

This article is instructive, because Tawadros wants to hold on to notions
of history and politics and tries to cut across the rather restricting
framework of the concepts of modernism and postmodernism. Ultimately
however, she goes for a project of radicalized modernism, in which black
practitioners and theorists contest existing cultural, philosophical and
artistic concepts. However, it is not quite clear precisely what are those
'black cultural politics' to which Tawadros refers. Similarly, the politi-
cal imperatives of the present she mentions are left vague. Black cultural
politics need an infrastructure to support their growth and development.
It is doubtful whether the current weakness of this infrastructure can be
addressed primarily by means of 'cultural politics'. Nonetheless,
Tawadros tries to grapple with the dominant cultural paradigms of the
late twentieth century and relate them to black (women's) art theory and
practice, which in one essay is no mean feat.[45]

Similarly, the American literary scholar Manthia Diawara would rather
preserve a critical modernism with a political edge:

'Elsewhere, I have defined blackness as a modernist metadiscourse on
the condition of black peoples in the West and in areas under Western
domination . . . Blackness, in the last instance, is a reflexive discourse,
what W.E.B.Du Bois would have called "an afterthought of moder-
nity", a critical theory on the cutting edge of modernity and mod-
ernism, a frontline discourse . . . Blackness, as a modernist
metadiscourse on the West imbued with revolutionary potential, is
always enabling as a model to other repressed discourses like
feminism, gay and lesbian rights, and minority cultures in totalitarian
systems'.[46]

What I wonder though, is whether the concepts of modernism and post-
modernism, as theoretical terms, are imprisoning, rather than enabling
ones; ones which perhaps should be set aside for a different approach.
What if, for example, we interrogated the production and theorization
of black culture in the late twentieth century from a Marxist perspective
using the concept of dialectical materialism, or giving more emphasis to

notions of class? These have been largely ignored or written out of the debate, leaving writers and critics to continue discussion within the rather restricted theoretical field of modernism and postmodernism; here, postcolonialism appears as a possible development of post-modernism and alternative choice. For the moment, however, let's look further at the concepts of modernism and postmodernism, their antago-nisms or interactions, in relation to some recent examples of visual culture made by black artists.

REPRESENTING BLACK MODERNISM?

An understanding of the supposed incompatibility between non-figurative art and social/political engagement on the part of the artist is crucial to any discussion of modernist visual culture and black identities. During the twentieth century, it has often been argued that non-figura-tive art – art which represents no recognisable objects from the mater-ial world – is concerned mainly with form, and therefore cannot be a suitable vehicle for the articulation of thoughts, opinions and experi-ences of a political or socially critical nature.[47] On the other hand, art which is naturalistic and realistic in a broad sense, has often been seen as the necessary mode of representation for artists who wish to challenge the dominant ideology of their particular society. Examples of this are, for example, French nineteenth century Realism or Soviet Socialist Realism, advocated by the Stalinized Communist Parties from the 1930s onwards in the (then) USSR and the rest of Europe. Party cultural officials argued that non-figurative art such as that of the modernists Rodchenko and Lissitsky, was too difficult and élitist for 'ordinary' people to understand. Effective critical art had to be figurative. Even the writer Bertold Brecht, a committed modernist who wanted to develop radical formal and technical innovations in his theatre, argued that a revolutionary realism was what modernism in the theatre was all about. However the supposed antithesis of non-figurative and figurative art was not so simple.

The well-known and extensive art historical and critical debates around American Abstract Expressionist painting have shown that even the most abstract, non-figurative works could be mobilized for political and ideological ends in the interest of the American 'free world', albeit largely unintended by the artists themselves. The works of the American Abstract Expressionists were exhibited abroad as representations of pure freedom in contrast to the totalitarian manifestations of Soviet Socialist

Realism prevalent in 'The Eastern Bloc' and China during the 1950s. Certain artists and critics argued that the act of painting modernist art was political in itself, for example Greenberg in his essay 'Avant Garde and Kitsch' from the late 1930s, or the American critic Harold Rosenberg, who argued that painting modernist pictures was a revolutionary act.[48] What is crucial here is not the particular ideology or stance embodied in the mode of pictorial representation of specific artworks, but the total historical, social, economic, political and cultural context in which they exist, and are viewed.[49] Obviously this context changes as the art works become part of cultural history. We need to be careful, then, of too restrictive a perception of the non-figurative, modernist art work as dead for social criticism and engagement, while the figurative art work or image is seen as automatically a better vehicle for the questioning of dominant cultural ideologies. Advertising imagery is an obvious example of how easily understood and accessible figurative imagery can have little critical edge at all. There are many examples which could demonstrate this, but the British TV advert for Danish bacon with international goalkeeper Peter Schmeichel as a singing pig-farmer takes some beating. Some artists have tried to subvert advertising imagery precisely to expose the ideological work it carries out in positioning, viewing and consuming subjects within a society structured around capitalist property relations with concomitant relations of social oppression.

Nonetheless it is true that many artists working in non-figurative and abstract styles have made a point of rejecting any link between their art and an interest in social and/or political comment. Speaking in the documentary *The Colour of Britain*, the sculptor Anish Kapoor, the UK Turner Prize winner in 1991, articulates a similar position to that of Rosenberg speaking of the American Abstract Expressionists – the creative act is a political act. For Kapoor, art should articulate the poetic and the sublime, making us aware of phenomenological presences, deep emotional responses and so on. The idea of more directly political or socially engaged art is alien to him, and he argues that poetic art is political art.[50]

Some non-figurative and abstract black artists have attempted to work through the relationship of their particular mode of image-making to black identity and consciousness. This has not always been easy. Modernism can be seen as a white creation, utilizing black culture for its own ends, but never fully acknowledging black, Asian or Oceanic cultures on their own terms. Should black painters attempt to avoid modernist painting and turn to figurative representation of black

experiences, engage critically with modernism, or paint modernist paint-
ings on the existing terms of modernist art? All of these alternatives
posed problems and, to some extent, still do, even in this postmodernist
period.

At a conference organised in 1967 by the Caribbean Artists' Movement,
Elsa Goveia (the first person ever to be appointed as a Professor of West
Indian History) asserted that some West Indian painters 'tend to think
in terms of abstract art rather than in terms of painting which can be
socially influential'. The two painters who spoke later that day both
worked in abstract styles, and were concerned to identify such painting
as no less important to black social commitment than figurative painting.
One of these painters, Aubrey Williams, was worried by a 'prevalent
conception that good art, working art, must speak, it must be narrative'.
But he was unwilling to be categorized as an abstract artist, saying that
Caribbean artists should be allowed to develop their own style, free from
labels. However, he felt that abstract work could automatically be appre-
ciated by Caribbean people since they live in an environment which
appears 'naturally "abstract", . . . not [yet] rearranged too much by the
hand of man. We are losing it fast, but we are lucky to have our roots
still in the earth of the Caribbean . . . It is a very strong landscape and
the primitive art that came out of this landscape remains unique. We
should be proud of our non-figuration.'[51] Williams, whose own work is
actually abstract rather than non-figurative, (that is to say it represents
identifiable objects painted in a non-naturalistic way), produced some
impressive paintings inspired by the native heritage of Central America
and his love of Shostakovich's music, creating powerful and sensual
coloured images. Non-figurative art, therefore, was not necessarily seen
as alien to black culture and the embodiment of black aesthetic sensi-
bilities. Even so, abstract art had its black opponents, as Richard Powell
has pointed out in his recent book on black art and culture. He illus-
trates an interesting cartoon published in the 1950s in a Pittsburgh news-
paper which shows a black artist with a beard and a beret standing beside
an abstract painting with some disembodied forms of an eye and an ear
floating in an indeterminate space. Another man looks at the canvas in
amazement. The caption reads: 'No, it don't make no sense to me niether
[sic] Bootsie, but white folks jus' wont buy nothin' if it makes sense!'
Powell feels that the cartoon was addressed to a largely sympathetic
black audience which viewed abstract painting as a 'con', and who felt
alienated from the white art world of the avant-garde.[52] This cartoon
raises interesting issues concerning the possibilities of a place for the

black modernist artist, however. Was there a space for the development of black experiences within abstract modernist painting? Would the black modernist painter enter a largely white art world and be viewed with suspicion by wider sections of black communities? For artists who travelled this road in real life, the experience was not at all amusing.

Frank Bowling, who, like Williams had been born in Guyana, was also committed to modernist non-figurative painting and 'emphasized the conscious and often effective insertion of a black cultural sensibility into such Western art protocols as painterly abstraction . . . Bowling claimed that a new form of racial and cultural authenticity could result from excavations of materials, methods and the self.'[53] (plate 1) Bowling's trajectory from figurative to non-figurative painting dates from the early 1970s, when arguably high modernist abstract painting was in decline. Given the debates which were taking place around black art, modes of representation and social meaning in the following decade, most of the younger black artists went in the opposite direction, from non-figurative to more figurative art, as for example in the case of Rasheed Araeen.

FRANK BOWLING AND MODERNIST PAINTING

Bowling was a member of a group at the Royal College of Art, London, who appeared to be on the way to successful careers. As recounted by Rasheed Araeen and Mel Gooding, Bowling was part of the emergence of 'new figuration' in Britain in the early 1960s, but found that he was being left out of group shows because his work was 'different':

'We were all painting from newspaper cuttings, photographs, films etc, but I wasn't allowed to be a Pop artist because of their preoccupation with what was Pop. Mine was to do with political things in the Third World. I chose my own themes, such as the death of Patrice Lumumba, because this was where my feeling was. So I was isolated. It was a racist thing anyway, the whole thing . . . I did not paint Marilyn Monroe because she did not interest me. Kitaj did not paint Marilyn Monroe either; He painted *The Murder of Rosa Luxemburg*'.[54]

Bowling was shocked and confused when he was left out of an important exhibition at the Whitechapel Gallery in 1964. He attempted to discover why he had been rejected and was told 'England is not yet ready for a gifted artist of colour.'[55] In the mid 1960s, Bowling left England to live in New York, and rethought his art and his career. Some tried to

point Bowling in the direction of famous black cultural figures of Afro-American descent, but Bowling shied away from specifically 'black' cultural precedents, not wishing to be labelled as a "black" artist:

'Distilling my drive to painting was the human dilemma and all this business about suffering; trying to put it right by showing it . . . Yes, soul. I felt that; and people turned me towards examples which they thought would be important to me, but were not. Like Richard Wright

plate 1 *Frank Bowling, Rule Britannia, 1995, acrylic on canvas, 66 × 51 cms. Courtesy of the artist. Photograph Mike Simmons.*

and Paul Robeson, people to whose tradition I don't really belong,
because I am British. What I painted was human concern'.[56]

After coming into contact with the influential critic Clement Greenberg,
Bowling felt his evolving ideas confirmed: 'The moment I met Clem
Greenberg I knew I was right . . . Clem was able to make me see that
modernism belonged to me also, that I had no good reason to pretend I
wasn't part of the whole thing.'[57] Now Bowling had to work through the
relationship of 'blackness' to modernism. He wrote: ' . . . there is some-
thing which is very distinctly Black – as there is something very
distinctly Jewish, or Scots/Irish. But there is no Black Art. I believe that
the Black soul, if there can be such a thing, belongs in Modernism. Black
people are a new and original people'.[58] Here Bowling seems to be
accepting the possibility of essential black identity, but arguing that there
is no particular cultural expression of this. As a new and modern peo-
ple, black people were a part of modernism in a historical sense, which
meant they could be part of it in an artistic sense. In an essay originally
written in 1970, Bowling maintained:

'My art is Formalist and my experience, that of a black artist.' For
Bowling, the sort of figurative and illustrative imagery of what passed
for 'Black Art' failed to articulate 'the awesome subtlety of black
experience, indeed experience of any sort. At any rate, that experience
doesn't show up in the handling.'[59]

Bowling's particular form of modernism was similar to that advocated
by Greenberg as the high point of painterly achievement. The purity,
self-referential and self-critical nature of the medium were paramount.
Experience and 'freedom' (Bowling's word) were not pictured or
narrated, but embodied in the making of the work. The works do not
express emotions or make points, but are there to be read by the spec-
tator as a material presence made up of paint, gel, bits of plastic and
acrylic foam, sometimes objects enmeshed in the paint, sometimes torn
strips of old paintings around the side, as in the example illustrated,
Rule Britannia. (plate 1) Layers of paint threaten to make the pure two-
dimensionality of the work split at the seams as the light falling on
the works reveals various depths and thicknesses of paint substances.
The top third of the canvas is dark blue, the bottom, two thirds yellow
with blue, red and green.The strips round the sides are painted pale
green, orangey-pink, and blue at the top.

However, Bowling still wondered how the authenticity, freedom and existential action of his art-making could be relevant to others within his notion of 'formalist' modernism. It is, in fact, arguable that his works are not strictly formalist i.e. concerned only with their own composition, making and arrangement. He asked: 'On confronting pictures, one asks oneself not only are they good? are they bad? but now ever more crucial; are they relevant, in what sense, to whom?'[60] Bowling's use of titles in more recent works begins to hint at other concerns outside the painted surface itself – personal, cultural, historical. The rich chromatic construction of his works are the opposite of traditional academic notions of black as a non-colour. The darkness in some of his works is multi-coloured, however in spite of his painstaking works, many of his questions seem unanswered. His continuing commitment to the development of a particular kind of modernist art as relevant to 'black experience' seems individually rather than more generally valid. His particular strengths and endeavour continue to give life to what seems in many ways an ahistorical art. This makes it very different from current concerns of many black theorists and cultural practitioners in their interrogation of history, however this concept may be embodied in cultural productions. Bowling's large, dense and rich testaments to the power of painterly labour are very much gallery pieces in a different way from the mixed media, computer-generated imagery or installation pieces produced by many among the current generation of black artists. The force of Bowling's work is, of course, in its presentation of painting as painting first and foremost, despite suggestive, sometimes playful connotations ascribed to it by his titles. It is left to the spectator to relate the title of *Rule Britannia* to the non-figurative shapes and different textures of the painted surface.

FROM MODERNISM TO POSTMODERNISM?

In contrast to Bowling, who has continued to produce non-figurative paintings, other artists decided that high modernism, with its emphasis on purity of materials and aesthetic concerns was not a comfortable space which the consciously black artist could inhabit. I want to look briefly at how this alternative trajectory relates to the work of Rasheed Araeen, and whether the change in his work during the mid 1970s can be defined as post-modern, or a development of modernism. It is important to bear in mind that not all modernism is, or was, of the kind advocated by Greenberg and Bowling, and that modernist works often engage with

political and social themes, as for example in Italian Futurism or even Cubism.

Born in Pakistan and trained as an engineer, Araeen left for to Paris and then London in the 1960s. His non-figurative sculptures produced in the mid-1960s and early 1970s ultimately proved inadequate for his purposes. While Bowling went to America and engaged with abstract modernism, Araeen rejected abstract modernism for an art practice which became both more figurative and more confrontational. His writings on art, collected under the title, *Making Myself Visible*, published in 1984, aptly sum up his change in direction from a nonexistent presence in his art, which appeared to be a rather cold, distant and impersonal international modernism, to engaged, present, visible and black. In view of the traditional 'invisibility' of black artists in modernism as it existed in imperialist countries, this was an important new departure for the artist, who was intent on interrogating his own cultural identity in what seemed more suitable forms. Araeen was also instrumental in founding the black art magazine *Black Phoenix*, in 1978, which was later incorporated into *Third Text* which began publication in 1987. However, was Araeen's change of direction a critical intervention in, and supercession of, modernism, or a qualitatively new development of a postmodernist black British art?

The British critic and art historian John Roberts tries to answer this in his essay, '*Postmodernism and the critique of ethnicity:the recent work of Rasheed Araeen*'. Roberts sees postmodernism as a progressive development for black artists and theorists, enabling them to 'decentre' the imperial and patriarchal discourses of power which constitute Western culture. However, Roberts pertinently asks a question that should be asked far more often: How does one position oneself differently, offer different subject or viewing positions, construct different ethnicities and diasporic narratives without falling into relativism? (Relativism believes there is no truth which is more accurate than another truth, since all values and beliefs are relative to particular sets of circumstances and are therefore variable.) Unfortunately, many of the writings I will mention in this book fail to address this crucial question. It is rarely confronted head on, and tends to be disguised in discussions of 'multivalence', 'ambiguities' and 'potentialities'. This is a weakness of most postmodern theory, which denies that we can know any truth which is not already constructed for us, placing us within a particular relation of power/lessness with regard to 'knowledge' and a proliferation of 'discourses'. Thus, there is no truth and so, postmodernist thought

side-steps the question of relativism. Roberts argues that relativism can be avoided by a democratic, anti-imperialist position, though this is articulated in a rather understated way:

'If, then, acknowledging what separates us can easily lead to the free play of the *différend* and the politics of the shopping list – there are no longer any special antagonisms which have a privileged status in constituting political divisions – the recognition of difference as the coming to speech of others is not to be separated from the question of self-determination and self-organization.[61]

I will return to these issues later. In the 1970s, Araeen was 'the Modernist who happens to be black', and his response to this positioning was rather different from that of Bowling.[62] How was he to enter into the 'Modernist/Postmodernist power-bloc' without losing the sense of a critical cultural identity? Roberts suggests that the solution for Araeen was to enter into a relationship with Western Modernity as both defender and critic.[63] Thus, argues Roberts, Araeen remains in this sense a modernist. His approach to previous and existing culture and its institutions is to question them from a self-aware and self-critical position. But surely any interesting art would work on and transform its material and context in some way? Surely one would not have to be a modernist to interrogate one's own practice? Is it the case, then, that the critical element of postmodern culture is hidden and implicit – ambiguous and unstable? Is it the adoption of particular *attitudes* to the critical use of form and materials that distinguishes the postmodernist artist from the modernist, or is it the adoption of particular theoretical positions on the unknowable meaning of truth, subjectivity and history? Or should we see modernism and postmodernism as purely chronological terms, which conveniently finish at certain identifiable times? The last is fairly easily dispensed with as modernism still exists, even in the fairly narrow sense defined by Greenberg and Bowling. But what of the others? Perhaps after a closer look at Araeen's *Green Painting* and the other works in this chapter we may hazard some conclusions.

GREEN PAINTING

Araeen's *Green Painting* of 1985–6 (plate 2) is indeed green as far as the painting sections are concerned, perhaps connoting the Pakistani flag, and thereby the flag paintings of the stars and stripes by Jasper Johns.

plate 2 *Rasheed Araeen, Green Painting, 1985–6; mixed media, nine panels, 173 × 226 cms overall, collection Arts Council of Great Britain. Photo Arts Council of Great Britain.*

However, the rest of this mixed media work is made up of photographs of blood on the ground following the ritual slaughter of animals during the Muslim festival of Eid-ul-Azha, and texts in Urdu taken from newspapers reporting Benazir Bhutto's house arrest and the former US President Nixon's visit to Pakistan. The grid-like structure set up by the green painted shapes recalls the canonical works of high modernist painting. At first sight, the photographs and texts seem to be the exact opposite of the mode of visual representation associated with international modernism. The photographs imply reality, documentation and a specific moment and place. The newspaper quotations refer to the world of politics, information and narrative. However, the artist's aim was to disturb these supposed antithetical modes of visualization. He has stated that 'the "primitive" periphery is cleared of all traces of expressionism (bloody ritual) which is then transferred to the central space (a cross/Ad Reinhard). The Modernity of Minimalism is thus "restored" to its origins in Islamic culture, which remains fragmented (four parts) and occupies corners of the dominant culture.'[64] Araeen dialecticizes the relationship of the different visual cultures, questioning their absolute difference and separation, and the hierarchy of the

relationship of modern/ist vs. primitive. He positions himself within a knowledge of, and participation in, both cultures, but this position is within the imperialist West. In Pakistan, the meanings of this painting may well be different. The common (religion-based) rejection of representations of the human in Islamic and also in high modernist visual culture are posited, but then undercut, as the photographs reassert themselves as 'real'. Araeen rejects the identity of 'ethnic artist' by demonstrating his ability to bring the two cultures of Pakistan (living ritual) and US/Europe (high culture in art galleries) into a fruitful contradiction. Roberts argues that this artwork is an example of international culture, but I would argue that it is an international culture which is positioned and exhibited in England. It has been pointed out that the Urdu texts mean that the final act of meaning lies with the Pakistani (or Urdu-speaking) spectator, as the white viewer will probably not possess the necessary skills to fully interpret the work. However is the work international because it addresses both Pakistani and white English viewers and means different things to both? Roberts argues that this work transforms modernism, and articulates a new postmodernist politics of reading by placing the onus of gaining new knowledge with the Western spectator. Roberts also maintains that this work shows that both naturalism and expression must be superseded in such politics of representation. Modes of cognition and representation cannot be 'givens' but must be subject to critical enquiry. He concludes that 'The useability of Postmodernism for black Third World artists such as Araeen therefore lies very much in the critical link it can make between the exhaustion of Modernism as a transgressive paradigm and a critique of the colonial discourse.'[65]

Interesting though it is, I am not totally convinced by Roberts' argument here, since he previously stated that Araeen's new project was to transform modernism. Now we are told that *Green Painting* is postmodernism due to the fact that it makes us question modes of cognition and representation, in this case specifically concerning relations of cultural and political imperialism. Surely this is at odds with much postmodern theory, which largely dismisses the notion of imperialism (the economic exploitation of countries carried out through direct or indirect means) in favour of the vague term 'postcolonial' (following the end of colonial rule). Could *Green Painting* not be read as a modernist work of a different kind to Araeen's earlier non-figurative pieces? Can we even decide this without situating the work within a totality of historical, cultural and social spaces which are notably absent from Roberts' essay,

despite his references to the politics of anti-colonialism? We cannot con-
clude on the evidence of an isolated art work whether it is modern or
postmodern, since this becomes merely a stylistic activity, akin to con-
noisseurship. A further point to note is the continuing recourse to state-
ments by the artist which are given the status of knowledge in this
postmodern age of the 'death of the author' (in my opinion this consid-
eration of authorial statements is necessary and useful). I feel this is a
particularly important point with respect to black artists who have been
silenced and marginalized in the past. Whatever the discourses of sex-
uality, colonialism, ethnicity or modernism may be, they are lived, and
worked on, by individuals in a social context. Without subscribing to
what is now considered a naïve view of human intention and agency, I
would maintain the importance of the authorial voice for our under-
standing of black visual culture. If we do not listen to the voices of the
creators of black culture, attempting to understand why and how they
represent certain things, then we also play a part in suppressing active
subjects from history and culture. Furthermore, it would be wrong to
preserve the voice of the critic and historian as an authorial voice while
the artists' words are reduced to the level of one possible discourse
among many others. Given the number of white theorists who have writ-
ten about black artists, this point is particularly significant in arguing
against 'the death of the author' with respect to black culture.

CHRIS OFILI

The exhibition of work by young British artists at the Saatchi collection
shown at the Royal Academy, London, in 1997 attracted considerable
media attention. However this was not, as might have been expected,
due to materials in one of the paintings which included elephant dung,
but rather to the inclusion of Marcus Harvey's huge portrait of Myra
Hindley, made up of hundreds of tiny children's handprints. Hindley
and her then lover Ian Brady were jailed for the infamous Moors murders
in Yorkshire in the early 1960s, which involved the abduction, torture
and killing of a number of children. Winnie Johnson, mother of one of
the victims, stood outside the gallery urging people not to go in and in
this way show their disapproval of the picture, and of Hindley's appeals
for release from prison. Hindley has repeatedly attempted to gain parole
on the grounds of her repentance as a Christian. The Academy saw the
protest as 'censorship' and refused to bow to it. The show went ahead
as planned. In this context, other works that might have attracted a more

sensationalist brand of criticism were relatively quietly received, among them one of the two versions of Chris Ofili's *Afrodizzia*. The second version is illustrated here. (plate 3)

Ofili's parents are Yoruba-speaking Nigerians who emigrated to Manchester shortly before his birth. Apparently, Ofili first used elephant

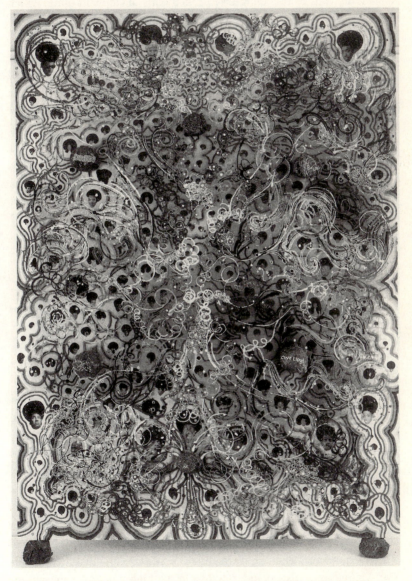

plate 3 *Chris Ofili, Afrodizzia, Second version, 1996, mixed media, acrylic, oil, resin, paper collage, glitter, map pins and elephant dung on canvas, 183 × 122 cms. Courtesy Victoria Miro Gallery, London.*

dung in his paintings while on a British Council travelling scholarship
to Zimbabwe in 1992. Although the US artist David Hammons had made
a series of sculptures of elephant dung in the 1980s, Ofili, apparently
unaware of this, embarked on his own artistic relationship with this
exotic and fetishistic organic material.[66] Ofili's large paintings lean
against the wall resting on tightly packed balls of elephant dung, which
is also sometimes used in the paintings themselves, pierced and deco-
rated by round-headed map pins. Ofili's activity has not been confined
to paintings though. In both Berlin and London, he went along to street
markets, spread out a bit of cloth on the ground and attempted to sell
elephant dung to passers-by, in a spoof art sale reminiscent of Dada
activities and David Hammons' snowball sale. He describes his stint at
London's Brick Lane market:

'It was in the cheap part of the market where people lay out old shoes
and odds and ends. Bourgeois people go down to the flea markets on
a Sunday afternoon and buy something off the poor. I wanted to place
myself in that situation. People were forced to think of the situation of
me, a man of African descent, selling something exotic and unnatural.
There was one guy hanging around, and when the crowds had died
down he asked if I had any dope'.[67]

Neighbouring traders were not impressed, however, thinking Ofili was
mocking them when he pointed out he was not really interested in selling
his wares.

The elephant dung is incorporated into Ofili's works along with
photographs, glitter, oil and acrylic paint, resin, and pins. The paintings
are built up in layers on underpainting. His work *Captain Shit and the
Legend of the Black Stars*, 1996, has lighting behind it and so glows in
the dark. His 'black madonna', *The Holy Virgin Mary*, 1996, has the tra-
ditional blue coloured robe and bared breast (the nipple formed from
elephant dung), but is surrounded not by adoring angels but by
photographs of female genitals scavenged from pornographic magazines.

Ofili's work would seem, at first sight, to be liable to criticism from
people offended by his attitude to religion, black culture, women, or
indeed shit. But the overall impression of his work is that of sensual
visual experience. The paintings glitter and dazzle in a real feast for the
eye. Though they are not autonomous in the high modernist sense, they
certainly offer a pleasurable experience of painterly construction to the
viewer. In addition, the content of Ofili's work certainly relates to black

history and high and popular culture in a quite original way. The works are playful, easily accessible and enjoyable and do not require an in-depth knowledge of difficult theory on the spectator's part. So far I have not come across any articles on Ofili's work by the 'big guns' of black cultural studies and I wonder if this is a coincidence. Is Ofili's work an example of playful postmodernism in the sense that identity, subjectivity and consumerism are not 'givens' of our psychic and social existences, but are pleasurably and constantly re-invented by playful or so-called 'ludic' performances of 'race', gender and sexuality? Could we all play at being Captain Shit or at believing in the Black Holy Virgin?

Both versions of *Afrodizzia*, in particular, are stunningly colourful and sensuous works, obviously picking up on one of the connotations of the title. Dizzy with visual sensations, the spectator then picks up the 'Afro' part of the Afrodizzia, and recognizes various photographs of famous black 'stars' wearing painted Afro hairdos, for example Cassius Clay, James Brown, Miles Davies, and Richard Roundtree (star of 'Shaft'). Clive Lloyd, Don King and LL Cool J join the list in the second version. Diana Ross is also recognizable. Ofili has said that it does not matter if the spectator is unable to recognize all the faces – the point is they are recognized as *black* faces.[68]

Though rather differently from some of the other artists I discuss in this book, Ofili sees himself as engaged in a creative reinterpretation of black culture, and as a black artist. He is interested in exploring aspects of black popular culture which have sometimes been seen as 'politically incorrect', such as the culture of so-called blaxploitation, or the use of black female models in pornographic magazines. In discussion with a friend, broadcast as part of a TV documentary on the artist, Ofili locates himself as an English artist in the tradition of Sickert and Turner but 'not like them'. He describes his art as English but confused and mixed up English. The friend laughs and says 'nigger English', and Ofili modifies this slightly by replying 'colonized English'. One of the works in his recent solo exhibition consisted of a ball of elephant dung with eyes, Ofili's baby teeth and some of his dreadlocks, entitled *Shithead*. This darkly humorous title suggested another side to Ofili from the play-ful, colourful and sexy feel of most of his paintings.

The hallucinatory explosion of pinks, blues and yellows in *Afrodizzia* goes well with the 1970s style of the era of both blaxploitation and black power. The figure at the bottom of the first version of the painting has the word 'respect' shaved across the lower part of his head under the Afro. Is this postmodern parody and playful nostalgia, or a modernist

intervention in the self-critical development of painting as painting? Certainly one critic has gone for the Modernist reading. Stuart Morgan writes: 'Like early Modernists, he borrows and adapts freely.' Comparing Ofili's interest in the circus with that of Picasso, Morgan comments 'For Picasso, the circus produced fine paintings one by one. For Ofili, it provides a thread, however nonsensical, by which painting can continue, commenting on itself, building a language, offering the development of the ego and contact with the beautiful. In short, style, brought to abstraction in a difficult time.'[69] Here the critic detects alive and well, and not surprisingly living in the Saatchi collection, the heroic lineage of the Modernist narrative, its self-interrogatory nature, its drive to abstraction or at least it does so in Stuart Morgan's view. While I would not agree with the particular emphasis of this reading of Ofili's work, it is clear that the death of Modernism and modernist painting has been much exaggerated. Not surprisingly, elements of modernist and postmodern culture can be seen in one and the same work, perhaps because they have been intentionally put there, or perhaps also because artists work through the culture that exists so as to eventually supercede it. For me, the elements in Ofili's work weigh down the scales on the side of the postmodern, rather than the modern, mostly because of the obvious visual playfulness of the work, and the idea that there is not so much a particular view of history and/or black culture embodied in the work, but rather a kaleidoscopic exposition of simultaneous choices and experiences which are made as part of the work and experienced as such. However just as there are different modernisms, there are different postmodernisms.

DESIRE, CULTURE AND POSTMODERNITY

Isaac Julien's film *The Attendant*, made in conjunction with Channel 4, opened at the Institute of Contemporary Arts, London in 1993. This short film admirably articulates a number of thematic concerns associated with postmodernist black culture; these include the decentering of European high culture, the interrogation of the position of sexuality and blackness within high culture, and the significance of black histories in understanding the economic and cultural identities of black people in the present. Reality and fantasy are entwined in the structure of the film, where both black and white and colour photography are used to good effect. The spectator is invited to think about his/her own position in relation to the various tableaux presented in the course of the film. The

film does not work through narrative but by the presentation of various moments, static tableaux, frozen images and slow motion shots and soundtrack. There is no dialogue as such, but a soundtrack includes the sound of whipping, moaning, Jimmy Somerville's voice, and 'Dido's Lament' from Henry Purcell's opera *Dido and Aeneas*. At points in the film representatives of black popular culture or cultural studies appear, for example Hanif Kureishi and Stuart Hall.

The film starts with a shot in colour of a nineteenth century French painting representing scenes of the slave trade in Africa by Biard, and ends with another colour shot where the camera slowly moves in towards the torso and face of a beautiful black man with shaven head, enigmatic expression and a jewelled collar resting on his shoulders. He stands in front of a curtain which is coloured a rich, saturated pinky/mauve. His brown body and bare chest and head stand out against this background as a beautiful icon of erotic gay male black desire (see cover illustration). Thus, the film is placed between these two images, one of slavery represented by a white European artist, where black people are dominated, and subject to violence such as whipping and branding; the other where the black body is not exploited as a commodity on the market, but as a highly fetishized sign of desire and sexual pleasure only consumable by the eyes. We cannot possess him through the film, merely look and fantasize, like the museum attendant of the film's title. Julien refers to the transformation of the Biard image as 'reworking the tableau – turning abolitionist pathos into images of dangerous desire!'[70]

The eponymous attendant is a black, middle-aged man who works in the Art Gallery in Hull. Among the pictures he guards is the one by Biard. This painting of the slave trade was originally exhibited at the Royal Academy in London in 1840 and was given to Sir Thomas Fowell Buxton 'to commemorate the abolition of slavery (1833) for which he had been among the most active workers, as well as promoter of exploration and the extension of legitimate trade in West Africa', as Hugh Honour puts it.[71] The motives of the white abolitionists certainly amalgamated humanitarian concerns with the economic interests of the upper classes among the colonial powers, who eventually came to believe that the hiring of free labour was more productive than the system of slave exploitation. When Biard's paintings of the evils of the slave trade were exhibited, however, they were said to represent events 'more morally beautiful than pleasant to paint' and a critic added, regarding one of the artist's later paintings, that 'these Negroes, to whom it was no doubt right to restore freedom, will always show up badly as principal figures

in a picture.'[72] Thus black people could be objects of pity, but not objects of beauty. Nor were they likely to be represented as subjects.

In the fantasies of the attendant, however, all this is changed. As the camera pans across the wall of this classically constructed museum, the images in the frames change from Biard's painting to tableaux of semi-nude males, both black and white, wearing bondage clothing. The violence of the slave trade becomes transformed into eroticized gay male sexual violence. (plate 4) The attendant, wearing his uniform and hat, is shown whipping a white visitor, while a black woman gallery employee listens in fascinated anticipation on the other side of the wall. As he walks downstairs afterwards, the attendant kisses her on the mouth. Thus sexuality and desire are seen as fluid, crossing 'races' and genders.

The boredom of the attendant's job is hinted at as the silent contemplators of high culture wander through the gallery and a ticking watch marks the time spend by the attendant in his labour as he searches through bags and sizes up the visitors. I was reminded of the many times I have visited exhibitions where all the gallery attendants were black, but the exhibition directors and organisers were white. In particular I noticed when I visited the small exhibition entitled *Picturing Blackness in British Art*, at the Tate Gallery, London, a couple of years ago, the only black person in the room who was not in a painting was the attendant.[73]

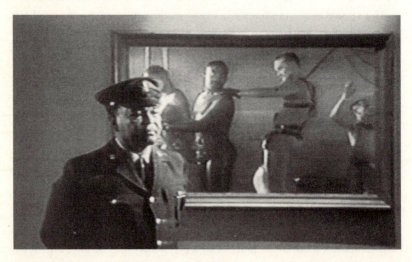

plate 4 *Isaac Julien, still from The Attendant, 1993, Normal Films. Courtesy Victoria Miro Gallery, London and Isaac Julien.*

The attendant also enters high culture in his fantasy. He is dressed in evening dress with a tail coat, and sings to an almost empty opera house, applauded in slow motion by the black female gallery worker seen earlier, now also in evening clothes. He mimes to a slowed-down version of 'Dido's Lament' with the refrain 'Remember me, remember me . . . '. Dido's tragedy as a beautiful African Queen abandoned by her white lover is perhaps linked to the frequent use of Dido as a name given to black female slaves by their masters.[74]

In this attractively ambiguous and sensual film, Julien articulates issues of sexuality, desire, history and culture in ways which make the spectator assume various viewing positions, and question his/her own relation to cultural consumption as well as assumptions about high culture. The only slight criticism one could make of this is that it is very much an 'art' film, and at the Institute of Contemporary Arts it was never likely to reach a mass audience. However this is hardly Julien's fault, and in any case its screening on television did alleviate this situation. One of Julien's concerns is to disrupt what he has called 'the "sameness" of old-fashioned (white) modernism', and change the situation where high culture is actually white art cinema and popular culture is where black cinema exists. Julien adds: 'We are in fact trapped within the confines of hetero-populist black culture in the cinema and comedy in television, while white "drama" and white British cinema – those uniformly high-cultural modernist occupations – continue to define who can enter its canon and who cannot.'[75] So, one of the points of the film is to entice the viewer into what appears to be a 'high-culture' experience of art and opera, and then challenge it by representing presences and desires usually excluded from élite culture. *The Attendant* goes some way to addressing these issues which Julien develops in other work which I will look at later. The great strength of this film is its suggestive undercutting and problematizing of binary oppositions such as black/white; gay/straight; white institution/ alienated black workers; reality/fantasy. Julien's work suggests more dialectical and interactive contradictions than structuralist opposition, and the film works really well because, as a visual and aural sensory experience, it makes a powerful impact. However I would hesitate to describe it as either modernist or postmodernist, preferring to see it as the dialectical coming together of both, resulting in a work that supersedes definitions in any limiting sense. While Julien uses many strategies associated with postmodernism such as irony, mimicry and the disavowal of linear narrative, his overall project of undercutting white high culture and creating strikingly

desirable images of black gay male sexuality suggests that for Julien, certain discourses are more emancipatory and valuable than others.

CONCLUSIONS

The frameworks of modernism and postmodernism have certain limitations as means of understanding black visual culture. Furthermore, it is clear that there is no consensus among black theorists and practitioners as to whether modernism is 'dead' as far as black art is concerned, or whether it can be radically transformed into a modernism where black history and culture exist as radical component parts of a living totality of complementary and contradictory factors. Also, while some critics view postmodernism as a new cultural departure full of radical possibilities for the previously fragmented and marginalized to move centre-stage, the rejection of any historical truths or knowledge by certain postmodernists causes serious problems. As we have already noted, Gilane Tawadros in her essay '*Beyond the Boundary:The work of three black women artists in Britain*' seeks to stand back from both modernism and postmodernism, speaking from a position attentive to black history and identities, attempting to argue for a modernism whose concerns are more relevant and conducive to black culture. My own sympathies tend to similar conclusions regarding the possibility of a radicalized modernism, though probably not for the same reasons as Tawadros. I doubt whether there is a radical kernel which can be extracted from the idealist fruit of much postmodernist theory. I would argue that in order to examine the historical significance of these terms in relation to black culture, a theoretical position is needed which situates social oppression and positioning of black subjects individually and collectively in contemporary capitalist and imperialist societies. Rather than modernism and postmodernism being the organizing categories of late twentieth century culture and its analysis, we need other theories and positions from which to analyse modernism and postmodernism themselves. The next chapter will look further at the historical and cultural contexts in which postmodernism became an important theoretical issue for and in black culture.

NOTES

1 Quoted by C.Enahoro, review article, '*The Other Story – Afro-Asian artists in post-war Britain*', *Women Artists Slide Library Journal*, no.31/32, Jan/Feb (1990), p 26.

2 R.Barthes, *'The Death of the Author'*, in *Image/Music/Text*, (Hill and Wang, New York, 1977), pp 142–8, and M.Foucault, *'What is an author?'*, in *Language, Counter-Memory, Practice*, (Cornell University Press, Ithaca, 1977), pp 113–38.

3 E.Shohat and R.Stam, *'The Politics of Multiculturalism in the Postmodern Age'*, *Art and Design*, vol.10, July/August (1995), p 11.

4 M.Diawara, *'Black Studies, Cultural Studies. Performative Acts'*, *Afterimage*, October (1992), p 7.

5 See for example F.Jameson, *Postmodernism, or the Cultural Logic of Late Capitalism*, (Verso, London, 1991).

6 R.J.Powell, *Black Art and Culture in the 20th Century*, (Thames and Hudson, London, 1997), pp 166–7.

7 Young, *'Where do we go from here? Musings on "The Other Story"'*, *The Oxford Art Journal*, vol.13 no.2, (1990), p 52.

8 C.Greenberg, *'Modernist Painting'*, published in 1965, reprinted in F.Frascina and C.Harrison eds, *Modern Art and Modernism: A Critical Anthology*, (Harper and Row in association with The Open University, London and New York, 1982), pp 5–10.

9 For a good recent discussion of Modernism as a term see C.Harrison, *'Modernism'*, in R.S.Nelson and R.Shiff eds, *Critical Terms for Art History*, (University of Chicago Press, Chicago and London, 1996), pp 142–55, quote from Simmel on p 143. Also useful are the introduction and chapter 1 of F.Frascina, N.Blake, B.Fer, T.Garb and C.Harrison, *Modernity and Modernism.French Painting in the Nineteenth Century*, (Yale University Press in association with the Open University, New Haven and London, 1993).

10 E.Zola, *'Edouard Manet'*, in Frascina and Harrison eds, *Modern Art and Modernism*, p 36. It is true though that Zola reduces almost everything and everyone in Manet's paintings to pretexts for formal experimentation. T.J.Clark, *The Painting of Modern Life: Paris in the Art of Manet and his Followers*, (Thames and Hudson, 1984), Chapter 2, also almost ignores the figure of the Negress. Harrison does not discuss the black servant either, see Harrison, *'Modernism'*.

11 Many thanks to Eddie Chambers for drawing this work to my attention. See *Black Art: Plotting the Course*, catalogue by Eddie Chambers, (Oldham Art Gallery, Oldham, 1988), artist's statement and notes on slide 3, no pagination.

12. A.Boime, *The Art of Exclusion. Representing Blacks in the Nineteenth Century*, (Thames and Hudson, London, 1990), and H.Honour, *The Image of the Black in Western Art IV, From the American Revolution to World War 1*, part 2, *Black Models and White Myths*, (Harvard University Press, Cambridge, 1989). L.O'Grady, *'Olympia's Maid. Reclaiming Black Female Subjectivity'*, *Afterimage*, Summer (1992), pp 14,15,23, quote from p 14.

13 Quoted in Honour, *The Image of the Black*, part 2, p 206. It is possible that Manet had changed his ideas somewhat by the time he painted *Olympia*, though we have no evidence other than a reference to Laure, the black model as 'Laure, a very beautiful negress.'

14 Mercer, *'Busy in the Ruins of Wretched Phantasia'*, in *Mirage. Enigmas of Race, Difference and Desire*, (Institute of Contemporary Arts, Institute of International Visual Arts, London, 1995), pp 50–51.

15 Araeen, *The Other Story*, pp 9–10.

16 I.Kant, *'On National Characteristics'*, in E.C.Eze, ed., *Race and the Enlightenment. A Reader*, (Blackwell, Oxford and Cambridge Mass., 1997), p 57. There is an interesting review of Eze's book with remarks on 'race'

and Enlightenment philosophy by Bob Carter, 'Out of Africa: Philosophy, 'race' and agency', Radical Philosophy, 89, May/June, (1998), pp 8–15.

17 Hegel, 'Geographical Basis of World History' in Eze ed., p 126.

18 ibid., p 145.

19 ibid., p 149.

20 E.Said, Orientalism, (Penguin, Harmondsworth, 1987), pp 153–6 for this argument.

21 See K.Marx, 'The Future Results of the British Rule in India', in Surveys from Exile, (Penguin, Harmondsworth, 1973), pp 323–4. Aijaz Ahmad has also criticised Said's representation of Marx in 'Marx on India: A Clarification', in In Theory. Classes, Nations, Literatures, (Verso, London and New York, 1992), pp 221–42. See also the excellent discussion by B.Chandra, 'Karl Marx, his theories of Asian societies and colonial rule', chapter 14 of Sociological Theories: Race and Colonialism, with an introduction by M.O'Callaghan, (UNESCO, Paris, 1980). This book also has a section on Marx and Engels and 'race' in N.N.Cheboksarov, 'Critical Analysis of racism and colonialism', chapter 13, especially pp 348–357.

22 K.Mercer, in Third Text, 10, Spring (1990), p 72. The footnote in his article refers to Said's book, not Marx's original text on nineteenth century France. It seems odd that Mercer does not find the postmodern thought of Foucault and Deleuze similarly 'Eurocentric'.

23 This is in spite of the fact that there have been considerable numbers of black Marxists, see C.J.Robinson, Black Marxism. The making of the Black Radical Tradition, (Zed Press, London, 1983). Though ultimately finding Marxism wanting, Robinson offers an interesting perspective on the possibilities and difficulties of building a 'black Marxism'. For a time the Sri Lankan Trotskyists formed one of the largest Marxist parties in South Asia and were probably more numerous than British Trotskyists.

24 J.Ross, 'The Timeless Voice. Reflections on imperatives for the new Language', in K.Owusu ed., Storms of the Heart. An Anthology of Black Arts and Culture, (Camden Press, London, 1988), p 233.

25 Malik, The Meaning of Race, pp 83–4.

26 S.K.Padover ed., The Letters of Karl Marx, (Prentice Hall, Englewood Cliffs, New Jersey, 1979), p 270. This remark by Gobineau was also noted with approval by the poet and black activist Aimé Césaire and the African poet Léopold Senghor, who both sought to emphasize 'négritude' (blackness) as the source of artistic inspiration and creativity.

27 The Letters of Karl Marx, p 218. See also pp 214,216–8.

28 Marx's nickname Mohr (German for Moor) was apparently due to his dark skin and admiration for Shakespeare's character Othello. Letters from his daughter Eleanor to him sometimes use this name as a term of endearment, see Y.Kapp, Eleanor Marx, vol.1, Family Life (1855–1883), (Lawrence and Wishart, London, 1972), pp 153–4.

29 Sander L.Gilman, Freud, Race, and Gender, (Princeton University Press, Princeton, New Jersey, 1993) deals primarily with Jewishness as 'race', and Michael Vannoy Adams, The Multicultural Imagination. "Race", Color, and the Unconscious, (Routledge, London and New York, 1996), has more on Jung than on Freud.

30 S.Gikandi, 'Race and the modernist aesthetic', in T.Youngs ed., Writing and Race, (Longman, London and New York, 1997) p 157.

31 T.McEvilley writing on West African artists at the Venice Biennale, 1993, quoted in D.C.Driskell ed., African American Visual Aesthetics. A Postmodern View, (Smithsonian Institution Press, Washington and London, 1995), p 17.

32 ibid., pp 45–6.

33 ibid., p 73.

34 ibid., p 91–2.

35 For examples of these and other black American artists' work see
C.A.Britton, *African American Art: The Long Struggle* (Todtri, New York,
1996).

36 Driskell ed. *African American Visual Aesthetics*, p 92.

37 The literature on postmodernism is now so vast that only a selection of
books can be suggested here. F.Jameson, *Postmodernism, or the cultural
Logic of Late Capitalism*, (Verso, London, 1991); D.Harvey, *The Condition
of Postmodernity: An Enquiry into the Origins of Cultural Change*,
(Blackwell, Oxford and Cambridge Mass., 1990); E.A.Kaplan,
Postmodernism and its Discontents: Theories Practices, (Verso, London,
1988); N.Wheale, ed., *The Postmodern Arts. An Introductory Reader*,
(Routledge, London and New York, 1995). An accessible discussion of
postmodernism in recent visual art can be found in P.Wood, F.Frascina,
J.Harris and C.Harrison, *Modernism in Dispute: Art since the Forties*, (Yale
University Press in association with the Open University, New Haven and
London, 1993), pp 237–256. For those struggling with postmodernism a
useful start might be R.Appignanesi and C.Garrett, *Postmodernism for
Beginners*, (Icon Books, Cambridge, 1995), which is also available on audio-
tape. For critical views of postmodernism see in particular A.Callinicos,
Against Postmodernism: A Marxist Critique, (Polity Press, Cambridge,
1989), and my *Materializing Art History*, chapter 6 'Marxism, the postmod-
ern and the postcolonial', (Berg, Oxford and New York, 1998).

38 A.Rattansi, '*Just framing: Ethnicities and racisms in a "postmodern"
framework*', in L.Nicholson and S.Seidman eds, *Social Postmodernism:
Beyond Identity Politics*, (Cambridge University Press, Cambridge, 1995), pp
250–86.

39 Gilroy, '*The peculiarities of the black English*', in *Small Acts: Thoughts on
the politics of black cultures*, (Serpents Tail, London and New York, 1993),
pp 49–62. This is not completely new, however, and it has been pointed
out that this also happened in the later nineteenth century, when racist
ideology became more 'popularized' among greater numbers of lower-class
people: 'The work of the French thinkers of the late nineteenth century
was important in allowing the themes of racial discourse to be recast in a
more acceptable form. Rejecting the idea of biological races, they neverthe-
less maintained the essence of a racial outlook while substituting culture
for biology as the medium of human difference.' K.Malik, *The Meaning of
Race: Race, History and Culture in Western Society*, (Macmillan,
Basingstoke, 1996), p 143. Racism can change at different times and may
re-utilize 'old' racist ideologies modulated in a new context.

40 For scientific racism see the section '*From Romantic reaction to scientific
racism*' in Malik, *The Meaning of Race*, pp 84–91, and for recent attempts
to return to scientific racism see M.Kohn, *The Race Gallery: The Return of
Racial Science*, (Vintage, London, 1996).

41 G.Tawadros, '*Beyond the Boundary: The Work of Three Black Women
Artists in Britain*', reprinted in H.A.Baker Jr., M.Diawara and R.H.Lindeborg
eds, *Black British Cultural Studies: A Reader*, (University of Chicago Press,
Chicago and London, 1996), chapter 13, p 243. This was originally
published in *Third Text*, 8/9, Winter (1989).

42 ibid., p 269.

43 ibid., p 262.

44 ibid., pp 274–5.

45 On these issues, but less useful than Tawadros' essay, see also M.Wallace, *'Modernism, Postmodernism and the problem of the visual in Afro-American culture'*, in R.Ferguson, M.Gever, T.T.Minh-ha, C.West eds, *Out There: Marginalization and contemporary Cultures*, (MIT press, Cambridge Mass. and London, 1990).

46 Manthia Diawara in G.Dent ed, *Black Popular Culture*, A Project by M.Wallace, (Bay Press, Seattle, 1992), p 290.

47 For a good discussion of notions of realism and political engagement in the inter-war period see Paul Wood, *'Realisms and Realities'*, chapter 4 in B.Fer, D.Batchelor, P.Wood, *Realism, Rationalism, Surrealism: Art between the Wars*, (Yale University Press in Association with the Open University, New Haven and London, 1993).

48 F.Orton, 'Action, Revolution and Painting', *The Oxford Art Journal*, vol.14, no.2, (1991).

49 I will be attempting to approach some key examples of visual culture from this perspective later in the book. For an extended example of the situation of an image in its total context see my *Materializing Art History*, (Berg, Oxford and New York, 1998), pp 115–137, where I discuss a photograph by the French artist Claude Cahun in the context of France in 1936.

50 *The Colour of Britain*, film by Pratibha Parmar for Channel 4, 1994.

51 A.Walmsley, *The Caribbean Artists Movement 1966–1972: A Literary and Cultural History*, (New Beacon Books, London, Port of Spain, 1992), pp 99–100, for this quote and further discussion of the Conference. Williams, who was born in Guyana and died in 1990, was recently the subject of a major solo exhibition at the Whitechapel Art Gallery, London in Summer 1998. I was surprised to discover that hardly any of the works of this significant British artist had been purchased for public collections, and many of his works were still for sale.

52 R.J.Powell, *Black Art and Culture in the 20th Century*, (Thames and Hudson, London, 1997), pp 107–8.

53 ibid., p 94.

54 *The Other Story*, p 39.

55 ibid., p 40.

56 *The Other Story*, p 120.

57 ibid., pp 120–21.

58 *The Other Story*, p 121.

59 M.Gooding, *'Grace Abounding. Bowling's Progress'*, *Third Text*, 31, Summer (1995), pp 43–4. For more by and on Bowling see Bowling's *'Formalist Art and the Black Experience'*, *Third Text*, no.5, Winter (1988/9), pp 78–82, and the exhibition catalogue from the City Gallery, Leicester, 1996, organised and curated by Eddie Chambers, *Frank Bowling: Bowling on through the century*.

60 Gooding, 'Grace Abounding', p 44.

61 J.Roberts, *'Postmodernism and the Critique of Ethnicity: The recent work of Rasheed Araeen'*, in *From Modernism to Postmodernism. Rasheed Araeen a retrospective: 1959–1987*, exhibition catalogue, (Ikon Gallery, Birmingham, 1987). There is no pagination in this catalogue – the quote is from page two of Roberts' essay.

62 Roberts' essay on Araeen, same page.

63 Roberts, page 2 of his essay on Araeen.

64 Roberts' essay on Araeen. p 5.

65 ibid., p 9.

66 On Ofili see L.Buck, *'Chris Ofili'*, *Artforum*, September (1997), pp 112–3; T.R.Myers, *'Chris Ofili Power Man'*, *Art/Text*, part 58, Aug-Oct. (1997),

pp 36–9; S.Morgan, '*The Elephant Man*', *Frieze*, issue 15, March-April (1994); G.Worsdale, '*Chris Ofili*', *Art Monthly*, July-Aug., (1996), pp 27–8; A.Searle, '*Feeling Frenzy*', *The Guardian*, 16 September 1997, pp 10–11; A.Searle, '*The best of British Painting?*', *The Guardian*, 19 November 1997. S.Durrant, '*Chris Ofili: Who flung dung?*', *The Guardian*, review section, 21 September 1998, pp 4–5; M.Coomer, '*The Boy Dung Good*', *Time Out*, September 30–October 7, 1998, pp 14–5; R.Cork, '*The name to droppings*', *The Times*, 6 October 1998, p 35. While probably enjoying his recent publicity, Ofili must be getting tired of the embarrassing titles of many of these articles and reviews. Also useful is the recently published catalogue, *Chris Ofili*, (Southampton City Art Gallery and The Serpentine Gallery, London, 1998). These are useful interviews with Ofili on websites, for example, http://www.illumin.co.uk/britishart/artists/co/co int9.html and int2.html.

67 J.Jones, 'Off the shelf', *The Guardian*, 18 December 1997, pp 10–11.

68 Ofili in TV programme *Fresh*, broadcast by London ITV 6 June 1998.

69 S.Morgan "The Elephant Man", *Frieze*, issue 15, March–April 1994, p 43.

70 Personal communication to the author.

71 *The Image of the Black in Western Art*, IV, From the American Revolution to World War I, vol I, *Slaves and Liberators*, (Harvard University Press, Cambridge and London, 1989), p 150. The painting is illustrated in colour as plate 89.

72 Honour, ibid., p 172.

73. *Picturing Blackness in British Art, 1700s–1990s*, Tate Gallery November 1995–March 1996. There is a leaflet by Paul Gilroy produced to accompany the exhibition.

74 Thanks to Liz McGrath, Warburg Institute, University of London for this information. See also the painting of Dido Lindsay and her half sister, both daughters of Sir John Lindsay. Dido's mother had been "taken prisoner" in a Spanish vessel by Lindsay and had given birth to his child later. In a will dated 1783 Dido Lindsay was left some money and her freedom. See colour illustration and information on p 26 of D.W.Bygott, *Black and British*, (Oxford University Press, Oxford, 1992).

75 I.Julien, "Burning Rubber's Perfume", in J.Givanni ed., *Remote Control. Dilemmas of Black Intervention in British Film and TV*, (British Film Institute, London, 1995), pp 59, 61.

CHAPTER 2

ECONOMICS, HISTORIES, IDENTITIES

In the later 1980s, some key theorists of black culture began to reject the very notion of black culture. They argued that the idea was essentialist and insufficiently subtle to designate the multiple ethnicities and subject positions embodied in the cultural productions and experiences of black artists, film makers and photographers. For example, in his essays 'New Ethnicities' (1989) and 'What is this "black" in black popular culture?' (1992) Stuart Hall argued that it was no longer what united black people that was most important – rather, it was the study of diversity in black culture and its new cultural politics of representation.[1] Why did this happen? What were the conditions in which this shift took place, and what has it meant for the theorization of black culture in its relation to the economic, political, social and ideological situations in which it is produced and consumed?

I want to try to answer these questions by looking at some photographic-based work by artists who, in their different ways, deal with aspects of black history. As understood by the artists themselves, these histories and identities are linked to wider issues of political, economic and cultural domination and exclusion. Postmodernist ideas seem less influential in artistic practice than in the writings of cultural theorists such as Hall. In order to compare and situate Hall's theoretical development in relation to recent examples of visual culture, therefore, this chapter will include an explanatory assessment of Hall's political and cultural views. The artists whose work I discuss here are Dave Lewis, Keith Piper, Roshini Kempadoo, Donald Rodney and Maud Sulter.

'YOUR COUNTRY NEEDS YOU'

I want to begin by looking at works by Dave Lewis. Lewis works with photography, not because he believes that it presents us with a singular 'Truth' and objectivity, but because he invites the viewer to look again at what might seem certain 'givens' of material existence. In this

way, he believes that the spectator can engage with 'various discourses which are otherwise hidden or not readily accessible.'[2] An example of this is his photograph included in a series of portraits of black ex-servicemen from the Second World War, *Allan Alexander, Merchant Navy Cook who served in the North Sea and the Middle East.* (plate 5) This portrait is different from the usual studio portrait photograph. The subject is posed as part of an elaborately staged tableau in front of

plate 5 *Dave Lewis, Allan Alexander. Merchant Navy Cook who served in the North Sea and the Middle East, ca 1996, colour photograph. Courtesy of the artist*

memorabilia evoking different aspects of visual culture relating to the War. Celebratory patriotic posters from the Imperial War Museum show Winston Churchill, the then British Prime Minister, white pilots looking onwards and upwards under a quotation from Churchill – 'Never was so much owed by so many to so few' – and in the top centre, an image of some very white and well-bred servicemen enjoying the opportunity to play sport in the Army. The Union Jack and the banner of the West Indian Ex-Servicemen's Association with a palm tree are accompanied by a text on the left of the image: 'The decision to rescind the colour bar', a text reading 'My blood was spilt', and an image with a soldier asking 'Is your journey really necessary?' Allan Alexander looks out at the spectator with a rather quizzical expression as he puffs on his cigar, perhaps intentionally reminding us of some of the famous images of Churchill used for propaganda purposes in the War. The rich colour of the photograph emphasizes the contemporary presence of Alexander and makes him seem more real than the flat-looking graphic imagery surrounding him, and presents him as an obvious focus for the cluster of meanings they suggest. Here, history is revolving around an individual who lived that history and helped to make it. Also, this individual shared certain experiences with others who, like him, came from the Caribbean (or from Asia) to serve in the British forces. Black service personnel like Alexander are hidden from the official posters, but foregrounded in Lewis' photograph. While the image certainly does not suggest a single truth or make a statement, it implies that there are alternatives to the imagery of the War which we usually see in history books and museum displays. It also infers that historical knowledge are often incomplete and are selected for us by institutions which, in many cases, give a view of British history and culture that omits or marginalizes black presences, contributions and indeed labour. Looking at this image, we may recall the phrase 'There ain't no black in the Union Jack', and think more about the relationship of people like Allan Alexander to the British state and its interests.[3]

Historical testimonies of black people involved in the war effort also help us to understand the meanings of Lewis' portrait photograph. One unidentified Jamaican who was interviewed by Pete Grafton for his book on 'People out of step with World War II' often wondered why on earth he volunteered. Was *his* journey really necessary? Stationed at Filey and bored by his training, he would ask himself 'What the hell am I doing here? There's no war in our country.'[4] This particular man had joined up in Kingston when he was 17. Although he was apprenticed to his

uncle, a carpenter, there was little work and local unemployment was high. Most of the work available was on sugar plantations. After the Americans came to build a base on the island, there was more work and he would have gladly stayed, but some army police came to pick him up. 'If I remember rightly, when the Americans started the base, Churchill told Roosevelt not to pay the amount of money they were paying to the Jamaican workers, for after they finished, there would be no more work and they'd be looking for the same pay.'[4] The Jamaican government paid an extra five shillings a week to Jamaican airmen, together with extra rations of sugar. This led to some envy from the other servicemen, but also meant whites would join the West Indian table in the hope of sharing sugar as well as company. Caribbean servicemen were sometimes subjected to racism in bars and clubs.[5] A vicar's wife near Weston-super-Mare suggested a code of behaviour for the local women which included as points five and six: 'White women, of course, must have no relationship with coloured troops' and 'On no account must coloured troops be invited into the homes of white women.'[6] *The Sunday Pictorial* newspaper condemned this attitude, stating 'There is – and will be – no persecution of coloured people in Britain.' It is sometimes stated that it was on the insistence of the American military that a colour bar and segregation occurred in wartime Britain, but the British Government certainly did little or nothing to prevent this. Churchill refused to contact the American military when some MPs complained. When the Colonial Secretary Viscount Cranborne (afterwards Marquess of Salisbury) protested in a Cabinet meeting that a black official at the Colonial Office was now barred from his usual lunch-time restaurant because it was patronized by American officers, Churchill is said to have replied 'That's all right; if he takes his banjo with him they'll think he's one of the band!'[7] After consulting senior American officers, a British major-general issued 'Notes on Relations with Coloured Troops', which stated that though there were many coloured men of high mentality,

'The generality are of a simple mental outlook. They work hard when they have no money and when they have money prefer to do nothing until it is gone. In short they have not the white man's ability to think and act to a plan. Their spiritual outlook is well known and their songs give the clue to their nature. They respond to sympathetic treatment. They are natural psychologists in that they can size up a white man's character and can take advantage of a weakness. Too

much freedom, too wide associations with white men tend to make
them lose their heads and have on occasions led to civil strife'.[8]

Both black and white people perceived the hypocrisy of many in Britain
who hid behind the excuse of American prejudice to racially abuse black
troops. Soon after the War ended in 1945, the weekly magazine *John
Bull*, (certainly noted for its patriotism) commented:

> 'Colonial troops came to this country to help us win the war. But they
> are bitter because the colour bar still exists in Britain . . . Rudeness to
> Colonial Service girls in this country is surprisingly common . . . A
> West Indian girl in the ATS was refused a new issue of shoes by her
> officer, who added:" At home you don't wear shoes anyway." . . .
> Colour prejudice still persists in the hearts and minds of many of the
> people of Britain, and it may increase again as war memories fade'.[9]

The contribution of 'the colonies' to Britain's war effort was impressive.
(Lewis' portrait photograph is only one of a series representing a num-
ber of former servicemen.) Thousands of Caribbean volunteers and a mil-
lion and a half Indians served in British forces. The Indian people
provided £287 million worth of materials plus £130 million for US
forces. Donations of £23 million were made by 1943 and a further £11
million was given to Britain in interest free war loans.[10] In the Bengal
famine of 1943, three million people died in five months as a result of
food requisitioning due to the War, while stores were kept 'in reserve'.[11]
During this time, Mahatma Gandhi had suspended his non-violent strug-
gle for Indian independence for as long as the War lasted. The total num-
ber of Indians enrolled in all the services came to over two and a half
million, which made them the largest volunteer army in history. Black
as well as white soldiers from Africa were involved in the British war
effort and the colonies there supplied copper, zinc and mica.[12]

Despite the efforts of Allan Alexander and his contemporaries in the
British forces, there is still a perception of the British state and its organs
as racist and discriminatory. This was openly referred to in 1997 by
none other than British Prime Minister Tony Blair, who stated his inten-
tion of 'letting the talents of all the people shine through.' In a speech
that year at the Labour Party conference he specifically pointed to the
lack of black representation in the higher ranks of British state organi-
sations – the army, police and law courts. While he did not propose pos-
itive discrimination, he attacked 'negative discrimination' against black

soldiers, black police and black lawyers. In the Army, for example, there is not one black army officer above the rank of colonel, and only 315 or 0.97 per cent of officers are of 'ethnic minority' origins.[13] Partly as a response to this, a new campaign was set up to recruit black personnel into the Army, and outlaw the racist abuse many suffer when they join. A new poster design was unveiled by General Sir Roger Wheeler, who admitted 'Whether we like it or not there is a perception that the Army is a racist organisation.' The poster, designed by prestigious advertising consultants Saatchi and Saatchi, was a modified version of the famous First World War image of Lord Kitchener pointing accusingly at prospective volunteers saying 'Your country needs you'. In the new poster, the figure is a serious-faced black soldier.

It is hardly surprising that the Army is considered racist. A newspaper article discussing the recruitment campaign cited five cases of serious racial abuse, including cases where one black recruit was given a spear, another had a banana thrown at him during a rehearsal for the Trooping the Colour ceremony, and several were called 'nigger'. The first black recruit to the Life Guards was forced to resign after his bed was constantly soaked in urine, he was called 'nigger', and was left a note which read 'There is no black in the Union Jack.' He eventually left, on what were officially, if euphemistically, termed 'medical grounds'.[14]

Apart from obvious economic reasons in many cases, why then would black people like Allan Alexander join the British forces? The Director of the British Ex-Serviceman's Association in Britain, Neil Flanagan, has recalled how the 'race' issue was used to encourage them to join up in the Second World War: 'We were told that Hitler was a tyrant and that black people would suffer most if he captured the world.'[15] This was at a time when the British state refused the right of entry to thousands of Jews fleeing Nazi persecution in Europe. So, was the Second World War really a war against racism and fascism, as many believed, and still do?

The British government had been quite willing to negotiate with Hitler until his plans for expansion threatened the economic and political interests of the British state. In 1939, Churchill wrote admiringly of Hitler and '. . . the courage, the perseverance, the vital force which enabled him to challenge, defy, conciliate or overcome all authorities or resistance which barred his path.' He admired the way Hitler had defeated the workers' organisations that stood in his way, writing:'I have always said that if Great Britain were defeated in war, I hoped that we should find a Hitler to lead us back to our rightful position among the nations.'

Churchill also admired the Italian Fascists' opposition to communism, addressing one of their meetings in Rome in 1927 to praise them for being 'the necessary antidote to the Russian poison.'[16] For the first few years of the War the British state concentrated on the struggle in North Africa and the Far East to preserve its colonial interests.

After the War it backed fascist forces against uprisings by working class forces, notably in Greece and in the south of Italy where the British supported Marshal Badoglio, a fascist general who had slaughtered Ethiopians during Italy's colonial campaigns.

While Indians were fighting for the British state and contributing work and raw materials to the war against Germany and Italy, British troops were given official encouragement to treat them like 'wogs'. 'It was like giving everybody an individual licence to do what they effing well liked. And to be quite frank, they did', said one fusilier later. 'Most of the guys there would have been just as comfortable sitting in a Nazi or SS uniform.'[17] Experiences 'on the ground' obviously did not always support official statements to black servicemen and women which encouraged them to believe that their efforts were helping the British forces fight racism and oppression.

It was not only the British government's propaganda which told people that the War was a war for democracy against fascism, so did the Labour Party, the trade unions and, after 1941, the Communist Party. A few hundred Trotskyists were the main group who argued that the War was a war of competing imperialist powers (with the Soviet Union allied to first Nazi Germany, then to the Allied side after Stalin was forced by the German invasion of Russia in 1941 to abandon his non-aggression pact with Hitler, signed in 1939). After that, it was hard to convince people of the real nature of the War, given that the British press carried reports hailing 'the Red Army' almost every day. However workers did not forget the pre-war Churchill as the man who sent troops to attack miners during the General Strike of 1926 and ordered machine gun-posts to be set up at pitheads. After the War, in 1945, Labour was voted into power with a huge majority of 185 seats; two Communist MPs were also elected to Parliament.

But after the so-called war for democracy which black servicemen and women were encouraged to support, Labour granted independence only to India (under conditions that will be discussed later), while other colonies were kept under British rule with occupying troops. Labour Prime Minister Clement Attlee revealed his own attitude to the 'colonial problem' when he privately denounced Nye Bevan's support for

independence by accusing him of colour prejudice – 'pro-black and anti-white.'[18]

Now the discussion of Lewis' photograph and the investigation of history which it has prompted, would probably be considered very crude and 'old-fashioned' by certain contemporary theorists who argue that truth, knowledge, the individual subject, and human agency do not exist, but are constructed by various discourses of power which situate us in our daily lives in relation to culture and society. But surely Dave Lewis has constructed his own view of the Second World War and its representations, and so we must assume he was able to situate himself critically in relation to various discourses of the War in history books and museums. The portrayal of Allan Alexander as an actual person specially photographed as compared to the anonymous people in the posters suggests we cannot easily dismiss his historical presence, or the photograph itself as just another text among many others. Obviously though, the way we read Lewis' photo of Allan Alexander depends on our perspective on black history and the intersection of that history with the economic, political and military histories of the Second World War. This is why questions of history, reality, truth, politics and ideology are important for the understanding of visual culture, and also why it is important to be somewhat critical in assessing the prevailing influence of postmodernist positions on these issues. As a Marxist who believes that the key to understanding developments in any society is an awareness of the economic imperatives underlying that society, its politics and its culture, I want to look for a moment at how postmodernist thought has influenced recent theory on black culture, in particular the writings of Stuart Hall, and to a lesser extent, Kobena Mercer and Paul Gilroy.

STUART HALL AND POSTMODERN THEORY

As Stuart Hall is a highly influential critical theorist of popular culture and black cultural studies, I feel it is important to be aware of his valuable contribution to the field. However, it is also important to use an awareness of his intellectual development to critically engage with his work. Hall's particular political history has clearly influenced the manner in which he positions himself with regard to questions of truth, ideology and theories of history and politics, as well as ways in which culture relates to these concepts.

During an interview in 1986, Hall resisted descriptions of himself as

either a modernist or a postmodernist. In contrast to the position artic-
ulated by Gilane Tawadros which I discussed earlier, he states: 'I don't
know whether I would locate myself now within the modernist
theoretical project.'[19] Hall distances himself from the more extreme scep-
tical forms of postmodernist thought, for example that of Baudrillard,
but expresses interest in such writers as the German Habermas, and
French writers Lyotard and especially Deleuze and Guattari.[20] He also
seems reluctant to describe himself as a postMarxist or a poststruc-
turalist, explaining that he is only a postMarxist in the sense that
he wants to move beyond what he terms 'orthodox Marxism', and feels
the same about structuralism.[21] Paul Gilroy and Kobena Mercer share
similar concerns in some ways. They explicitly distance themselves from
the likes of Baudrillard, who denies that the existence of the real is
knowable, but are united in their rejection of what they term 'the Left'
and Marxism. As Mercer puts it:

'Difference and diversity are values which are not particularly well
practised on the traditional Left. Confronted by the real implications
of political diversity, the Marxist tradition reveals that its impover-
ished condition as the monologic concept of class struggle is inade-
quate to the plurality of conflicts and antagonisms at work in
contemporary society. Classical Marxism is simply deaf to the dialogic
noise produced by the diverse voices, interests and identities that
make up contemporary politics'.[22]

He adds a couple of pages later:

'One doesn't need to invoke the outmoded base/superstructure
metaphor [of Marxism] to acknowledge the impact of deterritorialised
and decentralised forms of production in late modern capitalism'.[23]

Mercer is certainly correct that the fragmentation of the Left, the rise of
environmental campaigns, oppositional youth cultures and the defeats
of trade union struggles during the 1980s have given rise to a situation
in which Marxist politics must be refocussed and creatively applied to
remain relevant. However this is not his conclusion. Since he believes,
following Lacan and others, that the subject is structured by language,
he therefore rejects the basic premise of materialism, and also of Marxist
dialectical materialism, i.e. that 'being determines consciousness' and
not the other way about. Human subjects make language in a social

situation; language does not make them. We are influenced ideologically by available language and concepts, but there is no inevitability about language and it can be changed by people who consciously wish to do so. Mercer is very much a follower of Hall and stresses his admiration for the same writers as his mentor: Ernesto Laclau, Chantal Mouffe and Antonio Gramsci, of whom more shortly.

Paul Gilroy is careful to reject what he calls 'the lazy essentialisms which postmodern sages inform us we cannot escape', for example the construction of the subject by language, but in his emphasis on shifting identities, diasporas, discourse and 'the contingencies of truth-seeking ... and the active power of language to shape enquiry and the provisional status of scientific enterprises', Gilroy in fact shares many of the concerns of the postmodernists.[24] In his article about record sleeves and black culture, Gilroy subtly shifts the notion of a consumer (of commodities) to a user. Thus the exchange value of the commodity is split off from its use value. The commodity possesses both. Of course the way in which commodities function in capitalist society is full of contradictions, but it is a trend in postmodernist cultural studies to see consumption as empowering for the individual, who can reinvent her/himself playfully by participating in consumer culture, as we shall see later.[25] In his advocacy of cultural politics, Gilroy is in tune with Hall and Mercer, along with the more 'left' postmodernists such as Fredric Jameson. Gilroy, disenchanted with 'the Left' (he never mentions any specific organizations and treats Left politics as a homogeneous entity), opts for collective identities without formal organisations. 'The constructed "traditional" culture becomes a means . . . to articulate personal autonomy with collective empowerment focused by a multi-accented symbolic repertoire and its corona of meanings.' This rather undialectical notion of culture, bereft of class and gender tensions, does not seem to explain how white people could become anti-racists. They do not share the same roots or imagined communities as black people, and will therefore be 'different'. Thus Gilroy concludes: 'These identities, in the forms of white racism and black resistance, are the most volatile political forces in Britain today.' Not all whites are racist, however, just as not all blacks resist oppression.[26]

In an article on racism and the postmodern response, Steve Vieux shows how postmodern theory fails to criticize capitalist property relations. Society is 'not a valid object of discourse' according to the postmodern theorists Laclau and Mouffe, and for them and Foucault, the state is one discursive practice among others, not the fundamental

instrument of class power, however disguised this may appear in bour-
geois democracies. As Vieux points out, in much postmodern theory, no
particular primacy is given to any form of oppression: oppressions of
gender, sexuality, class and 'race' are seen as discrete and singular.
Postmodernists cannot argue against neo-liberal economic and political
theories because postmodernists see this as a philosophical problem:

> 'Knowledge is reduced to an immediate position of the power
> interests of competing subject positions. The production of knowledge
> becomes a simple ideological reflection of these positions, lacking its
> own methods of research, validation or verification. In this way,
> postmodernists find empirically-grounded research claims fundamen-
> tally uninteresting'.[27]

However it is important to note that support of, and opposition to, post-
modern theories and Left politics is not a black/white divide. The argu-
ments cut across 'race' (and gender) categories. Kenan Malik, for
example, is an example of a black writer and scholar who has been
highly critical of the application of postmodern theories to racial oppres-
sion. Malik has argued that the postmodernist and poststructuralist
analysis of 'race', resulting in the so-called 'politics of difference', 'has
evolved as the intellectual embodiment of social fragmentation.'[28] He
argues that contemporary postmodernist thought based on poststruc-
turalism is as hostile to Enlightenment values of universalism as was
nineteenth century racial theory. Arguing that society is not a totality
but a product of practices and discourses, poststructuralists maintain
that 'social phenomena cannot be reducible to another property that
bestows them with meaning. It is an outlook that renders all determin-
ate relations contingent, bereft of any inner necessity.'[29]

In arguing against the notion of 'the essential black subject', post-
modernist theorists of black culture have moved towards idealism and
relativism. Malik argues that all identities have been given equal valid-
ity and 'the result is that fundamental social relations such as racial
oppression become reduced to lifestyle choices.'[30] By celebrating inde-
terminacy and opposing notions of a social totality, identities are dis-
membered and isolated '. . . . this methodology resembles nothing so
much as the empiricism of the positivists . . . '[31]

Of course, there is no denying that important economic, social and
political changes are taking place in the late twentieth century and that
pre-existing theories cannot simply be applied in an unthinking way to

new configurations of reality. However the real test of any theory is whether it can be creatively applied to the test in practice, and whether theoretical thought approaches the actual material being considered.[32]

Postmodern theory has come to prominence at a time when traditional heavy industry has been decimated in the old imperialist countries (leading to arguments that the working class is dead), mass production and stockpiling have given way to 'just in time' production, a core of full-time workers is now supplemented by peripheral part-time staff with few employment rights or holiday and maternity benefits, information technology has revolutionized market trading and consumerism has supposedly taken over from production. Some have seen this as a new type of capitalism, others as post-imperialism. In America, these developments have had dire effects on the majority of black people whose general living conditions have declined since the 1970s. Wages have dropped, health care has worsened and 40 per cent, a disproportionate number of all US prisoners are black. In 1993, of 90,000 homeless people in New York, 90 per cent were black or hispanic.[33] The American scholars Marable and Mullings conclude that we are in a new historical period which needs new forms of political organization, otherwise the lure of black nationalism and the black capitalism of Louis Farrakhan, leader of the Nation of Islam, will increasingly seem like a positive way forward for black Americans. Among Farrakhan's business ventures has been the Nation of Islam Security Agency, staffed by Fruit of Islam bodyguards, who enforce 'law and order' among the largely black residents of government-subsidized housing estates in a number of US cities. Farrakhan's most publicized political campaign in recent years was the so-called 'Million Man March' which took place on 16 October 1995, when 400,000 black men demonstrated in Washington DC. Women were encouraged to stay at home, and leave the march for 'spiritual regeneration' on this 'holy day of atonement' in the charge of men. The patriarchal, homophobic and anti-semitic politics of Nation of Islam leaders have been articulated in speeches and writings. In my view, Marable and Mullings are correct to be concerned about the influence of this kind of reactionary black liberation politics, which misdirects the anger of the exploited and oppressed.

Obviously there is a relation between the changes in late twentieth century societies and the popularity of postmodern theories among intellectuals and students. What unites these theories above all is an opposition to Marxism as a means of understanding history and society, and thus attempting to destroy capitalism.[34] This is termed by Stuart Hall as

'classical Marxism'. However, the target of his criticisms is more cor-
rectly a Stalinized deformation of Marxism, and his picture of 'ortho-
dox' or 'classical' Marxism is not much like anything Marx, Engels, Lenin
or Trotsky ever said or would have recognized. For example, when Hall
quotes Marx himself rejecting the kind of economism and reductionism
that was put about as Marxism – 'if that is Marxism, then I am not a
Marxist' – Hall then adds 'Yet there certainly are pointers in this direc-
tion in some of Marx's work.' He does not tell us where, though.[35]

In an interview entitled *'The formation of a diasporic intellectual'*,
Hall gave his own account of his political and intellectual development.
Hall left Jamaica in the early 1950s and became a student at Oxford.
There, he took part in discussions with Communist Party members 'argu-
ing against the reductionist version of the Marxist theory of class'. This
is not surprising, given the rigid and undialectical version of politics
which passed for Marxism in the Stalinized Communist Parties. When
the Oxford branch of the Communist Party collapsed, a grouping around
the Socialist Society became 'the conscience of the Left, because we had
always opposed Stalinism *and* opposed imperialism. We had the moral
capital to criticize *both* the Hungarian invasion [by the Soviet Armed
Forces in 1956] and the British invasion [of Suez also in 1956].'[36]
Trotskyists, too, had always opposed both Stalinism and imperialism,
but the whole of the Trotskyist tradition of Marxist theory and politics
is never mentioned by Hall because of his closeness to Stalinism. Hall
later on became associated with the so-called New Left, influenced by
Althusser and Gramsci. In the light of his experiences with Stalinism,
Hall was put off 'revolutionary' parties, and preferred to remain a aca-
demic sympathetic to a particular Communist tradition. He went on to
become a hugely influential figure in British Cultural Studies, going to
Birmingham in 1964 and eventually leaving the Centre for Contemporary
Cultural Studies there in 1979 to go to the Open University. In
Birmingham, says Hall, 'We read Weber, we read German idealism, we
read Benjamin, Lukács, in an attempt to correct what we thought of as
the unworkable way class reductionism had deformed classical Marxism,
preventing it from dealing with cultural questions seriously.'[37]

The influence on Hall of French Communist Party philosopher
Althusser and the Italian communist Gramsci is significant. Althusser's
redefinition of Marxist theory of ideology stated that ideology was not
really a 'false consciousness' but a kind of gel which held all societies
together. It called to people and positioned them in a 'system of lived
relations'. Like the postmodernists, Althusser ended up with a belief that

'the objective world, and an account of its contradictory movement in thought, is not possible.'[38] Althusser offered Hall a way out of the 'outmoded' Marxist 'base/superstructure model', which held that ultimately it was the economic base which was the key factor in understanding developments in the superstructure of culture, philosophy, religion, politics and so on. As Colin Sparks puts it: 'The centre of attention shifted from the relations between base and superstructure into an elaboration of the internal articulation of the superstructure itself.'[39] The primacy of the economic is obscured and the various levels of 'the social formation' are given no hierarchical structure or privileged position. Economics, politics and culture are seen as affecting each other equally and there is no theory of causality to say why or how particular things happened. As scholar Neville Kirk has remarked, an emphasis on 'decentering' has some dangers: 'For example, opposition to a strict hierarchy of causation *can* lead to a refusal to admit any sense of causative priority, to a mere description of "free-floating", relatively valid and equally significant forces.'[40]

Also influential on Hall were the arguments of Laclau, who agreed with Althusser that subjects are interpellated (or called to) by ideology, but the subjects so called to are never social classes. 'In his account, social class is an economic abstraction which does not exist in any concrete social reality.'[41] Given Hall's trajectory, it is not surprising that he finally rejected any notion of Marxist ideology, which leaves no theory of how we know things, why one account is more truthful or accurate than another, or why people live through conditions of oppression and exploitation thinking they are 'natural'. Christopher Norris has remarked on a particular piece of writing by Hall: 'What Hall cannot countenance is any hint of a return to notions like "ideology" or "false consciousness", terms that might provide the beginning of an answer to the questions posed by his article.'[42]

In 1986, Hall published an article on the relevance of Gramsci for the study of race and ethnicity. Hall does not refer much to the political activist Gramsci, but to the theorist, imprisoned by Mussolini in 1926 and, by force of circumstances, a writer rather than an active revolutionary. Because of the unfortunate circumstances of his life, as well as the interest of his writings, Gramsci became a model for all kinds of Left intellectuals in Britain who believed in the efficacy of cultural struggles. Hall took up Gramsci's attacks on 'economism' and 'reductionism', which 'classical Marxism' supposedly used to reduce culture to the direct and unmediated expression of class and economics. Hall also took

up Gramsci's notion of hegemony to replace the concept of ideology. Hegemony occurs in a short-lived coming together of different social groups under the dominance of a leading group, bringing about economic, political and intellectual unity. Hall describes how, for Gramsci, such moments of 'national popular' unity make the formation of what he calls a 'collective will' possible. Crucially, Hall takes up Gramsci's revision of the Marxist theory of the state. Hall argues that the state is not simply coercive, but is pivotal in the construction of hegemony: 'it becomes not a *thing* to be seized, overthrown or smashed by a single blow, but a complex *formation* in modern societies which must become the focus of a number of different strategies and struggles because it is an arena of different social contestations.'[43] No mention is made of whether there is any need for a revolutionary party, or of the problem of potential violence from the defenders of the existing state – the police and armed forces. Now obviously the state does not only act as a coercive body; many people believe the state represents their interests, it provides health care, public housing, leisure facilities, and education, for example. The state can be pressurized for reforms. Marxists, however, argue that ultimately the state safeguards the interests of the ruling class in society.

Hall hails Gramsci as a kind of early postmodernist who can explain why working class people can have racist ideas (Hall argues that Marxists failed to do this). Gramsci also, according to Hall, can allow us to understand the self as contradictory and a social construction, thus helping us to understand how victims of racism are 'subjected' to 'the mystifications of the very racist ideologies which imprison and define them.'[44] Hegemony, says Hall,

'begins to explain how ethnic and racial difference can be constructed
as a set of economic, political or ideological antagonisms, *within* a
class which is subject to roughly similar forms of exploitation with
respect to ownership of and expropriation from the "means of
production". The latter, which has come to provide something of a
magical talisman, differentiating the Marxist definition of class from
more pluralistic stratification models and definitions, has by now long
outlived its theoretical utility when it comes to explaining the actual
and concrete historical *dynamic* within and between different sectors
and segments within classes.'[45]

As far as I understand Marxist dialectics, it *does* conceptualize

the contradictory nature of classes within social formations and also the nature of class formations as part of a totality, not static entities. Thus Marxists would seek to understand tensions and antagonisms within classes and between them as ultimately rooted in economic factors and 'the means of production', but not simple reflections of this so-called 'economic base'. I do not accept Hall's argument that Marxism is no longer useful for the study of class, 'race' and culture'.[46]

NEW TIMES

The consequences of all this for the fusion of politics and culture in Hall's approach can be seen in his article '*The Meaning of New Times*'. The '*New Times*' debate originated in the Communist Party of Great Britain's attempt to come to terms with the popular support of Thatcherism as well as the continuing crisis, and eventual collapse, of Stalinism in Eastern Europe. The split in the CPGB resulted in a parting of the ways between the pro-Soviet hardliners and the Euro-communist 'New Timers' around the journal *Marxism Today*. Rather than moving towards revolutionary politics, which the bureaucratized Communist Party had not done for many decades, this split moved further towards what one writer has called 'the politics of the possible'.[47] In Hall's '*New Times*' article, he argued that the individual subject, though fragmented, had become more important than collective subjects like class. The self was actually composed and constructed by discourse as 'multiple selves'. Postmodernism is the term which signals this more cultural character of '*New Times*' where economics and politics have no assumed correspondence. If we look to Gramsci for ideas, Hall suggested, we can find some answers that elude those struggling on the Left:' The sad fact is that a list of "new questions" . . . are most likely to engender a response of derision and sectarian back-biting at most meetings of the organized political Left today – coupled with the usual cries of "sell-out"![48]

Production is less important than consumption, states Hall, and its pleasures should not be dismissed:

'These [pleasures] already allow those individuals who have some
access to them some space in which to reassert a measure of choice
and control over everyday life, and to "play" with its more expressive
dimensions. This "pluralization" of social life expands the positionali-
ties and identities available to ordinary people (at least in the

industrialized world) in their everyday working, social familial and
sexual lives'.[49]

Resistance to 'the system' can be found in a new politics of the family,
of health, of sexuality, of food, of the body. Hall says nothing about the
capitalist state which all oppositional politics will come up against at
some point. The politics of food and of the body may sound very 'new'
and 'sexy' but there does not seem to be much playfulness and self-
expression in the politics of BSE in British beef, the politics of the body
of young black men beaten to death by police or racist attackers, or the
food politics of imprisoned illegal immigrants refusing to eat in protest
against their deportations.

In effect, the 'New Timers' hoped to influence the Labour Party with
their politics, having distanced themselves from Stalinized Marxism; in
Gramscian terms to 'hegemonize' it. Class antagonisms are now less
important than other issues in this political strategy. Englishness, and
its definitions, is now contested by ethnicities, not primarily by classes,
argues Hall. In a rather banal conclusion which evacuates any notion of
class he states: 'And the question of ethnicity reminds us that everybody
comes from some place – even if it is only an "imagined community" –
and needs some sense of identification and belonging.'[50]

Hall's article and the politics of 'New Times' have been subjected to
an impassioned critique by Ambalavaner Sivanandan. Sivanandan is a
long-time critic of the British non-Stalinist Left, (which he argues does
not adequately understand and combat working-class racism), and also
of the collapse into liberalism of the British Eurocommunist split from
the Communist Party. Sivanandan's most famous work is probably his
book A Different Hunger, which he published in 1982 when he was
director of the Institute of Race Relations. Stuart Hall wrote the preface
to this book. Clearly Sivanandan must have felt greatly disappointed to
have written such a critique of his former collaborator.

I have not the space here to enter into Sivanandan's criticisms in detail,
so what follows is rather brief, and I would encourage readers to follow
up the reference to this article. Sivanandan exposes the focus on the
self, the glorification of individual consumption, the idealism of such
statements by Hall as 'the word . . . is as "material" as the world'. He
argues that for Hall, politics became a matter of positioning in various
conjunctures of the economic, political and social, and culture was the
mode in which such positioning was expressed. Oppressed and
exploited peoples of imperialized semi-colonial countries are left out of

this picture almost completely. As Sivanandan points out, this theoretical dressing up and post-modernization of the old slogan 'the personal is political' 'has also had the effect of shifting the gravitational pull of black struggle from the community to the individual at a time when black was already breaking up into ethnics.'[51] The intelligentsia had come into their own as politics became culture. Sivanandan remarks:

> 'What *"New Times"* represents, in sum, is a shift in focus from economic determinism to cultural determinism, from changing the world to changing the word, from class in and for itself to the individual in and for himself or herself. Use value has ceded to exchange value, need to choice, com-munity to i-dentity, anti-imperialism to international humanism . . . A sort of bazaar socialism, bizarre socialism, a hedonist socialism: an eat, drink and be merry socialism because tomorrow we can eat drink and be merry again . . . a socialism for disillusioned Marxist intellectuals who had waited around too long for the revolution – a socialism that holds up everything that is ephemeral and evanescent and passing as vital and worthwhile, everything that melts into air as solid, and proclaims that every shard of the self is a social movement. Of course,the self is fragmenting, breaking up but when in Capital's memory was it never so?'[52]

Sivanandan is obviously deeply concerned about the political implications of Hall's views in the '*New Times*' article, and I must make it clear that in this case, my sympathies lie much more with his views than with Hall's. Despite Sivanandan's criticisms of '*New Times*' and Hall in particular, he himself does not advocate a Marxist party, preferring instead the organization of 'community' struggles. He sees the Third World as the centre of struggle for socialism, and believes it would be 'Left cultural imperialism' for British Marxists to make any political criticisms of liberation movements in colonized or semi-colonial countries. However Sivanandan is quite right, in my view, to point to the 'blindness' of certain organizations on the Left for failing to understand the reasons why white people can be racist.[53] Hall thinks this a fault of classical Marxism and is one of the reasons he rejects it, believing that the economic is not the key factor in influencing the development of society and culture. It can be seen from the rather lengthy discussion above, that cultural analysis can be political, though probably not in the sense meant by Paul Gilroy and Stuart Hall. For what is at stake here is not whether or not

we buy certain records because of the covers, or have our hair styled in particular ways as expressions of consumer choice and constructions of ourselves, but issues of truth, history, causality, ideology and agency. Despite the calling into question of Marxist and materialist approaches to these issues in what may be termed the 'postmodernist' phase of Stuart Hall's writings, a concern with these issues can be found in many contemporary works by black artists. They are not articulated in the same way, or engaged in polemically. Nor is it the case that they are Marxist, or necessarily socialist. Nevertheless, it is clear that many artists continue to creatively interrogate and embody themes of histories, economics and identities in their works, whether or not leading black British cultural theorists still locate such issues as their central concerns.

LEGACIES OF SLAVERY:TRADE WINDS

Economic factors have often been crucial in understanding Black histories. For example in 1992, there were several exhibitions which brought together works dealing with these issues around the quincentenary of Columbus' 'discovery' of America and also the moves to solidify a European Union. One of these exhibitions, entitled *Trophies of Empire*, developed from a series of commissioned works in three English maritime cities, Bristol, Hull and Liverpool. The intention of the project was to encourage artists to 'creatively and innovatively respond to their own individual interpretation of these legacies and events through artworks that directly and poignantly reflect both the physical and geographical locations of the project against the backdrop of 1992 with its myriad implications.'[54] Liverpool and Bristol were ports whose wealth was generated principally by the triangular slave trade, in which mainly English ships sailed to Africa, traded goods for slaves, took the slaves to plantations in the West Indies, and returned to England with sugar and other commodities. Involvement in the slave trade provided much of the capital for the expansion and success of the Industrial Revolution in the northwest of England, providing more investment in the docks and the mills of Lancashire. In 1795, a local Liverpool historian wrote that:

'Almost every man in Liverpool is a merchant . . . that almost every
order of people is interested in a Guinea cargo . . . It is well known
that many of the small vessels that import about an hundred slaves,
are fitted out by attorneys, drapers, ropers, grocers, tallow-chandlers,
barbers, taylors, etc.'[55]

Benefactors whose fortunes derived from participation in the slave trade endowed schools in Liverpool and Bristol, and this was consciously indicated in siting part of the exhibition in Bluecoat School in Liverpool, and including a work by the artist Carole Drake about Colston Girls' School, Bristol in the exhibition.[56] Since this exhibition, the Bristol Slave Trade Action Group, which includes city councillors, museum workers, academics and representatives of the Black community have been working to make more visible the history of the slave trade in relation to the merchants of Bristol. Their projects include a Slavery Trail, a historical walk which takes in the docks and an exhibition on slavery which will open next year. Also included is a visit to Edward Colston's tomb. As a local benefactor, he is honoured by the city but his role in the slave trade is usually ignored. Colston was a leading member in the London-based Royal African Company, which had the official monopoly on the slave trade until it was opened up to Bristol and the other ports at the end of the seventeenth century. Bristol later became an important sugar refining, tobacco processing and chocolate manufacturing centre. The almshouses and school which Colston founded were obvious examples of the material benefits which white English workers could gain indirectly from the slave trade, even though they were not the ones to profit most from it. More controversial is the plan for a British Empire and Commonwealth Museum to be housed in a former Victorian railway building in Bristol, due to open in the year 2000. Not everyone in Bristol is convinced that this will offer a critical view of the history of the British Empire.[57] However opposition to the exploitation of black people and their labour by Colston and others has come in the form of graffiti sprayed on his statue – 'Fuck off you slave trader.'[58]

In Hull, where there is a museum in honour of the abolitionist campaigner William Wilberforce, the artist Nina Edge undertook a residency which culminated in her work *Multi-Cultural Peepshow*, an ingenious construction which allowed the viewer to see the fruits of Britain's colonial exploitation. Readily identifiable everyday commodities such as cotton, coffee and tea, provoked the audience to relate the economic and political concerns of British capitalists to their everyday lives.

One ex-docker was particularly stimulated by Nina's use of PG Tips [tea] packaging. He had himself led campaigns on Hull docks boycotting the import of certain products where slavery was still being used. He remembered a ban on importing PG Tips when it was revealed that the chimpanzees on the TV adverts were paid more than the tea pickers.[59] The dock strike in Liverpool which ended in 1998 after two years shows

how the (largely white) work force at Britain's docks is not guaranteed to benefit from world capitalist trade, for they are given worse conditions or even sacked when the company owners have no more use for them.

Wilberforce House Museum commemorates the abolitionist campaigning of the politically moderate MP, William Wilberforce. As the artist and writer Keith Piper has correctly argued, although Wilberforce was genuinely committed to abolishing the evils of slavery, this coincided with a realization by many capitalists that the exploitation of free labour would be more productive. In *The Wealth of Nations* (1776) Adam Smith pointed out that 'whilst in the early stages of capitalist development, slavery acts as a useful generator of profits, its inherent inflexibility, its expensive demands for land and human resources, and its unskilled and brutalised workforce, begin to retard development.'[60] Added to this was the resolve of many slaves to escape their bondage and several important uprisings by slaves, in Saint-Dominique (Haiti) for example, in pursuit of their liberty and revenge for their brutal treatment. Thus the exhibition programme as a whole attempted to physically and geographically engage with sites of historical and cultural significance for the often hidden facts of the exploitation of black people by British capitalists, although it is also important to remember that there were also white slaves in the early modern period. Britain had sent Irish slaves to the West Indies before turning to Africa for greater supplies of 'manpower' which was thought more likely to survive the gruelling toil and hot climate. This proved not to be the case, however, and for every slave birth there were six deaths.

Keith Piper's installation *Trade Winds* was part of the exhibition in Liverpool and was located at the Merseyside Maritime Museum within the Albert Docks Complex in Liverpool.[61] Near the exhibition space, a counter programme of events to the Quincentenary Columbus Regatta tall ships race was mounted by the Five Hundred Years of Resistance Campaign. Piper is one of Britain's leading younger artists, and a pioneer of the contemporary Black art movement. He works in a variety of media, and is also a writer and curator. This particular installation was made up of twelve TV monitors encased in rough wooden packing cases. The cases were in groups of four, placed at three points in a triangle, representing the triangular pattern of the slave trade. The viewer, however, could not look at more than one monitor at a time, so that an overall, totalizing view could be gained only from a point suspended above the gallery. Thus the point from which a global understanding of the visual information is possible is outside 'normal' experience. As usual in

Piper's work, the visual imagery is rich, multi-layered and densely evocative, and is accompanied by sound which excellently echoes and responds to the visual material. Layers of sound, as in one of his previous installations *A Ship Called Jesus* (1991), offer not a single narrative or position, but hints of memories, testimonies and evidence which rise to the surface to be heard, then fall away again to be submerged by something else. The imagery on the videos includes waves, African masks, faces, passages of texts, slave log books, invoices and bills of sale as well as stock exchange figures from the present day.(plate 6) The viewer has to work to piece together an understanding of the images and sounds. History is not offered as an easily consumable linear narrative, but as something that must be constructed from a sometimes confusing and fragmented flow of material. But the material is hypnotic and sensual, and the viewer feels impelled to fathom the suggested connections. Obviously the watery imagery cannot be entirely like that of the Greek philosopher Heraklitus, who argued that when you put your hand in a river it is never the same hand and never the same river. The limitations of technology, time, and the exhibition are different from the ongoing nature of real historical time, so cannot continue indefinitely, but Piper nonetheless succeeds in conveying a truly sensual and powerful feeling for the evolving nature of historical and visual meanings.

The technology used by Piper is also significant. Developing from

plate 6 *Keith Piper, Trade Winds, 1992, colour video still from mixed media installation. Courtesy of the artist.*

earlier works based on painting and sculpture, in particular a large-scale
sculptural commission entitled *Chanting Heads,* Piper stated; 'I vowed
never to return to a physical materials-intensive practice!' He added:
'While I had used painting to address political issues through the nar-
rative conventions of a "history painting" tradition, these intentions led
elsewhere as a result of my desire to employ technology-based solutions
to the production of the work.'[62] In recent work, Piper's use of tech-
nology has become more interactive, incorporating CD-rom sound and
imagery. However Piper is aware of the contradictory nature of tech-
nology under capitalism. It can be enabling, opening up new possibili-
ties for artists and others, but it can also be seen as the opposite of
the human and the organic. Piper himself sees that new technology in
the visual field has the potential to develop new dialogues around racial
identities:

'Racial identities are rapidly evolving, partly caused by technology's
role in the production of new images. Take desktop publishing and its
promise and, one would hope, fulfilment in enabling a plurality of
identities to be heard. On the other hand, access to tools is limited
through the means of distribution. That inevitably lies with the large,
moneyed institutions'.[63]

While Piper and Roshini Kempadoo, whom I will discuss in the next
section, are among artists who have created impressive works depen-
dent on new computer technologies, there are many other artists who
still work in 'old' media. Eddie Chambers has sounded a cautionary note
on the subject of black artists and new media. He is concerned that artists
who do not produce works with new media, for whatever reasons, are
seen as old-fashioned and not suitable for exhibition in avant-garde
gallery spaces. This can lead to artists being penalized for being painters,
as Chambers puts it.

'I thought the attitude of the Spacex gallery, which has been repeated
in other galleries including Kettles Yard, Cambridge, seems to be very
typical of a lot of spaces: these spaces are quite interested in working
with African Caribbean artists, or South Asian artists, as long as it
involves modems and computer link-ups and video projections and so
on and so forth. If it is paintings on canvasses they are not really
interested.'[64]

There is another sense in which Piper's accomplished use of new visual technology is important. A significant argument of the postmodernists and those who believe we are now living in a new globalized economy, is that new technology has enabled more profitable production and distribution methods to be put in place by a truly internationalized capitalism. Similarly, the transfer of capital across national boundaries to international money markets is now able to generate more parasitic capital (ie. capital not generated directly by production) than ever before. Money moves in the blinking of an eye. However, there still remains a tension between the national location of even multinational companies, and the tendency of capitalists to place their investments wherever they will make the greatest profits. Nation states act to protect 'their' industries and markets, especially by controlling the movement of labour. Capital may be more able to travel globally, but due to immigration controls, many people cannot. Even so, some estimates put the number of people leaving poor countries at 75 million a year.[65] Private finance, rather than public or inter-governmental money has grown in importance. However, this supposed globalization of private multi-nationals has not meant the end of state intervention or of inter-imperialist rivalry between and within trading blocks. The tensions within this economic configuration are, however, increasingly hard to control once they reach a certain level.

An interesting parallel to the supposed globalization of the economy identified by postmodernist cultural theorists as well as certain economists, is the tendency to 'new internationalism' in culture. In some senses, this might be seen as high art following the globalization of consumer culture where Coca Cola, cigarettes and designer clothing permeate virtually all national markets. Others see new internationalism as a progression from Black arts, via ethnic arts, and multiculturalism to an engagement with the international. Postmodernity is seen as anticipating a new internationalism.[66] The founding of the International Institute of Visual Arts (inIVA) in London and its conference in 1994 institutionalized a view of 'internationalism' as located within the international avant-garde art world, rather than linked to a more political internationalism.[67] Notions of Black art, 'Third-World' art, or Pan-Africanism were absent. While the work of black artists is highly visible in inIVA's programme of exhibitions, events and publications, for example, the Aubrey Williams retrospective in 1998 or the Mirage exhibition inspired by Frantz Fanon in 1995, the work is subsumed under an over-reaching category of 'cultural pluralism'. The agenda of inIVA

is defined as the 'encouragement of knowledge and understanding of contemporary visual arts in the United Kingdom and abroad, giving priority to visual art practice and scholarship of the highest quality which have not been adequately represented or disseminated.' This includes 'the work of artists, academics and curators from a plurality of cultures and cultural perspectives.'[68] In some senses then, inIVA promotes a kind of alternative international avant-garde, though some of its individual projects have contributed much of great value to the dissemination and documentation of black visual culture. In practice, inIVA contributes a great deal to making the work of black artists and curators visible. However this may be due to the efforts of the particular staff in place at present, and the stated aims of inIVA could be reinterpreted by others to mean something rather different from what actually occurs at the moment.

The development of a diaspora of artists moving across the globe has been linked to the 'movement of transnational capital and the explosion of communications technologies with their effects on migration, national boundaries and cultural homogenisation'.[69] The writer and artist Allan deSouza quotes Sau-Ling Wong who states that 'instead of being mere supplicants at the "golden door", desperate to trade their sense of ethnic identity for a share of America's plenty, many of today's Asian immigrants regard the US as simply one of many possible places to exercise their portable capital and portable skills.'[70] This rather rosy picture of well-off migrants following capital in its international growth is not quite the reality experienced by many would-be immigrants, who are not themselves capitalists. The term 'internationalism' requires political interrogation. For some more successful artists and film-makers it may involve being part of the international art world, but this is not the norm. However some supporters of inIVA's new internationalism see it as an opportunity to move beyond possibly constricting notions of 'black' 'white' and 'women's' art to the advocacy of much broader and inclusive cultural constituencies of otherness which will raise contradictions rather than try to keep them apart.[71] For example the first inIVA publication *Disrupted Borders*, included work on photography in Bangladesh, Stuart Hall on the New Europe, AIDS, photographing Russia, the Dalai Lama, Lesbian dreams and women and medicine.[72] In some senses, this creates a lively interaction of disparate practices and theories. On the other hand, though, without some clearly articulated framework, priorities or theoretical overview, which generates and organizes such collections, the work of black artists within them can become

the liquorice in a pick and mix bag of sweets. But this raises difficult issues. Organizations and exhibitions devoted to black artists can run the risk of ghettoization; the inclusion of black artists in a group with all kinds of 'others' could result in a sidelined pluralism of marginalized issues and artists. There is no easy strategy here. The main thing to note, perhaps, is that this is not an issue which hinders the careers of many white artists in the same ways.

LEGACIES OF SLAVERY:SWEETNESS AND LIGHT

As with Keith Piper and many other black artists, the historical legacies of slavery, migration and economic exploitation are important issues in Roshini Kempadoo's work. Kempadoo, an artist, teacher and writer, produced her work *Sweetness and Light* as a website. (plate 7) Like Piper, Kempadoo is interested in the enabling potential of new technology as a means of dialogue between the user/spectator and the creator of the imagery. The spectator/user is not presented with meaning as a ready-made object of consumption, but with images and texts which have to be negotiated and worked with in an interactive way. Kempadoo writes:

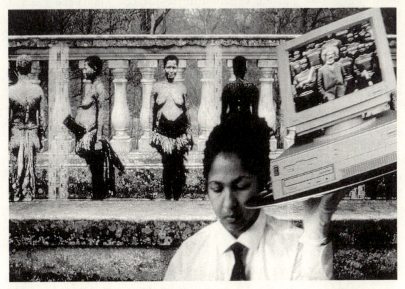

plate 7 *Roshini Kempadoo, Sweetness and Light, 1996–7, computer generated colour photographic montage for Website. Courtesy of the artist.*

'Conceptualising a "development" – who, how and by whom can
always be seen within a historical framework. As my inevitable
exploration of media/cyberspace, information networks and the uses of
new technologies takes hold, I begin to look at analogies and compar-
isons. My thoughts and experiences take me to that of colonialism and
the European expansionist past. More specifically, I begin to look at
the continuous replication of structures, hierarchies and power bases.
I choose to make an analogy – the colonialist experience as charac-
terised by the plantation – whether it is sugar, cotton or cocoa . . . The
work *Sweetness and Light* explores some of these thoughts from the
position of someone whose ancestry was the "subject" of the colonial
experience. Like all analogies, there are some fundamental differences.
So I cannot totally condemn this "development" of media/cyberspace
to a neat and simple comparison. Like all my work – it needs to be
seen as a statement or experience – for now, a description that will be
changed, is not fixed and should not be seen or experienced as a
definitive expression.'[73]

Like Piper's, Kempadoo's approach results in the construction of art-
works which are analogous in their being to the view of the histories
they present. History is not seen as fixed, linear or static but as moving,
changing and persisting into the present. There is no dividing line
between the past and our situation in the present. Kempadoo's use of
text in her website piece is more extensive that that of Piper, whose texts
have tended to be published separately as essays and articles. Also as a
photographer who has done some previous documentary work,
Kempadoo is more concerned than Piper to examine the contradictory
aspects of the photographic image as real and constructed at the same
time. 'I rework the photograph to produce what I call photo construc-
tions, which are generated by using a computer. I make use of [the] pho-
tograph's unique alliance with notions of reality and representations.'[74]
 Using historical and cultural research on sugar plantations and slave
labour, Kempadoo combines photographs and computer-generated
images with texts to accompany each image. The image in plate 7 is
accompanied by a quotation from William Green, *British Slave
Emancipation 1830–1865*, 1976: 'Occupation, in turn, was a function of
colour . . . Domestic servants, artisans and drivers . . . were sharply dif-
ferentiated in wealth, status, and privilege from the mass of field slaves
. . . '[75] Many plantations were isolated from the nearest town. As James
Walvin remarks: 'On Worthy Park in Jamaica in the late eighteenth

century the black-white ratio varied between sixty-eight to one and thirty-four to one. Moreover, such communities as Worthy Park were far from the nearest large white settlement, and there clearly developed a "siege mentality".[76] Slaves were 'managed', stratified and placed in hierarchies, the most obvious being the difference between house and field slaves. Ultimately violence was the threat which kept slaves in 'their place'. Female house slaves worked as childminders, cleaners, cooks, maids and waitresses. They were often sexually abused by their owners. Male slaves were also divided among house and field workers, the latter seen as stronger and less tractable. Keith Piper has shown how Malcolm X's comments on 'two kinds of Negroes', the 'house Negro' who looks out for his master and keeps the 'field Negroes in line' still applies to the way that key figures in Afro-American culture are perceived. Malcolm X was a 'field Negro', feared by his masters, while Martin Luther King was seen as more respectable and 'worthy of becoming a member of the family'. By taking on the mantle of a 'field Negro', Malcolm X was stigmatized as a dangerous outsider in American society. Piper points out how this renegade blackness has been commercially exploited to sell a range of macho images back to young black men.[77]

In Kempadoo's image, we see a waitress (a photographic image of the artist herself) with deferential downcast eyes, bringing us on a tray something to tempt our palates. This is a collection of computerised 'facts' and images that we can enjoy at leisure (if we have access to a computer of course). On the screen is an image of a white man with hands in pockets in front of a group of black men, all dressed in the same clothes. The white man is larger and in the foreground, individualized against a background of others. Behind the information 'waitress' who is serving things up, is a classical balustrade overgrown with moss with empty woodland beyond. This is inhabited only by ghostly images from the past in the form of 'ethnographic' photographs of an African woman posed in what came to be the classic scientific mode with a measuring device included to quantify her physical characteristics and qualify her 'racial' type. Her expression could be interpreted as a smile – something which everyone is supposed to 'wear' when photographed. But the wider context in which her image is placed makes us read her image as one placed within a framework of economic and cultural power over which she has little control. The sexual representation and economic exploitation of black women continue, but in different ways. From the house slave, we have moved to the still predominantly female occupations of the nurse, childminder, waitress, cleaner or secretary. Similarly, the

labourers on the plantation work in the interests of capital, just as the
labourers in the computer industry do.

The title of Kempadoo's work, *Sweetness and Light*, brings together
various connotations of whiteness and innocence. The nineteenth cen-
tury English intellectual Matthew Arnold, who became professor of
poetry at Oxford, published a book called *Culture and Anarchy* in 1869.
The first chapter is entitled 'Sweetness and Light' and argues that cul-
ture bears responsibilities for political progress and social well-being.
He postulates that culture can improve the human character, especially
through a classical education, and ameliorate class conflict.[78] However
the cultured lifestyles of the white plantation owners, and their nine-
teenth century descendants were possible only through the labour of the
slaves on the sugar plantations. Kempadoo's photographic images link
the classical beauty of English country houses to the exploitative rela-
tions of 'race', gender and class which underpin them.

The symbolism of light as goodness and purity as opposed to black-
ness, is also suggested. In an interesting discussion of aesthetics, tech-
nology and their ideological implications, Richard Dyer has discussed
how lighting techniques and film stock were developed to represent
white film stars and models. Consequently the black actors are not well
defined and perceived as 'problems' for the film technicians. Sometimes
the white actors are lit in such a way that they become a source of light
within the frame. At other times, light is manipulated so that it seems
to pass though the white person, ennobling them with a quasi-religious
aura. Dyer states: 'It is the combination of translucence and substance –
not translucence alone – which really defines white representation.'[79]
Thus it is not just content that has to be questioned in representing black
subjects in photographic imagery, but the very basis of the technology
itself and the ideology which surrounds its development and use. As we
shall see later, the entry of black people into British photography was
as scientific 'specimens' and oddities rather than as individuals worthy
of the same norms of studio portraiture as a middle-class white client.

EUROPE AND ITS CAPITAL(S)

Cultural Studies scholar John Gabriel has written:

'Attempts to define a "new" European unity draw on a reservoir of
ideas, myths and assumptions which date back to Christopher
Columbus' sighting of the Americas in 1492 and to the beginnings of

European conquest ... The year 1492 is one to be mourned by the
indigenous peoples in the Americas as much as it is to be celebrated
by the descendants of the first white settlers. How 1992, the year of
the single European market, will be remembered in 500 years' time,
and by whom, remains to be seen'.[80]

The year 1992 was not uncritically celebrated, however. The exhibition
Shifting Borders which was on show at the Laing Art Gallery in
Newcastle in that year examined the so-called 'new' Europe in relation
to cultural, economic and national identities. The exhibits included a
section by Roshini Kempadoo entitled *ECU – European Currency
Unfolds*, which consisted of ten colour photographic images mounted
on board, four of 84 × 84 cms and six of 152 × 84 cms, two large banners
and two panels of texts. The Spanish banknote image is illustrated here.[81]
(plate 8) The images are based on bank notes of different European coun-
tries. The banknote itself is the embodiment of the value of commodi-
ties. 'Money is the absolutely alienable commodity, because it is all other
commodities divested of their shape, the product of their universal alien-
ation. It reads all prices backwards, and thus as it were mirrors itself in
the bodies of all other commodities, which provide the material through
which it can come into being as a commodity.'[82]

With the coloured banknote as the embodiment of alienated labour
and objectified social relations which have created value and profit for
the capitalists of Europe, Kempadoo has constructed computer-gener-
ated montages of black and white photographs either from existing

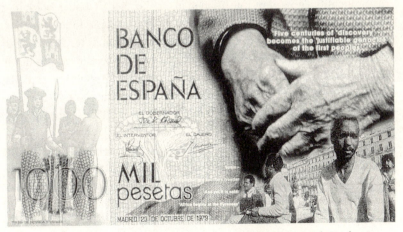

plate 8 *Roshini Kempadoo, European Currency Unfolds. Spanish Banknote,
1992, colour photographic panel. Courtesy of the artist.*

images or images specifically made by her for this project. The images of famous men and women who traditionally adorn banknotes such as Florence Nightingale or Charles Dickens are replaced or overlaid with individuals or groups representing immigrant or indigenous semi-colonial labour, usually those who have restrictions put on their citizenship and right of abode in European nation states. The more documentary and realist mode of the black and white photographs ironically makes them far more visually engaging than the coloured printing of the banknotes. The artist Chila Kumari Burman has also used a combination of a British banknote and a photograph of her mother. The printing on the note is like a tattoo on the woman's face, while the image of the Queen (a member of an older immigrant family) is juxtaposed with the portrait of a more recent arrival in Britain.[83] African, South East Asian and 'Eastern Bloc' countries quite often show woman workers on their banknotes, as labouring for the wealth of 'their' nations. However on European banknotes, women more often appear as allegorical figures, or very occasionally as a famous individuals from history.[84] Kempadoo's montaged banknotes invite us to see the real economic relations behind the currencies of Europe, as well as the political results of these relations in terms of immigration policies and the rise of racism in Europe in recent years, for example in the German and French banknotes. The French note normally shows the composer Claude Debussy, who is here replaced by a female figure from French 'outremer' former colonies. Below are the fascists who would like to send her back to where she came from, except she may have been born in France. Changes in nationality laws now mean that even the fact of being born in a European country does not automatically entitle people to legally claim the nationality of that country. This black woman may be as French as Debussy, but her colour, culture and social status do not entitle her to representation on banknotes, although it is partly through her exploitation (along with that of many others) that these banknotes have their value. The text at the bottom of the image reads 'The legitimation of racism and violence'.

The Spanish note (plate 8) shows the discovery of America, leading to the deaths of millions among the native population, and the extraction of precious metals which helped to develop early European capitalism. The hands of what we take to be a worker, and an image of 'immigrants' reverse the situation represented on the banknote. The Spaniards were able to go to the Americas, conquer the entire central and south of the continent, and exploit their new territories. Yet, when

people want to come to Spain simply to earn a living, they are often
prevented from doing so.. Spain and Italy are seen as the soft under-
belly of the European Community, an easy route for asylum seekers and
economic immigrants from Africa, Asia and the Balkans. It has been
noted that:

> 'Spain . . . has recently spent 520m pesetas fortifying the frontiers of
> its North African enclave, Melilla, with barbed wire, closed-circuit TV
> and monitoring equipment, and has announced the setting up of a
> maritime guard to patrol all of the country's 240–plus harbours. It has
> entered bilateral agreements with France to control the illegal entry of
> Turks and Africans, and has established six detention centres for
> those without papers and lacking means of subsistence'.[85]

In many of these detention centres now to be found in Europe, priva-
tized security companies have contracts to hold those who afterwards
prove desperate enough to commit suicide or go on hunger strikes rather
than be sent back to the countries from which they came.

The European Community has been much quicker to agree on restric-
tive immigration controls than on almost any other policy. For Europe
to function as a successful trading block in relation to America and Japan,
a single currency, single market and a European central bank are
required. Also the different nation states need to co-ordinate levels of
pay (eg. a minimum wage), conditions, maternity leave provisions and
so on for their workforces, not so much to benefit the workers, but to
ensure a level playing field without unfair advantage to the capitalists
of any one country. This also entails common immigration controls, stop-
ping the arrival of cheap labour from outside the European Union, and
the emergence of three classes of citizens in Europe: citizens, nominally
with full rights; denizens with full rights but with 'third country' nation-
ality; and migrants who have no rights at all. There are 7.5 million of
the latter in Europe.[86]

Before 1992, countries in the European Union deported large numbers
of immigrant workers, often committing violent attacks on their persons
in the process. Fines were brought in to penalize air traffic companies
who allowed any travellers with illegal travel documents to board their
'planes. Obviously, many political and economic refugees do not have
genuine passports or other documents.[87] Since 1992, the situation has
worsened, with the deportation of many more economic immigrants and
asylum seekers. In Britain in 1993, the number of asylum seekers

deported rose by more than 35 per cent over the previous year. A grotesquely named 'white list' of countries was drawn up from which British immigration officials would not consider any application for asylum on any grounds, even when photographs of evidence of torture had been taken by immigration staff themselves. France has set itself a target of 20,000 deported 'aliens' a year. It is estimated that a record 200,000 people were deported from Europe in 1995.[88] This 'Fortress Europe' which has been constructed through the power of the state, police and immigration services, in fact receives only five per cent of the world's estimated 17.5 million refugees. 'More than 80 per cent of refugees in the world today are concentrated in the poorest countries of the world.'[89] It is worth remembering that while culture often plays a part in constructing perceptions of people as 'others', it is ultimately the state through its legal and political force that decides who will become British and who will not.[90] It is clear that notions of 'democracy' are subject to economic and political forces. For example, in 1998, Britain is strongly supporting the USA in its plan to initiate air strikes on an Iraq crippled by years of sanctions after the Gulf War of 1991. At the same time as publicly describing Saddam Hussein as a tyrant, which may well be true, democratic Britain refuses to accept the asylum claim of Lawk, a Kurdish refugee from Iraq who was working for the UN in his homeland when he was threatened with murder. After a campaign in his defence he is still awaiting the result of his application.[91]

In another of Roshini Kempadoo's banknotes, the British ten pound note is superimposed with images from former British colonies, whose economies still maintain their subordinate status even though they have gained formal political 'independence'. A young woman carries boxes of bananas on her head. The text across the bottom of the image reads: 'Poverty and dependency, the legacy of colonial rule.' Many of these semi-colonial countries are reliant on single-crop agriculture whose products are destined for consumption in imperialist countries, which means they have no control over the prices for their produce, or any alternative means of sustaining the needs of their own populations through diversification of agricultural and industrial production.[92] The over-population of Jamaica due to slavery and its persisting semi-colonial status have meant poverty and unemployment for large numbers of its citizens. In addition, modern agri-businesses use dangerous chemicals severely detrimental to the health of the workers involved in the cultivation and harvesting of bananas in particular. The emigration patterns from the Caribbean have largely been directed by others: encour-

aged by Britain after the Second World War, when labour was needed, then slowed to a trickle during recessions.[93] Migrants are shunted around to suit the needs of the dominant imperialist economies.

It has been pointed out that even as the deportations proceed across Europe, some are warning of a looming demographic crisis which means that immigrants will soon be needed to man Europe's factories and building sites. The European Commission estimates that, as Europe's population ages in the second decade of the twenty-first century, net immigration could be allowed to to rise fourteen-fold, from its current level of 500,000 a year to seven million. Even as asylum seekers and illegal immigrants are shown the door across Europe, it is becoming clear that they may be asked to return sooner rather than later.[94]

THE PERSONAL AS POLITICAL

Donald Rodney recently died at the age of thirty-six after suffering from sickle cell anaemia for many years. This is a disease which mainly affects black people, and Rodney had to undergo several hip replacement operations in an attempt to preserve his mobility. These failed, and he spent long periods in hospital in the years before his death. At his last exhibition in 1997, a wheel chair moved around the gallery, as a constant reminder of the artist's presence and absence. An important contributor to British art and black culture, Rodney's exhibition *Nine Night in Eldorado*, September to October 1997, brought together in a mixed media exhibition some key themes in black history and culture. His personal and family experiences were mingled with more general themes of racism, popular culture, religion, knowledge and the yearning for some 'promised land', which seems utopian and unfulfilled. Rodney described himself as mainly a sculptor, but the exhibition assembled a rich array of photographic, constructed and installation materials. Exhibits included a small and well-thumbed Bible belonging to his sister, a cast of a complete set of the *Encyclopedia Britannica*, and a volume cataloguing the Arts Council collection 1984–8, documenting the first purchase of a work by a black British artist, Keith Piper. Two glass containers hold milk, honey and copper coins which merge into seepage, disappointment and disintegration. A wall is covered with camouflage on which words can just be made out: 'You can take the nigger out of the jungle, but you can't take the jungle out of the nigger.' In a parody of the grotesque stereotypes of black people found in popular entertainment, and still found in the contradictory responses to fame in the

person of stars like Michael Jackson, a fairground automaton whose mask filters pain and suffering goes through his mechanical performance for the viewer. Perhaps the most effective piece in Rodney's exhibition was *My Mother, My Father, My Sister, My Brother.*, a tiny fragile house constructed from pieces of the artist's skin removed during an operation and held together with dressmakers' pins. The skin house was exhibited in a glass case, as well as a large photograph of the house held in Donald Rodney's hand. (plate 9) The photograph is entitled *In the House of my Father*, suggesting religious veneration, protection, belonging and inheritance. The fragility and delicacy of the skin, the pain suggested by the pins, the ritual and magic aura of such a construction, are connected by the artist to his religious and family background, as well as larger social and political issues. The exhibition was dedicated to the artist's dead father, and the title refers to the tradition of nine nights which takes place in Jamaica, when friends and family of the dead person meet for nine nights to remember, drink, play cards, and talk. His father, whose favourite film was Howard Hawks' western *Eldorado* starring John Wayne and Robert Mitchum, came to England in 1958 seeking a better life in another Eldorado. Rodney's father bought a set of

plate 9 *Donald Rodney, In the house of my father, 1997, colour photograph by Andra Nelki, 153 × 122 cms. With permission.*

encyclopedias for his young son, hoping this would be the key to his success in Britain.

In other senses, Eldorado recalls the search for gold and precious substances in the New World of America, where European explorers came to exploit the land and its peoples, and later introduce African slaves. Thus, the notion of Eldorado is shown to be a complex and ambivalent one for black people. Historically, they have been exploited in the construction of a white Eldorado, but like Rodney's father they have visions of their own pleasures, sometimes linked to particular pleasures of popular entertainment, as in Hawks' western film of male trust and friendship in a harsh environment. In other senses, the ambiguities of popular culture and the function of the star persona, for example, Michael Jackson, provide both role models and continuing stereotypes of the black entertainer, who wants a white skin behind the black mask in a kind of grotesque reversal of Fanon's provocative statement on the oppressed black psyche. Rodney's own skin seen in the little house looks pale and translucent, and so different from the living skin of his hand with its pink palm outspread. In fact Rodney's skin is all kinds of colour, not only black. The little house as an emblem of his pain and perceived 'racial' difference links his personal experience and his physical body to that of his father's and family's history, and the histories of other black people.

MAUD SULTER AND BLACK WOMEN HER/STORIES

Maud Sulter's exhibited work is mainly photographic, but she is also a writer of poetry and prose. One of her main aims is to interrogate notions of black women's creativity and excavate lost histories. In an interview, Sulter said that she felt the debates around 'black art' in the 1980s were 'to some degree a very masculinist, navel-gazing practice of seeking to control rather than to expand'.[95] As a radical feminist, Sulter sees certain practices as masculine, and also agrees with Andrea Dworkin's stance on pornography, which sees a direct link between violence towards women and pornographic imagery. Sulter linked pornographic magazines on sale in newsagents with art images and anthropological photographs. All these images are linked in a pornographic chain of objectification and denigration.[96] I do not agree with either Sulter's view on the debates on Black art or her views on pornography. Nevertheless, she has produced many striking and powerful images informed by her own particular perspective on women's history and representation. Her

work is also significant for its determination to reinstate black women into history and visual culture. While I do not agree with Sulter's feminist stance, it seems to me that her work is important in helping to ensure that black culture is never uncritically glorified in a romanticized way. This can sometimes happen, for example, when no mention is made of the omission of issues of gender and gay and lesbian sexuality from art works concerned with 'race'.

Although photography has objectified women, it is also a useful weapon, writes Sulter. She argues that its development coincided with the abolition of slavery and the need to categorize the freed slaves as nonetheless 'other', different and inferior. Photographs of nude women were used by artists to objectify and abuse them, and photographers began to produce pornographic images very early on. Yet there is a tradition of black women's photography, states Sulter.

'Part of the difficulty for those of us engaged in the reconstruction of that participation, our herstory, is the lack of documentation and the difficulties inherent in trying to reclaim it. There are many Black photographers who are trying to explore the naming of that which remains unnamed ... to succeed in the face of the almost insurmountable odds which are stacked against us ...[97]

Sulter's particular perceptions of the tensions and contradictions within photography as a medium have resulted in her attempts to re-appropriate photography for use in black women's herstory, and to question modes of photographic representation by various methods. These include collage, computerized imagery, the use of nineteenth-century cameras to make images which are very critical of the historical period they originate in, and placing large colour photographs in gold frames to be exhibited in museum spaces. An important concern for Sulter is the reinstatment and making visible of black women and their creativity in museum and gallery spaces, which do so much to form people's ideas of cultural worth and historical positioning.

Sulter's work, however, is often difficult, and the catalogues and other pieces of writing which accompany her works are not particularly accessible. A knowledge of French, French culture, history and literature is helpful in understanding her works. Since historical facts have to be viewed with suspicion and interrogated by those who have been erased from history, her project is not to provide another set of 'facts'. Sulter uses a quote from Alice Walker to sum up her approach: 'As a black

person, and a woman, I don't read history for facts, I read it for clues.'
Sulter is a kind of historical detective, piecing together fragments of
evidence, scenes of crimes, people whose identities are unknown to us,
and inviting us to make what we can of the resulting art works, both
written and visual. Her knowledge of cultural history and of women's
and black history is truly impressive. However, not everyone is able to
pick up the traces of the narratives she weaves. For example, her
exhibition *Hysteria* (1991), based loosely on the life of Edmonia Lewis,
a real-life black American sculptress working in the nineteenth century,
requires a considerable amount of historical and cultural academic
knowledge on the part of the visitor.[98] Now of course, I am not arguing
here that exhibition visitors can be expected to engage only with things
they already know, but there are ways of attracting people's interest and
attention which work better than others. In Sulter's case I would argue
that her most effective weapon is the sensual power of her photographic
imagery. During a discussion on issues of accessibility of her work at
the Ikon Gallery, Sulter stated that it is not for black people to take white
people by the hand and explain things to them. This answer tended to
assume that all the black visitors to Sulter's exhibitions understood the
material comprehensively. As one reviewer pointed out, though, the
issue was more to do with accessibility and the desire to know and
understand more, which is only partly related to issues of femininity
and ethnicity in this case, and more to do with people finding art both
pleasurable and critical at the same time. If people do not understand
much of the art, then many of the interesting issues embodied in it will
pass them by.[99] For me, Sulter's work *does* repay close attention in spite
of the difficulties involved in finding one's way around the content
which it embodies. Bearing all this in mind, I want to try and discuss
some of the meanings which resonate for me in the image of *Calliope*,
the muse of epic poetry, from the *Zabat* series of 1989, which is also a
self-portrait of Sulter.[100]

The large colour photograph recalls mid-nineteenth century French
portraits by the photographer Nadar, and shows Sulter in profile look-
ing up to the left with bare shoulders, wrapped in a brown velvet cloak.
On a table in front of her, in a protective case, is a nineteenth century
daguerreotype (a photographic image fixed on a copper plate coated with
silver) . The *Zabat* series was exhibited in Sulter's photoworks exhibi-
tion, which was shown as part of the commemoration of the one hun-
dred and fiftieth anniversary of the invention of photography.

Zabat is made up of nine large colour photographs in gold frames of

'the daughters of memory' – the nine muses – and each is posed by a contemporary black woman who has contributed to culture, for example Alice Walker. Classical muses are replaced by black women, in line with Bernal's now well-known thesis concerning the genesis of classical culture from African influences in his book *Black Athena*. In some cases, the attributes of the muses replace Greek with African artifacts; for example, the lyre is replaced by a drum. The images are striking, uncluttered and almost like religious paintings in their serious and silent mode. They seem strangely timeless for a set of works concerned with history, powerfully abstract in spanning black women's presence, from early history to the present, signified by the use of contemporary models. The word *zabat*, found by Sulter in B.K.Walker's *Encyclopaedia of Women's myths and legends*, means 'sacred dance performed by groups of thirteen'; an occasion of power (possible origin of witches sabbath); black women's rite of passage (from the Egyptian eighteenth dynasty).[101]

Sulter's self-representation of herself as Calliope refers to her poetic writings and her construction of black women's herstories in artistic form, and also to her knowledge of nineteenth century cultural and photographic history. Her image re-enacts French nineteenth century photography with some important differences. Central to her research on black women's history in nineteenth century Europe is a photograph by Nadar, usually said to be of an unknown woman. Sulter proposes that we read this image as a portrait of Jeanne Duval, the poet Charles Baudelaire's lover, and the inspiration for the Black Venus of his erotic poems.[102] Thus, Duval can be reinstated in photographic and cultural history.[103]

The photograph of the unknown woman who is rescued from oblivion by Sulter as Jeanne Duval recurs in a number of her works. The image is seen in *Syrcas*, and again in *Jeanne: A Melodrama*.[104] The image of this young woman with luxuriant black wavy hair, draped in a velvet cloak and looking at the camera is montaged by Sulter into a variety of reconfigured contexts. In *Jeanne: A Melodrama*, her head appears as that of the black maid in Manet's *Olympia*, and in the margins of Courbet's painting *The Artist's Studio: A real allegory*.[105] At the right of Courbet's painting, Baudelaire is seated reading. Previously Jeanne was by his side but the artist painted her out; his reasons are unknown. Sulter's aim is to reinstate the lost presence of black women in European cultural history, especially in mid-nineteenth century France at the time of the origins of modernist art. She would like to imagine Jeanne as a creator of poetry in her own right, not as an appendage and muse to Baudelaire.

In her self-portrait as Calliope, Sulter also reincarnates Jeanne Duval, a forgotten woman of French modernist poetic culture.

In Sulter's Zabat poems, she speaks with the voices of forgotten black women, reminding us forcefully of their absent presence. In the prose poem Calliope, no doubt intended to supplant the prose poems of Baudelaire himself, Sulter speaks as Jeanne Duval, who, with a friend, walks through Père Lachaise cemetery where so many famous Parisians are buried. She notices the photographer Felix Nadar's tomb, which includes a gap waiting for his name to be engraved when he dies. She wonders what will become of her when she dies, and whether she will be invisible in death. How will she be remembered? How many black women are anonymous? She asks 'How could anyone think that we wouldn't both take the trip to have our photograph taken, and that once taken they would reveal the shallow notion of the theory of race? Aw shit, who cares? All I care about is getting my name back on my poetry and out of the adolescent scribblings whose influence is supposed to be me.'[106]

The photograph of the unknown woman does not conform to the stereotypical view of the black female with thick lips, black skin, and large buttocks and genitals, so, the implication is that what survives is the mythical view of Jeanne as the black Venus of Baudelaire's poems, not Jeanne as she actually was. Baudelaire's representations of black women and lesbians as alternatives to, and heroines of, modernity, did not mean that he recognized them in reality, as Walter Benjamin put it.[107]

In Sulter's large coloured photograph, she poses herself in a similar way to some of Nadar's more striking female sitters, for example the famous actress Sarah Bernhardt and the unknown woman. However she does not look at the camera, perhaps suggesting that she is not an object to be looked at, not the actual Jeanne Duval muse of Baudelaire, but an abstract inspirational force as well. Yet the off-the-shoulder velvet cloak suggests sensuality, and the lighting accentuates the warm tones of the skin. On the table in front of her is a nineteenth century daguerreotype in a presentation case. Perhaps the positions are reversed. Here the woman becomes the muse, and the unknown person in the photograph must be someone else. The photographer is at once creator, muse, model and poetess. Black women take a central place in the remembering and commemoration of cultural history.

CONCLUSIONS

Economics, histories and identities have been crucial to visual culture produced by black British artists, and, as we have seen, some artists make these themes explicit in their work. While new forms of exploitation and oppression have been experienced by black people in Britain and elsewhere in Europe, these have grown out of older types rooted in earlier forms of capitalism. While the interaction between society, economics and culture is complex, ambiguous and sometimes densely contradictory, it has been my argument here that economics remains a key factor in understanding the historical development of any society and the culture produced within it. Thus, I am at odds with much of poststructuralism and postmodernism which sees Marxism as outmoded and devoid of anything but a mechanistically reflectionist theory of cultural production. In the case of Stuart Hall, this develop-ment in his analysis of culture needs to be understood in a wider political context. It is clear that many recent art works *do* articulate notions of economics, history and identity in ways specific to visual imagery, and in particular in relation to possibilities provided by new computer technology. I am not arguing here that these artists have particular political views which can be deduced from their continuing attention to economics and history in understanding and creating black culture. What I *am* suggesting, though, is that many artists have been far less keen to distance themselves from an engagement with histories and their economic infrastructures than some of the major black cultural theorists such as Stuart Hall, Paul Gilroy and Kobena Mercer.

Clearly, art works have different approaches to these themes, as they are made by individual artists with their own historical, social, gender and sexual identities, as well as individual approaches to concepts of blackness and ethnicity. Sulter, for example, sees both gender and black-ness as key concerns in her projects of historical and cultural rewriting and representation. Gabriel concludes that the argument around a focus on black identity or on ethnicity has been falsely posed in oppositional terms: 'Instead of seeing the debate in either/or terms, the evidence from Europe suggests that both are equally relevant.'[108] I think the same could be said for representations of black identity and ethnicity in recent examples of black visual culture in Britain. An interest in notions of ethnicity and the many ways in which black identities and lived experienced are influenced and constructed, does not mean that artists

will necessarily give up the concept of black identities, black cultures or black histories.

In the following chapter I want to turn to the notion of the individual subject. While recent postmodern theories have attacked the notion of a coherent embodied conscious individual subject, the trajectory of black representation in visual culture has been somewhat different. The emergence of the conscious black subject in place of the objectified and stereotyped specimen has been the result of long and determined struggles in both cultural and social spheres, and such valued subject-hood is not likely to be given up lightly.

NOTES

1 Both these essays are reprinted in D.Morley and K-H Chen eds., *Stuart Hall: Critical Dialogues in Cultural Studies*, (Routledge, London, 1996).

2 Rohini Malik, 'Dave Lewis' in *Dave Lewis. Monograph*, (Autograph, London, no date), pp 4–5.

3 As I am writing this, there is an unusually large number of programmes devoted to black history and the voices of participants in black British history. This is to celebrate the fiftieth anniversary of the arrival of the ship *Empire Windrush* at Tilbury docks on 22 June 1948 with hundreds of Caribbean migrants on board who were invited to Britain to help with the shortage of labour during post-War reconstruction. For an account of the commissioning of some of these programmes by M. and T.Phillips, and their proposed screening in May/June 1998, see *Guardian Weekend*, May 16, 1998, pp 38–46. See also the book by M. and T. Phillips, *Windrush: The Irresistible Rise of Multi-Racial Britain*, (Harper Collins, London, 1998).

4 Quoted in P.Grafton, *You, You and You! The People out of step with World War 11*, (Pluto Press, London, 1981), p 45–6.

5 For an account see ibid., pp 96–9.

6 P.Fryer, *Staying Power. The History of Black People in Britain*, (Pluto Press, London, 1984), p 359.

7 ibid., p 361.

8 ibid., pp 360–1.

9 ibid., p 363.

10 Mayerlene Frow, *Roots of the Future: Ethnic diversity in the making of Britain*, (Commission for Racial Equality, London, 1996), p 29.

11 C.A.Bayly ed., *The Raj: India and the British 1600–1947*, (National Portrait Gallery, London, 1990), p 411.

12 For these and additional figures see *Roots of the Future: Ethnic Diversity in the Making of Britain*, pp 29–31.

13 A.Travis and D.Rowan, '*A beacon burning darkly*', *The Guardian*, 2 October 1997, p 17.

14 D.Fairhall, '*Equality promise to black soldiers*', *The Guardian*, 14 October 1997 and S.Milne, "*General goes to war on racists in the guards*", *The Guardian*, 20 July, 1999, p 12.

15 D.W.Bygott, *Black and British*, (Oxford University Press, Oxford 1992), p 51.

16 All quotes from '*D-Day. The Allies' Real Priorities . . .* ', *Workers' Power*, no.179, June (1994), p 8.

17 He describes with disgust soldiers raping old women and nursing mothers, and trying to bully young children begging near their barracks into giving them oral sex. P.Grafton, *You, You, and You!*, pp 90–92.

18 See '*Labour guards the Empire*', *Workers Power*, no. 190, June (1995), pp 8–9.

19 L.Grossberg, ed., '*On postmodernism and articulation*. An interview with Stuart Hall', in D.Morley and K-H Chen eds., *Stuart Hall: Critical Dialogues in Cultural Studies*, (Routledge, London and New York, 1996), p 139.

20 For an introduction to these writers and their ideas see R.Appignanesi and C.Garrett, *Postmodernism for Beginners*, (Icon Books, Cambridge, 1995) and on a more advanced level A.Callinicos, *Against Postmodernism: A Marxist Critique*, (Polity Press, Cambridge, 1989).

21 *Stuart Hall: Critical Dialogues in Cultural Studies*, p 148.

22 Mercer, '*Welcome to the Jungle: Identity and Diversity in Postmodern Politics*', in J.Rutherford ed., *Identity, Community, Culture, Difference*, (Lawrence and Wishart, London, 1990), p 48. Mercer does not specify what he means by 'the traditional Left' or 'classical Marxism' (is this Stalinism, any organization committed to building a revolutionary party, or any organization which believes the working class is the main force which can overthrow capitalism or what?), so the result of his position is, in practice, a condemnation of all the Marxist Left.

23 ibid., p 50. See also '*Travelling Theory. The Cultural Politics of Race and Representation*'. An interview with Kobena Mercer by Lorraine Kenny', *Afterimage*, September (1990), pp 7–9.

24 See Gilroy, '*Scales and eyes: "race" making difference*', in S.Golding ed., *The Eight Technologies of Otherness*, (Routledge, London and New York, 1997), pp 192,195. In this rather odd article, Gilroy argues that since anti-racists and anti-fascists 'remain wedded to the most basic mythology of racial difference' i.e. essentialist notions of black and white, the task of anti-essentialist intellectuals to argue against such notions is an uphill struggle. He bases this argument on a brief examination of an anti-fascist demonstration in suburban Welling, just south of London, when thousands of demonstrators marched on the headquarters of the British National Party with the aim of closing it down permanently. Gilroy quotes the words of a black policeman – mentioned in national news bulletins at the time – who claimed he was called a traitor by white demonstrators for being a black cop. He also stated that no black people were on the march. Gilroy believes this and argues that the march was 'undertaken by anti-racist demonstrators themselves acting in the name of their ideals and the prospect of the multicultural community waiting to be born in that area.'(p 191) As a participant in the demonstration, I can say that there were very large numbers of black youth on the demonstration, and this fact rather undermines the rest of Gilroy's argument. In any case, fascists are opposed by socialists not only because they are racists. In some countries, racism was not a particularly important facet of fascism. Socialists oppose fascism also because it is a virulent form of dictatorial and violent bourgeois rule which physically stamps out any workers' opposition as well as any other threat to its extreme right wing nationalist politics, hence the possibility of transferring the racism encountered in bourgeois democratic societies to organized racial persecution at a state level under fascism.

25 Gilroy is quoted by McRobbie in D.Morley and K-H.Chen eds, *Stuart Hall*, p 260: 'For the black user of these images and products, multivariant processes of "consumption" may express the need to belong, the desire to make the beauty of blackness intelligible . . . '

26 P.Gilroy, *'There ain't no black in the Union Jack'. The cultural politics of race and nation*, (Hutchinson, London, 1987), p 247.

27 S.Vieux, *'In the Shadow of Neo-liberal Racism'*, *Race and Class*, vol.36, no.1, July-Sept. (1994), p 28.

28 K.Malik, *'Universalism and Difference: Race and the Postmodernists'*, *Race and Class*, vol.37, part 3, (1996), p 3.

29 ibid., p 6.

30 ibid., p 9.

31 ibid., p 15. See also Malik, *The Meaning of Race*, chapter 8. Empiricism argues that we can understand facts only through sense experience and introspection, and some empiricists deny that we can grasp any general truths or concepts which are not directly available through experience.

32 As Ernest Mandel puts it in his introduction to Marx's *Capital*, vol.1, (Penguin Books, Harmondsworth, 1976), p 21,: 'In fact, he [Marx] starts from elements of the material concrete to go to the theoretical abstract, which helps him then to reproduce the concrete totality in his theoretical analysis. In its full richness and deployment, the concrete is always a combination of innumerable theoretical "abstractions". But the material concrete, that is, real bourgeois society, exists before this whole scientific endeavour, determines it in the last instance, and remains a constant practical point of reference to test the validity of the theory. Only if the reproduction of this concrete totality in Man's thought comes nearer to the real material totality is thought really scientific.'

33 M.Marable and L.Mullings, *'The divided mind of black America:Race, ideology and politics in the post Civil Rights era'*, *Race and Class*, vol.36, no.1, (1994), pp 62,66.

34 For an excellent article which clearly explains the political trajectory of postmodernism and the reasons for this, see C.Lloyd, *'Marxism versus postmodernism'*, *Trotskyist International*, issue 21, Jan.-June (1997), pp 38–48. Also very accessible is E.M.Wood and J.B.Foster eds, *In Defence of History: Marxism and the Postmodern Agenda*, (Monthly Review Press, New York, 1997). More difficult but interesting is M.Zavarzadeh, T.L.Ebert, D.Morton eds, *Post-Ality: Marxism and Postmodernism*, Issue 1 of *Transformation: Marxist Boundary Work in Theory, Economics, Politics and Culture*, (Maisonneuve Press, Washington DC, 1995).

35 S.Hall, *'Gramsci's relevance for the study of race and ethnicity'*, in *Stuart Hall*, p 418.

36 See *Stuart Hall*, p 493.

37 ibid.,p 499.

38 Lloyd, *'Marxism versus postmodernism'*, p 45.

39 Sparks, *'Stuart Hall, Cultural Studies and Marxism'*, in *Stuart Hall*, p 83.

40 N.Kirk, *'History, language, ideas and postmodernism: a materialist view'*, *Social History*, vol.19, part 2, May (1994), pp 221–40, quote from p 227.

41 Sparks, p 89.

42 Quoted by McRobbie, *Stuart Hall*, p 256. Norris is referring to Hall's article on *'New Times'* which I will discuss shortly.

43 Hall, *Stuart Hall*, p 429.

44 ibid., p 440.

45 Hall, ibid., p 437.

46 I have explained at some length elsewhere how rejections of Marxism as economistic and reductive have usually been made by people who have not understood that Marxism as a method is based on dialectical material-ism, and/or have equated Marxism with Stalinism. For more on this see my book *Materializing Art History*, (Berg, Oxford, 1998).

47 A.Sivanandan, 'All that melts into air is solid: The hokum of New Times', Race and Class, vol.31, no.3, (1989), p 2. See also J.Gabriel, Racism, Culture, Markets, (Routledge, London and New York, 1994), pp 172–3.

48 Hall, Stuart Hall, p 231. This is certainly true of the atmosphere in some Left meetings, in my experience, but it is a vast generalization to say that all meetings of the organized Left in Britain are like this. In any case, Left political organisations have to confront new questions every day in practice. For a collection of Marxist writings by black and white scholars on what Hall calls 'new questions' see for example E.M.Wood and J.B.Foster eds, In Defence of History:Marxism and the Postmodern Agenda., (Monthly Review Press, New York, 1997).

49 Hall, ibid., p 234.

50 Hall, ibid., p 237.In discussion with me, Karun Thakar (an artist whose work I discuss later) has remarked that 'Cultural factors must be seen in the context of other factors which may be more pressing or more important to members of some black communities. It is important to note a distinction between ethnicity – based on imputed customs, traditions, religion, language, ethics and morality – and the actual 'lived' culture in black communities which may be based on social, economic and historical factors rather than simply on ethnicity.' At times, Hall risks fetishizing ethnicities and approaches an 'ethnic determinism' to replace the economic determinism he rejects.

51 Sivanandan, 'All that melts into air is solid: The hokum of New Times', p 15.

52 ibid., p 23. In the Communist Manifesto, Marx and Engels wrote that in its drive to develop the productive forces, capitalism had swept away all certainties and fixed beliefs so that 'All that is solid melts into air, all that is holy is profaned, and Man is at last compelled to face with sober senses, his real conditions of life, and his relations with his kind.' K.Marx and F.Engels, 'Manifesto of the Communist Party' in Karl Marx and Frederick Engels: Selected Works in One Volume, (Lawrence and Wishart, London, 1968), p 38.

53 See the section "Race and Class", pp 27–34, especially pp 30–31 on Sivanandan in Socialism and Black Liberation. The revolutionary struggle against racism, (Workers Power Publication, London, 1995). The Workers Power pamphlet argues that the basis for racism and imperialism was a relatively privileged layer of workers who were open to ruling class ideology and that they and the trade union bureaucrats transmitted such ideas to other workers. To buy the loyalty of this section of workers imperialists used profits from raw materials and cheap labour in the colonies. Supplies of gas and water for skilled workers set them apart from the miserable conditions of poorer working class people in the heyday of imperialism. Nowadays the media carries out part of this ideological task. The point is, some white workers still are racists, there is a material reason for racism and white workers do benefit in the short term from racism. It is not inevitable and natural, and it is not inexplicable in terms of marxist theory, even although some left groups prefer to argue that there is no material basis for racism, and as soon as black and white workers struggle together, racism will disappear. See pp 5, 27–9. For example an article on 'After the Windrush' by Gary McFarlane in the SWPs' Socialist Review, July/August, 1998, p 8 states that 'Black and white unity inside the working class is uneven but is nevertheless a reality that stands as a bulwark against any future resurgence in popular racism.'

54 *Trophies of Empire*, Exhibition Catalogue, (Bluecoat Gallery and Liverpool John Moores' University, 1994), p 5.

55 Ibid., p 11, quoted by Keith Piper in his essay. By the late eighteenth century, Liverpool accounted for three-sevenths of Europe's total slave trade. Manchester became a centre for the manufacture of cotton cloth, taken to Africa to trade for slaves, while Birmingham's metal manufacturing industry grew to provide chains, padlocks, branding irons as well as articles of trade such as pans, kettles and guns. See also R.Segal, '*The chains of shame*', *The Guardian*, 17 December 1997, p 2.

56 Many celebrated figures of the Enlightenment, such as Defoe, Locke and Swift were shareholders in slave-related companies, as were many members of Parliament. See R.Segal, '*The chains of shame*', p 3. This article also has a useful comparison between patterns of European and Islamic slavery of Africans and others.

57 C.Nevin, '*Murder. Slavery. Theft. Why would anyone want to remember the British Empire?*', *The Guardian*, 12 April 1997, pp 12–13.

58 G.Gibbs, '*Slavery tarnishes city's "wise son"*', *The Guardian*, 7 February 1998, p 10.

59 ibid., essay by Jayne Tyler, p 15. The work is illustrated on pp 26 and 45. For an excellent and accessible account of the cultivation of tea, coffee and sugar, slavery and capitalism, see N.Rowling, *Commodities: How the world was taken to market*, (Free Association Books, London, 1987).

60 ibid., essay by Keith Piper, p 14. Recently Robin Blackburn has argued that slavery was not the result of capitalism's emergence from feudalism, but part of the rise of 'modernity' and 'civil society'. See Blackburn, *The Making of New World Slavery – from the Baroque to the Modern 1492–1800*, (Verso, London, 1997). However the information provided in his book shows that colonial projects, although licensed by the English crown, received no material support from the state initially, which meant that from the outset they were controlled by the new capitalist merchant class. Plantations were run to maximize profits, though productivity was low and slave death rates high. After the preconditions for 'free' wage labour developed, where the labourer was separated from the means of production, slavery became increasingly inefficient. In the given historical conditions of labour shortage in the seventeenth and eighteenth centuries, therefore, slavery was a necessary phase for early capitalism and inextricably tied to it. See the review of Blackburn's book by Bill Jenkins, '*Capitalism's savage Birth*', *Workers Power*, no.213, July-August (1997), p 7. Marx noted with pleasure a letter from an 'outraged' former West Indian plantation owner, complaining that the freed slaves 'content themselves with producing only what is necessary for their own consumption, and alongside this "use value" regard loafing (indulgence and idleness) as the real luxury good; now they do not care a damn for the sugar and the fixed capital invested in the plantations but rather observe the planters' impending bankruptcy with an ironic grin of malicious pleasure, and even exploit their acquired Christianity as an embellishment for this mood of malicious glee and indolence.' Marx adds that the former slaves have declined the 'opportunity' to become wage labourers in favour of being self-sustaining peasants, thus avoiding a relationship with capital through either direct or indirect forced labour. Direct forced labour, says Marx, can never create 'general industriousness' and is therefore of less use to developing capitalism than the indirect sort. K.Marx, *Grundrisse. Foundations of the Critique of Political Economy (Rough Draft)*, (Allen Lane, Penguin Books, London, 1973), pp 325–6. This quotation is cited though not discussed and

fully referenced in P.Gilroy, *'There ain't no black in the Union Jack': The cultural politics of race and nation*, (Hutchinson, London, 1987), p 153.

61 In 1994 a permanent display on the slave trade was opened at the Maritime Museum, Greenwich, south London. This is still inadequate, in the view of one commentator, but he believes it would probably be too distressing for visitors to experience the real conditions of imprisonment aboard a slave ship. (This would be impossible in any case.) However a display of a middle class eighteenth century family's drawing room shows that almost all of its contents were derived from the trade. He concludes: 'In spite of my strictures, this is an exhibition which we should all see because there are no others like it. At the same time we should be demanding a full and proper exhibition, perhaps as an apology endorsed by the Queen and her ministers.' D.Roussel, *'Against Human Dignity. Transatlantic Slavery'*, *Flava Magazine*, Summer (1997), pp 20–22, quote from p 22. Some of the museum's trustees have voiced concern about the 'controversial' display. See J. Ezard, "Empire show arouses pride and prejudice", *The Guardian*, 23 August 1999, p 30.

62 *Keith Piper: Relocating the Remains*, exhibition catalogue, (inIVA, London, 1997), p 43.

63 *'The Sample Art of Keith Piper'*, interview in *Creative Camera*, August-September (1995), p 33.

64 E.Chambers, *'New media and Black artists'*, in S.Merali and J.Mulvey eds., *Radical Postures: Art, New Media and Race*, (Panchayat, London, 1996), pp 19–25, quote from p 20.

65 L.Day, *'Globalisation. A New stage of world economy?'*, *Trotskyist International*, issue 21, Jan-June (1997), p 3. Day sounds a cautionary note concerning the globalization of new technologies, however:' As long as two-thirds of the world's population live more that two hours walk away from the nearest phone, then the material means for being a citizen of the global village are non-existent.'(p 1) On a more mundane level, I recently experienced the practical difficulties of making artworks using new technology available to a larger audience. I wanted to speak about Keith Piper's work on CD-rom for Mackintosh computers while showing the images on a large screen, but was unable to do so because problems of arranging insurance for the appropriate computer in another building were too complex. I had to use slides instead.

66 See G.Jantjes, preface to J.Fisher ed., *Global Visions: Towards a new internationalism in the Visual Arts*, (Kala Press in Association with inIVA, London, 1994), p vii.

67 Gilane Tawadros, whose article on modernism and black women artists I discussed earlier, is the Director of inIVA. InIVA is funded by the Arts Council and the London Arts Board, but also has to raise money from private sponsors. In a job advertisement for Head of Development (Fund Raising and Commercial Initiatives), inIVA described itself as 'working with a wide range of partners, from conventional galleries to schools and businesses and has a special interest in new technologies, international collaborations and site-specific commissions.'

68 Quoted from p 2 of the inIVA Agenda for 1996–7.

69 A.deSouza, *'The Flight of/from the Primitive'*, *Third Text*, 38, Spring (1997), p 66.

70 ibid., p 66.

71 *'Imagining a New Internationalism'* interview with Sunil Gupta, *Creative Camera*, April-May, (1994), pp 18–23.

72 S.Gupta ed., *Disrupted Borders: An intervention in definitions of boundaries*, (Rivers Oram Press, London, 1993).

73 Quoted in Deborah Willis' introduction to Kempadoo's work in *Roshini Kempadoo. Monograph*, (Autograph, London, 1997), p 12.

74 ibid., p 13.

75 ibid., p 17.

76 J.Walvin, *Slavery and the Slave Trade: A short illustrated history*, (Macmillan, Basingstoke, 1983), p 112. Also very useful is the chapter on sugar in N.Rowling, *Commodities*.

77 '*A contest of Markets. Notes on the selling of Black Masculinity: 11*', in K.Piper, *Step into the Arena: Notes on Black Masculinity and the Contest of Territory*, (Rochdale Art Gallery, Rochdale, 1992), p 22.

78 There is an extract from this in J.Munns and G.Rajan eds, *A Cultural Studies Reader: History, Theory, Practice*, (Longman, London and New York, 1995), pp 19–32.

79 See R.Dyer, *White*, (Routledge, London and New York, 1997), chapter 3, 'The Light of the World', p 116. See also B.Winston, *Technologies of Seeing: Photography, Cinematography and Television*, (BFI, London, 1996), chapter 2, '*The Case of Colour Film. White Skin and Colour Film: The Ideology of the Apparatus*'. Also useful on whiteness, culture and ideology is the special issue of the journal *Transition*, no. 73, 1998, *The White Issue*, published by Duke University Press.

80 J.Gabriel, *Racism, Culture, Markets*, (Routledge, London and New York, 1994), p 157.

81 For discussions of these examples of Kempadoo's work and illustrations, see F.Gierstberg, '*Roshini Kempadoo. Cultural Identity and Representation*', in *Perspektief*, no.45, Rotterdam, Dec.1992–Jan. (1993), pp 7–18, and my *Seeing and Consciousness: Women, Class and Representation*, (Berg, Oxford and Washington, 1995), pp 191–3.

82 K.Marx, *Capital*, vol.1, (Penguin, Harmondsworth, 1976), p 205, from the section '*Money, or the Circulation of Commodities*'.

83 This image from 1994 is discussed in L.Nead, *Chila Kumari Burman:Beyond Two Cultures*, (Kala Press, London, 1995), pp 11–13.

84 For interesting illustrations see V.Hewitt, *Beauty and the Banknote: Images of Women on Paper Money*, (British Museum Press, London, 1994).

85 F.Webber, '*From ethnocentrism to Euro-racism*', *Race and Class*, vol.32, no.3, (1991), p 16.This is a special issue on racism and Europe.

86 Gabriel, p 164.

87 For material on the European Community and Immigration see the educational material produced by Steve Cohen, *Imagine there's no countries: 1992 and the international immigration controls against migrants, immigrants and refugees*, (Greater Manchester Immigration Aid Unit, Manchester,1992), and *Race Equality Fact Pack*, (Birmingham City Council Race Relations Unit, Birmingham,1991).

88 L.Doyle, '*EU slams the door on fleeing victims*', *The Guardian*, 23 March 1996, p 14.

89 R.Brown, '*Racism and immigration in Britain*', *International Socialism*, no.68, Autumn, (1995), p 28. This is a very useful article on the subject.

90 This is sometimes underplayed by those pointing to the shift away from scientific racism to cultural racism in the later twentieth century. See for example the discussion '*Rethinking the "New Europe"*' in A.Brah, *Cartographies of Diaspora: Contesting Identities*, (Routledge, London and New York, 1996), pp 165–177. Other material on the cultural constructions of European identity can be found in J.Nederveen Pieterse, '*Fictions of*

Europe', *Race and Class*, vol.32, no.2, (1991), pp 3–10, and M.O'Callaghan, '*Continuities in imagination*', in J.Nederveen Pieterse and B.Parekh, *The Decolonization of Imagination: Culture, Knowledge and Power*, (Zed Books, London and New Jersey, 1995), chapter 2.

91 See *No Refuge*, published by *The Guardian* in association with Amnesty International, 30 May 97, p 11. I phoned Amnesty International in July 1999 to find out what had happened to Lawk, but was not able to get any further information.

92 For more information on Kempadoo's work on banana farmers in collaboration with the national farmers' union of St. Vincent in the Caribbean in the mid 1980s, some of which is incorporated into the British ten pound note, see Roshini Kempadoo, '*Working to Commission*', in M.Fuirer ed., *Whose Image? Anti-Racist Approaches to Photography and Visual Literacy*, (Building Sights, Birmingham, 1989), pp 5–8.

93 See Brown, '*Racism and Immigration in Britain*'.

94 L.Doyle, '*EU slams the door on fleeing victims*', p 14.

95 '*Maud Sulter: An interview*' with Mark Haworth-Booth, *History of Photography*, vol.16, no.3, Autumn, (1992), p 266.

96 M.Sulter, '*The Nature of Photography: Black Notes from the Underground*', *Feminist Art News*, vol.3, no.2, (1989), p 13.

97 Ibid., p 14.

98 For information on Edmonia Lewis see A.Boime, *The Art of Exclusion: Representing Blacks in the Nineteenth Century*, (Thames and Hudson, London, 1990) pp 162–171.

99 See A.Cullis, "*Missing presumed black: Maud Sulter at the Ikon Gallery*", *Creative Camera*, no 314, Feb/March, 1992: "The desire to 'to know, to understand a story, is hardly odd. It can of course be represented as a discourse of power (Foucault's 'power-knowledge'), but there are two sorts of power getting confused here. The 'power' of the visitor in wanting to get a grip on what the show is about is scarcely powerful at all compared to the power of the ACGB [Arts Council of Great Britain]-funded gallery which presents that show. This show is not in fact difficult in the old Modernist, formal sense . . . but in the sense that it's obscure and convoluted and inaccessible." p 46.

100 Maud Sulter refused me permission to reproduce this work, now in the Victoria & Albert Museum, London. A colour reproduction can be found on p 189 of R.J.Powell, *Black Art and Culture in the 20th Century* (Thames & Hudson, London, 1997).

101 Interview with Mark Haworth-Booth, p 264. this interview is very helpful in understanding some of the details of Sulter's work.

102 E.J.Ahearn, "*Black woman, white poet: Exile and Exploitation in Baudelaire's Jeanne Duval Poems*", in *The French Review*, vol LI, no 2, Dec 1977, pp 212–20.

103 J.Beckett and D.Cherry, "*Zabat: Poetics of a family tree*", *Women Artists Slide Library Journal*, no 31/2, Jan/Feb, 1989, p 37.

104 See the *Syrcas* catalogue, Wrexham Library Arts Centre, 1994, *Duval*, and *Art History*, vol 17 no 4, Dec 1994, pp 513–6.

105 On *Olympia* and black women see L.O'Grady, "*Olympia's maid: Reclaiming black female subjectivity*", *Afterimage*, Summer 1992, pp 14–15.

106 "Calliope" in *Zabat*, Urban Fox Press, Hebden Bridge 1989, no pages.

107 On Baudelaire and women in the context of representations of women and modernity in France see my *Seeing and Consciousness: Women, Class and Representation*, (Berg, Oxford, 1995), pp 75–6.

108 Gabriel, p 179.

CHAPTER 3

OBJECTIFIED BODIES OR
EMBODIED SUBJECTS?

Why is subjectivity such an important issue in the study of black visual culture? This chapter seeks to provide some answers. When the term 'subjectivity' is encountered in contemporary cultural theory, it does not mean a state of being personally involved and lacking impartiality or objectivity. It refers to the being of a person, selfhood – a thinking and acting human subject, rather than a passive object. Put simply, a subject is an individual person.[1]

In much visual culture of the nineteenth century, black bodies were represented not as the physical being of conscious individual subjects, but as specimens of racial types collected and documented for study by European, and later American, scientists. Ethnography and anthropology developed together with the increasing technical accomplishments of photography, though it is worth remembering that most so-called ethnographic photographs were black and white, and therefore in this respect were not naturalistic. Ethnography comes from ethnos, meaning people/race/nation and graphein meaning writing/description. Thus a definition of ethnography includes notions of classification and learning, 'the science which considers races and people and their relationship to one another, their distinctive physical and other characteristics'. Anthropology, a related discipline, is defined as 'the science of Man or Mankind, in the widest sense'.[2] The disciplines did not take on a scientific status until the later nineteenth century, and anthropology found its first institutional homes in museums, rather than universities. The amassing of collections, both of material culture and of photographs, 'propelled anthropology towards institutionalization, as curators started to define themselves professionally as anthropologists'.[3]

Ethnographic collections include not only artifacts and photographs of black and other colonized peoples, however; in many cases actual human parts or even whole bodies were included. The most notorious example of this is probably the preservation of the genitals of Saartje Baartman, the so-called Hottentot Venus, dissected in France in the early

nineteenth century and still housed in a Parisian museum. More recently, Australasian native people have campaigned for the return of their relatives' remains from institutional and private possession in Britain. For example in May 1988, a London auction house, Bonhams, was going to sell a preserved Maori head for an estimated £10,000. After protests, the 'owner' agreed to return the head to New Zealand.[4] The main figure who initiated the flow of native people's remains to Britain was the botanist Joseph Banks who accompanied Cook on his 1768–70 voyage to Australia. He collected thousands of botanical specimens as well as a dead wallaby which was taken back to England to be stuffed. In 1803, Banks, now the possessor of a knighthood, received a gift in recognition for his services to science from the Governor of New South Wales. It was the preserved head of the Aboriginal warrior Pemulwoy.[5]

Black artists, therefore, have in many cases developed critical responses to museums and institutions of science and culture, which in the past have often seen them as specimens rather than curators, managers and participants in cultural conservation and development.[6] In recent years, this has been somewhat rectified by black artists working with and in museums, to create alternative installations which question the existing collections, for example Renée Green's *Bequest* (1991–2) at the Worcester Art Museum in New England, where screens overlaid with almost mythological texts of Americanness by Melville and Hawthorne were juxtaposed with other texts revealing the parallel and hitherto obscured absence from the museum of the histories of Afro-Americans.[7] Similarly Fred Wilson's *Mining the Museum* (1992) sponsored by the Museum of Contemporary Art in Baltimore, reclaimed and reframed historical exhibits to evoke histories not often displayed and mostly Afro-American. For example in an exhibit labelled 'Metalwork 1793–1880' he placed a pair of slave manacles.[8] In England, Sonia Boyce created *Peep* (1995) at the Green Centre for Non-western Art and Culture at the Royal Pavilion Art Galley and Museums, Brighton. Objects were wrapped in tracing paper, as were the cases which housed them. To view the objects, visitors were obliged to peer through holes cut in the paper. Thus the voyeuristic nature of the museum display of objects from material culture, especially those of 'other' cultures, was brought to the fore. Visitors were encouraged to ask what they were doing, why they had come to the museum and what they believed was being presented to them.[9]

The classification systems of ethnographic collections are not simply reflective of the culture in the collection, but also construct our

perceptions of it. Most of these collections are arranged by country, though some, notably the Pitt-Rivers collection at the University of Oxford, are arranged by types of artifact, for example weapons, head ornaments, fishing tools, or lighting devices. We should remember that the archival collection is always a *selection* from living cultures, not the larger picture, and a selection made in many cases by scientists working directly or indirectly under the patronage of imperialist states. An example of such a project was that devised by the Asiatic Society of Bengal in 1865 which, in truly encyclopedic fashion, aimed to exhibit living representatives of the races of the Old World (or at least of India).

'A somewhat meagre but similar outcome realized instead of the exhibit of life specimens was constituted by E.T.Dalton's *Descriptive Ethnology of Bengal*, (1872), illustrated with lithographs based on photographs, and the eight volume *The People of India: a Series of Photographic Illustrations with Descriptive Letterpress of the Races and Tribes of Hindustan*, (Watson and Kaye 1868–75); this was commissioned by the British government and covered the native peoples of this area of the British Empire.'[10]

However, some later nineteenth-century exhibitions *did* involve the construction of 'typical' homes and even villages of black, Asian and native North American peoples, whom the largely white public would pay to visit and observe as they performed cultural activities. Many years afterwards, from the 1930s onwards, there was a decline in these international and colonial exhibitions featuring specimens of 'living culture' and also in the significance of the ethnographic photograph.[11] These displays were increasingly criticized on moral grounds. Film and the illustrated anthropological book took over much of this display of spectacle of other cultures. Within anthropology itself, fieldwork by the European anthropologist became the basis of scientific and truthful observation rather than the photograph. Christopher Pinney, Chair of the Royal Anthropological Institute Photography Committee, has argued that the body and mind of the anthropologist now functioned as a photographic negative. Exposed to the culture of 'other', s/he returned home imprinted with the traces of the 'other's' material life.

After "exposure" during fieldwork, and after suitable processing, the anthropologist was able to provide a "positive" in the form of the ethnographic "monograph", the standard professional publication. It is in this sense that photography and a metaphorization of its technical

and ritual procedures have, perhaps, informed the nature of written texts which anthropologists now often privilege over visual documentation.[12]

However the equation of the photographic image with scientific truth was for a long time the basis of ethnographic and anthropological studies. Though anthropology is now much more critical of itself as a discipline and its methods, recent work on these nineteenth and early twentieth century century archives has shown how they contributed to the construction of both academic and afterwards more popular conceptions of colonized peoples as primitive, uncivilised and in need of 'help' from Europeans and North Americans to 'develop' their societies and economies.[13]

IMAGES OF THE ARCHIVES

Dave Lewis' contributions to *The Impossible Science of Being* exhibition organized in 1995 by the Photographers' Gallery, London, attempted to question and disturb the perceived relationship of anthropology and photography as one of scientific truth. (plate 10) Lewis visited anthropological and ethnographic collections, sometimes to use material from

plate 10 *Dave Lewis, Haddon Photographic Collection, Cambridge University Museum of Anthropology and Ethnography, 1995, sepia photograph.Courtesy of the artist.*

their archives in a constructed image, sometimes to employ the actual buildings as settings for his own models. Access was refused by Imperial College, London, where the staff would not let Lewis photograph the images or even the outside of the boxes in which they were stored. Lewis felt that things were 'being hidden away'. His idea was to 'make the viewer aware that this is one person's point of view, using the visual codes of photography; that is colour, wide angle lens, multiple expo-sures and so on.'[14] These strategies were intended to disturb the fiction of the neutral all-seeing but absent observer, who is situated in a posi-tion of knowledge and whose viewpoint we are unknowingly invited to share. One of Lewis' photographs taken in the Pitt Rivers Museum, Oxford, shows a black figure with cables around his wrist attached to an old camera which is in a museum exhibition case. 'Those three wires are like three lines of vision going to a single point of view . . . but they are bent, warped, distorted.'[15] In another of his works, taken in the Royal Anthropological Institute, a naked black male figure lies on a table or desk top below the clothed and robed figure in an oil portrait of one of the white scientists whose work is honoured by the Institute. The jux-taposition of the clothed and unclothed bodies suggests oppositions of mind and body, scientist and specimen, subject and object. The black body is not personalized by the archival collections, whereas the white anthropologist is honoured by an individual portrait.[16]

Many ethnographic photographs sought to show human beings naked, in order to measure and classify them. In the mid-nineteenth century, Lamphrey and Huxley devised systems using grids and measurements so that ethnographic specimens could be measured against a Western high art norm. Huxley's scheme of 1869 was submitted to the Colonial Office. 'By means of such photographs, the anatomical structure of a good academy figure or model of six feet can be compared with a Malay of four feet eight in height; and study of all those peculiarities of con-tour which are so distinctly observable in each group, is greatly helped by this system of perpendicular lines.'[17] However it was really only in prisons and other extremely coercive situations that these proposals were carried out. Even within social relations of colonial power, people attempted to resist or negotiate with those sent to photograph them and the institutions they represented. Contrary to the arguments of some recent writings on photography inspired by French philosopher Michel Foucault's notions of power and knowledge, the making of images rep-resenting people does not inevitably construct them as passive victims.[18] Edwards points out that:

'A number of colonial governors reported back that they were unable
to comply with the request from Huxley and the Colonial Office
because of local resistance to being photographed "in a state of total
nudity" and the governors' unwillingness to interfere with either the
local colonial *status quo* or indigenous sensibilities'.[19]

In another case, a group of lepers in North Africa threatened to touch a
French photographer unless he paid them more.[20] These were not iso-
lated incidents. In the early twentieth century, Ota Benga, an African
pygmy, was put on display at the Bronx Zoo and the American Museum
of Natural History. At the museum, the frustrated man threw a chair at
museum benefactor Florence Guggenheim.[21] A group of women from
Dahomey, now the Republic of Benin, were part of a troupe put on dis-
play at an exhibition in Chicago in 1893 by a French showman. They
were not usually paid anything for their performances, and were often
ridiculed by the mainly white visitors. In revenge, 'these Dahomean
women evidently derived great pleasure from chanting in their native
language, "We have come from a far country to a land where all men
are white. If you will come to our country we will take pleasure in cut-
ting your white throats."'[22]

In a thoughtful review article, art historians Annie Coombes and Steve
Edwards argue that views of photographs as exclusively documents of
power are somewhat exaggerated and based on relatively few examples
of images showing people in prisons, asylums, reform schools and impe-
rialized countries, many taken in studio-type situations or attempts to
simulate the studio 'in the field'. Coombes and Edwards link this to 'the
current theoretical anti-realist consensus' which 'serves to boost the
status of the studio and produces the photograph as its phantasmagori-
cal residue'. This focus on 'studio'-type images is seen by them as a
move away from the 'documentary' and interventionist work of the
1970s, and is related to the current interest in poststructuralist theory,
especially that of Foucault, who perhaps more than any other post-
modernist thinker has influenced analysts of visual culture. Writers like
Lacan and Derrida, for example, are more interested in language, whereas
Foucault's theories of the body, sexuality and power have been eagerly
applied to the study of representations of the human form in a variety
of art media.

'As a counterweight to textualist poststructuralism, Foucault's worldly
variety has been perceived as a way of thinking about the power

relations embedded in representation. Drawing on Foucault's examina-
tion of the institutions of disciplinary power/knowledge, photography
has come to be seen not simply as reflecting some prior instance, but
as a crucial site in spreading the mechanisms of surveillance through-
out the social body. Power, on this account, comes to constitute its
object so that the problem of rule is resolved at the price of establish-
ing a metaphysics of power. State power as an issue is dissolved into
localized powers and consequently resistance is fragmented. In this
space, the familiar photographic studio object emerges; frontal,
illuminated and specimen-like.[23]

I will return to the issue of Foucault and the photographic archive
shortly.

Lewis' images convey something of the disquiet he felt as a black per-
son entering institutions where the archives are preserved, and also his
unease with the type of photographs contained in the archives. Lewis'
critical practice, 'unlike the anthropological photographs he is com-
menting on, does not aspire to a singular "Truth" and objectivity, but
recognizes the necessity to question and to encourage different ways of
seeing and looking.'[24] In plate 10 – a composite image using an early
twentieth-century photograph of a young man from Southern Africa from
the Haddon Photographic Collection, Cambridge University – Lewis
attempts to question and unsettle the 'natural' and normalized way of
looking at ethnographic images, their categorization and their use. Far
from appearing accurate, it is distorted. The use of a fish eye lens gives
the impression of a warped perspective and space. Instead of being inside
the cases and boxes, the ethnographic photo is outside them, resisting
categorization. The files are arranged by country, as individuals from all
over the world are 'sorted' by the institution for future study. The image
is bathed in a golden sepia tone, suggestive of old and yellowed archival
material, which perpetrates old fashioned ways of looking and know-
ing. The filing drawers have now been overtaken by computerized
sources of knowledge and archival information. But how different is the
method behind it? The archive is geared to facilitate certain types of
enquiry and make others more time-consuming and difficult.

One of the problems encountered by the photographer who wants the
viewer to question surface appearances is the limitations of the visual
image. While Lewis manipulates the images in order to make viewers
rethink their everyday perceptions of the institutions, there is a limit to
what the image on its own can do. David A.Bailey reflects on this in

relation to his own photographs of Egyptian mummies displayed in cases in the British Museum being viewed by visitors. Recalling what the German playwright Brecht said about the limitations of photography, Bailey discusses the difficulties encountered by the photographer who wants to lay bare the social and economic relations of power which underlie cultural and scientific institutions supported by the state, the church and prestigious seats of learning.

'My work on the British Museum is a statement about photography in relation to realism, power and knowledge within the traditions of Brecht. He said that a photograph of a Krupp's ammunition factory told you nothing about Krupp's or the industry. So a photograph of the British Museum is only an image of it. The reality of the British Museum is in its history and its structure, the forces and relations of its production and in its political and financial power. It is the combination of these agencies (along with external forces) which has enabled the British Museum to appropriate Black historical artifacts and treasures . . . Yet this reality is not visible in the photograph, nor to the eye, nor in the physical fabric of the British Museum itself. However realistic a photograph of the British Museum might be, it will not offer any knowledge of this truth, for we cannot photograph the history of social structures. Therefore the real power of the British Museum hides itself in its visible appearance'.[25]

Now, this view is rather different from those based on the views of Foucault and other postmodernists who argue that there is no knowledge which is not already constituted for us by the language of power. According to this position, we cannot know what the British Museum is 'really' about. Clearly, neither Lewis nor Bailey share such views, but believe that, situating ourselves in a critical oppositional location, we can question cultural institutions. However, using techniques which intentionally interrogate the nature of the photographic medium, both realist and modernist photography have limitations – as Bailey argues. Bailey and Lewis have different approaches to the photographing of cultural institutions. Despite the difficulties inherent in producing in a single image, a critical view of such institutions, Lewis' work manages to suggest that not all perceptions of ethnographic archives are equally valid, and he manages to 'make strange' the naturalized view we have of such academic and cultural institutions.

I now want to return briefly to Foucault and the implications of

approaches based on his work in the understanding and use of photographic archives. It is tempting to approach actual photographic archives as examples of Foucault's notion of 'the archive', but I think we ought to be careful to distinguish between the two. In Foucault's *Archaeology of Knowledge*, (1969) the archive corresponds to the 'play of rules which determines within a culture the appearance and disappearance of statements'. The archive is a machine generating social meaning. In his work on colonial photography, David Bate is sympathetic to Foucault's approach, writing that 'Archives are the representations out of which the past is produced in the present.'[26] While this is partly true – and we must remember that collections of material from the past are never 'innocent' – Bate's statement implies that representations become facts, and that the past is always produced rather than having existed. Its being cannot be known without representations and language which produce it for us in the present. Discussing Foucault's notion of the archive, Merquior points out that it disavows the human subject. 'An archivist, after all, does not busy himself with personalities, just with documents and their classifications.'[27] He also points out that Foucault's concept refuses to choose between science and ideology. Science is demolished in the archive as 'the machine of discursive meaning . . . at bottom a *Weltspiel*, a wordplay, a ludic cosmos ever engendering new active interpretations (discourses as practices) of life and society. And it is indeed a highly ironic archive; with it, no meaning remains stable, no truth is better than the next one.'[28] It is one thing to question the premises of scientific knowledge, quite another to reject the notion of science altogether. The relationship of ideology to science and knowledge requires to be investigated, not theorized out of existence. This brings us to the status of the material in the photographic archives. It is important to see the conditions in which the archival material was assembled as living social relations embodying tensions, contradictions and struggle. Thus the material, though it attempts to fix and categorize people in line with the dominant views of European scientists, cannot fully render these tensions static and dead. Within the photographs themselves are traces of actual material situations in which the image was made. In Lewis' photograph (plate 10) we see the traces of an actual person represented in the photographic print, traces which persist in spite of the imposition of the archival categories and structures on his image. The photograph is not only constructed (or reconstructed) but also embodies material traces of actual people and situations is therefore contradictory. Even in the worst kind of photographs which attempt to victimize people

and turn them into nameless specimens, we learn about the past, despite the fact that we do not like what we learn. Whatever the photograph evidences and embodies is supplemented and interpreted by the viewer. Contrary to the arguments in much poststructuralist and postmodernist thought, which seek to undermine the conscious agency of individual subjects and their ability to critically analyse their society and culture, the spectator brings both conscious and unconscious thought to the viewing process. I would argue, therefore, that there are ways in which these archival collections of ethnographic images are vital sources of knowledge which have the potential to be utilized in ways very different from some of those envisaged by those who assembled them. Based on knowledge derived from other sources, we can also usefully ask what is *absent* from the archive. For this to happen, we need a perspective and theory of history which stands outside the archive and assesses it critically, a perspective which is not constructed by the discourse of the archive. Otherwise, the archive will indeed formulate history for us, as well as our own place in historical discourse.

Many explorers, military men and scientists believed that they were bringing the beginning of history to uncivilized countries undergoing colonization. David Livingstone wrote in 1865:

'In our exploration, the chief object in view was not to discover objects of nine days' wonder, to gaze and be gazed at by barbarians; but to note the climate, the natural productions, the local diseases, the natives and their relation to the rest of the world: all which were observed with that peculiar interest, which, as regards the future, the first white man cannot but feel in a continent whose history is only just beginning'.[29]

This creation of history on the colonisers' terms is one of the ideological implications of the archive, but we know that African history predated the archive, and can therefore critically assess its structure and contents through additional knowledge and theory.

Dave Lewis' photographic practice is informed by theory, and one of the texts with which he strongly identified during his project on anthropological institutions was Hal Foster's 'The Artist as Ethnographer'. Foster argues that, compared to the time when Walter Benjamin wrote his famous essay 'The Author as Producer' in the 1930s, 'today the high-modernist triangulation is long gone'.[30] By this 'triangulation', Foster means the conjunction of artistic innovation, socialist revolution and

technological transformation within which Benjamin argued for the alignment of the radical cultural worker with the proletariat. Today advanced art of the Left aligns itself with the cultural or ethnic 'other', according to Foster. In my opinion, however, Foster does not explain very convincingly why this shift has taken place. I believe it has much to do with the collapse of co-called 'actually existing socialism' in the Stalinized states of Eastern Europe, various defeats inflicted by capitalist states on their own working classes, the social reformism of the leaders of the trade union movement and the postmodern dismissal of Marxist theory. This has been accompanied by the continuing existence of campaigns based on single issues and the persistence of life-style politics among certain groups of the socially oppressed, such as black people, women, gays and lesbians, and youth. It must be noted, however, that the mass movements of a generation ago around women's, black, lesbian and gay rights, have since disintegrated. If we accept Foster's argument, the artist as ethnographer aligns her/himself with the cultural and theoretical practice of the ethnic 'other', rather than political and social movements undertaken collectively. Nevertheless, Foster raises some interesting questions:

'However, for all the insight of such projects, the deconstructive-ethnographic approach can become a gambit, an insider game that renders the institution not more open and public but more hermetic and narcissistic, a place for initiates only, where a contemptuous criticality is rehearsed. So, too . . . the ambiguity of deconstructive positioning, at once inside and outside the institution, can lapse into the duplicity of cynical reason in which artist and institution have it both ways – retain the social status of art, and entertain the moral purity of critique, the one a complement of compensation for the other . . . *the quasi-anthropological role set up for the artist can promote a presuming as much as a questioning of ethnographic authority, an evasion as often as an extension of institutional critique*'[31]

I am not suggesting here that I view the works of Lewis or of other black artists in this way, i.e. as examples of contemptuous criticism 'in the know' – far from it. However, it is important to maintain a critical understanding of the situation of the artist in a capitalist society as well as an awareness that many of the visual and theoretical materials mobilized by artists are probably not accessible to potential users excluded from,

or on the margins of, cultural and academic life. As David A.Bailey has remarked: 'We are now living in a kaleidoscopic photographic age, where on one extreme we have millions of people consuming photographic images in newspapers, magazines, advertising, and on the other, inaccessible debates on postmodernism, with no reconciliation or dialogue between the two.'[32] It is one of aims of this book to make some of the debates about postmodernism more understandable, and also to make more people aware of the visual imagery which makes many of these issues more interesting than they seem to be in written, academic discussions . It must be noted, however, that many academic writings by and about postmodernism are designed to impress, rather than effectively and accessibly communicate, and it is often not the reader's fault when they find these writings largely impenetrable. Perhaps visual imagery with a critical edge, accompanied by discussion and analysis, is a better way to draw people into an awareness of the issues involved.

BODIES OF EVIDENCE

Part of Keith Piper's computerized body of work *Relocating the Remains*, is entitled *The Fictions of Science* (plate 11). This still from the work shows different modes and conventions of visual representation associated with the measuring and classification of black people's heads. In the top left is an artist's illustration of heads and the measurements of angles of the nose and forehead, which were supposed to indicate the degree of development of the 'type' of person measured. On the right is a photographic image of a black man's head overlaid with a ruler and a clamp, while in the lower left, a ghostly shape of a skull floats in indeterminate space between the text and the hand drawn illustrations. This image is in colour, but rather sombre, with the light wood-coloured ruler and pink areas around the skull as the main areas which stand out from a predominantly black and white image. The different modes of representation, whether drawn by hand, photographic or computerized, have all played their part in measuring and classifying. To what extent do black people control new information technology and its content, and to what extent are they more likely to encounter computerized imagery as consumers or workers? Grids and measurements were used by artists during the Renaissance to facilitate the construction of convincing naturalistic forms in space, and also to formulate ideal body proportions and concepts of beauty. By the later nineteenth century, these measuring systems were developed in parallel with colonial expansion and

plate 11 *Keith Piper, colour still from The Fictions of Science, 1996, computer generated image for CD Rom. Courtesy of the artist.*

social management of deviance, for example in the form of criminality and illness. Anthropometry was devised in the seventeenth century by Elsholatz, who investigated the proposition that body proportions and various diseases were related. Later, this approach was used to measure the living human body in order to determine its respective proportions at different ages, and also to distinguish different 'races' and their relationship to one another.[33] An anthropologist in India in 1890 argued that cranial measurements were absolutely scientific, since they did away with any subjective input by the anthropologist and his unreliable objects of study:

'First and in some respects most valuable of all, because most trustworthy, we have the actual physical confirmation of the individuals comprising any tribal or caste unit . . . No one who has not made

the attempt can well realise how difficult it is to secure a full and
accurate statement on any given point by verbal enquiry from
Orientals and still more, from semi-savages . . . Cranial measurements,
on the other hand, are probably almost absolutely free from the
personal equation of the observer'.[34]

Even photographs of skulls were considered to be unreliable by one
scientist, due to variations in lighting, because the photographers
were seldom artists or scientists. Thus photographs by non-specialists
were suspect, because they did not already know what they were
supposed to be looking for. However those who *did* were considered
objective.[35]

In his influential article '*The Body and the Archive*', Allan Sekula
discusses the development of body measurements and their assemblage
in archival collections during the nineteenth century. Phrenology, devel-
oped by the Viennese doctor Gall, sought to relate the structure of the
skull to mental faculties. This eventually developed into craniometry,
referred to in Keith Piper's image. The completely unscientific and class-
based ideology of the 'theory' is apparent in Gall's description of his
first 'experiment'.

'I assembled a large number of persons at my house, drawn from the
lowest classes and engaged in various occupations, such as *fiacre*
[carriage] driver, street porter and so on, I gained their confidence and
induced them to speak frankly by giving them money and having
wine and beer distributed to them. When I saw that they were
favourably disposed, I urged them to tell me everything they knew
about one another, both their good and bad qualities, and I carefully
examined their heads'.[36]

Sekula comments that these were discourses of the head for the head,
and that physiognomy and phrenology 'contributed to the ideological
hegemony of a capitalism that increasingly relied upon a hierarchical
division of labour, a capitalism that applauded its own progress as the
outcome of individual cleverness and cunning'.[37] Thus, the workmen
were workmen because they were less intelligent than the doctor and
scientist. Some of the class and gender, as well as racial, ideologies
informing such investigations are apparent in this statement made by
G.Campbell, the author of *The Ethnology of India* (1872) in 1865: 'I soon
expect to find that, instead of collecting postage stamps, young ladies of

an intellectual turn will collect nice little cabinets of crania for the inspection of their friends . . .'[38] This clearly relates to the upper class collectors of the specimens. It is interesting to note that craniometry was generally applied only to male skulls (usually by male scientists). For women the head was not considered a defining feature so much as the skeleton, and in particular the pelvis. This region was seen as indicative of woman's destiny to breed and give birth.[39]

Other applications of such theories in the later nineteenth century involved the work of Galton, who sought to link intelligence to racial groups, with the highest being the Ancient Greeks and the lowest being Africans. It was argued that simple tribes and peoples all looked very 'typical' while Europeans possessed appearances of rich individuality. This defines the Europeans as subjects, as against the Africans who are denied subjectivity. The anthropologist E.B.Tylor recommended the use of photography to the Royal Geographical Society, noting that in simple tribes 'the general likeness of build and feature is very close, as may be seen in a photograph of a party of Caribs or Andaman Islanders, whose uniformity contrasts instructively with the individualized faces of a party of Europeans . . . The consequence is that the traveller among a rude people, if he has something of the artist's faculty of judging form, may select groups for photography which will fairly represent the type of a whole tribe or nation'.[40]

Bertillon, the later nineteenth century French police photographer, created a huge archive of photographs by which criminals could be identified based on key cranial and facial features. At the same time, the art historian Giovanni Morelli attempted to construct a model for identifying art works based on the way different painters depicted ears.[41]

Today, this all seems rather far-fetched and discredited, but perhaps in this age of new technology the basic approach has not changed very much. I was surprised to read a newspaper report recently of how a burglar had been convicted because a print of his ear had been taken from a window against which he had pressed it to find out whether there was anyone in the house he proposed to burgle. A cast of the ear was illustrated on the front page of the newspaper with a measuring grid. It was reported that the burglar used his natural, almost animal-like gifts: 'He has the ears of a cat.'[42] Apparently criminality and animality are still linked and measurable.

Most of these attempts to classify and naturalize specific 'races' ignored the fact that genetic differences between people in different parts of the world are very small because humans come from a very small

gene pool; until about 10,000 years ago, there were only about 10,000 humans on the whole planet. It has been pointed out that supposed 'racial' characteristics have been selected precisely to create difference.

In Europe, North America, and Australasia, the idea of "race" is now usually (although not exclusively) employed to differentiate collectivities distinguished by skin colour, so that "races" are either "black" or "white" but never "big-eared" or "small-eared". The fact that only certain physical characteristics are signified to define "races" in specific circumstances indicates that we are investigating not a given, natural division of the world's population, but the application of historically and culturally specific meanings to the totality of human physiological variation.[43]

In addition to the designation of colonized peoples as 'other' and degenerate, the poor, the sick, the sexually 'deviant' and the lawbreaker within European countries were pathologized as specimens for scientific investigation. 'Primitives' could be found by the scientists at home as well.[44] When the deviants at home became too unmanageable, many of them were transported to the colonies, to live alongside the 'racial' others; this occurred, for example, after the 1848 Revolution in France when many were sent to Algeria, or after the suppression of the Paris Commune in 1871 when some of the insurgents who survived were sent to penal colonies in New Caledonia (Kanaky). In Britain, where transportation was a sentence second in severity only to death, offenders were shipped to Australia after 1787. Unfortunately their oppression at the hands of European states did not make all of these deportees opponents of colonial policies and racial discrimination. The parallel development of oppressive ideologies of deviancy, and class and 'racial' inferiority in the later nineteenth century are apparent in Gobineau's theory, which has already been mentioned in an earlier chapter:

'It has already been established that every social order is founded upon three original classes, each of which represents a racial variety: the nobility, a more or less accurate reflection of the conquering race; the bourgeoisie composed of mixed stock coming close to the chief race; and the common people who live in servitude or at least in a very depressed position. These last belong to a lower race which came about in the south through miscegenation with the negroes and in the north with the Finns'.[45]

In the section of his book on 'race' and class in Victorian England, Malik shows how Darwin's theories were adapted to suit the ideology of an expanding and increasingly imperialist capitalism, and by 'the end of the nineteenth century, national and racial thinking had ceased to be an élite ideology and became part of popular culture'.[46] By the early twentieth century the idea of 'race' changes from something which also existed in the lower orders of European societies, to something applied mainly to non-European peoples. This was linked to the development of a labour aristocracy and a reformist political working class party in Britain, where lower-class 'others' could find a place to belong within the imperialist strategies of British capital and the state.

In terms of viewers and spectators of ethnographic photographs, we are speaking of a restricted community of European scientists, mostly male and largely upper class. Most of the photographs were doubtless taken without much opportunity for the people in the images to control their own representations, or to own them. Work by artists like Dave Lewis and Keith Piper seeks to reclaim and rework these historical images, theories and institutional locations, and situate them in new contexts of looking and understanding. Lewis' works are available in reasonably priced books as well as at exhibitions. Piper's exhibition is accompanied by a CD-rom, which disavows the fine art concept of the unique individual artwork, although clearly, users must have access to the relevant technology at home or in a library or computer laboratory. The different modes of photographic representation and dissemination have clear implications for the nature and number of viewers and users of these images. This is something I want to consider in more detail by looking at some examples of studio photography representing Caribbean and South Asian sitters from the post-Second World War period in Britain.

SUBJECTS IN THE ARCHIVE

I want to look now at examples of photographs from another archive, the Ernest Dyche collection of photographic prints and negatives housed in the Central Library, Birmingham. This collection is somewhat different from the examples of ethnographic visual material referred to earlier. Ernest Dyche (1887–1973) worked from his studio in Birmingham, which was situated in the suburb of Balsall Heath from 1920 onwards. He specialized in studio portraits of music hall performers, doing his best to make them look glamorous in publicity photographs. However,

after the Second World War, live performances on stage declined as people watched more television and cinema, and Dyche was on the lookout for a new clientèle. He found it among the many Afro-Caribbean and South Asian workers who arrived in Birmingham looking for employment in the early 1950s. However, the Dyche collection of about 10,000 negatives and prints is an archive of Black British history and culture with a difference.[47] Although taken by a white photographer, the images are portraits, paid for by black clients, who probably had their own opinions on how they wanted to appear. However, due to the fact that Dyche's son failed to preserve the account books with the addresses of the sitters, many of them have become anonymous, in terms of the archive. Attempts are now being made through exhibitions of material from the archive to re-personalize these images by inviting the erstwhile sitters to identify themselves. They oscillate between types such as the nurse, the busdriver (plate 12), the musician, the glamorous woman, and the individual. Of course, many portraits seek to represent the particularity and individuality of the sitter with indications of his or her social role or status. The development of bourgeois portraiture obviously depended heavily on the notion of the uniqueness of each individual and the celebration of that individuality within a society seen as conducive to the development of each person's talents and career.[48] The individual isolated, or as part of a couple or a family, is posed in the studio to visually represent his or her being in history and society; at the same time, they are abstracted out of that society and placed in a constructed setting where different props and lighting effects help to give an air of glamour and 'class' to many of the photos. Interestingly, the photographs of sitters in uniform were seen as signs of status, but relating to class in a different kind of way from the photographs in 'best clothes'.

In an interview, a woman who posed for Dyche as a girl with members of her family, pointed out how the possession of a uniform meant status and security for the newly-arrived migrant worker when the photograph was sent back to other family members in the Caribbean.[49] As the driver (or conductor?) poses quietly in Dyche's studio with a vase of flowers as a prop, one history is traced but another remains excluded from the image. (plate 12) It was no doubt an achievement to get a job on the buses for some of those who arrived in England at the time. Until 1954, jobs on the Birmingham buses were given only to white workers.[50] In 1963 the bus company in Bristol refused a job to a black applicant, who, inspired by a recent visit to America where he had experience of

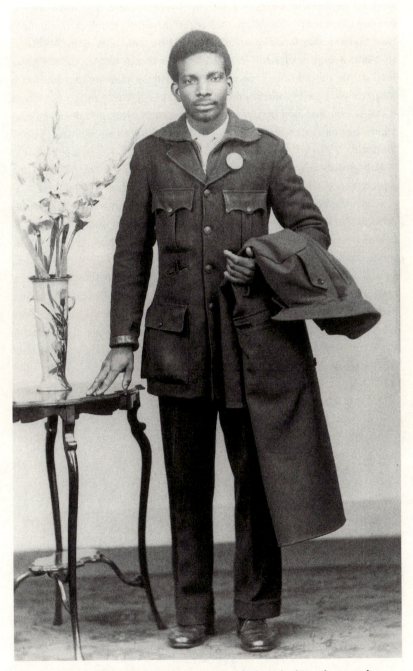

plate 12 *Ernest Dyche, Busworker, ca 1960?, black and white photograph, Dyche collection Birmingham Central Library.*

the civil rights movement, called for a boycott of the buses and a demonstration. Eventually the company backed down.[51] The black residents of Birmingham also faced discrimination in housing and even at church. In 1956, a survey of white residents showed that 64 per cent of those responding thought black people less intelligent than whites, with only 17 per cent viewing black people as equal.[52] A West Indian cleaner in Birmingham summed up the experience of most black people in the mid-1950s as 'bad accommodation, lack of social amenities and hurtful taunts'.[53]

This distressing experience is, however, absent from the photographs, which construct a studio image in a different, but related historical moment. (plate 13). Interviewed much later, the children in this family portrait, (posed in their best clothes in January 1958 and one wearing a new coat in the studio!) recounted how their father had started a clothing business from humble beginnings, going round knocking on doors selling from a suitcase. The Kenth family now has a highly successful clothing business employing thirty workers, with a £5 million annual turnover.[54] Some immigrants already had educational qualifications when they arrived, and many also gained City and Guilds diplomas, but were still refused work. Goaded on by this rejection, a number succeeded in setting up businesses like that of the Kenth family.[55]

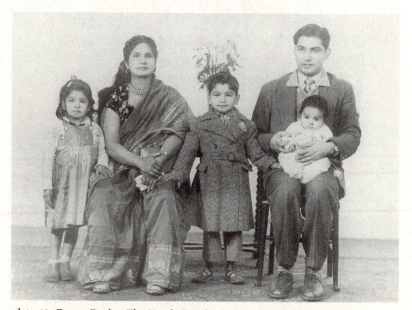

plate 13 *Ernest Dyche, The Kenth Family, January 1958, black and white photograph, Dyche collection, Birmingham Central Library.*

These photos served a number of purposes. They were commemorative, historical, personal, but destined for circulation, hence not entirely private. In a kind of reverse immigration, the images were sent back to the Caribbean, India or Pakistan, to family members or as part of courtship or marriage arrangements.[56] Sometimes hand colouring would be added, especially to the photographs sent to India, or sometimes skin tones would be lightened. According to a source quoted by Dilip Hiro, commercial photographers in Jamaica sometimes pandered to an ideal of whiteness or paleness, in order to please their clients. In a particular Birmingham school in 1963, only two West Indian mothers ordered school photographs of their children, the others declining because in photographs, their faces looked 'too dark'.[57] This was interpreted as meaning that the mothers preferred deception to reality, but perhaps it is also partly to do with the practice referred to above, whereby photographs and films are lit with the white subject as the key, thus disadvantaging any black people in the frame. Whatever else Dyche's portraits do, it can certainly be said that many of them (though not especially the ones illustrated here) show black people as potentially and actually glamorous and 'good-looking'. They are not specimens, victims or performers. As Stuart Hall has pointed out, these photographs are a powerful counterweight to the tradition of black people as social problem/documentary images.[58]

However, the relationship of photographer and clients was basically an economic one. A friend of Dyche interviewed recently said that he probably did not want to mix socially with his Afro-Caribbean and South Asian sitters, but that being a professional photographer meant you had to be sociable to people you might not want to be associated with.[59] It is also claimed that some photographers did not want to take photographs of black clients because they could be 'too demanding', wanting to look 'clean' and 'white' and insisting on poses which displayed new watches, pocket handkerchiefs and banknotes in pockets.[60] This indicates that the black clients wanted to participate in the construction of their own images. Of course, it is likely that many white clients could be just as demanding, and these remarks betray a prejudice which still exists even decades after Dyche's death. However, we should not judge the meanings of the photographs according to what we might suspect about Dyche's views on black people. Whatever he thought, he had to produce a satisfactory product in order to keep his business going, and in any case a visual image is not equivalent in meaning solely to the intentions of its maker.

The nature of the photographic medium itself is important in this context. The photographic image carries with it the possibility of mass reproduction. However, in the case of 'ordinary' people, this mass reproduction and dissemination of images does not usually take place. The potential is there in the negative, but normally, only a small number of prints are made to give as gifts to friends and family members. Photographs for passports and other forms of identification tend to be viewed differently, and are evaluated in terms of whether they are a 'good likeness' rather than whether they make the sitter 'good looking'. Of course, in the opinion of many clients, a good identity photograph will do both. All the same, the potential for reproduction in photography, and especially in the context of commercial studio photography, means that there is a mass of material which exists outside the archive, scattered over different parts of the world in different people's homes. This is a kind of diaspora in reverse.[61] The scattering of people from their origin to far-off places, is mirrored by the dissemination of the photographs away from their source, in Dyche's studio records and negatives. These photographs have a social and cultural existence outside the archive and this should always be borne in mind. The archive itself does not in this case construct historical knowledge in itself. It exists in a specific social, historical and institutional context, and the uses made of it are the result of interaction and agency by subjects who can change the meanings of the archive. The archive is not a discourse which constructs its subjects, but a collection of material made by people and though inanimate, it exists in a social context and therefore its meanings change. It is not a discourse which constructs a given meaning which remains static. These remarks are even more true of the Dyche photographs than of the ethnographic collections.

The photograph is also positioned in a different relation to notions of high and popular culture than the painted portrait. These photographs are on the interface between the private and the public, the boundary between fine art and popular culture. Hall remarks of the Dyche photographs that 'they are the bearers of the professional photographer's aspiration to "art".'[62] In some ways this is true. The attention paid to notions of glamour, elegance, status and fashionable self-presentation in many of the photographs is comparable to art photography or painted portraits. The influence of film and cinema publicity material also seems apparent. In others, we see what look like compositional 'mistakes', for example the flowers which appear to be growing out of the boy's head in the Kenth portrait.(plate 13)

In 1950s Britain, it was far more difficult for black people to become iconic public images of glamorous fame than it became in the 1990s. Even as entertainers, certain restrictive stereotypes made blackness a kind of cultural ghetto. Take the case of Shirley Bassey. Bassey was born in the Bute Town area of Cardiff, where black seamen had lived for many years. In 1919, black residents were attacked by crowds of violent whites and a young Arab man was killed. By mid-September, 600 black men had been 'repatriated'.[63] In 1943, a researcher found that the black inhabitants of Cardiff had been ghettoized, segregated and forced into the worst jobs. 'Discrimination ... has interfered seriously with the possibilities of the Coloured children, particularly the girls, from obtaining virtually any but the lowest-paid occupations.'[64] By the mid 1960s, things had not changed much and black people were still living in a 'quasi-ghetto'. 'The author's study of Bute Town revealed that over the previous two generations the black community of 4,000–5,000 had produced only four professionals: two teachers, one architect and one civil engineer, who was working in America.'[65] Bassey herself began working in a poorly paid factory job at the age of 15, but inspired by the likes of Al Jolson and Judy Garland, she joined 'an all-coloured revue', appearing in the West End in *Hot From Harlem*.[66] Her first hit record was the British cover version of 'the colonial kitsch' *Banana Boat Song* of Harry Belafonte in the era of the Notting Hill 'race' riots. Andy Medhurst has pointed out that underpinning Bassey's strength 'perhaps, though it's never a subject she readily discusses, is the fact of her blackness and the determination it must have taken to establish herself in the Britain of the Fifties'.[67] Bassey's rise to international status involved a transcendence of categories of 'race' and class and almost even of gender, as she has become a cult icon for gay men. Her songs of survival in the face of rejection and adversity, sung 'in the key of loud' (as Medhurst aptly puts it) gleaned from a variety of international sources, have made her a true queen of glamour. Dressed in outrageously expensive and feminine gowns at odds with her obvious strength and toughness, she is now fêted as a member of high society. At a celebration of her sixtieth birthday on television in 1997, guests included enthusiastic current and former Cabinet Ministers and their wives. It might be tempting to see Bassey in terms of a diasporic *'diva'* (whose money and status obviously makes it easier for her to have homes in several countries and travel freely), a woman whose hybridity is empowering, and who embodies Judith Butler's notions of the performance of femininity.[68] However, I am tempted to argue that whatever contradictions persist within Bassey's

public visual presentation, they have emerged partly as a result of the
continued suppression of her blackness which may result from decisions
she made early in her career in a different historical moment. To view
Bassey's public life and stage performances as a celebration of hybrid
and diasporic glamour would be to abstract a particular cultural dis-
course from its context.

I want to consider for a moment Hall's suggestion that the professional
photographer aspires to, or mimics the look of 'art', along with the
writings of cultural theorist Homi K.Bhabha on the terms hybridity and
mimicry. I wonder about the assumptions behind Hall's remark on
photography and 'art'. Should the photographer not aspire to 'art'?
Doesn't this remark have negative suggestions that 'pure' and 'non-
commercial' photography is good, but commercial photography that
knowingly refers to 'art' is less so? Might High Street studio photography
be referred to as inauthentic 'kitsch' if we recognise some lighting effect
or pose from an oil painting or an 'arty' photograph taken by Cecil
Beaton? In the study of visual culture, we surely need to interrogate
notions of 'art'. Famous artists are always using visual motifs from past
art. If a photographer does this, does it make him or her a producer of
some inauthentic cross-bred or hybrid culture? In any case, isn't this
kind of culture what cultural critics such as Hall himself, Homi K.Bhaba
and others tell us is empowering and exciting – the cross-over, the
hybrid, the in-between?

In so-called post-colonial studies, Bhabha has been influential in
arguing for the liberating and oppositional potential of both hybridity
and mimicry. Hybridity is seen not as something impure and inauthen-
tic, but as a mixture of cultures and identities in flux which empowers
subjects in a post-colonial world. The hybrid culture of the diaspora
allows subjects to play with identities, reconstruct themselves and
destroy stereotypes. Mimicry, for Bhabha, is a 'flawed identity imposed
on colonized people who are obliged to mirror back an image of the
colonials, but in an imperfect form: "almost the same but not white".'[69]
The 'mimic men' have to inhabit an ambivalent zone which is almost
the same 'but not quite', hence difference always exists. This mimicry
becomes 'at once resemblance and menace'.[70] Bhabha locates positions
of mimicry and hybridity in a 'third space', an in-between space, where
subjects are free to construct their identities as neither the One nor
the Other: 'They are now free to negotiate and translate their cultural
identities in a discontinuous intertextual temporality of cultural differ-
ence.'[71] Roughly translated, this means that the cultural identity of the

colonized, say, can become a playful, free and creative invention of self-identity which takes place in non-linear time. McClintock ably points out that while Bhabha's argument usefully illuminates the relationship of desire, fantasy and domination, the question of agency in his argument is problematic. In Bhabha's argument, discourse and the fractures within it are the source of the destabilization of colonial power. It is not the struggles of the colonized nor the tensions within imperialism, but discourse which is paramount. McClintock asks whether ambivalence in itself is inherently subversive, and, given that ambivalence is everywhere Bhabha looks, at what point does it become subversive?[72] For example we could say that certain aspects of fascism were ambivalent – in relation to male bonding, homosociality and homo-sexuality – yet is fascism subversive of the dominant capitalist order? It is hard to see how.

McClintock hits on a key problem with Bhabha's poststructuralist theories when she raises the question of agency. Bhabha's theories rarely make any analysis of specific events, people or cultural productions. His arguments take place on rather an abstract level, where disembodied concepts and cultural discourses are theorized, but few human subjects are active. What happens if we try to apply these notions to the Dyche studio portraits? Is Dyche mimicking art portraiture in a critical way, or indeed in any way? Is he doing this in a subversive fashion by taking pictures of black people when other commercial photographers were reluctant to do so? Is his mimicry inherently non-subversive because he is white and a citizen of an imperialist society? Can only colonized people engage in mimicry? Are the bus driver and the Kenth family unconsciously or consciously mimicking the codes of white bourgeois portraiture in a subversive way? Are they playing at belonging in Britain when they go to Dyche's studio? I feel uneasy with some of the impli-cations of Bhabha's arguments, mainly because I do not find that they have much connection with the articulated desires and experiences of actual people. Nor do they appear to relate particularly well to examples of visual culture. Discussing their lives, the identified sitters of the Dyche portraits talk of their struggles, their attempts to make their own lives, to interact with others, to contribute to society, their sense of success or failure, to be accepted for what they are. We do not find a desire to mimic and subvert 'white' society articulated verbally. Of course, it might be argued that this mimicry goes on partly or wholly unconsciously. Yet if this is so, then what status does consciousness have? Does the scholar or academic then dismiss the voices of black

British people because she or he gives more weight to hypothetical unconscious processes of, for example, mimicry, of which we have very little evidence in this case? The concept of ideology, on the other hand, is a different matter, one which is essential when we seek to understand the ways in which the things people consciously say about what they think and do, relate to the real social meanings and effects of their ideas and actions. In their photographs, black nurses and bus conductresses are dressed proudly in uniforms probably because they are black nurses and bus conductresses and their possession of the jobs means something, not because they are performing a masquerade of white people in uniforms. When Bhabha argues that these things take place in the unconscious, he relegates the articulated thoughts of human agents to an inferior status. I feel it is somewhat patronizing to impose such theoretical concepts on human subjects when there is no evidence in what they say to warrant it. What do we say when black photographers are influenced by European art traditions in their work? Are they producing hybrid culture and examples of mimicry? I think the photographers themselves would reject this view. I will return to this later.

Of course, black people often try to challenge and subvert white society (many also try to become part of it at all levels), but they do this outside as well as within the cultural sphere, and areas outside culture are largely ignored by Bhabha. I am not denying the power of ideology, and the fact that people's expressed views and aims often cannot be equated with the underlying causes and motives of their actions and views, but this is rather different from the arguments which Bhabha puts forward. If we do not take account of the histories of the subjects in the archive as articulated by the subjects themselves, then the archive remains the determining 'discourse' and changes only because it is interpreted by a different scholar – a postcolonial scholar rather than a Victorian anthropologist. If we do not want to pay attention to the voices of living people whose images are part of an archive, then they may as well be dead, like their nineteenth century ancestors represented in museum collections. The diaspora of the photographic archive existing in the world outside the library or university is silenced and marginalized. We need to remember the point made by David A.Bailey and referred to above, to the effect that there is a gulf between poststructuralist theory and the everyday images people use and see in their lives. Such writings as Bhabha's do little to narrow this gap.

PRACTISING PHOTOGRAPHERS

Contemporary photographic studio practice encompasses a wide range of visual material. In order to compare contemporary examples of studio photography with images from the Dyche collection, I visited photographic studios in Leicester. Among them was Bharat Studio, which combined a photographic business with a video lending library. This is not uncommon in Asian photographic businesses and obviously attracts customers and supplements income from the purely photographic side of the business. The premises were laid out like a normal shop, with counters and displays of photographs in the window and on the walls inside. A variety of types of images are displayed, including wedding photos, graduation photos, family portraits and children. This is a family business but the male partner takes the photos while his wife helps in the shop and deals with customer queries, including mine. He takes the photographs which are then sent off to a laboratory for development. Customers can indicate their needs and preferences, but the final decision on poses and so on lies in this case with the photographer. Clients can choose from 'pattern books', selecting particular formats. These include montage portraits, done in the laboratory, which show married couples surrounded by garlands of flowers, shrines and so on.[73] For nominally Christian couples there is an option of a small head and shoulders portrait floating above a bible open between two lighted candles. The majority of photos on display here were of Asian clients, but there were also white people's portraits. All the photographs were in colour, which immediately makes them look very different from Dyche's work. The lush saturated colour makes the shop look bright and highly decorated. This decorative aspect of the contemporary colour photo is much stronger than the Dyche images, and is acknowledged as a selling point by the photographers to whom I spoke.[74]

Two examples of photographs from those displayed at the Bharat studio should give an indication of the similarities and differences since the 1950s and 1960s. Displayed just inside the front door was a wedding photograph. The luscious reds and greens of the woman's clothing draw the eye to the image. The bride looks in the mirror at the spectator, displaying her beauty and her invitation to the spectator to look at her.[75] The composition thus relates to a 'high art' tradition, and in fact is visually quite complex and densely packed into the frame. The sitter is not shown just facing the camera. Displayed nearby in a photograph selected from images of the wedding preparation and celebration, the

bride's feet are represented, adorned with painted decorations. Thus, the portrait does not have to focus on the face, but represents any individualized part of the body. The special make up and decorations are specifically for an individual person at a particular time. At first I was assured that there was no problem about getting prints of these negatives and so the sitter's individual ownership of these images was not initially an issue. However on subsequent visits, I could see that the photographer, and especially his wife, were reluctant to let me have any prints of their work, nor would they contact any of their clients on my behalf to ask for permission to allow the photos to be reproduced in this book. Thus, this particular 'archive' is inaccessible for different reasons from some academic archives. In this instance, the co-owners (the clients are also owners) and gatekeepers of the living archive became more and more reluctant to allow me access to the images and the people represented in them. Eventually, after giving me a number of different explanations over a period of weeks, the female proprietor told me that it would be bad for business if they let me reproduce images of their clients. I was not completely convinced by this, as the photographer at the same time offered me images of people who, according to him, 'would not mind'. Even so, I decided it was probably best not to proceed. The archive takes on a very different meaning outside an institutional and academic context, where notions of intellectual property and knowledge are subordinate to everyday business practices. This is not to say, however that they are unrelated. The Asian client represented in these photos is not an ethnographic specimen whose feet are evidence of strange 'rituals', but just an ordinary person who happens to get married, have her photos taken, and she and her family pay the photographer if she is satisfied. The majority of the prints are hers to do with as she pleases. Later, though, I began to wonder whether I appeared to the owners of Bharat Studios as a pretty alien figure who had come to do 'fieldwork' in their 'archive'.

The second photographic studio I want to discuss was very different. This, too, is a family business but the most important member is Maz Mashru. His advertisements describe him as a 'photographic artist' and he has lectured and exhibited his work widely in Europe and the USA, gaining many awards. One of the leaflets about the studio proclaims 'Highest qualified Indian photographer' and 'Fifth European and first ever Indian to achieve a Master's Degree' (in photography). The last point is interesting since the photographer describes himself as both European *and* Indian. He views photography as a means of visual communication

which transcends national boundaries, and believes his photographs can be understood and appreciated in any country. His pride in his qualifications is very understandable. Maz Mashru was working as a photojournalist in Uganda, from where he was expelled by the dictatorial ruler General Amin in 1972. Mashru came to Britain, but was told he had insufficient qualifications to get an NUJ (National Union of Journalists) card, and without this card he could not work as a journalist. In his own words, he had to re-enter the photographic world in Britain 'through the back door' building up a studio practice devoted mainly to portraiture, though he also does landscapes. The awards he later received were doubly gratifying, since they were from the type of institutions which had previously sought to marginalize him. Maz Mashru seeks to utilize influences from European and American painting in his photographic work. Nothing is copied, but sources are re-interpreted and used in different contexts. For example a portrait of a woman playing an instrument recalls aspects of Degas' paintings; a portrait of Margaret Beckett MP in her study in the House of Commons has references to the sombre bourgeois conventions of Dutch seventeenth century portraiture. The public part of the studio is laid out not like a shop but like an art gallery. Large colour portraits are exhibited on the walls, framed like oil paintings, and sometimes printed on paper which gives the look of canvas. Some of the photographic images are printed on mirrors. There is a statue in one corner of the exhibition space. Prices range from five pounds for passport photos which are done 'while you wait' to hundreds of pounds for large photographic portraits. Sitters range from MPs and the Lord Chancellor to 'ordinary people'. The images displayed show both white and British Asian clients. Maz Mashru feels that an important aspect of his work is to offer the possibility of a glamorous image to the client, and that the studio photograph is not the record of an everyday event, but a special moment related to fantasy and desire, which the photographer helps the sitter to realize. It is usually practical considerations that determine whether the photograph is taken in the client's home, at work, outdoors on location, or in the studio. As Christopher Pinney remarks of photographic studios he visited in India, one of the aims of the clients and photographers is to achieve an image which in some senses does not exist. 'The photographic studio becomes a place not for solemnization of the social but for the individual exploration of that which does not yet exist in the social world.'[76] I think perhaps that many successful studio portraits do both these things. This moment of desire existing within a particular social context is then commemorated and

materialized in a densely coloured and decorative image, whose visual impact has been intensified by the manipulation of coloured dyes in the printing process. The desired image begins in the studio, but continues to be worked on by the photographer and other technicians after the sitter is absent. It is clear that none of the large photos exhibited in Maz Mashru's photo centre could be done by amateur photographers taking snapshots, and the difference is what you pay for. As well as being the realization of a fantasy, a commemoration of a specific historical moment, the photograph is seen as a decorative item of domestic furnishing. Again the photos are positioned in relation to notions of 'high' and 'popular' art, the public and the private, but in a different way to the Dyche images and indeed most of the photographs from the Bharat Studio.

A good example of Maz Mashru's work is this large self-portrait taken in 1987. (plate 14) Mashru is photographed in a study with an old camera on the desk beside him. He leans on a brown leather chair wearing a

plate 14 *Maz Mashru, Self Portrait, 1987, colour photograph, 48 × 58 cms, The Portrait House, Leicester.*

dark suit and a red and blue tie. The predominantly dark colours emphasise the face and hands, as in many examples of Dutch seventeenth century portraiture. An impression is created of someone who thinks about his work, and knows the history of his profession. The pose recalls Renaissance portraits of scholars in their studies, and links also to portraits of people shown at work in their offices. The photograph also functions as an advertisement for the photographer's work, just as many self portraits by oil painters promoted the skills of their makers. The photograph has quite a heavy frame and is the size of a small painted portrait, 48cms × 58cms. I would be wary of interpreting this work in terms of Bhabha's notions of hybridity and mimicry. Is the photograph supposed to be a representation of a hybrid visual culture or individual, who is undermining the notion of essentialism and its marginalization of people considered to be 'others'? Is the very visual construction and mode of the photographic representation mimicking European art in order to subvert it? Judging from what the photographer has told me, I think such a reading would be a distortion. The photograph does not seek to mimic but to utilize European art history and merge aspects of it in a new image, whose purpose is celebratory and affirmative. We should also remember that European art is only one of the photographer's sources. The lushly printed colour of this image, its careful composition and its scale make it very different from the Dyche portraits of previous decades, and of course it is an Indian British photographer who is in charge here of his own image, his own professional practice and his own business.

SELF REPRESENTATIONS

Many recent academic writings have rejected the 'modernist' notion of a unified, coherent self: an individual subject which, as an agent, can consciously act on the world. As we have seen, poststructuralist and postmodernist theories have led many writers on 'race' and culture to reject the concept of the individual subject as a fiction. Among them are Amina Mama and Avtar Brah. Mama describes subjectivities as 'positions in discourses that are historically generated out of collective experience'.[77] 'Subjectivity is a process of constitution and movement through already constituted positions.'[78] She concludes that 'Analysing subjectivity as positions in discourse allows for the person to be conceptualised historically, as changing over time and in different contexts.'[79] Leaving aside the issues of whether there are other

approaches which could equally well conceptualize subjects historically, or do it better, it is clear that this approach subordinates living individuals and social groups to negotiating pre-existing frameworks mapped out for them. The idea that discourses of class, 'race', sexuality and gender are made and reinforced by people in specific economic, social and political situations and therefore can be changed is not one which is important in Mama's theoretical framework. For Mama, the realization that subjectivity is dynamic, contradictory and multi-layered, enables people to progress in self-development and cultural creativity. I have no particular argument with these conclusions on a certain level. However this is a rather restricted view of the possibilities for individual and social change in societies where social oppression is built into the very structures of economic, political, social and cultural life. The relation of the individual to society is not extensively examined in Mama's book, though she sees subjectivities as related to 'collective experience'. Yet the notion of experience has proved problematic for postmodernist theorists. Experience for many postmodernists smacks of the material, of real people, but at the same time is conceptualized as something passive. Discourses are experienced and lived, so that both experience and life are posed as *passive* rather than active. I would argue that lived experience is both active *and* passive, with the balance of these tensions changing at different times. In postmodern theory, experience is not generally theorized as active experience, as agency or as engagement with social reality with a view to changing what is surrounding the subject as well as the subject her/himself.

Similarly, in Avtar Brah's book, a theory of discourse heavily influenced by Foucault results in her statement that the power of discourse is performed through 'her' and other 'Asians'. 'I' and 'We' are constructions but are experienced as 'realities', whereas, states Brah, they are in fact fantasmic entities.[80] At least Brah sees a difference when the fiction of 'I' and 'me' is *subjected* within specific discursive practices i.e. when the fantasmic 'I' is speaking from personal experience.[81] Brah wants to keep notions of experience and 'agency', but decides to reject them as fixed categories 'rather than modalities of multi-locationality continuously marked by everyday cultural and political practices'.[82] I think this means that experience and agency are complex, shifting positions which are constantly brought into being anew by discourses (of religion, education, 'race', gender, the law, medicine). For Brah, following Foucault, discourse is practice, therefore deconstructing discourse is a challenge to oppressive discourses of power. The subject is a 'subject-in-process', which at any

given moment experiences itself as the 'I'.[83] Yet there is no real individual lurking behind this fiction of subjectivity. Thus, if we ask, for example, why certain immigration laws were passed, there is no particularly good answer available using this sort of theory. Presumably, the laws were passed by people who at any given moment experienced themselves as an 'I' within particular discourses of 'race', class and imperialism. This is already unsatisfactory as a partial explanation, but if we pursue this question further, we find there are no theories offered as to why people should pass restrictive immigration laws, or why they should refuse to do so. By what means do these fictions of identity – 'I' and 'We' – refuse to carry out socially oppressive acts or consciously change their views about society and its 'discourses' as they exist?

Following Stuart Hall's interest in Gramsci, Brah states that 'The enabling potential of the Gramscian paradigm for understanding "experience" and the "experiencing subject" as both a conceptual category and lived contradiction was enormous.'[84] There remains much work to be done on a Marxist theory of the subject, but it does not take much effort to realize that a Marxist theory of the human subject would see that subject as contradictory, since, for Marxist dialectics, contradiction is inherent in nature and human society. I am also unclear as to why seeing 'experience' and the 'experiencing subject' as 'a conceptual category' and a 'lived contradiction' is an empowering theoretical advance. Such writings and theories have not been particularly helpful in discussing actual artists and their work. For example, are artists to be seen as consciously making art, engaging with ideas, changing raw materials by their labour into something different, or are they merely inhabiting for a time a fictional 'I' which is positioned by discourses? How to we explain why their works turn out the way they do and not some other way? Why are certain discourses engaged with and not others? While I have no wish to equate the meanings of art works with the intentions of the artists, I want to argue for the retention of what has been termed a 'modernist' notion of the artist as human subject, riven with contradictory tensions of both individual and social natures, both a product and an agent within a specific social, historical and cultural conjuncture. The conscious and unconscious psychic life of such a subject is ultimately influenced by the material conditions in which s/he lives, existing in a human body in human society, but not in a simplistic and deterministic way.

In any case not all theorists would agree with the emphasis on multiple and unstable subject positions posited through discourse. Pratibha

Parmar has argued for a notion of the self which asserts itself against demeaning and oppressive identities created by dominant ideologies: 'It is in representing elements of the self, which are considered the 'other' by dominant systems of representation, that an act of reclaiming, empowerment and self-definition occurs.'[85]

I want to look now at some examples of art works to further investigate notions of the self/subject. In particular I want to look at how these artists see the self as multifaceted, changing, contradictory and developing in time, but nevertheless represent and articulate the self as a conscious agency. The self is not seen as a fiction which passively experiences discourses. The self/subject changes and evolves in contradictory ways, but the self is knowable, at least in part.

SAMENA RANA

Samena Rana's series of colour photographs, *Flow of Water*, which include *Awakening* (plate 15) were described by the artist as images which encompass 'my past, present and future'.[86] Born in Pakistan, Rana was seriously injured at the age of nine and was brought to Britain by her father for medical treatment. The Home Office did not allow him to remain, although her family later moved temporarily to Britain, where her father, a civil servant, had to find the only job available to him, in

plate 15 *Samena Rana, Flow of Water, Awakening 1990–1, C-Type photograph, dimensions variable. Copyright the Estate of Samena Rana and Panchayat.*

a factory in Romford. Extensive periods in hospital and many operations did not result in Rana's complete recovery, and when she died suddenly at a tragically early age in 1992 she still had to use a wheelchair. Rana thus had personal experience of living with ideologies of gender, racism and disability. Her aim, however, was not just to negotiate these and re-invent herself, but to struggle against the restrictions placed on her as a disabled person and as a so-called 'fire-hazard' at the college where she initially enrolled in to study photography.[87]

Rana stated:

'Often I'm quite distressed by the images of disabled people I see in the media – especially those horrible, grey posters one sees every-where because charities want to raise money. They want to produce people's images as being grey and passive. I find this hurtful, and it makes me very angry. So I'd like to take photographs which depict disabled people as active and positive people, because that's who we are. People who are doing things – everyday things, ordinary things – but actually doing things, not being passive'.[88]

Many of Rana's photographs are richly coloured, using textiles and jewellery. Sometimes the textiles are immersed in water with photo-graphs and fragments of mirrors. When the dyes begin to run, a visual equivalent of the changing nature of identity is captured for a moment and isolated from the flow of water and the flow of life.

In the first few images of the series, *Memories 1,11,111*, sepia photo-graphs of her early childhood in Pakistan are arranged, overlapping one another and sometimes coming in and out of focus. Family members and Rana herself as seen as represented by her father, an enthusiastic amateur photographer. Then, in a striking image referring to her acci-dent, *The Silence 1V*, a knife stained with red cuts through delicate 'Oriental' textiles. The series continues with *Fragments of Self*, and *Awakening.* (plate 15) Rana talked of the photographs as being

'about my struggles to bring unity and harmony to my life as a (dis)abled woman in a foreign culture. Through the layers of water, diffused colours and a series of metaphors, I reconstruct my feelings which are about loss, trials and reclamation. There is a sense of confusion and vagueness about myself and about my identity in the latter images. Especially when I first became (dis)abled and came to England, a sense of isolation, displacement and fragmentation prevails.

Harmony and integration come and go and the broken pieces do
become cohesive, even the grey metallic wheelchair merges itself with
the more sensual aspects of myself'.[89]

However for Rana these fragments, contradictions, and shifting
borders are not something playful and empowering in themselves,
though they impelled her to produce some outstanding art works. These
are representations of fragments of her existence and experiences which
were worked on and constructed by Rana as artist and subject. Rana is
not constructed by discourses of disability and orientalism. She seeks
to challenge them: 'I want to make photographs that challenge and come
to some kind of conclusion'.[90] Of course, these conclusions may be
temporary, but nevertheless Rana's statements imply that there is a
position of embodied knowledge from which the human subject can crit-
icize ideological stereotypes based on socially structured oppression.
Rana's experiences are not passively structured by discourse, but become
a source for active agency. To deny this would be to imprison her once
again within the stereotype of Asian women as 'passive, weak, meek
little creatures that don't have a voice' and disabled people as self-
effacing victims.[91] As I wrote in an earlier discussion of Rana's work:

'Simply to see Rana's photographs as visualisations of a shifting
subjectivity of fragmentary discourses of the feminine, the oriental, the
disabled (the cripple?), tempting as they may seem if the works are
taken on a purely formal level at the outset, would, I think, reconstruct
Rana in the passive role she so earnestly tried to challenge. She tried
to construct her own discourses, not be defined by those of others'.[92]

LYLE ASHTON HARRIS

The American artist Lyle Ashton Harris has also incorporated family pho-
tographs into his work for an exhibition dealing with private and public
images of black identities. *The Good Life* (1994) comprised a series of
large full-colour photographic prints by Harris and, dating from the 1940s,
smaller photographic images from the 'family album/archive' created by
Harris' grandfather, an economist at the Port Authority in New York City.
The smaller photographs from the past were grouped together and pinned
onto the walls, whereas the large saturated colour prints were presented
as 'art objects' framed for display. The private and public aspects of black

history and the black 'family' are constructed and further interrogated: 'In exploring his archive I became very interested in the different ways he and I portrayed the family. I see my project as an expansion of his documentation.' For Harris, history, accompanied by a questioning of the presentation of the self in history, are important. As a gay man, Harris asks questions about sexuality and identity often absent from the concerns of much 'black culture' and black community leaders. Harris is interested in an international and global humanity, rather than a position in the margins, fragments and interstices so valued by theorists such as Bhabha. 'Do we have access to international humanism? I'm interested in that but not as a second class citizen. I am interested in the extent to which my history and I have charted the ground.'[93]

In Harris' own large-format polaroid portraits, the sitters are posed against the colours of the red, green and black UNIA (Universal Negro Improvement Association) flag. Referring to another work made with his brother, the film maker Thomas Allen Harris, Harris stated:

'This collaboration with Thomas – using masquerade as our mode of transgression – is a way of expanding the notion of who can lay claim to the liberatory potential envisioned in the UNIA flag. We are challenging a construction of African nationalism that positions queers and feminists outside of the black family, the Million Man march [organized by the Nation of Islam] and other black institutions'.[94]

In various guises, Harris and other models are posed as Michael Stewart (a young black man beaten to death by police), the Venus Hottentot, and Toussaint L'Ouverture, the leader of a successful slave revolt against the French in Saint-Dominique (Haiti) in 1793–1804. Dressed in an elaborate uniform with a plumed hat and make up, Harris appears as a beautiful image of desire in drag, aptly summed up by the leaflet accompanying the exhibition as interweaving 'black pride, pleasure, desire and black history.' Harris' desire to situate himself within history, while at the same time questioning that self and that history, need not culminate in a poststructuralist disintegration of the self into the fragmentary and the contingent. Harris' images are visually striking, full of sensuality and pleasure in spite of the seriousness of the issues raised by the lives of the historical figures he and his models 're-enact' for the camera.

SAMINA KHAN

The last work I want to look at in this chapter is a box made by Samina Khan. (plate 16) This work represents the elaborate, complex and multi-layered construction of the subject, yet preserves the notion of the subject nonetheless. The box is covered with textiles made up from fragments of machine embroidered cloth. Within the textiles are photocopies of family photographs covered with gauze. Some of Khan's textiles incorporate cloth or jewellery purchased during a family visit to Pakistan from her home in England. Inside the box lid is a copy of the photograph of Kahn at her graduation, accompanied by her parents, who were initially doubtful about her choice of a career in the arts. Lying inside the box are textiles incorporating photographs representing different aspects of the artist's life and experiences, together with a dried rose.

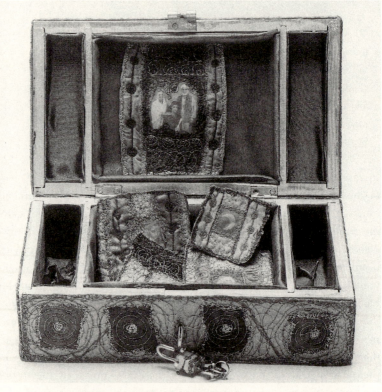

plate 16 *Samina Khan, Facing Identities: Family Box, 1998, mixed media, embroidery, textiles, photocopies, dried flower, length 30.5 cms. Private collection. Photograph Mike Simmons.*

The box is designed with a lock. Khan says the box is herself. Only when you know her better and are aware of her history and the different facets of her life, will you have access to what is inside the box. However the viewer is encouraged to approach the box, lured by the bright colours of gold, deep blue and scarlet of the silk textiles, and the gold and silver thread with which the cloth is decorated. This exotic looking construction promises oriental secrets, but the content combines the trappings of orientalism with fragments of the artist's life experiences in her English home. Pride of place is given on the open lid to a photocopied image of the artist in academic robes at her graduation, with her mother and father.

These artists have produced work where different modes of photographic practice and theory converge. In Khan's box, family photography, the notion of the original photograph and the copy, the decorative aspect of the photograph as a two dimensional image and notions of art and craft come together. In Samena Rana's work the manipulation of the photographic image, its construction and deconstruction, and family photographic history were embodied. In both artists' works the notion of 'art' is important. In both cases, and also in the work of Harris, family photographs are re-interpreted as art, and exhibited in galleries, which makes them socially and culturally different from the domestic photograph. Colour is very important to Rana and Khan, as decoration and as personal affirmation of a particular heritage originating from Pakistan which nonetheless refuses the term orientalism. Colour is not orientalized and exoticized, but is used to represent a part of an individual subject's life in its complexity within family and wider histories. In Harris' photographs, the luscious colour photographs in frames recall oil paintings. The red, green and black UNIA colours were significant both within the photographs and on the walls of the gallery where the works were hung. Thus the personal histories of the artists as individuals are situated within larger geographical and cultural contexts.

Despite recent writings on the demise of the individual subject, it can be seen that the self remains an important concept for contemporary artists whose basic activity is of course transformation of materials by labour. It is hard to see how this could happen in the absence of embodied subjects. In view of the ways black people were represented in photographic imagery in the past, I would argue that it is crucial to hold on to the concept of the human subject. For many of these past images showed people as bodies *without* subjectivity. For generations, subjectivity in practice was largely the privilege of the white upper class. It

seems to me to be a mistake for academics investigating black culture to join in the theoretical destruction of the idea of the conscious individual subject capable of acting on the material world, when so much theoretical and practical struggle has been devoted to reclaiming subjectivity for those previously denied it.

In the following chapter, I want to look at issues of desire, fetishism and black bodies. What strategies have black artists used to represent embodied objects of desire without simply objectifying black people and undermining their subjectivity once again? In trying to answer this question, I will be looking at the ways in which different forms of fetishism relate to the production and understanding of black visual culture.

NOTES

1 For definitions and discussion of the subject see the entry by E.Grosz, in E.Wright ed., *Feminism and Psychoanalysis: A Critical Dictionary*, (Blackwell, Oxford, 1992), pp 409–416.

2 H.Lidchi, *'The Poetics and Politics of exhibiting other cultures'*, in S.Hall ed., *Representation: Cultural Representations and Signifying Practices*, (Open University and Sage, London, 1997), p 160.

3 Ibid., p 187.

4 D.Langsam, *'Quest for the missing dead'*, The Guardian, 24 February 1990, p 23.

5 Ibid., p 23.

6 For more on this see S.Price, *Primitive Art in Civilized Places*, (University of Chicago Press, Chicago and London, 1989), and M.M.Ames, *Cannibal Tours and Glass Boxes: the Anthropology of Museums*, (University of British Columbia Press, Vancouver, 1992).

7 For an illustration, see the catalogue *Mirage. Enigmas of Race, Difference and Desire*, (ICA and inIVA, London, 1995), p 75.

8 H.Foster, *'The artist as ethnographer'*, in *The Return of the Real: The Avant-Garde at the End of the Century*, (MIT Press, Cambridge Mass. and London, 1996), p 191.

9 See the catalogue Sonia Boyce, *Peep*, (inIVA and Brighton Art Gallery and Museums, London, 1995).

10 R.Corbey, *'Ethnographic showcases, 1870–1930'*, chapter 4 of J.Nederveen Pieterse and B.Parekh, *The Decolonization of Imagination.Culture, Knowledge and Power*, (Zed books, London and New Jersey, 1995), p 75. For details of these and other ethnographic photographic projects in India see chapter 1 of the fascinating book by C.Pinney, *Camera Indica: The Social Life of Indian Photographs*, (Reaktion Books, London, 1997), and the essays by Pinney and John Falconer in C.A.Bayly ed., *The Raj: India and the British 1600–1947*, (National Portrait Gallery, London, 1990), pp 252–277. Also very useful on the role of photography in British colonies is J.R.Ryan, *Picturing Empire: Photography and the Visualization of the British Empire*, (Reaktion Books, London, 1997). Alexander Butchart, *The Anatomy of Power: European Constructions of the African Body*, (Zed Books, London and New York, 1998), uses Foucault's theories to look first

at historical constructions of the black African (male) body and then to the disciplining management of black mineworkers in modern South Africa.

11 For interesting discussions and illustrations of postcards of these exhibitions see R.W.Rydell, '*Souvenirs of Imperialism: World's Fair Postcards*', in C.M.Geary and V-L.Webb eds, *Delivering Views: Distant Cultures in Early Postcards*, (Smithsonian Institution Press, Washington and London, 1998) chapter 2.

12 See *The Impossible Science of Being: Dialogues between Anthropology and Photography*, (The Photographer's Gallery, London, 1995), p 8. This point was a development of remarks in C.Pinney, '*The parallel histories of anthropology and photography*' in E.Edwards ed., *Anthropology and Photography 1860–1920*, (Yale University Press, New Haven and London, 1992), pp 74–95.

13 For example the artist Zarina Bhimji had to modify her original plans for her project for *The Impossible Science of Being* exhibition. She concluded that anthropology had shifted: 'I thought I was going to make a critique of it, but I can't do that. '*The Impossible Science of Being*, p 26.

14 *The Impossible Science of Being*, p 30.

15 ibid., p 31. The work is illustrated in the colour plate section of this catalogue.

16 Illustrated in *Dave Lewis. Monograph*, (Autograph, London, n.d. 1996?) p 13.

17 E.Edwards, '*Ordering Others: Photography, Anthropologies and Taxonomies*', *In Visible Light*, p 56.

18 An example of a Foulcauldian approach to photography is John Tagg's book, *The Burden of Representation: Essays on Photographies and Histories*, (Macmillan, Basingstoke, 1988). See also the interesting work by S.Lalvani, *Photography, Vision, and the Production of Modern Bodies*, (State University of New York Press, Albany, 1996). I have discussed this at more length in my study of photographs of women prisoners taken after the suppression of the Paris Commune of 1871, in chapter 4 of my book *Seeing and Consciousness. Women, Class and Representation*.

19 *In Visible Light*, p 57.

20 S.Graham-Brown, *Images of Women: The Portrayal of Women in Photography of the Middle East 1860–1950*, (Quartet, London, 1988), p 46, mentioned by A.Coombes and S.Edwards, '*Site unseen: Photography in the colonial empire: Images of Subconscious Eroticism*', *Art History*, vol.12, no.4, December, (1989), p 515.

21 *Delivering Views*, p 51.

22 Ibid., p 51.

23 Combes and Edwards, Ibid., p 513.

24 *Dave Lewis. Monograph*, introductory essay by R.Malik, p 5.

25 Bailey, '*Re-Thinking Black Representations. From positive images to cultural photographic practices*', *Ten.8*, no.31, (no date, 1988?) p 47.

26 D.Bate, '*The Occidental Tourist. Photography and Colonizing Vision*', *Afterimage*, Summer (1992), p 11.

27 G.Merquior, *Foucault*, (Fontana, London, 1985), pp 81–2.

28 Ibid., p 83.

29 J.R.Ryan, *Picturing Empire: Photography and the Visualization of the British Empire*, (Reaktion Books, London, 1997), p 37.

30 H.Foster, *The Return of the Real: The Avant-Garde at the end of the Century*, p 275.

31 Ibid., pp 196–7, italics in original.

32 D.A.Bailey, '*The Black subject at the centre: Repositioning Black*

Photography', in M.Reeves and J.Hammond eds., *Looking beyond the Frame: Racism, Representation and Resistance*, (Links Publications, Third World First, Oxford, 1989), p 35.

33 F.Spencer, *'Some notes on the attempt to apply photography to Anthropometry during the Second Half of the Nineteenth Century'*, in Edwards ed., *Anthropology and Photography*, p 106.

34 Denzil Ibbetson, President of the Anthropological Society of Bombay, quoted by C.Pinney, *'The Parallel Histories of Anthropology and Photography'*, in Edwards ed., *Anthropology and Photography*, p 80.

35 Spencer in Edwards ed., p 103.

36 A.Sekula, *'The Body and the Archive'*, *October*, vol. 39, (1986), p 11.

37 Ibid., p 12.

38 Bayly ed., *The Raj*, p 273.

39 R.C.Bleys, *The Geography of Perversion: Male to male Sexual behaviour outside the West and the Ethnographic Imagination, 1750–1918*, (Cassell, London, 1996), p 87. Huxley wanted photographers to pay special attention to the contours of the breast, 'which is very characteristic in some races'. Quoted by F.Spencer, *'Some notes on the attempt to apply photography to anthropometry during the second half of the nineteenth century'* in Edwards ed., p 100.

40 Ryan, *Picturing Empire*, p 148.

41 ibid., p 30.

42 J.Ezard, *'Ear marks out serial burglar'*, *The Guardian*, 21 February 1998, p 1.

43 R.Miles quoted by K.Malik, *The Meaning of Race*, p 5.

44 Ibid., p 81 referring to D.Pick, *Faces of Degeneration: A European Disorder ca.1848–ca.1918*, (Cambridge University Press, Cambridge, 1989). See also J.R.Ryan, *Picturing Empire. Photography and the Visualization of the British Empire*, chapter 5.

45 Malik, ibid., p 83.

46 Ibid., p 116.

47 For more on the Dyche collection see E.Edwards, *'From Negative Stereotype to Positive Image'*, leaflet to accompany the touring exhibition of the same name organized by Watershed Media Centre, Bristol and S.Courtman, *"What is missing from the picture? Reading desire in the Dyche studio photographs of the Windrush generation"*, *Wasafiri*, no 29, Spring 1999, pp 9–14.

48 On the development of portrait photography in the nineteenth century see J.Tagg, *The Burden of Representation: Essays on Photographies and Histories*, (Macmillan, Basingstoke, 1988), A.Rouillé, *L'Empire de la Photographie: Photographie et pouvoir bourgeois 1839–1870*, (Le Sycomore, Paris, 1982), and the fascinating book by A.Rouillé and B.Marbot, *Le Corps et son Image: Photographies du dix-neuvième siècle*,(Contrejour, Paris, 1986).

49 She also stated that her grandmother's home in Jamaica was full of such photographs, and of children growing up at various stages. See the video *Being Here*, by Annabel Leech, Royal College of Art, 1997. Some of Dyche's sitters are interviewed in this video after having come forward to identify themselves after a selection of the archive was exhibited by Peter James, Head of Photography at Birmingham Central Library, and local newspapers publicized the collection. This project of re-personalization and reclamation is continuing.

50 D.Hiro, *Black British White British*, (Grafton Books, London, 1991), p 26. Opposition by white transport workers was overcome, and by the end of

1954, 257 black people were employed by Birmingham Transport Department, C.Chinn, *'The Cultural Revolution'*, *Birmingham Evening Mail*, 18 May 1996, p 15.

51 Hiro, p 43. See also M.Dresser, *Black and White on the Buses: The 1963 colour bar dispute in Bristol*, (Bristol Broadsides, Bristol, no date ca.1986).

52 Hiro, pp 282–3.

53 Hiro, p 35. For more information on black experiences of Birmingham see A.Madden, *From Paradise to Motherland. A reminiscence pack of photographs, slides, audio cassettes, notes and newspaper cuttings to assist Birmingham's post-war Caribbean immigrants in recalling their past*, (Birmingham City Council Library Services, Birmingham, 1993).

54 *Being Here*, video.

55 Hiro, pp 121–2.

56 ibid., p 159.

57 Hiro, p 24.

58 Hall, *'Reconstruction Work. Images of Post-War black settlement'*, in J.Spence and P.Holland eds, *Family Snaps: The Meaning of Domestic Photography*, (Virago, London, 1991), p 156. There is a slightly different version of this, with colour plates, in *Ten. 8. Critical Decade*, vol. 2, no. 3, Spring (1992), pp 106–113.

59 Interview on soundtrack of *Being Here* video.

60 ibid.

61 Originally the term diaspora (Greek dia-through and speirein-to scatter) was used to describe the dispersion of the Jews, see A.Brah, *Cartographies of Diaspora. Contesting Identities*, p 181.

62 Hall in *Family Snaps*, p 156.

63 See Fryer, *Staying Power: The History of Black People in Britain*, (Pluto Press, London, 1984), pp 302ff.

64 Ibid., p 358.

65 Hiro, *Black British White British*, p 253.

66 K.Simmons ed., *Top Pop Stars*, (Purnell, London, 1961), p 61.

67 Medhurst, *'Why the boys love Bassey'*, *The Observer*, 11 September 1994, Revue p 2. Many thanks to Andy Medhurst for kindly sending me his piece on Bassey. A new biography of Bassey was published in 1999, entitled *My Life in Record and in Concert*.

68 Judith Butler argues that women perform femininity constantly as a way of ensuring that gender difference is lived and reinvented every day, thus keeping it in place. The performance of femininity draws on, and covers over, the conventions which mobilize it. Butler distinguishes between performance and performativity: 'performance as bounded "act" is distinguished from performativity insofar as the latter consists in a reiteration of norms which precede, constrain, and exceed the performer and in that sense cannot be taken as the fabrication of the performer's "will" or "choice"; further, what is "performed" works to conceal, if not to disavow, what remains opaque, unconscious or unperformable. The reduction of performativity to performance would be a mistake. 'Butler, *Bodies that Matter: On the discursive limits of 'sex'*, (Routledge, London and New York, 1993), p 234. For an excellent critique of Butler see T.L.Ebert, *'(Untimely) Critiques for a Red Feminism''*, in M.Zavarzadeh, T.Ebert, D. Morton eds., *Post-Ality: Marxism and Postmodernism*, (Maisonneuve Press, Washington D.C., 1995), pp 113–149.

69 A.McClintock, *Imperial Leather: Race, Gender and Sexuality in the Colonial Contest*, (Routledge, London and New York, 1995), p 62.

70 Ibid., p 63.

71 Bhabha, *The Location of Culture*, (Routledge, London and New York, 1994), p 38.

72 McClintock, pp 63–5 for critiques of Bhabha's articles '*Of Mimicry and Man: the Ambivalence of Colonial Discourse*', October 28, Spring, (1984), and '*Signs taken for Wonders: Questions of Ambivalence and Authority under a tree outside Delhi, May 1817*' in F.Barker et al., eds., *Europe and its Others*, vol.1, (University of Essex, Colchester, 1985). While there are aspects of McClintock's theoretical framework with which I disagree, primarily her refusal to give any causal primacy to economic factors, thereby equating the significance of gender, class, sexuality and 'race' on a theoretical level, her comments on Bhabha are very useful.

73 For interesting examples of composite wedding photos from Indian studios see Pinney, *Camera Indica*, pp 132–4.

74 It has been argued that the decline of the professional studio family photograph in favour of the family snapshot has resulted in a large number of images in 'family' possession which will deteriorate badly. Ian Richardson points to 'the poor archival quality of many modern colour photographs ... The colour dyes in many of the photographs will be lucky to survive more than a decade or two- even less if they are displayed in bright light. Mantelpieces are littered with colour photographs that have faded to a sickly blue tone.' '*Thanks for the memories*', *The Guardian*, 29 October 1997, p 9.

75 This traditional invitation to the viewer, legitimizing his (usually) right to look is discussed and illustrated by John Berger in *Ways of Seeing*, (British Broadcasting Corporation, London and Penguin, Harmondsworth, 1972).

76 Pinney, *Camera Indica*, p 178. Pinney quotes Kobena Mercer discussing works by the Malian photographer Seydou Keita: 'With various props, accessories and backdrops, the photographer stylizes the pictorial space, and through lighting, depth of field and framing, the camera work heightens the *mise-en-scène* of the subject, whose poses, gestures and expression thus reveals a "self" not as he or she actually is, but "just a little more that what we really are".' For more impressive 'fantasy' photographs of a different kind see V.Williams and A.Fox, *Street Dreams*, (Booth-Clibborn Editions, London, 1997).

77 A.Mama, *Beyond the Masks: Race, Gender and Subjectivity*, (Routledge, London and New York, 1995), p 82.

78 Ibid., p 98.

79 Ibid., p 99.

80 A.Brah, *Cartographies of Diaspora: Contesting Identities*, (Routledge, London and New York, 1996), p 11.

81 Ibid., p 9.

82 Ibid., p 117.

83 Ibid., p 125.

84 Ibid., p 218.

85 From *Ten.8*, vol 2, no.3, p 58 quoted by L.Nead, *Chila Kumari Burman: Beyond Two Cultures*, (Kala Press, London, 1995), p 44.

86 A. deSouza and S.Merali eds., *Crossing Black Waters*, exhibition catalogue, (City Gallery Leicester, Oldham Art Gallery, Cartwright Hall, Bradford, 1992), p 63.

87 S.Rana, "Disability and Photography", *Feminist Art News*, vol 2 no 10, Spring 1989 pp 22–3.

88 S.Rana, "The flow of water", in S.Gupta ed., *Disrupted Borders. An intervention in definitions of boundaries*, Rivers Oram Press, London, 1993, p 167.

89 *Crossing Black Waters*, pp 63–4.
90 *Disrupted Borders*, p 168.
91 *Disrupted Borders*, p 168.
92 Doy, *Seeing and Consciousness. Women, Class and Representation*, Berg, Oxford and Washington D.C., 1995, p 194.
93 A.Read, ed., *The Fact of Blackness: Franz Fanon and Visual Representation*, (ICA London and Bay Press Seattle, 1996), p 151.
94 For illustrations and discussion of Harris' work see *Mirage: Enigmas of Race, Difference and Desire*, (ICA, London, 1995), pp 60–64 and the exhibition catalogue. J.Blessing *et al.*, *Rrose is a Rrose is a Rrose: gender Performance in Photography*. (Guggenheim Museum, New York, 1997) p 111, and L.A.Harris and T.A.Harris "*Black Widow: a conversation*":, chapter 14 in D.Bright ed., *The Passionate Camera: Photography & Bodies of Desire*, (Routledge, London & New York, 1998). For Harris in the context of contemporary representations of black males see T.Golden ed., *Black Male: Representations of Masculinity in Contemporary American Art* (Whitney Museum of American Art, Abrams, New York, 1994).

CHAPTER 4

DESIRE, FETISHISM AND BLACK BEAUTIES

Visual culture and pleasure are intimately related. Representations of black bodies and black beauties have been seen as visualizations of desire, threat and fear for the viewer of the so-called Other. But in this chapter, I want to look at the visualization of desire in relation to black bodies not from the persepective of a spectator who is Other and different, but primarily with respect to images created by black artists themselves.

Photographs of black male nudes by Robert Mapplethorpe have become something of a touchstone for the analysis of images representing the black male as an object of desire. I will be discussing the analysis of Mapplethorpe's images in the essays by Kobena Mercer where he explores his relationship as a black gay man to the 'objects of desire' shown in the American photographer's studies of black men and parts of their bodies. Mercer's different essays on these images provide a useful insight into the relationship of the spectator to the image – meaning does not reside in the image itself but in a coming together in specific situations of the image and those who view it. These spectators bring their own experiences and understanding of class, 'race', gender and sexuality, along with particular notions of art and culture. Without allowing Mapplethorpe's work to continue to set the tone of the debate, I want nevertheless to acknowledge the crucial insights of Mercer's comments on his work, and the differences between black bodies in Mapplethorpe's images and in those of black photographers Rotimi Fani-Kayode and Ajamu.

The concept of fetishism is linked to sight, desire, threat, objectification and the capitalist commodity, and so constitutes a thread running through this chapter's investigation of desire and the sight of the black body. The black body, as well as being a site for the construction of desire, is a commodity which can be sold along with others – underclothing, sportswear and so on. From poorly paid workers in hospital

or airport cleaning and catering jobs, to highly paid and publicized icons of football, black workers sell their ability to create surplus value by labour. In the second part of this chapter I will be looking at the black body and commodity fetishism.

In the final section, I want to look at a third aspect of fetishism, that of so-called anthropological or religious fetishism, specifically concerning the body of the Afro-American and African woman as represented in examples of art by Tam Joseph and Renée Stout. Finally I want to look at a work by Karun Thakar which combines aspects of religious, commodity and sexual fetishism.

ECSTATIC ANTIBODIES

Ecstatic Antibodies: Resisting the AIDS Mythology, published in 1990, was edited by Sunil Gupta and Tessa Boffin. On the cover was a photographic image produced by Rotimi Fani-Kayode in collaboration with his partner Alex Hirst.[1] (plate 17) Unfortunately, both Fani-Kayode and Hirst are now dead. The image was an inspired choice for the cover, given the emphasis on the body and different ways of representing it in the work of Fani-Kayode and Hirst. Also, in his article, 'Traces of Ecstacy' Fani-Kayode explains that he wanted to approach a spiritual reality in his images through an imaginative, rather than a documentary, use of photography. Seeking to emulate the 'technique of ecstacy' of Yoruba priests in his native Nigeria, Fani-Kayode sought to 'ritualistically' transform imagery of black men.[2] Fani-Kayode's parents, who were forced to leave Nigeria as political refugees in 1966, were from a family who held the traditional title of Keepers of the Shrine of Ifa, the oracle. In the 'technique of ecstacy' the priest in a trance communicates with the deity. Fani-Kayode and Hirst 'held the view that the artist needs to establish a similar relationship with the unconscious mind'.[3]

In the *Ecstatic Antibodies* cover image, *The Golden Phallus* (plate 17), a black man wearing a white mask reminscent of a bird or a Commedia del'Arte mask, kneels down with his hands behind him exposing a golden penis supported by two strings which hold it erect. The myth of the ever-erect black member is shown to be a fallacy, a penis like any other man's. In another image from the same series (*Communion*), *Gold Phallus* (1989), the black figure in the mask crouches down and his mask points towards his penis which is painted gold (or perhaps he is wearing a gold condom). Referring to *The Golden Phallus* in an essay in *Ecstatic Antibodies*, Fani-Kayode and Hirst write: 'We pay circumspect

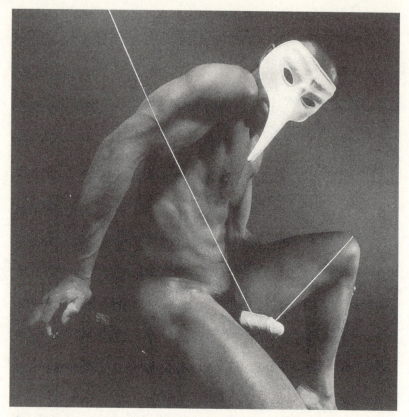

plate 17 *Rotimi Fani-Kayode with Alex Hirst, Golden Phallus, 1989, colour photograph. Copyright Estate of Rotimi Fani-Kayode and Autograph.*

"homage" then, to the drag-queen of "Liberty" in whose ambiguous shadow our erections have turned from base and shameful dross into amulets sporting golden condoms.'[4] America is seen as a contradictory beacon of Liberty, home of the modern gay liberation movement, home also of many descendants of African slaves, home of drug companies who make profits from the treatments of HIV and AIDS.[5] The image recalls the title of Frantz Fanon's book *Black skin, white masks*, in which the psychiatrist investigates the way in which black men, in particular, internalize myths of blackness invented by colonial society and damage their psyches in the process. The black man becomes a sexual object par excellence for the white man and woman – he becomes the phallus, image of sexual power and a threat. As Fanon puts it 'the Negro is eclipsed. He is turned into a penis. He *is* a penis.'[6] However the bird-like mask also suggests the ororo bird of thought and inspiration from

Yoruba mythology. Fani-Kayode also invokes the Yoruba god of inde-
terminacy, Esu. This trickster is at once joyful and sinister, causing dif-
ficulties everywhere, mixing up 'normal' procreation and birth.'At every
masquerade . . . he is present, showing off his phallus one minute and
crouching as though to give birth the next. He mocks us as we mock
ourselves in masquerade. But while our mockery is joyful, his is poten-
tially sinister.'[7] Esu is often represented with a large penis or double
penis, but despite this is seen as genderless, or of dual gender. 'He' has
male and female aspects, extending across indeterminate boundaries.
Despite his 'remarkable penis', he represents a genderless or androgy-
nous state which was the original state of spirits in Dogon and Yoruba
cultures. Esu represents the interface between truth and understanding,
and as a form of the verb *to be* linking a subject with its predicate i.e.
what is affirmed or denied about the subject.

The photographs are mostly in colour with emphasis on bodies placed
against plain backgrounds. The rich tones of the bodies are brought out
by lighting and by the ways the scenes are staged with props of masks,
Nigerian clothes or 'exotic' flowers, fruit and fish. The artificiality and
the materiality of the scenes are both clearly present. These striking
images are ambiguous and suggestive, full of both conscious connota-
tions and unconscious possibilities. They can be read in many complex
ways. I do not want here to circumscribe the meanings of these works,
which resonate with connotations. Many aspects of culture and ritual,
masquerade, performance and sexuality are mobilized here. Fani-Kayode
was adamant that his work was 'Black, African, homosexual photogra-
phy'.[8] Some white critics said his work derived from that of
Mapplethorpe, thus setting up a comparison where the rather formalist
art photographs of the white image-maker are preferred to those of Fani-
Kayode.[9] This devalued the suggestive and culturally rich aspects of
Fani-Kayode's work, which were thus posited merely as devices allow-
ing him to imitate Mapplethorpe. The Photographers' Gallery in London
refused three times to show Fani-Kayode's work on the grounds that it
was a poor imitation of Mapplethorpe's photography.[10] I will return to
Mapplethorpe's representations of black males later.

Fani-Kayode was very aware of the difficulties he faced as an exile
from Africa, and the ways in which his art was approached as exotic
and diasporic, while being compared to the more (in)famous
Mapplethorpe. While showing his photographs in the cities of Europe,
he came to believe that no one would understand their powerful sym-
bolism apart from Yoruba villagers he had in mind when creating the

images, but who he himself had only ever known as a 'tourist' even in Nigeria. The position of these imagined villagers should perhaps be posited as the ideal place from which to read such images of the black male; a position sensitive to spirituality and images of power.[11]

Fani-Kayode was also keenly aware of the contradictory responses to the explicit homosexuality of his imagery. On the one hand it meant rejection and censorship (for example he was asked to remove his photographs from an exhibition at Oval House, London so as not to offend those attending the unveiling of a plaque commemorating the birth of Lord Montgomery of Alamein), on the other: 'The homosexual bourgeoisie has been more supportive – not because it is especially noted for its championing of Black artists, but because Black ass sells almost as well as Black dick.'[12] Fani-Kayode also knew that modern Yoruba art sold as a commodity on the art market, valued for its exotic appeal. His own work was 'inevitably caught up in this'.[13] All this continued against the background of military dictatorship in Nigeria, and the exploitation of the country's resources by foreign oil companies, especially in Ogoniland.

BLACK AND GAY

Sunil Gupta has written of the difficulties faced by black gay photographers: 'I feel under constant pressure to produce black gay images because there are so few people doing it. I think when straight/white photographers start making interesting images about us then we can start to produce other images.'[14] Because of racism among some white gay men, black gay artists have tended to situate themselves within the black community rather than the gay community.[15] From this position, images which challenged the objectification of the black male body could be produced. However an awareness of racism does not automatically mean that black gays and lesbians are always supported in their communities. Within Afro-Caribbean communities, gay sexuality is sometimes seen as problematic – a white man's disease, and a threat to the propagation of the 'race' and the macho image of black men fostered by the media.[16] In addition, according to examples from the USA, resentment against white gays is compounded because in some cases low income black communities are uprooted as middle-class gays move in.[17]

On the other hand, many white gays do not question racism. Men of Africa and the African diaspora have also been demonized by much of the publicity around HIV and AIDS, which helped to construct homo-

phobic, racist and imperialist ideology around the disputed causes and sources of disease. Thus the body of the black gay man is a site of powerful and conflicting ideologies, mobilizing desire and fear. Kobena Mercer and Isaac Julien have pointed out that

> The notion of a secret hidden truth of sexuality, which must be confessed, is clearly related to this [notion of savage sexuality], as it is based on the idea that sex is the most basic form of naturalness which is therefore related to being uncivilized or *against* civilization.[18]

However the existence and representation of black gay sexuality in itself challenges this ideology at its very core, for by this argument natural sexuality is gay sexuality. For Freud, uncivilized sexuality was bisexual: 'freedom to range equally over male and female objects – as it is found in childhood, in primitive states of society and early periods of history, is the original basis from which . . . both the normal and the inverted types develop'.[19] Krafft-Ebing argued that the more developed the society, the greater the distinction between man and woman: 'The higher the anthropological development of the race, the stronger these contrasts between man and woman, and vice versa.'[20] Homosexuality, argued sexologist Havelock Ellis, must be inherited, not aquired, since (hetero)sexuality could not be aquired. The urge to propagate the race was dominant, he maintained. Merl Storr, lecturer in Sociology at the University of East London, concludes from her study of these views that notions of sexuality are linked to 'race', and in fact, '"race" is precisely what sexuality is all about.'[21]

In an interesting study of European views of male sexual behaviour in non-European countries, Rudi Bleys has investigated the ways in which homosexual behaviour was conceptualized by European colonists.[22] Bleys suggests that the 'ethnographic gaze' which undressed, measured and photographed the black male, could disguise erotic fascination on the part of the white male scientist.[23] In this respect it is interesting to see Fani-Kayode's work as a refusal of the ethnographic image, where the body is isolated from a cultural and social context, and seen as a specimen. Erotic desire is masked in the ethnographic image by a pseudo-scientific objectivity, whereas in Fani-Kayode's work the luscious tones and colours offer a sensual pleasure openly. Often in his work there are two men interacting, which works against seeing the black body as a specimen or a passive object to be looked at. Under the 'ethnographic gaze', writes Bleys, black Africans were not seen as

feminized, since this conflicted with the needs of the slavers to constuct African men as virile, strong and beasts of burden, whereas Asians, American Indian and Pacific males were seen as effeminate.[24] By the later nineteenth century sexual deviance was seen as located in the mind rather than in certain physical practices. As a result of racialist discourse, in the later nineteenth and early twentieth century homosexuals were presented as endemic in less developed societies, and as cases of degenerative pathology in Europe.[25] Regulation of social and sexual life in African colonies in the later nineteenth century was undertaken to prevent social disorder and maximize economic gain. The European troops sent to Africa were thought to be in danger of engaging in homosexual behaviour partly through 'contamination' by their surroundings, or by the absence of suitable heterosexual partners. One French Doctor wrote in 1911:

> The uprooted easily becomes a sodomite . . . [but] real homosexuality
> is very rare . . . Many are sodomites by necessity, but real homosexu-
> als are few in number. The shortage of women or the presence of Arab
> and black prostitutes, who are dirty, stink and carry diseases pushes
> the uprooted to prefer sex with ephebes. Their behaviour is incidental
> and will be dropped when they return to the North. [26]

Other writers were less convinced that this behaviour would be overcome, and believed that 'the survivors, crushed by the sad colonial experience' would never experience 'normal' heterosexual relationships.[27] Thus socially invisible gay men were seen to be homosexuals due to circumstances e.g. of war, or imprisonment. Socially visible gay men were labelled 'congenital'. Bleys concludes that 'Ethnographic discourse reflected superbly how the reification of desire into identity was the price of the ticket to homosexual affirmation.' This discourse took as its objects colonized others abroad and those who eventually were stigmatized by the identity of perverts at home.[28]

Frantz Fanon's discussions of black homosexuality tended to deny its validity as sexual identity or practice except as pragmatic responses to particular situations such as engaging in homosexual behaviour in Europe. Fanon famously referred to the absence of the Oedipus complex in the French West Indies, hence the Freudian rationale of sexual object choice was rejected as only applicable to white Europeans. Bleys suggests that Fanon was perhaps responding to psychoanalysis's 'rigid view of homosexuality as a neurosis'.[29] In addition, faced with generations of

European writing on the sexual lasciviousness of inferior 'races', Fanon denies any 'vice' except when French West Indians arrive in the imperialist heartland. Fanon's views on homosexuality have correctly been seen as 'troubling'.[30] Kobena Mercer points out that for black masculinity, homosexuality is often seen as 'the enemy within'. Colonial racism has so constructed the black body as 'phobic object – I think it would be rather surprising if this binary code did not somehow feature in black people's experience of the emotional reality of the unconscious. We too have our fears and fantasies that have been shaped by the violence of history.'[31]

Fani-Kayode and other black gay photographers such as Sunil Gupta and Ajamu make visible the same-sex desire which is sometimes repressed by black culture. In the cases when this desire is acted upon by black and white lovers, it is seen as even more transgressive. For black artists and film makers, the representation of the black male as an object of homosexual desire is complex. Isaac Julien points out that he was worried that, in showing the black male as desirable, he might offer an object which could merely be consumed by an unquestioning white gaze.'I was worried about that gaze, and that meant that to an extent I annihilated my own ambivalent desire around the black male body.' In his film *Looking for Langston* (1989) Julien 'really wanted the black male body to be the site of pleasure'.[32] In addition, Julien had to confront the problem of representing the white male body as an object of desire for black men, without constructing the black spectator as an Other who sees himself as inferior to the erotic image he desires. A further problem I have noticed in looking at many of these images is that they represent the body of the black male as beautiful, young, athletic and desirable. In the case of gay men since AIDS, this sometimes has an undercurrent of transience and poignancy, of possible wasting and death, but in other senses it constructs the black gay man as something of a stereotype of beauty, someone who is not old, wrinkled, or overweight. However it is important not to conflate these images of desire with documentation. In many cases desire is a fantasy which may or may not be fulfilled. The photograph is a trace of that desire, either of its past or its possible future realization.

FETISHISM AND VISUAL CULTURE

Fani-Kayode's photographs are powerful configurations of desire, ritual and the black body, and are made to be gazed at. As such they are

intimately related to notions of fetishism on several levels. However they are not reflections of theories of fetishism, but rather ambiguously positioned in relation to what have been described as sexual, anthropological and commodity fetishisms. In describing these three theories of fetishism, Lorraine Gamman and Merja Makinen seek to relate them to women, since women have for a long time been excluded from discussions of fetishism.[33] In Freud's writings on sexual fetishism, the fetishist is usually male, and probably usually white. In the following discussion, I want to consider the black male as a subject and object of fetishism, adapting some of the existing writings on fetishism.

In Freud's theory of fetishism, the male subject becomes a fetishist as a response to the sight of the woman's 'castrated' genitals. The woman is seen as existing in a condition of incompleteness and lack. The woman in whose body he perceives this lack is usually the young male's mother. If the boy is to choose a love object from among women, he must reassure himself that this castrated state is one from which he will be protected. However Freud should not be taken too literally. The perception of woman as incomplete, as suffering from a lack, is symbolically related to the real position of women in society, especially in the early twentieth century when Freud was developing his theory. Women do still suffer from social oppression and are therefore perceived, consciously and unconsciously, as not being the same as men and enjoying the same privileges culturally, economically, socially and sexually. All males experience this shock at the female genitals, says Freud. In order to reassure themselves that the woman's penis is not actually gone (though they know at the same time it is), some men will replace the missing penis with a fetish object which will 'complete' the female object of their desire, thus reassuring them. This fetish object can be a part of the woman, a piece of clothing, a shoe, possibly something associated with the genitals and last seen before the shock of seeing the castrated woman, such as underwear.

Thus the foot or shoe owes its preference as a fetish – or a part of it – to the circumstance that the inquisitive boy peered at the woman's genitals from below, from her legs up; fur and velvet – as has long been suspected – are a fixation of the sight of the pubic hair, which should have been followed by the longed-for sight of the female member; pieces of underclothing, which are so often chosen as a fetish, crystallize the moment of undressing, the last moment in which the woman could still be regarded as phallic. But I do not maintain

that it is invariably possible to discover with certainty how the fetish was determined.[34]

Thus all men are potential fetishists for Freud. The shock of the castrated female genitals may have other consequences. The male may not seek a love object like his mother, but one like himself, hence a possible same sex love object choice. In this case his chosen lover may unconsciously be reassuring him against his fear of castration. Freud does not mention homosexual fetishism, though he viewed homosexuality as a 'peculiarity of object-choice', not an illness or a vice. Indeed it may be that for Freudian theory, homosexual fetishism is an impossibility, since he writes that 'It [the fetish] saves the fetishist from becoming a homosexual, by endowing women with the characteristic which makes them tolerable as sexual objects.'[35] However Freud does describe homosexuality as 'an arrest of the sexual development' thus supposing a 'normal' sexual development.[36]

What would fetishism mean for the male homosexual? Since Freud's theories should be understood metaphorically and symbolically, it is important to see the connection between the woman perceived as inferior and lacking, and other socially oppressed groups. Thus although male, the homosexual is also socially and culturally perceived as lacking. Similarly the black male, though ideologically perceived as supersexual, is seen as culturally, economically and even sexually lacking, since he does not have an equal choice of love objects as the economically and culturally more powerful white male, nor is he seen as in control of his sexuality. He is seen as a penis, as Fanon has put it. Thus the black gay male is seen as a site of seriously disturbing contradictions. He is the phallus, the objectified fetish par excellence, so powerful that it denies the fear and existence of castration. This objectified phallus/person is at once the super fetish object and the denial of the need for a fetish. But the black man as fetishized and phallic is supposedly also a threat to the white male, so the fear of castration is still present. In theory, black homosexuality should save the black gay male from persecution, since white men should feel reassured that 'their' women are no longer at risk from black sexuality. However this is not the case. The choice of a love object from the same gender entails the danger of an additional form of persecution. The question of sexual fetishism cannot be divorced from a consideration of power relations and social oppression. Elizabeth Grosz has looked at the question of lesbian fetishism, arguing that it does exist and concluding that the

lesbian's '"fetish" is the result not of a fear of femininity but a love of it; it does not protect her from potential danger, for it introduces her to the effects of a widespread social homophobia'.[37] In considering representations of gay black males we should bear in mind a symbolically 'feminizing' discourse in terms of voyeurism and fetishism, though I am not suggesting that the positions of white women and black gay men should be equated. Their relationship to notions of incompleteness and lack is different, partly due to the construction of the black male as an objectified phallus in much of European pseudo-scientific discourse on 'race' and sexuality. The fetishized body of the black gay male functions in different ways from that of the fetishized female body. We should also remember that black Afro-Caribbean men were, and perhaps still are, more likely to be seen as phallic and masculine, whereas black Asian men are deemed effeminate, as Bleys points out in *The Geography of Perversion*. What we do notice is a variety of types of fetishism apparent in representations of black men, from Mapplethorpe's fetishization of the black male body primarily for a white gay viewer, to the more playful eroticism of Ajamu's photographs, where much more ambiguous subject and corresponding viewing positions are suggested by the use of clearly fetishistic underwear, lace gloves and jewelery. (plate 18) Fetishism and desire are associated with the people in the photographs, not just the mechanics of the viewer's gaze. I will return later to this example of Ajamu's work.

The second aspect of fetishism important for us is so-called anthropological fetishism. This has been (mistakenly) used to describe religious fetishes said to be used by Africans. William Pietz has shown by detailed research on the history of the term and its meaning that 'the fetish, as an idea and a problem, and as a novel object not proper to any prior discrete society, originated in the cross-cultural spaces of the coast of West Africa during the sixteenth and seventeenth centuries'.[38] Pietz located the genesis of the fetish in a clash between two radically different types of society during the emergence of the commodity form. In the fifteenth and sixteenth centuries Portugese traders on the West African coast used the term to describe religious objects and amulets. The term feitiço had already been used in Europe by the Church to denounce illicit popular rites linked to disruptive female sexuality. In the encounter between mercantile capitalism and its enslavement of societies with different value systems, the European notion of the fetish was born. The traders and slavers visiting the African coast came to see fetishism as an obstacle to their desire to introduce market forces.

plate 18 *Ajamu, Malcolm, 1993, black and white photograph. Copyright Ajamu.*

Radically different notions of value prevailed in the two confrontational powers of Europe and Africa. As Anne McClintock points out, use value was more important to African people than exchange value. European explorers often had porters killed for dropping cases of goods into rivers,

or carelessly discarding rifles. One writer noted that Henry Morton Stanley was unable to convince his African workers of a capitalist value system. Since the goods they carried 'lack any concrete social role for them in the customs, directives and taboos of their tribal lives, the carriers are forever dropping, discarding, misplacing, or walking away with them. Incensed, Stanley calls this theft.'[39] It was only in the later nineteenth century that fetishism became associated with the phallus. Perhaps this should be seen in the context of increasing self-organization of women for economic and civil rights, as well as the increasing visibility and related legal oppression of homosexuals in Europe.

McClintock argues that the fetish should not be seen as merely a phallic substitute, but is also associated with 'race' and class. However I feel her definition of the fetish is rather too general, though it points to very important and fruitful aspects of the concept. She writes:

fetishes can be seen as the displacement onto an object (or person) of contradictions that the individual cannot solve at a personal level. These contradictions may originate as social contradictions but are lived with profound intensity in the imagination and the flesh. The fetish thus stands at the cross-roads of psychoanalysis and social history, inhabiting the threshold of both personal and historical memory. The fetish marks a crisis in social meaning as the embodiment of an impossible irresolution. The contradiction is displaced onto and embodied in the fetish object, which is thus destined to recur with compulsive repetition.[40]

McClintock's remarks on the fetish are most useful in considering the fetish in relation to black visual culture, as we can see that the issues she mentions as bound up with fetishism are key to many of the works I have been discussing so far in this book. However I wonder whether we can see the fetish as primarily a displacement of contradictions? If a person does not experience any contradictions in their social existence, is it then impossible for them to be a fetishist? If I experience a contradiction between my income and the amount of food I need to buy my children do I solve this by becoming a fetishist, a thief, or a revolutionary (or some combination of the three)? Is fetishism only a means of resolving contradictions on an unconscious level and what do I do consciously about them? What about the artist who consciously interrogates or plays with and enjoys fetishism in his/her work? McClintock usefully remarks elsewhere that the fact that 'fetishism is founded in contradic-

tion does not necessarily guarantee its transgressiveness; that cross-dressing [for example] disrupts stable social identities does not guarantee the subversion of gender, race or class power'.[41]

The third form of fetishism is that of commodity fetishism, theorized by Marx in *Capital* in the later 1860s. 'A commodity appears, at first sight, a very trivial thing, and easily understood. Its analysis shows that it is, in reality, a very queer thing . . .'[42] Marx shows how social relations are mystified under capitalism to become relations between things. However Marx solves this mystery by getting to the root of 'The fetishism of the commodity and its secret.'[43] I want to leave further discussion of commodity fetishism and the black male body until later in this chapter. For the moment, I want to return to questions of fetishization and objectification of the black male in Robert Mapplethorpe's photography. How do notions of 'race' interact with other factors in our understanding of his photographs? Are other images of black gay men different, and if so, why?

THE BLACK MALE BODY AS ART OBJECT

The most interesting discussions of Mapplethorpe's photographs of black men are to be found in a series of essays by Kobena Mercer.[44] In 'Looking for trouble' published in 1993, Mercer explains the different stages of his readings of Mapplethorpe's photographs of black men. When he first saw Mapplethorpe's book of photographs *Black Males* (1982) he was shocked by the first image he saw, the famous *Man in a Polyester Suit* (1980). The image shows the central part of a black man with his head and lower legs cropped. His hands hang loosely by his sides with one slightly turned towards his crotch. His trousers are open and a penis framed at the top by a white shirt hangs out. Mercer was at once fascinated and disturbed. The other images of black men in Mapplethorpe's book showed them nude. They wore no trappings of their own fetishistic (or other) desires, no bondage wear. Their bodies were nude, formally objectified by the techniques of high art photography, and their bodies made into fetishes by and for Mapplethorpe's creative look. Mercer felt the black men had been objectified by the male gaze of the white homosexual in a manner comparable to the way in which women are objectified by the heterosexual male gaze. The black men are there to be looked at, not think or do anything. Sometimes they are shown on a pedestal, for example *Ajitto*, (1981).[45] Sometimes a part of the body is shown in a fetishistic way as in *Derrick Cross* (1983) (plate 19), where the body

plate 19 *Robert Mapplethorpe, Derrick Cross, 1983, black and white photo-graph. Copyright Estate of Robert Mapplethorpe. Used by permission.*

shape has been compared to the formalistic modernism of Brancusi's sculptures. As I mentioned above, Mercer, in his original responses to *Man in a Polyester Suit* recalled Frantz Fanon's indictment of the colonialist gaze which, in seeing a black man, sees only a penis – it makes him into a penis.[46] Disturbed, Mercer felt that in spite of the disruption caused to dominant cultural codes by Mapplethorpe's homosexual imagery, the photographer's work tended to reinforce, not question, racist assumptions. His black models were not there to have desires of their own, but to fuel those of white spectators. In spite of the fact that Derrick Cross is named as an individual, he basically appears as a beautiful bum and thighs. In a recent interview the black film maker Steve McQueen is talking to Jaki Irvine:

> JI:I am thinking about this idea of the body. I could be wrong . . . but
> when I am thinking about a body I am thinking about somebody.

SM:(applauds) Absolutely, cut all the other shit out and just put that in.[47]

McQueen wants to show people as subjects in a narrative where they are themselves, not standing for symbols, representing 'women' or being anonymous. 'Just like everyone else I want people to think beyond race, nationality and all that kind of crap.'[48] However this is not something that can be easily achieved when many people do consider individuals as 'representatives' of some other category, like Derrick Cross as a black man. Also naming and personalizing someone in an image does not necessarily make him/her a subject, rather than an object. However it is necessary to bear in mind here that the process of photographic image making which reduces living three dimensional full colour reality to a flat static image, entails objectification. This however, should be distinguished from fetishization.

Maybe Mapplethorpe's images simply transformed possible visual material for pornography into art, but the social and cultural values and power relations were not really questioned.[49] Mercer later began to change his mind about the contradictory meanings of Mapplethorpe's images of black men, but other writers on black culture did not.

When Mercer began to question his earlier readings of the works he wrote: 'But now I am not so sure whether the perverse strategy of visual fetishism is necessarily a bad thing, in the sense that as the locus of the destabilizing "shock effect" it encourages the viewer to examine his or her own implication in the fantasies that the images arouse.'[50] Mercer realized he too was implicated in the viewing position previously inhabited by the white male subject when he viewed images of desirable black men. It was also the case that although Mapplethorpe formally objectified his male nudes, he did at the same time show black males as 'worthy' of inclusion into the pantheon of the classically conceived high art category of 'the nude', put on a pedestal to be aesthetically worshipped.[51] However most crucial for Mercer was consideration of the New Right attacks on, and attempted censorship of, Mapplethorpe's work by Senator Jesse Helms among others. Helms actually tried to pose as a liberal by condemning public funding for all art that denigrates 'on the basis of race, creed, sex, handicap, or national origin'.[52] Mercer concludes that possible complexity of reading Mapplethorpe's images of black men 'suggests that intederminacy doesn't happen "inside" the text, but in the social relations of difference that different readers bring to bear on the text, in the worldly relations "between".'[53]

Mapplethorpe himself felt that his images of black men were unavoid-
ably racist, but redeemed by a formal beauty which transcends black-
ness and whiteness.

> I think it is racist. It has to be racist. I'm white and they are black.
> There is a difference somehow, but it doesn't have to be negative. Is
> there any difference in approaching a black man who doesn't have
> clothes on and a white man who doesn't have clothes on? Not really,
> it's form and what you see into that and do with it.[54]

It seems rather depressing to suggest that desire and/or its representa-
tion between white and black people is bound to be racist. What seems
to be crucial here is the relationship of model and photographer, and
the way in which the model is made into an object which is hailed as
formally beautiful by the artist and critics. It was suggested to me by a
reader of this chapter that I had overlooked an important issue by fail-
ing to enquire into the feelings of Mapplethorpe's black models. In this
way, I too was treating them as objects, not people. So far, however, I
have found no information which will help us to know what Derrick
Cross and other black men thought about being photographed by
Mapplethorpe. This is an interesting point, however. Donald Sutherland,
Cindy Sherman and Patti Smith have all been photographed by
Mapplethorpe, but we feel perhaps that their feelings about the sessions
would yield less food for thought than those of the black men in the
photographs. Also there are other means of hearing their voices. They
are not known merely as people who were photographed by
Mapplethorpe. We may assume (rightly or wrongly) that their relation-
ship with the photographer was one of equality. If a photographer por-
trays the Queen, we do not really want to know what her feelings were.
We know that she is often photographed, the photographer probably
treats her with deference, and that the photographer is her 'subject'.
However some of us want to know more about the feelings of the black
models portrayed by a white photographer because we want them to
move from being objects into being subjects, and we still believe that
hearing their own views, their own testimonies, helps them to escape
from this 'objecthood', despite arguments against the existance of the
coherent human subject able to articulate his/her own authenticity.

Sunil Gupta felt ambivalent about *Man in the Polyester Suit*, recog-
nising that it was 'on the edge of being yet another big, Black dick, and
a more complex reference to Black men in culture'.[55] The polyester suit

suggests that although the black man attempts to enter the world of business and economic power, he will always manage it badly, hence dressing in cheap suits, and never escaping from the dominant ideological definition of him as a sex machine. While I agree very strongly with Mercer's remarks on what is 'outside' the image in motivating particular readings, what is 'inside' the image is clearly also important, and the two interact. I found it useful to consider Mapplethorpe's images of black men by asking whether the images represent something as obvious, natural, or just how things are, or whether the images had the potential to make us question what is natural and 'given'. I (and many of the students who discussed with me in seminars dealing with Mercer's essays on Mapplethorpe) felt that many of the nudes simply belonged to a fairly familiar objectification of the body (of the male or female, black or white) in the name of 'aesthetics', and really were not very disruptive of sexuality, culture or anything else. *Man in a polyester suit*, however, is a different matter, and it would be more difficult for a spectator to look at the image, simply shrug and say that 'that's how things are anyway'.

Vivien Ng, comparing Mercer's later views with those of Audre Lord on pornography, follows Lorde in arguing that pornography 'emphasizes sensation without feeling'. She therefore concludes that Mapplethorpe's images are racist and pornographic. She also cites Richard Fung's analysis of Asian men in pornographic films, where they are presented as anuses, as passive, and lacking the penis, therefore lacking sexuality. In pornography, writes Ng, anti-racism has had little impact.[56] There is a problem with Ng's argument about feeling and sensation though. Can a photograph represent feelings? How would it do this? Is the photograph a staged performance or 'genuine' feeling? In any case are the feelings *in* the photograph or generated in (some?) spectators when they view the image? Important to Mercer's revision of his arguments was precisely the fact that spectators are situated in complex configurations of gender, sexuality, class and 'race', and thus photoraphs can be read differently by different people, and also their meanings can change when viewed at different times and in different contexts.

In comparing Fani-Kayode's work with Mapplethorpe's, Mercer perceptively writes:

> In place of the sharply defined subject/object dichotomies we
> encounter in the scopophilic force exerted by the gaze in the work of
> Robert Mapplethorpe, in which the black body is fetishised to ward

off the threat of the ego's loss of control, in Fani-Kayode's phantasia
the viewer's look is cruised, caressed and seduced in the masquerade
by which the protection of the gods is requested.[57]

I agree with his point here, especially concerning the formal qualities of
Mapplethorpe's work which operate more clearly to objectify his mod-
els, but I would argue there are traces of fetishism and a reworking of
notions of fetishism in Fani-Kayode's and Hirst's work. However this
is not fetishism as defined by European capitalists and explorers.
Pleasurable mechanisms of fetishism can also be used as means by which
a spectator is drawn in to engage with the work, and then led further to
encounter unfamiliar questions. As Isaac Julien puts it in relation to the
'popular' feel of his film *Diary of a Young Soul Rebel* (1991): 'I don't
believe audiences really want to hear what I'm saying [so] One has to
work within and against the grain of fetishism to draw them to hear ques-
tions that they might not want to hear.'[58] And perhaps Mercer is right in
arguing that fetishism is not destined to be always a repressive mecha-
nism of power, sexuality and formation of identity. In other contexts, and
consciously used by other subjects, perhaps fetishism can be a powerful
source of creativity and cultural interrogation. Fetishism in its various
forms in capitalist society based on oppression and repression is con-
cerned with lack and objectification – but need it always be so?

AJAMU

Ajamu's photographs in his first major exhibition, *Black Bodyscapes*
(1994) included portraits, self-portraits and body studies of black males.
One reviewer remarked that Ajamu uses the body 'as a site for various
playful excursions . . . A body builder in a bra, a lace gloved first around
an erect penis, a man in lingeries. Others are simpler studies of body
parts, often embellished with the notion of gender construction and
transgendering and point to a hybridity that is possible with queer iden-
tity.'[59] Ajamu's use of black and white photography results in striking
images where tonal contrasts are clearly articulated and the body,
face and body parts stand out against plain backgrounds. (plate 18)
Sometimes the men wear women's clothing, jewellery or wigs, as in the
example illustrated where the model wears long black lace gloves,
emphasizing his naked body and contrasting with his skin. In another
image, the central part of a man's body is shown, slightly turning towards
the camera, as he takes off a skimpy pair of women's pants which still

just cover the tip of his penis. The viewers is teased in a playful and erotic way by this performance staged for the camera. One of the images shows a black man's lips, almost filling the whole image. This image reminded me of some comments by Kobena Mercer about Isaac Julien's film *Looking for Langston* (1989). In the film, Beauty, a man desired by both black and white lovers, is eroticized by the camera and his desirability is heightened by the contest of 'looks' of the black and white men over the object of their desire. Mercer argues that here Julien transgresses the hegemonic fetishism of Mapplethorpe's representations of black men, by proposing a different kind of transgresssive fetishism which emphasizes the very thing that dominant fetishism of black people tries to repress. Instead of turning the black man into a beautiful formal object, Julien emphasizes the 'thick lips' of the black man to reposition him as a person who exists, as a subject, not as an object constructed solely by another's gaze:

> It is here that the aesthetic trope of racial fetishism found in Mapplethorpe's photography makes a subversive return in close-up sequences which lovingly linger on the sensous mouth of the actor portraying "Beauty", with the rest of his face cast in shadow. As in Mapplethorpe's text, the strong emphasis on chiaroscuro lighting invests the fetishised fragment with a powerful erotogenic residue. The "thick lips" of the Negro are hyper-calorised as the iconic emblem of Beauty's impossible desirability. In other words, Julien takes the artistic risk of replicating the racial stereotype of the "thick lipped Negro" precisely to reposition the Black subject as subject, and not object, of the look; to reinscribe the Black subject as the agent, and not the alienated other, of representation: and to represent the Black man who wants (to look at) another Black man.[60]

Some of Ajamu's photographs can be read in a similar way. Ajamu's photographs have a powerful sense of the staged, the masquerade and the performance. The camera is looked at, flirted with and emphasized as a means to voyeuristic pleasure. The familiar concept of male spectatorship is played with and subverted at the same time, as the theoretical male spectator is in this case likely to be an actual male spectator, but perhaps also invited to position himself as feminized as he looks at desirable images of same-sex eroticism. Or is the person being photographed playing with the feminized position by dressing in items of women's clothing and troubling notions of masculinity?

Previously Ajamu's models were close friends or ex-lovers but this became problematic because of confidentiality, privacy and personal boundaries. In the last few years the photographer has employed models who were mainly drug pushers, or rent boys located through cards in phone boxes – men who needed to raise money quickly. Ajamu tries to create an equal relationship with his models by discussing their fantasies and experiences, and by participating in the mood of eroticism. He does not wish to remain a detached spectator or voyeur.

> I have to find the "model" sexually attractive and while I am working, both of us have to be nude, on one level this breaks down the power imbalance between photographer and "model" but also that sexual tension/atmosphere (I also tend to work late at night into the early hours with porn being shown in the studio) makes the session more conducive for me to create.
>
> The pictures that turn me on are the ones that I think have worked regardless of whether it is a.male body or a female body. I have also wanted to a large extent to create sexually charged images or erotic images that turns on the spectator regardless of his/her sexual orientation or gender.
>
> I dictate the sessions to a large extent but if the "model" has a particular fantasy or sexual experience that I don't know much about then together we discuss how to translate those experiences on to film.[61]

Recent writings on performance and masquerade are relevant to Ajamu's work, but we need to take care in applying them to an analysis of the images. Performance art has been seen as particularly suitable to the expression of diasporic identities, since it represents being as a process, 'the self as contingently and performatively produced', rather than the expression of a pre-existing formed identity. Performance art also challenges the commodification of art, since it cannot readily be sold on the market. Real face-to-face performance, writes Paul Gilroy, challenges the pseudo-performances of identities which sell commodities to us.[62] The evolution of performance art from the early 1970s was linked to questions of the body, cultural taboo and social issues.[63] Ajamu's work, therefore, can usefully be seen as traces of performance for the camera, the photographer and the spectator, and represents an invitation 'to be looked at'. Narcissism and fetishism are strongly implicated in the works, though these drives are presented not as oppressive and objectifying, but

as enjoyable performances by subjects conscious of their own pleasures.

The erotic nature of the works is heightened by the fetishistic possibilities of the still photograph as discussed by the film critic and theorist Christian Metz. Metz argues that the still photograph is more suited to becoming a fetish than the film, though both can represent fetishism. The viewer can possess the photograph as an object, the trace of something which no longer exists – a dead person, a moment, a former lover – and look lovingly at it for as long as s/he wants. The film seen in the cinema can represent moments of fetishistic voyeurism in the close-up, in particular, but generally the viewer is not in control of the filmic experience; it is the film and its viewing space and time which control the experience of the viewer. The photograph's preservation of indexical traces of what is represented in the image also heightens its fetishistic possibilities of presence/absence, possession/loss. In a rather difficult passage on striptease and fetishism, Metz states that the social institution of striptease is at once regressive and pathological, *and* progressive: 'a collective nosography [symptomatic description of disease] and ... at the same time, a progressive process of framing/deframing – pieces of clothing or various other objects are absolutely necessary for the restoration of sexual power. Without them nothing can happen.'[64] In Ajamu's work we sometimes see underclothes – mainly women's – used as a striptease for the camera, but in this case the relations of power, voyeurism and clothing of the 'normal' heterosexual striptease are troubled. There is also space for the identification of the viewer with the models as embodied subjects, rather than simply identification with them as objects of the male look or with the male looking. Often Ajamu's models, and he himself, look directly at the camera, working against mechanisms of visual objectification.

The male striptease is a highly fetishistic performance of masculinity for a (usually) female audience. It reveals and conceals, oscillating between undermining and restoring the phallic power of social and sexual masculinity. The final strip parodies the shock of the young male child seeking his mother's 'castration', as the female audience is treated to a view of the male genitals and laugh and shout at their own 'lack' and the others' possession of the phallus. In the recent highly successful film *The Full Monty* (1997) the final scene shows a group of unemployed men performing a one night only full striptease to a hall packed with (mainly) women. Suffering from lack of money, unemployment, problems with access to children from broken relationships, impotence and general lack of social power and self-esteem, the men end the film

in what is, on balance, a positive note showing the audience and the spectator in the cinema that they still 'have it'. (The film ends, however, in a frozen moment just as the men take their hats away from their genitals to the tune of Tom Jones singing 'You can leave your hat on').It is significant that one of the group members overcomes his problems of impotence towards the end of the film. The group of men contains two gays and a black man, who, in the filmic narrative, does not have the largest penis and is shown as concerned about what will happen when the audience realizes he doesn't live up to the stereotype of black sexuality. In this film, the characters' gay sexuality appears not to disturb their public image as men with penises – they strip at the end as heterosexuals.

This performance of masculinity in a mainstream and highly successful film is very interesting in the way it relates to economics, sexuality and power. Theories of performance and performativity have recently been very influential in analyses of sexuality, gender and culture. A recent exhibition, entitled *The Masculine Masquerade*, looked at theories and art practice in relation to both white and black masculinities. The main argument was that men act out not a pre-existing sexual identity, but a social performance of gender expectations, which is both oppressive to them and works to preserve the social status quo. Thus black men act out what is expected of them socially and culturally. Since these expectations are restrictive and oppressive in many cases, black men suffer by internalizing this performance which they constantly act out.[65]

These theories have recently been most influential in the writings of Judith Butler, who has developed them using earlier work by Joan Rivière, Michel Foucault and Luce Irigaray. Published in 1929 Joan Rivière's Freudian paper 'Womanliness as a masquerade', discusses how certain, mainly professional, women would act out an exaggerated masquerade of femininity in situations where their expertise and intelligence were perceived as a threat to men. Thus they unconsciously worked to divert retribution directed towards them by the threatened males.[66] Developing Rivière's arguments via Foucault and Irigaray, Butler argued that there was no difference between sex and gender, and that all femininity was a performance. As noted above, Butler distinguishes betweeen performance and what she terms performativity:

> performance as bounded "act" is distinguished from performativity
> insofar as the latter consists in a reiteration of norms which precede,

constrain, and exceed the performer and in that sense cannot be taken
as the fabrication of the performer's "will" or "choice"; further, what
is "performed" works to conceal, if not to disavow, what remains
opaque, unconscious, unperformable. The reduction of performativity
to performance would be a mistake.[67]

Thus performativity is deeply fetishistic, concealing, disavowing and yet
at the same time preserving gender power. There are a number of prob-
lems with Butler's views, which it is not necessary to discuss in detail
here.[68] Briefly, however, her view of all sex and gender as discourse does
not take account of how the 'norms' which are performed come into
being in the first place, why they and not other things are 'norms', in
whose interests they function, and the role of the state in defining fem-
ininity, masculinity, homosexuality, and disability. Consideration of the
material foundations of gender oppression thus disappear. Butler, in fact,
redefines 'the material' in an idealistic manner.[69] If all gender is perfor-
mance and performativity, then how can parody and mimicry present a
cutting edge against dominant ideologies of femininity, since the latter
are also performed? How can any performance or masquerade be con-
sciously subversive?[70] What about the performance of masculinity? Is it
the same for white men and black men, for queers and straights? I don't
think so. Class exploitation and forms of social oppression tend to dis-
appear in Butler's seemingly radical questioning of (female) sexual and
social identities. Mercer and Julien write, in another context, 'we ques-
tion whether it's possible to overcome this history of domination by
focussing all our attention on sexuality'.[71] Similarly in an interview
speaking about his film *Young Soul Rebels* compared to the films of
Spike Lee, Julien states 'being black isn't really good enough for me:I
want to know what your cultural politics are'.[72] The separation of black-
ness, sexuality, class and gender in theorizations of social oppression
and cultural representation is a mistaken strategy which usually ends
up with an inadequate assessment of why a particular configuration of
circumstances exist and how to engage critically with it in order to
change things.

I want to conclude this section by looking briefly at an example of
performance which was pleasurable, but also socially and culturally
critical and subversive. This is offered as a alternative example to the
type of performance and performativity refered to by Butler. This was
the Mr. Black/Asian Gay and Bisexual Londoner Contest, held in
November 1996 and won by Tshan. (plate 20) The event was organized

by the charity Black Liners, which was founded in 1989 to promote AIDS awareness among black gays, help those already infected with the HIV virus, and promote black gay pride in the face of both homophobia and racism. The evening began with a song and dance performance by a trio of black gay men dressed in fake furs, costume jewellery and high heels. After 'the girls' had finished, the contestants paraded to the crowd and were interviewed. In this mimic and parody of what are now considered to be demeaning women's beauty contests, these contestants' statements about their lives and ambitions were very different from the usual 'beauty contest' interviews. 'Hi, I'm Andrew. What's the hardest thing about being black and gay? Well my family are Muslim so coming out was very hard.'[73] Lorne told the crowd to loud applause: 'The hardest part of being black and gay is not being able to speak to my family – but I'm living my life and just getting on with it.' The fun of the evening was linked to serious issues. After the winner was crowned with a tiara and presented with a bouquet of flowers, the contestants all returned to the stage to dance in their designer briefs. However one of the contestants refused to go further, saying 'I'm not taking my clothes off. A Christmas present is much better when it's wrapped.'

This public performance and masquerade parodies Miss World contests and erotic dance shows, and enables black gay men to subvert the

plate 20 *Kippa Matthews, 'Tshan', winner of the Mr Black and Asian gay and bisexual Londoner contest, 21 November 1996, colour photograph. Copyright Kippa Matthews.*

objectification involved in such commercial and commodifying spectacles. By dressing in women's clothing on occasions like this, gay men also confront and defy definitions of femininity as inferior and shunned by men as a threat. Black masculinity is redefined and the stereotype of the macho male is undercut. It is also worth remembering that the queens at the centre of the famous Stonewall riots so important to the modern gay liberation movement were all black or Latino.[74] Discourses of sexuality, 'race' and gender may position us and make us think that it is natural to lead our lives in certain ways and not others. But there are many examples of those of us who seek to re-write these discourses individually, or better still, collectively.

COMMODITY FETISHISM

The fetishism of commodities, as theorized by Marx in the first volume of *Capital*, explains how, under capitalist property relations, commodities are produced for exchange on the market. While most commodities are objects, not all are. Labour power can be a commodity, as can the body. Commodities embody use value and exchange value, which is realized when the commodity is exchanged against money in the marketplace. Money is the commodity through which other incommensurable commodities are exchanged. In this way, capitalism makes social relations of production and consumption appear to be relationships between things, and therefore objectified. Marx explains what goes on by using the example of the way light reflected by an object falls on the eye. The object appears to be something separate, but in fact there is a physical link between the object, the light and the eye. In comparison to this, there is no physical relation between the commodity form and the physical nature of the commodity. Thus a photographic print, for example, seems to be a discrete object, existing on its own. However it is not, because it is a product of a physical link between the object photographed and the light falling on the exposed film. The commodity, on the other hand, appears as as an autonomous object isolated from any physical and social relations. We do not know the real social meaning of the commodity and how it got to be what it is.

> In the same way, the impression made by a thing on the optic nerve
> is perceived not as a subjective excitation of that nerve but as the
> objective form of a thing outside the eye. In the act of seeing, of
> course, light is really transmitted from one thing, the external object,

to another thing, the eye. It is a physical relation between physical things. As against this, the commodity-form, and the value relation of the products of labour within which it appears, have absolutely no connection with the physical nature of the commodity and the material [*dinglich*] relations arising out of this. It is nothing but the definite social relation between men themselves which assumes here, for them, the fantastic form of a relation between things. In order, therefore, to find an analogy we must take flight into the misty realms of religion. There the products of the human brain appear as autonomous figures endowed with a life of their own, which enter into relations both with each other and with the human race. So it is in the world of commodities with the products of men's hands. I call this the fetishism which attaches itself to the products of labour as soon as they are produced as commodities, and is therefore insepara-ble from the production of commodities.[75]

Thus it is not the object itself and its material properties which make it a commodity but the social relations within which it is produced. The possession of the commodity is believed to empower its owner, who in possessing the object can possess social power. Marx also argues that under capitalism production creates its own consumers, its own sub-jects, who desire the object.'Production not only supplies the want with material, but supplies the material with a want . . . The object of art, as well as any other product, creates an artistic and beauty-enjoying pub-lic. Production thus produces not only an object for the individual, but also an individual for the object.'[76]

The most obvious form in which production creates its own consum-ing subject is through advertizing. Photography is an important visual mode of address in advertisements, since it carries with it the lure of believable reality. The commodity may appear as autonomous in the market, but if we see someone wearing it in a photograph, it is placed within a constructed mis-en-scène where new social relations beckon to us. The black model in these scenarios is also commodified. (plate 21) The visibility of black models in some recent adverts has somewhat con-tradictory effects. While black models in predominantly 'white' envi-ronments such as mainstream fashion and beauty magazines can signify the acceptance of black beauty and function as role models for black consumers, the very function of the model is to work as a body on which to display clothes or make-up. With increasing incomes of some black households in the US, advertisers have recognised that subjects are out

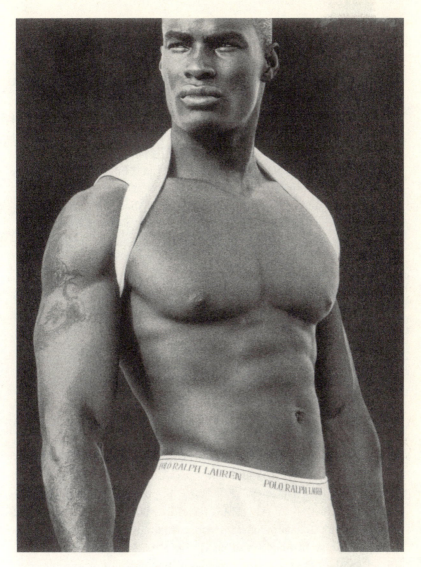

plate 21 *Advertisement for Polo Ralph Lauren, 1997, colour photograph.*

there to be turned into consumers.[77] However it is only a certain kind of blackness which is seen as fashionable. Djimon Hounsou, star of the film *Amistad*, was told while working as a model in Los Angeles that he should have his nose and lips surgically altered as they were thought unattractive to white customers.[78] Tyson Beckford, black male supermodel, who appears in this underwear advert (plate 21) is associated with a designer brand with sporting connotations and also is seen as 'strong' and 'masculine'.[79]

Tyson Beckford's muscular body is emphasized against the white underpants and vest, which is pulled back behind his neck in a taught and restraining position with connotations of bondage. However he appears too strong to be restrained. His arms are tatooed, suggesting toughness and resistance to pain, non-middle classness, and 'tribal' decorations. He looks proudly past the camera, disdaining eye contact. He is seen as untouchable, remote and to be looked up to. But are these qualities 'natural' or bestowed by the fetishistic commodity, the underpants? Could the consumer look just as good and his body fit the pants as well as Tyson Beckford? The advert plays with stereotypes of the well-endowed and athletic black male, whose 'threat' of phallic power is hidden by the pristine white underwear and the name of Ralph Lauren in a classic piece of fetishism offered to the male and female consumer alike. Both can buy the underpants, as gifts or for themselves, modelled not by Tyson Beckford as an individual but by 'a black man'. It is also possible that the photograph is intentionally addressed to gay consumers. Recent articles have argued that as gay households in America are relatively well-off, advertisers knowingly use what is termed 'gay window advertising'. This means that an advert addressed primarily to straight consumers allows a gay reading as well, for those who know how to look for it.[80]

Studies of Benetton's advertising campaigns and their use of black models have been critical. While posing as liberal humanists, Benetton market images which reinforce national and ethnic stereotypes, while their commercial productivity relies on trade agreements which discriminate against semi-colonial countries through the multi-fibre agreement. This agreement restricts 'foreign' imports into Europe, further exploiting workers in the 'Third World' who do poorly paid and unskilled work. Luciano Benetton said in 1988: 'We want also to analyse the opportunity of manufacturing in Far East Asia, because we have solved for the next future the problem of the competition coming from those countries and the best way to face the competition is to combine our technology with very low ... labour cost.'[81] Isaac Julien has commented that the commodification of race in such adverts as the Benetton campaigns, seems transgressive and even progressive, till you look more closely and see that difference is articulated in a transgressive way primarily for a white, not a black, audience.[82]

A development which I view with some concern, relates to recent work on advertising and the subject which sees consumerism as empowering. This position posits late capitalism as a site of playful self-

production, where the consumer can perform various masquerades, for example by buying different clothes or perfumes. 'This "parodic practice" is not the concealment of a "true self" but the invention of multiple selves.'[83] Thus consumerism is seen as a progressive exploration of multiple identities. The conclusion is that feminists should not condemn, but on the contrary must engage with, fashion and consumerism, since fashion and consumerism are discourses in which women must participate. This kind of argument vastly overstates the liberatory possibilities of buying commodities. What if we do not have the money for designer perfumes or clothes? Would we not be more likely to steal food rather than designer perfumes or fashions? Why do cultural theorists not argue that stealing and looting is a progressive construction of multiple subject identities? In any case many white consumers enjoy black culture and perhaps could be described as playfully taking on roles of black dancers, musicians and so on, but the white consumer does not therefore have to endure the effects of racism and immigration laws. I am not trying to argue here that buying commodities is 'bad', and in fact we have little choice to do otherwise. What I am saying is that I disagree with the overvaluation of consumerism as liberatory. This has much to do with a postmodernism rejection of Marxism and a materialist understanding of the world, arguments that production is now much less important than consumption, and a belief that subjectivities are constructed by discourses. For many people in semi-colonial countries, the personal liberation of consumerism is virtually a non-starter.

Desire and commodification come together in the fetishization of the black sportsman. Seen as naturally gifted, black athletes' long hours of training are ignored. In professional sports such as football, they are valuable commodities, sold on the market, while fans adore and worship the teams they play for, despite continuing evidence of racism in football. Keith Piper's video of 1990 *The Nation's Finest*, represents the bodies of black male and female athletes against emblems of nationalism, competition and imprisonment. A voice on the soundtrack invites us to consider whether the stadium is a place for black athletes to compete on an equal basis, or whether it is a holding pen, where black energies can be contained and restricted to 'suitable' activities.

In *Brazilian Kisses*, made in 1996, (plate 22) Nick Cornwall represents an emblem of desire dedicated to Pele, the famous Brazilian footballer. As the first black superstar of football, Pele was idolized by Cornwall as a boy. Pele's talents and his superstar image exist in a sporting world where financial interests make profits out of enjoyment and feelings of

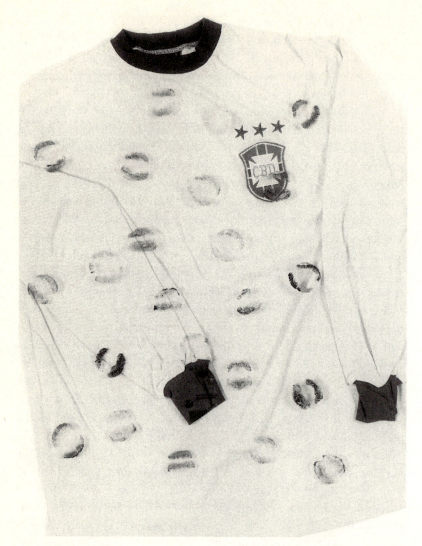

plate 22 *Nick Cornwall, Brazilian Kisses, 1996, mixed media, perspex, lipstick, football shirt, 83 × 65 cms. Private collection. Photograph Mike Simmons.*

loyalty on the part of the fans. Football shirts are notoriously costly, and are changed every season mainly to bring in more money from sales or publicize a new sponsor. Football shirts are seen as an important item of male (and occasionally female) fashion. Whereas children used to be picked by the team as mascots, walking out onto the pitch with their heroes before every match, now the families of the kids have to pay hundreds of pounds for this privilege. Talented players from Africa and the poorer countries of the former Eastern Block are lured to Europe, thus

weakening the infrastructure of the game in their home countries. These cherry-picked players do not usually experience difficulties from the immigration authorities in the richer countries. Pele's status as *the* great black player is symbolized by the framing of the Brazilian shirt almost as a holy icon, to be kissed by believers. Lipstick traces of Cornwall's lips on the perspex covering seem to hover just over the shirt. The process of putting on lipstick and kissing this inanimate object made the artist consider notions of masculinity. Without lipstick, there would be no indexical sign of his desire and admiration, whereas women wearing lipstick can leave traces of their physical contact on cigarettes, cups, faces or clothes. To put on lipstick to kiss is to take on a feminized position in relation to the object of desire, whereas footballers often kiss on the football field, without being seen as questioning heterosexual masculinity. In addition, the lip traces are of black lips (wearing a mixture of black and red lipstick), like Ajamu's photographs of lips, traditionally seen as alien to notions of white classical beauty.

RE-PRESENTING THE FETISH

As we have seen, European concepts of African fetish objects and fetishism arose when two different economic, social and religious value systems came into contact on the coast of West Africa in the period of the development of early European mercantile capitalism and the slave trade. The fetish was seen as an object endowed with magical powers to ward off evil spirits and bring destruction to enemies – the mark of primitive peoples who had not developed the civilized social and religious ideologies of Western Europe. This view of the fetish as a constructed object which wards off evil spirits and threats, which keeps the human subject whole and independent, was still present in Picasso's writings on so-called 'fetish objects' (examples of African art) in the twentieth century. In discussing how he was influenced by African art in the production of his famous work of 1907 *Les Demoiselles d'Avignon* (originally called *The philosophical brothel* or *The brothel of Avignon* now in the Museum of Modern Art, New York) Picasso later recounts his visit to an ethnographic museum in Paris, filled with examples of sculptures, masks, dolls and other art objects. However Picasso did not view them as art, but as powerful fetishes.

The masks weren't just like any other pieces of sculpture. Not at all.
They were magic things. But why weren't the Egyptian pieces or the

Chaldean? We hadn't realised it. Those were primitives, not magic
things. The Negro pieces were *intercesseurs*, mediators ... They were
against everything – against unknown, threatening spirits ... I
understood; I, too, am against everything. I too believe that everything
is unknown, that everything is an enemy! Everything! I understood
what the Negroes used their sculpture for ... The fetishes were ...
weapons. To help people avoid coming under the influence of spirits
again, to help them become independent. Spirits, the unconscious
(people still weren't talking about that very much), emotion – they're
all the same thing. I understood why I was a painter. All alone in that
awful museum, with masks, dolls made by the redskins, dusty
manikins. *Les Demoiselles d'Avignon* must have come to me that very
day, but not at all because of the forms; because it was my first
exorcism painting – yes absolutely![84]

It has been argued, convincingly I think, that Picasso appropriated the
notion of the fetish in his use of African masks in order to ward off his
own evil spirits which threatened him, among which were women's sex-
uality and fear of sexual contamination through contracting venereal dis-
ease.[85] In this sense his fears were to be calmed by fetishes which were
just as much sexual as anthropological. Women's sexuality as threat was
to be neutralized in this act of painting.

Picasso's interpretation of African masks and figures is not particu-
larly accurate, however. In recent catalogues accompanying exhibitions
of African art works, especially central African power figures, the func-
tions and meanings of the objects are described. Power figures (nkisi or
in the plural minkisi) are basically thought of as containers though
they usually represent male figures. Sometimes a large shell, gourd or
bag may also function as a container. In the central area of the figure's
body, a containing space is present. A special type of nkisi which is
dominated by nails or other metal objects hammered into it is called
nkondi. This is more intimidating as a power figure, but its main
function is to render oaths binding and thus is used in treaties, initia-
tion vows and so on. Other minkisi are used to promote healing and
sometimes contain medicines. They are also used to help detect thieves
or other wrongdoers, and mete out justice. The object is seen as an
empowered ritual artefact, controlled by human agency which has
constructed the object and makes use of its power for various cultural
and social functions. The figures are not constructed mainly to ward
off evil spirits, as European tradition would have it. Those in control

of the objects are called nganga, a class of what might be called priests.[86]

A number of artists have worked to reappropriate the notion of the fetish in their own practice, and to utilize it in a different way from white European artists such as Picasso. Maud Sulter, for example, in her exhibition *Syrcas* (1994–5), has produced photographic images which combine views of lakes and mountains in Austria or Switzerland, with examples of African masks, dolls and other artefacts. Also included in some of the images are photographs of black people such as Alexandre Dumas, the famous French novelist. Thus images of European culture are confronted with those of other cultures which have been marginalized and suppressed because of their difference. The exhibition seeks to activate memories of the holocaust of slavery and also that of fascism in the 1930s and 1940s. The picture postcard images of Austrian lakes and mountains are seen as the backdrop to the youth of Adolf Hitler and the source of ideas of 'blood and soil' ideologies of the pure Aryan nation. In her essay on Maud Sulter's works, Lubaina Himid remarks: 'In many ways these works operate as fetish objects with power beyond their materiality, a power that transports the viewer into many areas of discourse and emotion.'[87] Materials are assembled, their juxtaposed qualities generate potential power and knowledge, and the artist acts as a creator and facilitator for the release of this power, to heal, to judge or to commit oneself.

A previous exhibition of works by Sulter from 1993, *Fetish numbers 1–6*, displayed enlarged images of Mende masks, used in West African rituals preceding female circumcision (more accurately genital mutilation), together with metal plaques inscribed with the words Blood, Flesh, Incise, Sharp, Blunt, Rusty. This forces the viewer to consider the extent to which the fetish is bound up with power and fear, in this case of woman's sexuality. Unlike the woman's castration in Freudian theory, this castration actually takes place physically. While there are aspects of African cultures which revere women's power and fertility, genital mutilation is practised in twenty African countries as well as in parts of India, Asia and the Middle East. Sulter's clear feminist perspective on her African heritage makes her work a particularly focussed reading of African diasporan histories.

Some artworks dealing with notions of fetishism include parts of the artist's own body such as hair. Hair is a particularly charged aspect of fetishism for black artists, since the nature of black hair was seen as one of the important criteria for placing black people low on the evolutionary

ladder of civilisation. In Maxine Walker's self portraits exhibited in *Self-Evident*, she poses for the camera with different hairstyles and wigs, including a planitum blonde one. How do we identify her and what role does her hair play in her social image?[88] Different hairstyles and wigs can also function as disguises and the appropriation of different identities. Walker's commitment is to blowing apart the notion of the stereotype, building on the work done in her earlier set of photographs entitled *Black Beauty*. As we look at Walker, we are forced to consider our expectations of black women and stereotypes of sexual and social identity as Walker performs various identities for the camera, from dreadlocked black woman to blonde (black) bombshell like Marilyn Monroe, icon of whiteness. More recently Joy Gregory's project *Blonde*, which consists of an exhibition and a website, investigates the reasons why non-Europeans go blonde. 'Their reasons for being blonde were both political and personal, ranging from the serious to the superficial.The main aim was a personality change, be it temporary or permanent . . .'[89] Visitors to Gregory's website (www.iniva.org/blonde) are invited to enter into a dialogue with contemporary and historical blondes, select items from the wig gallery, and try out a 'blonde' identity. The black blonde immediately signifies transgressive hybridity and rejection of 'the natural', as well as disturbing the usual ideological expectations of whiteness and blondeness.

Kobena Mercer has analysed the significance of hairstyles for black identity and self-respect in predominantly white societies. 'Caught on the cusp between self and society, nature and culture, the malleability of hair makes it a sensitive area of expression.'[90] Sonia Boyce's contributions to the *Fetishism* exhibition focussed on hair as sexual and racial fetish. Dreadlocks and plaited hairpieces are detatched from heads of individuals, isolated and presented in fetishistic ways. Boyce also constructed pouches made from nylon tights and filled with black hair, so wiry and strong that it bursts through and penetrates its covering. Although the visitors were not allowed to do so, the catalogue pointed out that these were intended as tactile objects, made to be handled.[91]

Hair clips and combs are some of the objects that appear in the photographer Joy Gregory's project *Objects of Beauty* (1995). These 'exquisite photographs', as they were described in a recent leaflet produced by the Museum of Lndon, are strangely isolated and surrealistic images in black and white, which represent things used by women to change their appearances – one false eyelash, a comb, a bustier (waist-length strapless bra), black stockings, high heeled and pointed toe shoes.

Accompanying some of these objects is a measuring tape stretched out along one side of the image, recalling the measuring grids used to classify black people in ethnographic photographs. Women have also been categorised and evaluated by their measurements, whether these relate to long legs, small waists, or big busts. The isolated objects hold our fascinated gaze, as we perceive them as fetish objects which stand for social relations which result in particular practices and industrially mass-produced devices being applied to the female body. The stockings and underclothes also relate to sexual fetishism in the Feudian explanation of the origins of fetishism in the sight of the mother's (castrated) genitals.[92]

One of the most consistent and impressive reappropriations of the notion of the fetish is to be found in the work of the African-American artist Renée Stout. It is with her work and a briefer discussion of reappropriated fetishism in works by British artists Tam Joseph and Karun Thakar that I want to conclude this chapter.

THE FETISH REAPPROPRIATED

Renée Stout's *Fetish no.2*, (1988) a life size cast of the artist herself, has been given cowrie shells for eyes, and her neck is hung with bundles of medicines. (plate 23) The monkey-hair headdress includes three beaded or feathered braid extensions. In the centre of the figure, similar to many nkisi nkondi, is a glass fronted box containing dried flowers, a postage stamp from Niger, and an old photo of a baby. Sometimes the contents of Stout's art works are not visible, and the pouches remain closed. Here however, the glass is used to recall water, or mirrors, which in the African figures are seen as points of contact with the spirit world, a passage between life and death. The contents of the box have a personal significance. The child refers to innocence and the ability to counteract evil as well as potential motherhood, the stamp to journeys to and from Africa so important in black history. Her own hair is enclosed in small balls stitched into the top of the head. The artist has emphasized the importance of hair to her, and she collects hair of her friends and family. Stout often works in her studio without clothes, which enhances the ritual quality of her work. She has, she says, gone beyond just making art. The viewer is positioned as a ritual observer or participant, as Stout empowers herself through creating and assembling the objects for her art. 'I was using my own figure to empower myself, to give myself the strength to deal with the things you have to deal with every day.'[93] The

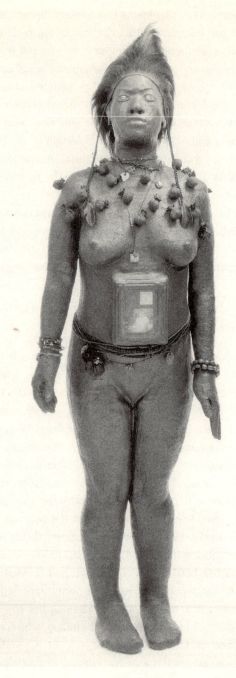

plate 23 *Renée Stout, Fetish no.2, 1988, mixed media, height 162.6 cms,*
Metropolitan Life Foundation Purchase Grant, Dallas Museum of Art. Copyright
Renée Stout.

creation of the black body as an object and source of power is obviously significant in the light of the physical violence perpetrated on the bodies of many African-Americans. However it is also significant that the female body is presented here not as an erotic sight for the male spectator, but as a female power figure. It is interesting to note that the minkisi figures rarely represent women, and that it is not usual for women to act as nganga, except when the client and concerns relating to the power figure are specifically about women. M.D.Harris has pointed out that this makes the figure very different from the traditional female nude as represented in much European art. However I feel he overstates his case when he argues that 'the sexualized female nude is seldom a subject in the work of African-American artists' and that much African art work venerates and empowers women.[94] It is understandable that Harris wants to distinguish African and European representations of women, but in his desire to do so, he gives the impression that Africa is some sort of paradise for women where oppression and objectification do not exist, and women are respected and powerful.[95] I think it is important to remember that female genital mutilation is practiced on African women in some countries in Africa, and also on some women in the African diaspora. Maud Sulter's *Fetish* exhibition is an appropriate reminder that a respect and love of African history and heritage need not be uncritical. Rather than extend a critical re-examination of fetishism and the nude female body to all African-American work, I would apply it in particular to Stout's work. It is important to note that she takes over the position of the nganga from the usually male priest, transforming herself into a female creator.

Stout takes objects and signs of past histories, personal and collective, and reassembles them, transmuting them into an artwork which functions on another level. Thus earth from graves of black Americans, hair, bones, and various herbs are wrapped or enclosed in some container in order for the artist/nganga to absorb but also control their power. Stout uses the materials swept up from the floor of her studio and saved to include in future works. In this way meanings can grow into others, and later works can resonate with elements of those produced earlier. This can be compared to the way in which artists like Keith Piper use computers to incorporate aspects of earlier works into an ongoing construction of histories and identities. The meanings of the materials contained in her works, for example in the stomach container, are 'almost like the answers to everything you'll ever need to know . . .'[96]

Stout is interested in her African heritage, and traces the journeys of

black Africans from West Africa and the Congo to the Caribbean and the
Southern States of America. As well as constructing imaginary histories,
letters and identities behind her art works, she reactivates the lives and
histories of actual dead black people, for example the vodun priestess
Marie Laveau of New Orleans (1794–1881), who during her life prac-
tised both vodun and Roman Catholicism. Laveau became a woman of
property as well as a famed priestess, and in the last years of her life
spent time helping prisoners who had been condemned to death.[97] Stout
visited Marie Laveau's tomb in New Orleans and recreated her own ver-
sion *Headstone for Marie Laveau*, (1990). The tombstone was covered
in dirt and rubbed until the surface was metallic, and painted to look
weathered. Bags of seeds, hair, and rusty washers and bottle tops were
put around the base of the stone, along with small clay heads. From the
top left broken corner of the tombstone twisting shapes like snakes, hair
or roots emerge. One of several meanings of the work was to suggest that
Marie Laveau could still reach up to people, even in death. People still
write write crosses on her tombstone in New Orleans to make requests
to her soul. Thus a powerful female figure and a black ancestor lives
on.[98] An important aspect of Stout's work is the revalidation of the power
of black art and the power of the woman in black history and culture.
Whereas Picasso misread the fetish and utilized it as a means of ward-
ing off the threat of women, and incorporated African art into European
modernism, Stout reappropriates her African-American and African her-
itage from the position of a black woman. Fetishism in Stout's work is
something which can empower the creative woman. African art inspires
her not to revitalize European art, but to create something quite origi-
nal, which is different from European and North American modernism
and at the same time very different from African art. The sense of power
and history in her work comes partly from her strong sense of personal,
family and community identity, and her interpretation of the role of
the artist as a ritual, empowering creative function. The importance of
women in preserving and constructing these identies is crucial. She reap-
propriates and transforms the so-called fetishes by parodying 'the world
of ethnography by creating objects reminscent of those originally enter-
ing the Western consciousness through ethnographic collection as a
result of conquest and colonization'.[99]

A different engagement with Euoropean notions of fetishism can be
seen in the painting *Native Girl with Fetish* (1985) by Tam Joseph (plate
24). The naked woman lies on a bed, flexing her buttocks in a ridicu-
lous pose like many female nudes in Western painting. She is in a hotel

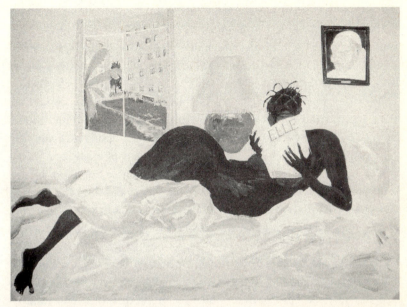

plate 24 *Tam Joseph, Native Girl with Fetish, ca 1985, acrylic on canvas, 123 × 164 cms, collection of Cartwright Hall, Bradford. Photo Mike Simmons.*

or a block of flats in modernist style, reading a copy of *Elle* magazine (suggestive of French colonialism?) and a picture of the Pope is on the wall. A table lamp suggests a desire for western consumerism, and the way in which Africa 'serves as a market for western junk'.[100] Hagiwara, discussing the painting, points out that the Pope's portrait is distributed widely in Francophone West Africa, where the Catholic Church competes with Islam for influence. Joseph's view is that fetishism is a western invention, not a product of African culture. His own experience of religious fetishism in Dominica at Christmas was of seeing children stand in line to kiss the cheeks of a white doll representing the baby Jesus.[101]

The black woman reads the magazine to model herself on the blonde version of white beauty which adorns the cover, not a black female model. Her African hairstyle is different from the long straight hair of the European model. Nail varnish has been painted on her finger and toe nails. The white Pope looks out of his picture frame in this scene which unites commodity, sexual and religious fetishism in a deeply ironic way. Its tone recalls the exhibition of 'European fetishes' by the French Surrealists in 1931, where photographs, identity cards(?), a statue of the Virgin and Child and a charity collecting box with a black child saying 'merci' were on show. This was part of an anti-colonial exhibit

devised to turn visitors away from the huge colonial exhibition taking
place at the time, and instead encourage them to visit a counter-exhibi-
tion entitled *La Vérité sur les Colonies*.[102] Joseph's painting is like a par-
ody of Gauguin's famous picture *Manao tupapau (The spectre watches
her)*, 1892, (Albright-Knox Art Gallery, Buffalo, New York), where a
young black woman lies naked on her bed frightened by the spirit of the
dead seen in the background (compare the image of the Pope in this
work). Joseph's style is sparse and lacking in tonal gradations and sub-
tle effects of exotic colours. In this case the sense of exotic and primi-
tive religion constructed by Gauguin's painting is replaced by the
fetishism of European Catholicism, no less irrational than the mysteri-
ous scene conjured up by Gauguin. The effects of Catholicism on Africa,
with its condemnation of birth control and the wearing of condoms in
countries where large numbers of people are infected with the AIDS
virus can be devastating to women in particular, who often have to look
after children when they themselves are sick. Fetishism, in this case, is
not an enjoyable facet of desire, but something distorting and mystify-
ing – a site where economics, ideology and the urge to possess meet as
we gaze on the body of the young black woman.

In *Untitled* (1998) by Karun Thakar various aspects of fetishism and
desire are also embodied.(plate 25) An antique wooden box from
Pakistan which is shaped like a European medieval reliquiary opens up
to reveal a variety of sensual delights. Cloves are studded around the
top of the box. Brightly coloured peacock feather decorations are placed
around the sides. These jewelled trinkets are used to decorate Indian
shrines. As the viewer bends forward to see inside the box and smell
the spices, this Orientalist and religious fetishism merges with more
secret and forbidden potential pleasures. Around the box are placed tiny
adverts cut from gay men's magazines' 'lonely hearts' pages. Men glimpse
one another at shopping centres, underground stations, airports, in
Church on Easter Sunday, or at a carol service. One reads:

Phoenix, London, 18.10.97
You:White guy, white T-shirt, jeans.
Me:Sikh guy, turban, too much eye contact but did not speak.
R.U.interested, I was. Let's meet, Box BC11406.

The box contains fragments of histories, experiences, potential relation-
ships which perhaps will never happen. In the box, secret or forbidden
relationships between people become relationships between things;

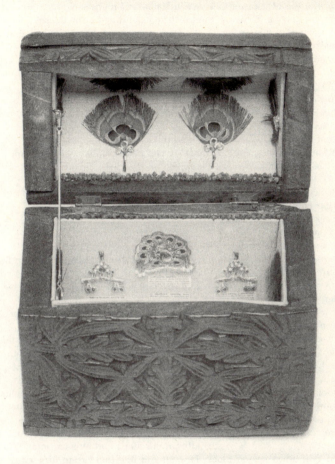

plate 25 *Karun Thakar, Untitled, 1998, wooden box with mixed media, jewels, newspaper cuttings, peacock feathers, cloves, length 34 cms. Collection of the artist. Photo Mike Simmons.*

beautiful, exotic and inanimate objects redolent of smell, sight and touch, but which take the place of life.

NOTES

1 T.Boffin and S.Gupta eds., *Ecstatic Antibodies. Resisting the AIDS Mythology*, (Rivers Oram Press, London, 1990).
2 R.Fani-Kayode, '*Traces of Ecstacy*', *Ten.8*, no. 28, (1992), pp 36-43.
3 A.Hirst, '*Acts of God*', in *Rotimi Fani-Kayode and Alex Hirst: Photographs*, (Autograph and Editions Revue Noire, London and Paris, 1996), p 33.
4 *Ecstatic Antibodies*, pp 83–4.
5 The phrase 'drag-queen of "Liberty"' reminded me of the cabaret perfor-

mance of the Mexican artiste Astrid Hadad, who poses as the Statue of Liberty, referring to her as 'the prostitute standing by the docks' and adds that a common joke in semi-colonial countries is 'Visit America before America visits you.'

6 Quoted by V.Ng, 'Race Matters', in A.Medhurst and S.R.Munt eds., Lesbian and Gay Studies: A critical introduction, (Cassell, London and Washington, 1997), p 225.

7 Fani-Kayode quoted in the excellent discussion of his photographs by Kobena Mercer in Rotimi Fani-Kayode and Alex Hirst: Photographs, p 119.

8 'Traces of Ecstacy', p 42.

9 Rotimi Fani-Kayode and Alex Hirst, p 69.

10 D.A.Bailey, 'Photographic Animateur.The photographs of Rotimi Fani-Kayode in relation to Black Photographic Practices', Third Text, Winter (1991), p 62.

11 Jean Loup Pivin, "A rooted elsewhere to be built like a spirituality", in Rotimi Fani-Kayode and Alex Hirst:Photographs, p15.

12 'Traces of Ecstacy', p 42.

13 Ibid., p 41.

14 M.Reeves and J.Hammond eds., Looking beyond the frame: Racism, Representation and Resistance, (Links publications, Oxford, 1989), p 50.

15 S.Gupta, 'Culture wars. Race and queer art', in P.Horne and R.Lewis eds., Outlooks: Lesbian and Gay Sexualities and Visual Cultures, (Routledge, London and New York, 1996), p 171.

16 See for example the text of the Black Handsworth Community Forum Newsletter, no.2, ca. 1995: 'The reader should be reminded that the acceptance of such a practice [homosexuality] in the black public, could have far reaching implications for the next generation. The immediate threat is that our children will become exposed to this activity to the point that it will not only be taught in education (i.e. infant and secondary schools), but exercised politically (i.e. gay rights overriding black rights to resources and development and socially in the form of sexual orientation). The overwhelming danger is that our next generation could become even more corrupt, than the present generation and the victim of the new stereotype (e.g. Rent Boy, sexually promiscuous and aids carriers). 'Thanks to SPYCE, Birmingham Black, Lesbian and Bisexual Group for a copy of the leaflet.

17 L.Icard, 'Black Gay Men and conflicting social identities: Sexual Orientation versus racial identity', Journal of Social work and Human Sexuality, vol.4, (1985-6), pp 83–93 and R.Staples, 'Homosexuality and the Black Male', in D.Morton ed., The Material Queer: A LesBiGay Cultural Studies Reader, (Westview Press, Boulder Colorado and Oxford, 1996), pp 229–235.

18 Mercer and Julien, 'Race, Sexual Politics and Black Masculinity: A dossier', in R.Chapman and J.Rutherford eds., Male Order:Unwrapping masculinity, (Lawrence and Wishart, London, 1988), p 107.

19 Quoted by M.Storr, 'The sexual reproduction of "race": Bisexuality, history and racialization', in BI Academic Intervention eds., The Bisexual Imaginary: Representation, Identity and Desire, (Cassell, London and Washington, 1997), p 85.

20 Ibid., p 80.

21 Ibid., p 79.

22 R.C.Bleys, The Geography of Perversion: Male-to-male sexual behaviour outside the West and the Ethnographic Imagination, 1750–1918, (Cassell, London and New York, 1996).

23 Ibid., p 11.
24 Ibid., pp 46,90.
25 Ibid., pp 191–2.
26 Ibid., pp 148–9.
27 Ibid., p 149.
28 Ibid., p 254.
29 Ibid., p 4.
30 S.Hall, '*The after-life of Frantz Fanon: Why Fanon? Why now? Why 'Black Skin, White Masks'?*', in A.Read ed., *The Fact of Blackness: Frantz Fanon and Visual Representation*, (ICA and Bay Press, Seattle and London, 1996), p 30.
31 Mercer, '*Decolonisation and Disappointment: Reading Fanon's Sexual Politics*', *The Fact of Blackness*, p 125.
32 I.Julien and C.McCabe, *Diary of a Young Soul Rebel*, (British Film Institute, London, 1991), p 128.
33 L.Gamman and M.Makinen, *Female Fetishism: A New Look*, (Lawrence and Wishart, London, 1994), chapter 1 "*Three types of Fetishism: a Question of Definition*" is a useful introduction.
34 From '*Fetishism*' (1927) in S.Freud, *On Sexuality: Three essays on the theory of sexuality and other works*, vol.7, (Penguin Freud Library, Harmondsworth, 1991), pp 354–5.
35 Ibid., p 353–4.
36 See the entry on homosexuality in E.Wright ed., *Feminism and Psychoanalysis: A Critical Dictionary*, (Blackwell, Oxford, 1992), p 159.
37 E.Grosz, '*Lesbian Fetishism?*', in E.Apter and W.Pietz eds., *Fetishism as Cultural Discourse*, (Cornell University Press, Ithaca and London, 1993), p 114.
38 Pietz, '*The problem of the fetish, 1*', *Res*, part 9 (1985), p 5. Pietz published parts two and three of his study in *Res*, part 13, (1987) and *Res*, part 16, (1988). A more recent condensation of his historical research is his essay '*Fetish*', chapter 15 in R.S.Nelson and R.Shiff eds., *Critical Terms for Art History*, (University of Chicago Press, Chicago, 1996).
39 McClintock, *Imperial Leather: Race, gender and sexuality in the colonial contest*, (Routledge, London and New York, 1995), p 230.
40 Ibid., p 184. McClintock's whole discussion of fetishism is fruitful, however she concludes 'fetishes can be any object under the sun'. p 185.
41 Ibid., p 67. For more discussion of fetishism and visual culture see L.Mulvey, *Fetishism and Curiosity*, (British Film Institute and Indiana University Press, Bloomington and Indianapolis, 1996) and the interesting catalogue edited by A.Shelton, *Fetishism: Visualising Power and Desire*, (South Bank Centre and Lund Humphries, London, 1995).
42 Quoted at the beginning of D.Clark, '*Commodity Lesbianism*', chapter 12 in H.Abelove, M.A.Barale, D.M.Halperin eds, *The Lesbian and Gay Studies Reader*, (Routledge, New York and London, 1993).
43 This is the title of section four, part one of the first volume of *Capital*, introduction by E.Mandel, (Pelican, Harmondsworth, 1976).
44 See for example K.Mercer, '*Imaging the black man's sex*', P.Holland, J.Spence and S.Watney eds, *Photography/Politics: Two*, (Photography Workshop/Comedia, 1986), pp 61–70, Mercer, '*Just looking for trouble: Robert Mapplethorpe and fantasies of race*', in L.Segal and M.McIntosh eds, *Sex Exposed: Sexuality and the Pornography Debate*, (Virago, London, 1992), pp 92–110, and an illustrated variant of this '*Looking for trouble*', chapter 24 in H.Abelove, M.A.Barale and D.M.Halperin eds, *The Lesbian and Gay Studies Reader*, (Routledge, New York and London, 1993). I will

be using this last essay for my discussion. A version of this essay is also published in Mercer's book *Welcome to the Jungle: New Positions in Black Cultural Studies*, (Routledge, London and New York, 1994), chapter 6, '*Reading racial fetishism: The photographs of Robert Mapplethorpe*'.

45 Illustrated p 370, *The Lesbian and Gay Studies Reader*. The (in)famous *Man in a polyester suit* is illustrated on p 352.

46 Mercer returned to many of the issues he raised about Mapplethorpe's work in other writings, e.g. '*Fear of a black penis*' in *Artforum*, April (1994), pp 80–81, and p 122.

47 *Make*, no 74, Feb/March (1997), p 6.

48 Ibid., p 7.

49 Mercer used strong language.'In Mapplethorpe's imagery the stench of racist stereotypes, rotting in the soil of a violent history, is sanitised and deodorised by the clinical precision of his authoritative, aestheticising master vision.' See '"*True Confessions": A discourse on images of black male sexuality*', in *Ten. 8, Black Experiences*, issue no 22, (1988), pp 5–6.

50 '*Looking for Trouble*', p 354.

51 The director of Cincinnati's Contemporary Art Center reported that unusually large numbers of black people visited Mapplethorpe's exhibition there and that based on his discussions with black visitors he surmised that Mapplethorpe 'glorified and gave great credibility to the black male – in a time when the black male was demeaned in society'. See S.Dubbin, *Arresting Images: Impolitic Art and Uncivil Actions*, (Routledge, London, 1994), p 345, note 60. This book has a useful discussion of the censorship debates around Mapplethorpe's work on pp 170–96. See also A.Sekula, '*The weight of commerce*', in *Ten. 8*, no 35, Winter (1989–90), p 55, who concludes that the censorship attack was linked to budget issues: 'This attempt to control the sphincters of government spending may well be a cover for the spendthrift impulses of conservatives themselves.'

52 Ibid., p 359. These attempts at censorship continue. Recently there was an attempt to remove books by Mapplethorpe from the library of the University of Central England, Birmingham, and when I visited my university library to research this chapter several of the relevant books were marked 'unavailable' in the computerized catalogue, having been removed. The Crown Prosecution Service announced on 30th September 1998 that it would not proceed with charges against the University of Central England, arising from the 'discovery' of Mapplethorpe images intended for inclusion in a thesis on art and pornography. Local MP and Government Minister Jeff Rooker said that police should be charged with 'wasting police time' after he borrowed the Mapplethorpe book in question from the House of Commons Library. See C.Dyer, '*CPS rules out obscenity charge against university*', *The Guardian*, 1 October 1998, p 8.

53 Ibid., p 359.

54 G.Celant, *Mapplethorpe*, (Hayward Gallery, London, 1992), p 51.

55 Gupta, '*Desire and black men*', *Ten.8*, no 22, (1988), p 19.

56 '*Race Matters*', pp 227–8.

57 *Rotimi Fani-Kayode and Alex Hirst: Photographs*, p 116.

58 I.Julien and C.McCabe, *Diary of a Young Soul Rebel*, (British Film Institute, London, 1991), p 138.

59 P.Ride, review of '*Black Bodyscapes*', *Creative Camera*, Oct-Nov. (1994), p 39. The exhibition was accompanied by a publication, *Black Bodyscapes – photographs by Ajamu*, with an essay by K.Mercer, (David.A.Bailey, London, 1994).

60 K.Mercer, '*Dark and Lovely: Notes on Black Gay Image-Making*', *Ten.8*, vol.2 no 1, Spring (1991), p 81.

61 Letter from Ajamu, 26 July 1998. Very many thanks to Ajamu for taking the time to reply to my questions about his work and working practices.

62 Gilroy in C.Ugwu ed., *Let's get it on: The Politics of Black Performance*, (Institute of Contemporary Arts, London and Bay Press, Seattle, 1995), p 24.

63 Ibid., p 160.

64 C.Metz, '*Photography and Fetish*', in C.Squiers ed., *The Critical Image: Essays on Contemporary Photography*, (Lawrence and Wishart, London, 1990), p 160.

65 A.Perchuk and H.Posner eds, *The Masculine Masquerade: Masculinity and Representation*, (MIT Press, Cambridge Mass. and London, 1995). See the useful essay by Harry Brod, "*Masculinity as Masquerade*".

66 See '*Womanliness as a masquerade*' in V.Burgin, J.Donald, C.Kaplan eds, *Formations of Fantasy*, (Routledge, London and New York, 1996), pp 35-44.

67 J.Butler, *Bodies that Matter: On the discursive limits of "sex"*, (Routledge, London and New York, 1993), p 234.

68 These are discussed in Chapter 4 '*How is the Personal Political?*' of my *Materializing art history*, (Berg, Oxford and New York, 1998) in relation to Claude Cahun's photographs.

69 See the excellent critiques by T.L.Ebert, '*(Untimely) critiques for a Red Feminism*', in M.Zavarzadeh, T.L.Ebert, D.Morton eds, *Post-Ality: Marxism and Postmodernism*, (Maisonneuve Press, Washington D.C. 1995), pp 113–149, and Ebert's book *Ludic Feminism and After: Postmodernism, Desire, and Labor in Late Capitalism*, (The University of Michigan Press, Ann Arbor, 1996). Also excellent for a critique of Butler, Foucault and discourse theory specifically relating to gays is R.Hennessy, '*Queer visibility in commodity culture*', chapter 6 in L.Nicholson and S.Seidman eds, *Social Postmodernism: Beyond Identity Politics*, (Cambridge University Press, Cambridge, 1995).

70 Butler says that the subject called 'queer' can take up or cite this term 'as the discursive basis for an opposition. This kind of citation will emerge as *theatrical* to the extent that it *mimes and renders hyperbolic* the discursive convention that it also *reverses.*' *Bodies that Matter: On the discursive limits of "sex"*, p 232. She argues that theatricality is part of contemporary queer politics but at the same time manages to write any notion of conscious agency out of these politics.

71 '*Race, sexual politics and black masculinity*', in R.Chapman and J.Rutherford eds, *Male Order: Unwrapping Masculinity*, p 107.

72 I.Julien and C.McCabe, *Diary of a young soul rebel*, p 130.

73 Vivek Chaudhary, '*Prejudice purged as black gays party with pride*', *The Guardian*, 23 November 1996.

74 A.Medhurst, 'Camp', in A.Medhurst and S.R.Munt eds, *Lesbian and Gay Studies*, p 286.

75 K.Marx, *Capital*, vol.1, p 165. Several writers on Marx's theory of commodity fetishism state that Marx refers to 'savage' and 'primitive' religions. This is not accurate as his point is about all religions. See for example L.Williams, who states 'He forthrightly accuses all under the spell of the commodity of being like savages', '*Fetishism and the visual pleasure of hard core: Marx, Freud and the "Money Shot"*', *Quarterly Review of Film and Video*, vol.11, (1989), p 29.

76 From 'Introduction to *A contribution to the Critique of Political Economy*", in M.Solomon ed., *Marxism and Art: Essays Classic and Contemporary*, (Harvester, Brighton, 1979), p 65.

77 H.Quick, '*Undercover Girls*', *The Guardian*, 22 March 1995, p 11.
78 A.Smith, '*They wanted me to lighten my skin, to get my nose and lips done . . .* ', *The Guardian*, 12 February 1998, p 8.
79 C.B.Arogundade, '*Black male on the catwalk*', *The Guardian*, 2 March 1998, pp 8–9, and J.G.Veneciano, '*Invisible Men: Race, Representation and Exhibition(ism)*', *Afterimage*, Sept-Oct. (1995), p 13. Many thanks to my student Andrew Hay for bringing this image to my attention. For a useful general discussion of commodification and black men see K.Piper, '*A contest of markets. Notes on the selling of black masculinity*', in *Step into the Arena: Notes on Black Masculinity and the contest of Territory*, (Rochdale Art Gallery, Rochdale, no date), pp 20–3.
80 D.Clark, '*Commodity Lesbianism*', in Abelove, Barale, Halperin eds, *The Lesbian and Gay Studies Reader*, pp 189–90. See also S.Maynard, '*What colour is your underwear? Class, whiteness and homoerotic advertising*', *Border/Lines*, 32, (1994), pp 4–9, thanks to Richard Dyer for a copy of this.
81 A.Ramamurthy, '*Constructions of illusion: Photography and commodity culture*', in L.Wells ed., *Photography: A Critical Introduction*, (Routledge, London and New York, 1997), p 192. See also L.Back and V.Quaade, '*Dream Utopias, Nightmare Realities: Imaging Race and Culture within the World of Benetton Advertising*', *Third Text*, no. 22, Spring, (1993), pp 65–80. Recent Benetton adverts include photographs of Down's syndrome children, see John O'Reilly, '*Advertising or exploitation?*', *The Guardian*, Media Review, 21 September 1998, pp 4–5.
82 *Diary of a Young Soul Rebel*, p 128.
83 A.Partington, '*Perfume: pleasure, packaging and postmodernity*', in P.Kirkham ed, *The Gendered Object*, (Manchester University Press, Manchester, 1996), p 215.
84 J.Richardson, *A Life of Picasso 1907–1917:The Painter of Modern Life*, vol.2, (Pimlico, London, 1996), p 24.
85 See for example A.Chave, '*New encounters with Les Demoiselles d'Avignon:* Gender, Race and the origins of Cubism', *Art Bulletin*, 76, Dec. (1994), pp 596–611.
86 See J.Mack, '*Fetish? Magic figures in central Africa*', in A.Shelton ed., *Fetishism: Visualising power and desire*, (South Bank Centre, London, 1995), pp 53–66, and W.MacGaffey, '*The eyes of understanding: Kongo Minkisi*', in *Astonishment and Power*, (Smithsonian Institution, Washington, 1993), pp 21–106.
87 M.Sulter, *Syrcas*, (Wrexham Library Arts Centre, Wrexham, 1994), p 31.
88 *Self-Evident*, (Ikon Gallery, Birmingham, 1995).
89 Quote from inIVA's Agenda for 09/98–12/98, month 11.
90 Mercer, '*Black Hair/Style Politics*', in R.Ferguson, M.Gever, T.T.Minh-ha and C.West eds, *Out There: Marginalization and Contemporary Cultures*, (MIT Press, Cambridge and London, 1990). This essay is also reprinted in Mercer's collected essays *Welcome to the Jungle: New Positions in Black Cultural Studies*, (Routledge, London and New York, 1994).
91 *Fetishism: Visualizing power and desire*, p 115. For more on black culture and hair see L.Jones, *Bulletproof Diva: Tales of Race, Sex and Hair*, Penguin Books, New York, 1995), R.D.G.Kelley, '*Nap Time: Historicizing the Afro*', *Fashion Theory*, vol.1 issue 4, pp 339–351, and M.Craig, '*The Decline and Fall of the Conk; or, How to Read a Process*', ibid., pp 399–419. Grant McCracken's *Big Hair: A Journey into the transformation of the Self*, (Indigo, London, 1997) does not deal with Black hair at all as far as I could see. In Autumn 1998 Bisi Silva of the Fourth Dial Art Project, organized two Hair Daze in London and Bristol on '*The Cultural Politics of*

Black Hair', including poetry, talks, films and discussions with artists including Sonia Boyce. Thanks to Eddie Chambers for information about these events.

92 For illustrations see *Joy Gregory. Monograph*, (Autograph, London, no date, 1996?).

93 M.D.Harris, '*Resonance, Transformation and Rhyme: The art of Renée Stout*', in *Astonishment and Power*, p 132.

94 M.D.Harris, '*Ritual Bodies – Sexual Bodies: The role and presentation of the body in African-American Art*', *Third Text*, no.12, Autumn (1990), pp 83–87.

95 He claims that misunderstandings and criticisms are the result of 'feminists unfamiliar with the cultural context', ibid., p 87.

96 Harris, "*Resonance, transformation and rhyme*", p 149.

97 M.Harris, M.Levitt, R.Furman, *The Black Book*, (Random House, New York, 1974), pp 140–142.

98 For an illustration see '*Resonance, transformation and rhyme*', p 128.

99 Ibid, p 137.

100 H.Hagiwara, '*Here history unfolds*', in *Tam Joseph: This is History*, (Eddie Chambers, Bristol, 1998), no page numbers.

101 Ibid.

102 See *Fetishism: Visualizing Power and Desire*, p 68.

CHAPTER 5

THE POSTCOLONIAL AND VISUAL CULTURE

I have already discussed the notion of the postmodern and its relation to the work of black artists. Closely linked to the notion of the postmodern is that of the postcolonial. So-called postcolonial criticism, although claiming to decentre Eurocentric theory and history, has been heavily influenced by European theorists of poststructuralism and postmodernism. Foucault, Derrida, Baudrillard, and Lacan are among those who have influenced such postcolonial critics as Stuart Hall, Homi K.Bhabha, Gayatri Spivak and Edward Said. It may be tempting at first sight to turn to the theoretical writings of postcolonial critics as explanatory texts with which to approach works produced by black artists in the later twentieth century. These artists are usually members of families whose countries of origin were previously colonized by Britain or other imperialist powers, and now live in a Britain which has apparently come to terms with the loss of most of its former empire. The work of young black British artists has seemingly decentered the formalist modernism created for the most part by European and North American artists which held sway in the art world until only a generation ago. The rise of postcolonial criticism to a fashionably prominent place in the academic world has indeed been paralleled by the rise to prominence of a number of younger black British artists. Yet, while postcolonial criticism and the works of black artists have many interests in common, there is no straightforward coming together of the two. While they sometimes seem to converge, they are not identical, either in theory or in practice. I would argue that while postcolonial criticism can bring a valuable anti-colonial perspective to the study of history and culture, it would be wrong to completely replace previous approaches to history and culture as irredeemably polluted with colonial values. For example, the importance of economic factors in underpinning cultural developments, and the significance of individual and collective subjects continue, in my view, to be important for the understanding, and making,

of contemporary culture. As we shall see, though, these issues are not seen as central by a number of important postcolonial critics. In this chapter, I want to discuss some aspects of the work of key postcolonial critics, relating their theories to a number of recent art works.

WHAT IS THE POSTCOLONIAL?

Obviously in the space I have available, I am unable to give a detailed history and analysis of the use of the term 'postcolonial' or of the varieties of postcolonial criticism.[1] Throughout this short introduction, I hope the reader will bear in mind that I am focussing on the main characteristics of postcolonial critical thought, rather than bringing out the diversity of approaches within it. Postcolonial criticism seeks to overturn the Eurocentric emphasis of colonial views of history which marginalized colonized countries and peoples, views which constructed them as the other half of binary oppositions, for example white/black,civilized/native, here/there. What was once marginalized has now been brought to the very centre of European academic discourse, as the postcolonial critic decenters the master narratives of Enlightenment thought which previously held sway over intellectuals, creative writers and academics. Postcolonial theory is seen as largely the creation of scholars and writers who have migrated or been exiled from countries which, post-empire, acquired the description 'Third World countries', and who have now become acclaimed academics in North America or Britain, rather than in their (or their families') countries of origin. ('Third World' was previously used to designate states which, politically, sided with neither the First World 'Western bloc' countries led by the United States nor the Second World 'socialist bloc' countries led by Soviet Russia. It later came to describe 'under-developed' or, later, 'developing' countries.)

I want to look briefly at some examples of postcolonial critics and their writings before going on to examine some problems with the term 'postcolonial' itself and the particular approaches of these critics.

EDWARD SAID

Said's critical output is considerable, so I will focus mainly on his book *Orientalism*, published in 1978. Said's monumental deconstruction of the notion of orientalism was important for many writers and artists who were seeking critiques of Eurocentric representations of Muslim and other Middle Eastern peoples. This hugely influential work set out to

show how European discourses of Orientalism constructed their object of study in order to dominate the countries and peoples seen as oriental. Heavily influenced by Foucault and by Nietzsche, Said argued that language constructed its own truth, and that there was no real truth outside it. A view of the Orient as despotic, sensual and dirty 'was such a system of truths, truths in Nietzsche's sense of the word'. The Orient that appeared in orientalism was a system of representations which were political. Said then remarked 'It is therefore correct that every European in what he could say about the Orient, was consequently a racist, an imperialist, and almost totally ethnocentric.' He concluded: 'Orientalism is fundamentally a political doctrine.'[2] Here, Said is conflating the cultural and the political in a way I think mistaken. The notion of ideology is left out, so that there is nothing between culture and politics. While it is clear that his book exposes the racism and ideological blindness of many writers on the Middle East, he makes no distinction between politicians, poets, generals, translators, or between any different political positions. For Said, Karl Marx is an orientalist and so is Disraeli. In Said's book everyone is either an Oriental or an Occidental. His tendency to over-politicize culture is rather surprising from someone who has a dismissive view of Marxism as reductionist (i.e. it reduces art, religion and other culture phenomena to reflections of economic struggles) and is 'extraordinarily insufficient'.[3] Said rejects the need for any totalizing theory, seeing this as Eurocentric. 'I don't see the need for a master discourse or a theorisation of the whole.'[4] It is arguable, though, that his critique of orientalism is itself such a totalizing theory, heavily influenced by European thinkers such as Foucault. As a teacher, Said does not believe in giving his students a theory through which they will be enabled to understand cultural productions or real-life situations while not under his guidance: 'I've always thought of my teaching . . . as actually performing acts of analysis or reading or interpretation, rather than providing students with methodologies that they can go out and apply to situations.' Such is his aversion to so-called totalizing theories that he rejects 'encoding insights in some way that can make them useful tools later on, I just don't seem to be able to do that'.[5] This is in line with much poststructuralist and postmodernist thought. Perhaps improvements could be made on this approach as a teaching practice, since Said the lecturer offers personal insights and interpretations of cultural works to students, without allowing them to reciprocate unless they are as gifted and insightful as he is himself.

Said's rejection of Marxism leads him to ignore, more or less, the role

of capitalism and imperialism in the construction of orientalism. He rejects the Marxist definition of imperialism, which sees it as a later nineteenth century development impelled by economic forces, claiming that imperialism as conquest started at least one hundred and fifty years earlier. (In fact, it could be argued that the economic plunder of other countries by European powers began over three hundred and fifty years before, with the Spanish conquests in the Caribbean and, later, Mexico and Peru). This means that Said misses the importance of imperialism in diffusing racist ideas among sections of the lower classes during the later nineteenth and earlier twentieth centuries. This is how an ideology, rather than a politics, of racism came to be present in much European culture. Without any understanding of the reasons for this, and so of possible solutions, Said describes how 'elements of a society we have long considered to be progressive' were out-and-out racists:

> I speak here of advanced writers and artists, of the working class, and of women, groups whose imperialist fervour increased in intensity and perfervid enthusiasm for the acquisition of and sheer bloodthirsty dominance over innumerable 'niggers', bog dwellers, babus, and wogs, as the competition between various European and American powers also increased . . . [6]

There is no notion of contradiction or dialectics here, or how class struggle, ideology and consciousness are riven with internal tensions. No Europeans can oppose colonialism or orientalism, argues Said, because they are produced by these discourses and cannot stand outside them. These arguments will be familiar by now. However in fairness to Said, it must be pointed out that as a radical Palestinian, he has courageously taken a public stand against both Zionism and the Arafat leadership, which he believes has misled the struggles for self-determination and national rights of the Palestinian people. This has been dangerous for him, but he has used his position as a world-famous intellectual to draw attention to matters outside the academy; the same cannot be readily said of many other prominent postcolonial critics. Many postcolonial critics overemphasize the importance of cultural criticism, seeing culture as political, and this leads almost all of them to neglect political concerns. In this sense, they are very different from Frantz Fanon, a major influence on much postcolonial thought, as we shall see later. Although Said has not proved to be the political force that Fanon was, it is important to note that he has been faithful to his own view of the 'politics of culture'.

In an excellent discussion of Said and other postcolonial critics, Aijaz
Ahmad, Senior Fellow at Nehru Memorial Museum and Library, New
Delhi, points out that Said sees the most impressive postcolonial critics
as those who work in the Western centres, addressing the metropolis
and decentering Western power and knowledge. Perhaps it would be
more radical to work in the Middle East or in Asia, helping to train oth-
ers? To be fair, Said is an exile who would not be able to return to
Palestine in current circumstances. However Said conflates immigration
and exile. We should remember that most postcolonial critics are free
to choose where they want to work.[7] Methodologically, Said emphasizes
race (not 'race') over class and gender, stating: 'I have always felt that
the problem of emphasis and relative importance took precedence over
the need to establish one's feminist credentials.' Ahmad notes the con-
temptuous dismissal of gender issues, as imperialism is collapsed into
a 'racial sense'.[8] In fact *Orientalism* is a text where attention to women
is minimal, and it is noticeable that it is mainly female postcolonial
scholars who pay any attention to gender issues.

Gayatri Spivak, in her famous essay on texts concerning widow- burning
in India, asks 'Can the subaltern speak?', and concludes that the answer
is No; the subaltern (oppressed subject) cannot speak. There is no voice
of the colonially oppressed, especially the woman's, which can be heard
from the archival texts which have been provided by the colonizing
observers.[9] It has been pointed out that the disparaging of nationalist dis-
courses (in which the subaltern *does* speak), is accompanied by the ele-
vation of the postcolonial woman intellectual, 'for it is she who must plot
a story' by using deconstructive methods (learned from European sources)
to read texts 'against the grain', thus articulating a critique of imperial-
ism. Spivak argues that no critique of imperialism can turn the 'Other'
into a self, because the discourse of imperialism always positions the col-
onized as 'Other'.[10] Much more useful and understandable attempts to dis-
cuss issues of the self, finding a voice, being represented as 'Other' and
going beyond discourses which marginalize and oppress black women can
be found in the writings of Himani Bannerji.[11] Her work is free from the
difficult jargon of much postcolonial writing. Using accessible language,
she tries to grapple with the relationship of class, gender and 'race', both
in theory and in practice. Condemning both cultural reductionism and
relativist multiculturalism, Bannerji supports Ahmad's views:

'If the political implications of post-modernist/poststructuralist forms
of thought were to be fully spelled out, we would get the same

cultural reductionism, ahistorical imaging of communities or liberal individualism. Aijaz Ahmad's introduction in *In Theory* puts forward this fact forcefully . . . [12]

BHABHA AND THE POSTCOLONIAL

Given the recent retirement of Stuart Hall, perhaps the most influential postcolonial academic working at present is Homi K.Bhabha. Originally from Bombay, Bhabha taught at Sussex University and is now Professor of English Literature and Art at the University of Chicago. Bhabha's emphasis on hybrid cultural work in the academy exists in the interstices, the in-between spaces of the centre and the margins, neither One nor the Other, and is as influential as it has been heavily criticized. The following quotation is fairly typical of Bhabha's rather convoluted style of writing:

'Hybrid hyphenations emphasize the incommensurable elements . . . as the basis of cultural identifications or aesthetic evaluations. What is at issue is the performative nature of the production of identity and meaning:the regulation and negotiation of those spaces that are continually, contingently "opening out", remaking the boundaries, exposing the limits of any claim to a singular or autonomous sign of identity of transcendent value – be it truth, beauty, class, gender or race . . . (W)here identity and difference are neither One nor the Other but something else besides, in-between (there is an *agency* that finds its creative activity) in the form of a "future" . . . an interstitial future, that emerges *in-between* the claims of the past and the needs of the present . . . The "present" of the world that appears in the art-work through the breakdown of temporality signifies a historical *intermediacy*, familiar to the psychoanalytical concept of *Nachträglichkeit* (deferred action) . . . '[13]

The postcolonial critic, he argues, must shift away from sterile discussion of class, and look at other 'historical contingencies', rejecting 'totalizing theories': 'The postcolonial perspective resists the attempt at holistic forms of social explanation.' Focus is on the postcolonial intellectual as a privileged bearer and interpreter of knowledge (but at the same time that knowledge is indeterminate, contingent, and hybrid).[14] Bhabha links postmodernity in art and the postcolonial,

arguing that postmodernity in art opens up a hybridity, an in-between-ness, glimpsing the future of art instead of being fixed and imprisoned by the past. Historical indeterminacy is 'the performative condition of its futurity'. He does little to clarify many of his statements, though.

In relation to the subject, Bhabha in 1994 asked rhetorically: 'Can such split subjects and differentiated social movements [as those of the post-colonial era], which display ambivalent and divided forms of identifi-cation, be represented in a collective will that distinctively echoes Gramsci's enlightened inheritance and its rationalism?' – obviously expecting the answer No.[15] This marks a difference between Bhabha and Stuart Hall, who looks to Gramsci's writings for ways in which to the-orize the relation of constructed subjects to cultural representations and political hegemony. Hall uses Gramsci to argue that the 'postcolonial state' is a complex formation, not an *thing* to be destroyed.[16] However in his essay on Postmodernism/Postcolonialism, Bhabha *does* say that he thinks the subject has returned, 'in the guise of a politics of new, ignored, and different subjectivities, sexualities and identities'. The sub-ject is now placed at an angle to life and history and although the subject still possesses agency, there is no mastery or sovereignty, no 'author of the story of life' and the future is open.[17]

Bhabha's writings on culture have been much admired, but also criticized. Some of Bhabha's earlier work, such as his article on stereo-types and colonial discourse, was more suggestive and accessible than much of his later writing, and looked at Orson Welles' film *A Touch of Evil* (albeit rather briefly), to show how his theoretical arguments relate to an actual example.[18]

Ahmad, a scholar who has remained in India while engaging critically with postmodern and postcolonial thought, argues that Bhabha is a per-fect example of the way in which radical thought in the universities of the imperialist world 'paid homage to the postcolonial national bour-geoisies by shifting its focus, decisively, from socialist revolution to Third-Worldist nationalism – first in political theory, then in its literary reflections'. Disillusionment with the national-bourgeois states of Third World countries on the part of their intelligentsia led the latter to argue that poststructuralism and deconstructive theories were the means for a critique of nationalism itself. Bhabha, says Ahmad, clearly does so in his book *Nation and Narration*.[19] Since many of the postcolonial critics came from élite families, they were uninterested in offering any critiques of their own positions, or bourgeois or petty-bourgeois nationalist poli-tics, from a class perspective based on the interests of urban and rural

working class people. Thus hybrid cultural work is elevated to the status of cultural political criticism. In the rather convoluted words of Benita Parry, such scholars as Gayatri Spivak and Homi Bhabha share a 'programme marked by the exorbitation of discourse and a related incuriosity about the enabling socio-economic and political institutions and other forms of social praxis . . . their project is concerned to place incendiary devices within the dominant structures of representation and not to confront these with another knowledge'.[20] Parry compares the poststructuralism of both Spivak and Bhabha unfavourably with the dialectical thought of Fanon. Instead of an enabling perception of dialectics, contradiction and instability in the natural and social world which Fanon derived from Marxism, Bhaba's notions of hybridity and inbetweeness result in scepticism, uncertainty and the refusal to take positions. For Bhabha, dialectical thought has been transformed into a glorification of the liberatory potential of the in-between, the ambivalent and the hybrid. This mangling of dialectical thought into in-betweenness and 'third spaces', is a kind of playful pun on the Third World and the aspirations of Third World liberationists – perhaps not an appropriate target of humour. This is not the only difference between Fanon and postcolonial critics of today, as we shall see.

I have already mentioned some of Anne McClintock's critiques of Bhabha's notions of mimicry, hybridity and ambivalence as subversive, as well as her view that Bhabha makes these abstractions into historical actors in the absence of individual or collective subjects who consciously make their own histories.[21] Elsewhere, McClintock raises some useful questions about the term 'postcolonial' and its meaning. She asks whether it has become a totalizing theory itself, and questions its lack of specificity. How can Britain, the USA and India, for example, all be postcolonial?[22]

Ahmad finds it ridiculous to designate a critic as postcolonial simply because he/she came of age after decolonization, as if they can all be differentiated in this respect from those who lived and matured under colonial rule.[23] However, the most devastating critique of postcolonial criticism is to be found in an essay by Arif Dirlik. Dirlik argues that postcolonial criticism and its rise to prominence in academic circles can be understood only by situating this intellectual and cultural phenomenon within developments in global capitalism in the late twentieth century. Third World intellectuals like Bhabha, he says, have been 'completely reworked by the language of First World cultural criticism', and focus totally on the postcolonial subject to the exclusion of the world

outside the subject, so that, consciously or not, their work becomes an apology for the *status quo* in a global culture dominated by imperialism. Postcolonial criticism 'rearranges ... themes into a celebration of the end of colonialism, as if the only tasks left for the present were to abolish its ideological and cultural legacy'.[24] Dirlik argues that the postcolonial critic mimics the tendencies in colonialist intellectual thinking. This position is clearly dismissive of Bhabha's notion of mimicry on the part of the colonized and postcolonized as being politically radical. Dirlik argues that Eurocentrism has not disappeared, but has transformed itself in new ways. He claims, correctly in my view, that it is surprising that 'a consideration of the relationship between postcolonialism and global capitalism should be absent from the writings of postcolonial intellectuals'.[25] 'They have mystified the ways in which totalizing structures persist in the midst of apparent disintegration and fluidity. They have rendered into problems of subjectivity and epistemology concrete and material problems of the everyday world.'[26] Now, I would not completely agree with Dirlik's conclusions which see no contradictions or tensions within postcolonial thought, and at times he implies that postcolonial critics have consciously set out to construct a body of theory that will support global capitalism. However, I feel that the weight of the contradictions within postcolonial criticism itself, and between this body of theory and its material context, does actually result in writings which do little to offer a critical perspective on the plight of the imperialized (a term I much prefer to the postcolonial) world. Anyone who is eager to intervene in cultural or any other politics would do well to supplement their reading of postcolonial criticism with a variety of other material, preferably political theories designed to be tested in practice, rather than merely tried out against other theories.

STUART HALL AND THE POSTCOLONIAL

Not surprisingly, Hall is stung by Dirlik's criticisms of postcolonial intellectuals, since he is one of them himself, and dismisses Dirlik's arguments as banal reductionist functionalism and 'an echo from a distant primeval era'.[27] Hall has entered 'new times', as I explained earlier, and is now less than sympathetic to cultural theorists who try to understand the development of cultural trends by referring to economic factors as crucial explanatory forces. So what does Hall say about the postcolonial and culture? Actually not a great deal, because most of his article on the topic is an attempt to discredit Dirlik's method and

conclusions, while admitting that he says much that is quite correct. This is not an easy task for Hall, and it is debatable whether he succeeds.

Hall accuses critics of postcolonialism of wanting to return to the 'good old days' of binary oppositions when there were 'goodies and baddies'. These days are gone, says Hall, citing the Gulf War as a case in point; there, ambiguity and ambivalence characterized the political situation, making it 'a classic "post-colonial" event'. This, Hall argues, is because it involved the violence of force used in defence of Western oil interests as well as the violence used by Saddam Hussein against his own people 'and the best interests of the region'. This is a typical event of our 'new times', says Hall.[28] In fact, many conflicts in the past were not particularly clear cut,nor did they involve one-dimensional goodies and baddies, and it is quite possible to look at the Gulf War, understand the complexities involved, and work out which side to take, why, and what political programme should be put forward both in the imperialist countries and in Iraq.[29] I am not convinced that notions of postcoloniality bring much that is politically new or useful to this 'classic "post-colonial" event'. If, for example, we take the examples of the military coup in Chile, the struggle against the British in Northern Ireland (which is not even postcolonial in this supposedly postcolonial period), it is difficult to see them as conforming to Hall's notion of the 'classic "post-colonial" event'. Most historical and political events are complex and do not result from single causes. This does not necessarily make them postcolonial. For Hall, the postcolonial is obviously equated with 'new times' and the death of 'old' revolutionary politics. For him, the postcolonial 'produces a decentered, diasporic or "global" rewriting of earlier, nation-centered imperial grand narratives' and concerns the different ways in which postcoloniality stages the encounters 'between the colonising societies and their "others"'.[30] In Hall's view of things, colonization and ensuing postcolonialism are no longer parts of a larger development i.e. of capitalism and imperialism, but become a major narrative superceding this previous view of history. Thus capitalist modernity is displaced from its privileged position. Hall no longer believes it is historically necessary to get rid of capitalism as a major determining force of semi-colonial economic and political domination. He simply states that it is essential to displace this 'whole grand historiographical narrative' because it is Eurocentric. Thus the postcolonial is 'really challenging' to 'the epistemic and power/knowledge fields around the relations of globalisation'.[31] Despite Hall's arguments against McClintock,

Dirlik and others, I find his article unconvincing as a defence of the political radicalism of postcolonial theory.

POSTCOLONIAL ART?

Postcolonial theory, is, as we have seen, closely linked to particular political interpretations of the late twentieth century world where many countries are still dominated by imperialism, although they are theoretically autonomous and independent. The term 'imperialism', however, is not often used in postcolonial criticism. Much postcolonial criticism is concerned with cultural politics in a general sense, and does not discuss individual works in detail. When examples are analysed in relation to postcolonial theory, they tend to be works of literature rather than visual culture. It is tempting to link postcolonial theory to the recent flourishing of black British art, and, as noted above, there has clearly been some interaction between the two cultural spheres. In particular, the writings of Kobena Mercer have been successful in relating some of the favourite concepts of postcolonial theory to visual culture, notably in his discussions of 'race' and male desire in the photography of Mapplethorpe and Rotimi Fani-Kayode, and the films of Isaac Julien. My overall impression, however, is that Kobena Mercer is something of an exception. In general, current practice by black artists, while often relating to issues discussed in postcolonial theory such as identity, displacement, mixing of cultures and peoples (hybridity) and indeterminacy, is rather more successful than written pieces by postcolonial theorists in representing these meanings and their striking cultural potential. Since works of art and visual culture are not themselves expositions of theories, or positions in cultural politics, they are much better suited to represent the shifting concepts and fluid notions of the indeterminacy of postcolonial thought. When postcolonial theories are applied in practice to the politics of the real world, we have difficulty in seeing precisely what the outcomes are. With art works, we often do not expect practical outcomes, but rather enhanced perception, aesthetically satisfying experiences, and expanded and more critical thought. Of course, one can have endless arguments about what art works are, but for the moment, I think it is possible to say that the ways in which written theories and visual culture represent meanings are different. In my view, visual culture is able to represent some of the concepts of postcolonial theory more seductively than written communication. For example, when postcolonial critics attempt to suggest ambi-

guity, in-betweenness and indeterminacy in their use of language and sentence structure, it can often seem merely obscure. In art works, however, such qualities are what viewers have learned to expect, and are interested to see.

In the remaining part of this chapter, I want to look at how some artists' works relate to issues in postcolonial theory. Firstly, I have chosen the photographer Surjit Simplay, in order to discuss concepts of the postcolonial, the subject, gender and agency. I ask of her work the same question as Gayatri Spivak: 'Can the subaltern speak?', and this time, the answer is Yes, definitely.

Simplay's recent photographic images, including this example (plate 26) were exhibited in a series of exhibitions in 1997 and 1998 entitled *Independent Thoughts*, which were special commissions in response to the 50th anniversary of Indian and Pakistani independence. I will be referring later in this chapter to some other works shown in this series. Simplay's works, some of which are digitally produced, vary in scale, some monochrome, some in highly saturated colour. Subjects include landscapes and monuments from the Indian subcontinent, male representatives of major religions, re-appropriated orientalist images of

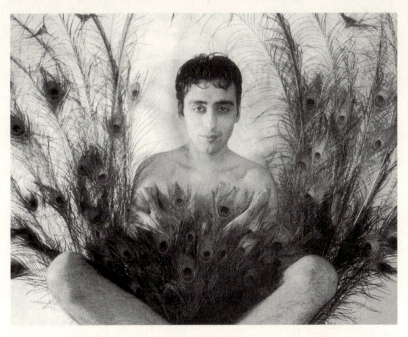

plate 26 *Surjit Simplay, The Beautiful Asian Peacock, 1997, colour photograph, dimensions variable. Courtesy of the artist.*

eroticism and desire, and, especially prominent, images relating to
gender and sexuality. In one, a life-size image of a young Asian woman
with short hair, an impressive cleavage, folded arms and legs spread,
sits on a chair looking straight at the spectator. Across her crotch a
no-entry sign is placed. We see that young women can wear sexy clothes
and outrageous platform shoes, but that does not mean that 'they are
asking for it'. Small sepia photographs, *Erotic Series 1 and 2*, show close
up parts of Asian women's bodies with jewels on the skin, suggesting
an erotic pleasure for the wearer as well as a questioning of the voyeuris-
tic pleasure of the fe/male viewer. Simplay is influenced by advertising
imagery and media images of all kinds, examining their potential recu-
peration for a female eroticism. Struck by images of white women in
wet tee-shirts on beaches, she translated this into an image inspired by
an Indian film of a woman dancing in the rain wearing a soaking wet
sari.'I thought that was powerful and at the same time very sensual. I
tried creating it in colour; it looked cheap and nasty, like pornography.
I tried it in black and white and it changed its whole tone, it became
erotic.'[32] *The Beautiful Asian Peacock* (plate 26) plays with the sensual
images of Orientalism but criticizes them from a female point of view,
totally absent from Said's book. The emphasis placed by Said on the
West's feminization of the oriental man, leaves little space for the artic-
ulation of black and Asian female voices critical of masculinity.[33]
Simplay exhibited a series of images showing the young Asian man as
narcissistic, proud and displaying his masculinity like a peacock. The
peahen, of course, lacks the beautiful plumage of the male. The peacock
feathers, a powerful signifier of the exotic Orient, seem to sprout from
his crotch as he sits with his arms folded like a religious figure deserv-
ing of our adulation.

In Simplay's work, both the representation of women and the articu-
lation of women's desires and consciousness are major features. Her
evolving perceptions of positions from which she can offer criticisms,
voices and alternative images of Asian women is very much based on
her own experience and developing practice, rather than book-derived
theory. 'I am not one of those people who can come out with reams of
analytical explanations about the work. I can say how I did it and why
I did it. I have found people read more into the images than my own
original idea – which is good.'[34] Certainly the different cultural influ-
ences on her work could be termed hybridity, or in-betweenness if need
be, but there are probably other terms which are just as useful, for
example ambiguity, contradiction, or even confrontation. In fact I would

argue that Simplay's work varies from images which are very direct and hard-hitting to more subtle ambiguous images which are more contemplative. To characterize all her imagery as hybrid does not seem to me to be particularly useful.

Simplay did not train as an artist or photographer in higher education, but became a secretary, a receptionist and then an administrator at a media centre in Wolverhampton, where she also took some practical courses. Her training is very much pieced together from short courses and, as she puts it 'Coming from a family where no one had gone on to higher education, I couldn't look to anyone to guide my ambitions.'

Compared to Simplay, an established fine artist such as Zarina Bhimji refers extensively to cultural theory in her interviews. In *The Impossible Science of Being* exhibition, Bhimji exhibited photographs of Leighton House, West London, including one of the entrance hall complete with stuffed peacock and decorated ceramic tiles. This orientalist shrine built by late Victorian painter Frederic Leighton (Baron Leighton) was so convincing to Bhimji that she felt she had entered a mosque. She had read Said's *Orientalism*, Foucault, Kristeva and Mary Douglas' anthropological work *Purity and Danger*.[35] Bhimji, however, did not initially find it easy to become known as a professional artist, able to articulate her ideas backed up by cultural theory: 'To be successful can mean a lot of sacrifices. There are so few role models. I am the first in my family to go to college. Achieving anything is difficult to deal with when there are so few black or Indian women in that position. I remember how exciting it was to see Gayatri Spivak delivering an academic lecture dressed in a beautiful sari.'[36] While it is possible to criticise some of the positions of postcolonial scholars, both black and white, the significance of leading Black and Asian intellectuals as role models both in academic life and in more popular media roles, where Stuart Hall has been particularly important, should not be underestimated. Bhimji's work is clearly placed within the domain of high culture and academic theory, whereas Simplay's evidently acknowledges popular media and personal experience as sources and inspirations for her photographs. I am not trying here to make judgments as to which is the more valuable, but to point out that there are different types of art work produced by different British Asian artists. While some may be informed by postcolonial (and postmodern) cultural theories, some are most definitely not. I also want to point to the continued relevance of such concepts as experience, agency and the conscious subject, which have almost been theorized out of existence by many poststructuralist, postmodernist and

also postcolonial writers. I am not arguing for a naïve and untheorized notion of experience or consciousness, but simply for the recognition of what actually exists in the lives of young Asian women who want to make culture for themselves and others. They are not constructed by discourse in the sense that they internalize social and cultural ideas of femininity in a totally passive manner. They make choices, often in difficult circumstances, but, as Simplay puts it, they have their own aims. These do not necessarily involve a rejection of their cultures or histories, but imply a critical appraisal of them, as well as and appraisal of European cultures. For example, Surjit Simplay states that the family and marriage are not necessarily rejected, but there is more to being a modern woman than these:

> 'Younger girls today are more focused, more aware of education and job opportunities compared to when I was growing up. They see what their grandparents and parents got out of being here, why they came. Some don't want to be like their older brothers and sisters, they want to do other things besides getting married. Their confidence about themselves has a sense of direction; ambition and career sit next to the importance of marriage.[37]

THE POSTCOLONIAL FANON?

In 1995 the seventieth anniversary of Frantz Fanon's birth was celebrated in London with an exhibition and a conference organized by the Institute of Contemporary Arts. The exhibition and book which accompanied it, *Mirage: Enigmas of Race, Difference and Desire*, focussed in particular on art works and essays related to issues discussed by Fanon in his book *Black Skin, White Masks*, published in 1952. Kobena Mercer pointed out in his introductory essay that whereas previous generations valued the Marxist ideas which informed Fanon's writings and political activities, 'the fading fortunes of the independent Left during the 1980s provided the backdrop to renewed interest in *Black Skin, White Masks*, Fanon's first and his most explicitly psychoanalytical text'.[38] A number of black artists from Britain, the USA and Martinique were invited to contribute works inspired by Fanon's text. The accompanying conference resulted in a book, with contributions by Bhabha, Hall, Mercer and others. The book opens with an essay by Stuart Hall, who defends Bhabha's postcolonial reading of Fanon's work; a reading which depoliticizes and

dehistoricizes it by largely ignoring Fanon's political ideas and activities. Hall defends Bhabha against accusations of making Fanon into a kind of 'premature poststructuralist' heavily influenced by Jacques Lacan.[39] He adds: 'I agree, then, with the reasons which Homi K.Bhabha advances for the importance of *Black Skin, White Masks* at this conjuncture.'[40]

It has been pointed out that there are different approaches to Fanon's work in this so-called postcolonial period.[41] One has been to criticize Fanon for his apparent lack of consideration of homosexuality and women, another has been to try to draw out of Fanon's work relevant concerns for the present, rather different, social, political and cultural situation. However 'with the political and academic weight of the figures who dominate the postcolonial studies stage, there has not been much room for the cultivation of alternative research on Fanon, which thus has had less access to resources that could present it to wider audiences'.[42] A serious consequence of the appropriation of Fanon by postcolonial critics has been, in most cases, the depoliticization of Fanon's life and thought. Bhabha is particularly responsible for this, and this has been defended by Stuart Hall above. For example, Bhabha writes in *The Location of Culture*, that 'In shifting the focus of cultural racism from the politics of nationalism to the politics of narcissism, Fanon opens up a margin of interrogation that causes a subversive slippage of identity and authority.'[43] In Bhabha's 1986 introduction to *Black Skin, White Masks*, he begins with a vituperative attack on 'the Left', Trotskyism and trade unionism, claiming that these have ignored and repressed Fanon. Thus, Fanon is set up as 'the Other' of revolutionary politics and workers' organizations. Bhabha then delightedly discovers that in *Black Skin, White Masks* there is 'no master narrative or realist perspective that provides a background of social and historical facts against which emerge the problems of the individual or collective psyche'.[44] Excellent! Fanon must be a poststructuralist postmodernist. Fanon evokes the colonial condition 'through image and fantasy', we are told, and even better, he focusses on the 'in-betweeness' that 'constitutes the figure of colonial otherness.'[45] At times, we are not sure whose arguments we are being introduced to, Fanon's or Bhabha's. When Fanon attempts to 'restore the dream to its proper political time and cultural space', this, according to Bhabha, 'blunts the edge of Fanon's brilliant illustrations . . .'[46] What has happened here is the splitting of Fanon into at least two selves, a psychiatrist who was interested in the psychic malaise of black people alienated in a society dominated by white eco-

nomic, political and cultural power, and Fanon the political activist and revolutionary who tried to change the specific historical societies resulting from colonialist exploitation and oppression which existed in the post-war period, and gave rise to the psychic disturbances. It is quite true that there is little historical specificity in *Black Skin, White Masks*, but one of the reasons for this was that the ideas in this book are only part of a totality of Fanon's writings and actions, which comprise an engagement with specific historical situations and economics with a view to changing them by revolutionary struggle. The latter has become the repressed for scholars such as Hall and Bhabha. I do not wish to speculate here on the reasons for this. However, it is clear that such readings of Fanon do not occur because these academics are nasty, or intentionally seek to deceive people. If this is an influential trend in Fanon scholarship, it is not an accident, but is ultimately related to the so-called postcolonial reality of the late twentieth century. It is true that revolutionary politics are seen as being in decline and that successful national liberation struggles such as those in Vietnam or Algeria, have resulted not in prosperity and democracy for the people. but oppression of a different kind. It was interesting to note that in the discussion of Fanon in the 1995 publications referred to above, there was no attempt to assess the situation of Algeria and Fanon's participation in the war of independence against France in relation to the current state of Algeria today where massacres regularly take place, and democratic rights are few. Surely it is no accident that nothing was said of this, for the particular political interests of postcolonial criticism are not primarily concerned with the real world and intervening in it, unlike Fanon the revolutionary intellectual.[47] The question of Fanon and Algeria has been fetishized in the past in order to conceal a lack in the present – ossified, individualized and culturalized. Algeria is made a question of psychic ambivalence, rather than a question of the power of imperialism and semi-colonialism to mangle the physical and mental lives of its victims, a situation Fanon understood very well.

So what was Fanon really about? Fanon was born in the French colony of Martinique, and died of leukaemia in 1961 at the early age of 36. He went to Europe during the Second World War to fight against the fascists, but was disgusted at the racism he encountered on the anti-fascist side. After the War, he worked for the election campaign of the poet Aimé Césaire, who was standing as a communist candidate. Continuing with his education in medicine and psychiatry, Fanon published *Black Skin, White Masks* in 1952. It had originally been intended for submission as

his dissertation. In 1953, Fanon went to Algeria to take up a post at a psychiatric hospital. He became a member of the Front de Libération Nationale and helped in the war of independence by aiding the guerrilla forces, training nurses, providing safe accommodation for fighters, and reportedly teaching Algerian nationalists how to bear up under torture and control their reactions while setting bombs. In this, Fanon put to shame many French leftist intellectuals and the majority of the French working class movement. Only a few supported the Algerians in their struggle for independence, including Jean-Paul Sartre and Simone de Beauvoir. The French Communist Party actually voted in favour of the emergency powers which allowed the French military to commit atrocities while protected by law.[48] Such treachery did much to alienate Fanon from the idea that the working class was the main revolutionary force which could mobilize itself against imperialism and racism. Instead, Fanon saw the forces that role being played by the FLN, the Algerian nationalist liberation movement , which was based on the peasantry, the middle-class and the lumpen-proletarian poor of the cities, led by guerrilla fighters using revolutionary terror as a weapon. In fact a major strike by Algerian workers completed the struggle for independence, though their participation was seen as an adjunct to the existing strategy and methods of the FLN.[49] Fanon, however, was scathingly critical of the African bourgeoisie, who, he believed, simply took over where the colonialists left off. They wanted to be white, do white things, and possess what the whites had possessed. This led them into racist oppression of other peoples in their desire for power. Against the Communist Party line, Fanon argued that a bourgeois nationalist stage of the liberation struggle was not always necessary. Oppressed and impoverished workers and small farmers were able to move towards socialism in struggling against imperialism, without going through the stage of an independent capitalist bourgeois nation which the Communist Parties thought essential. He concluded that 'the combined effort of the masses led by a party and of intellectuals who are highly conscious, armed with revolutionary principles ought to bar the way to this useless and harmful middle class'.[50] Fanon's view of revolutionary struggle entailed freedom for all: 'women will have exactly the same place as men, not in the clauses of the constitution but in the life of every day: in the factory, at school and in the parliament.'[51]

How different this vision is from the fundamentalism that threatens Algeria today, along with the militarized state that presides over capitalist exploitation of the Algerian masses. The big landowners who

finance the Fundamentalists, the clerical fascists of North Africa, seek to develop 'Islamic businesses' and return women to the middle ages: 'Women are there to produce men, especially those most essential of men, Muslims: they are not there to produce material goods. It has been scientifically shown that it is impossible for a woman to reconcile a job with her family obligations.'[52] In the present situation of almost daily massacres, partly carried out by Islamic militant terrorists, and probably by government forces as well, the tradition of violent terrorism inherited from the liberation struggle continue, but this time turned against the victims of imperialism. European governments refuse asylum to most refugees fleeing the violence, although more famous political refugees such as the champion athlete Boulmerka (who has been condemned to death by Fundamentalists for running in shorts) and the Rai singer Khaled (threatened with murder for singing about desire) now live abroad. The USA has urged President Zeroual to incorporate 'moderate' Islamic elements to try to stabilize the situation. But in the context of falling oil prices, unemployment and the collapse of social welfare (to be replaced by Islamic charity) even taking children to a state school is seen as an outrageous act of disobedience calling for the ultimate punishment.[53]

Fanon's particular view of human liberation was influenced by Marxism, his study of psychiatry and psychoanalysis, and by existentialist thought. This meant that, for him, the psychic alienation felt by the individual needed to be understood in a social context and overcome by changing the society that had brought about that alienation. Specifically for the black person, this meant casting off the alienating identity of 'the Negro' imposed by white capitalist society with its inbuilt racism. For whites, it mean joining in struggles with the oppressed to destroy imperialism. In carrying out revolutionary struggle and violence, the individual constitutes her/himself as an authentic unalienated self who enters freely into action.

Despite the influence of psychoanalysis on him, Fanon thought it pessimistic. He wanted to connect personal with social freedom, and believed that alienation was produced socially, culturally and politically.[54] The black people of Martinique, argued Fanon, had split egos and a double consciousness, due not to the Oedipus complex and the family, but because of racism. This is why he does not locate any examples of the Oedipus complex in the French colonies.

Fanon saw black identity, black culture and Negritude as dead ends. Since the black/negro is a concept and identity created by the white, it

will disappear when oppression is thrown off: 'To believe that it is possible to create a black culture is to forget that niggers are disappearing, just as those people who brought them into being are seeing the break-up of their economic and cultural supremacy.'[55] Poets and writers who want to write about black people must see that their reality is not static, but changing and unstable.

'Let us be clearly understood. I am convinced that it would be of
the greatest interest to be able to have contact with a Negro literature
or architecture of the third century before Christ. I should be very
happy to know that a correspondence had flourished between some
Negro philosopher and Plato. But I can absolutely not see how this
fact would change anything in the lives of the eight-year-old children
who labour in the cane fields of Martinique or Guadaloupe'.[56]

Fanon argued that there would never be such a thing as a national black culture because no black politicians wanted to set up black republics with social relations which would make a free future possible for humanity. 'It is this that counts; everything else is mystification, signifying nothing.'[57] Without freedom, culture cannot flourish. Colonialism tries to preserve an old, frozen black culture, to fix a black identity which in reality is always changing, and eventually, argues Fanon, will disappear. Fanon's hope was for an integrated human culture which would enable human expression to develop the best aspects of all traditions in a living, changing fusion and progression. These views recall the kind of arguments that once centred round proletarian culture after the Russian revolution. Some supported the notion of proletarian culture, but Trotsky, among others, argued that since the proletariat would disappear as a class presence and identity in a society dedicated to the eradication of any vestiges of class oppression, it was a retrograde concept to glorify and build proletarian culture. However, we should remember Fanon was writing in a different world situation, and writing mainly of colonized or recently de-colonized countries. Much current discussion of black culture has taken place within imperialist countries, discussing the culture of black diasporas. Yet it is surely a measure of the extent of available freedom and democracy for black British people, and their continued oppression as black, that the debate about black culture still exists. Perhaps this is one of Fanon's most suggestive contributions to the question of culture and oppression, one which has still to be adequately discussed.

VEILING AND EXPOSURE

Isaac Julien's film of 1996 *Frantz Fanon: Black Skin White Mask*, is a fascinating look at Fanon's life and work. As the title suggests, the central focus of the film is Fanon's book of 1952, with its analysis of black alienation in white capitalist society. However although the film is typical of Julien's *oeuvre* with its concerns of desire, sexuality, the look at (and of) the 'Other', and the relationship of all these to racism and the black subject, Fanon's politics are by no means ignored in the work.[58]

The film is a richly constructed work, using clips from other films, such as Pontecorvo's *The Battle of Algiers*, newsreels, documentary film, still images, and carefully constructed tableaux with actors. The sound uses voice-overs, actors' voices, 'talking heads', music and sound tracks of the film footage montaged into the work. While I would agree that a great deal of emphasis is given to the preoccupations of current cultural theory with Fanon's examination of the look, the 'Other', identity, recognition and the subject, there is still plenty of interesting material relating to the war of liberation in Algeria, and the link between Fanon's practice as a doctor and his political work. It is fascinating to hear the views of Fanon's family, of doctors who worked with him, and of a former member of the FLN government, though perhaps less interesting to listen to some of the pronouncements of the 'cultural critics'. Leaving these aside, many parts of the film are successfully ambiguous, suggestive and visually gripping. The film effectively represents the complexity of Fanon's short life, created from family memories, critics' interpretations, dramatic (re)creations and historical visual records, and the viewer makes her/his own acquaintance with the meanings of Fanon as a private and public historical figure.

In Julien's film a recurring motif is that of the Algerian woman, veiled or unveiled. (plate 27) This appears almost subliminally early on in the film, and recurs in different forms more insistently as the film progresses. There has been much discussion about Fanon's comments on Algerian women and the struggle for independence, especially concerning his essay '*L'Algérie se dévoile*', published in 1959.[59] Usually translated as 'Algeria unveiled', this should read 'Algeria unveils herself'. The difference is important. Rather than being unveiled by another, Algeria is feminized and made an active subject who decides to unveil herself; the nation is equated with active womanhood.

Within the first few minutes of Julien's film, the image of the veiled and unveiled woman appears, as a photograph of a bareheaded woman

plate 27 *Isaac Julien, still from Frantz Fanon: Black Skin White Mask, 1996. Courtesy Victoria Miro Gallery, London.*

with tattoos on her face projected onto the black silhouette of a heavily draped woman. There is a question posed here about the nature of image and reality, of change, impermanence and lack of fixity in history and representation. Issues of agency and the position of women are also suggested. It is not so much the brief sight of the image that does all these things, but the context in which we see it, and the later variations and reappearances of the image which build on the early appearance of un/veiled women. Newsreel film in black and white shows General Charles De Gaulle driving through Algiers in triumph after the Liberation at the end of the Second World War. A battleship fires its guns. Then, we see briefly three women robed in black who raise their hands as if to protect themselves. We see the battleship again and then the image of the slide projected on the side of the draped woman's head. Who is liberating whom? Who is liberated?

These heavily veiled women appear at various points in the film, sometimes standing in a posed tableau in front of the central section of the large photographic work by the artist Mitra Tabrizian, entitled *Surveillance* ; this shows the heavily veiled women standing in front of a huge crowd. The woman in the centre occupies a pedestal inscribed 'In His name memory is mute. History speaks in the quickening of the dead.' A dead woman in western dress lies at the foot of the pedestal. One of the veiled women is blindfolded.[60] Images of Algerian women

reappear, sometimes accompanied by clips from Pontecorvo's film *The Battle of Algiers*, which show women who contributed to the liberation struggle by hiding weapons under their clothing and also 'Europeanizing' themselves by cutting off their hair, and putting on Western dress and make-up in order to move around more freely, carrying messages and bombs.

Fanon's essay, published five years after the fight for freedom had begun, argues that the veil cannot be understood as oppressive in itself, but must be understood in the changing relations of colonialism and anti-imperialist struggle. Forcible unveiling and colonial penetration of Algeria identified women with the nation. Women were able to turn the veil back against the colonizers, asserting their cultural traditions against European domination, and in the process of struggle became active as fighters and as women. Fanon hoped this would develop further in the liberated Algeria. In his essay '*The Algerian Family*' he argued that the patriarchal family was challenged in the liberation struggle, by both young women and young men.[61] However, as is suggested in Julien's film, there are problems with glorifying the veil as a symbol of women's self-determination and conscious agency. Mohammed Harbi, a former member of the FLN government, states in the film that many FLN members felt that Fanon's essay was open to very conservative interpretations about the current and future roles of women. Harbi says women often encountered discrimination in the liberation army, and were in fact evacuated to Tunisia to keep them away from danger. After independence, the state's attitude to women was disappointing. The Family Code of 1984 in effect nullifies the formal political equality given to women in the 1964 and successive versions of the Charter of Algiers. Women are legal minors till they wed, require permission to marry, the dowry system is maintained, married women need their husbands' authorization to work, and men retain rights of polygamy and repudiation of their wives.[62] Against a background of high male unemployment, the access to education of unveiled, urban, middle-class women has put them into potential economic competition with men from newly urbanized middle and lower-middle class backgrounds. These men are likely to be attracted to fundamentalist and clerical fascist programmes in order to return women to the home, while at the same time encouraging the growth of all-male Islamic businesses.

To understand Fanon's comments on the veil, it is important to remember the weight of colonial occupation and culture on North Africa, which sought to unveil women as a means of controlling and dominating what

was perceived as an alien way of life. Articles and books on photography in North Africa and the Middle East have shown the sexual and economic motives behind the drive to know, expose and dominate oriental women.[63] However it was largely urban and higher class women who wore veils in North Africa, and peasant women who, usually, did not. In addition, young girls before the age of puberty are not veiled, as veiling also signifies control and possession of women's sexuality. As Dennis puts it: 'For Muslim culture, the veil signifies both the spatial and the visual quarantining of women, who present the sexual threat of intervening in the relationship between man and Allah.' [64] Some women who unveiled themselves in public were vilified and attacked, for example Anbara Salamaam in the Lebanon in the 1910s and 1920s. Sarah Graham-Brown provides an excellent discussion of women's clothing and its meanings in the Middle East, relating it to historical, social and cultural contexts. She argues that the wearing of veils and other types of scarves is not just due to fundamentalist oppression, but is sometimes practised by women as an identification with anti-Western values or as a visible protest against class privilege 'associated with ostentatious Western-style consumerism'.[65] The main point, surely, is whether women can freely choose what to wear in a context of social and political equality, or whether certain modes of dress or undress are 'suggested' for them under duress of various kinds.[66]

In Julien's film, the images of Algerian women keep coming to the surface and growing stronger and more persistent as the film progresses, like a kind of failed repression of their freedom, their desires and even their very existence. The women cannot be made invisible by the dark clothing which covers them. The thoughtful face of the tattooed woman projected onto the veil is a trace which persists, and will not be hidden from sight. The film is not there to give direct answers, but to suggest, question, and to engage the spectator through the sensuality of the imagery as well as the shock of recognizing the torture and dehumanization of colonial oppression and the struggles needed to break its domination.

INDEPENDENT THOUGHTS

The series of exhibitions of work specially commissioned to commemorate Indian independence and the partition of India and Pakistan in 1947 was on show in a number of locations in England in 1997–8. Among these works in a number of different media were the

constructions of warrior figures made from fleecy material and copper by Perminder Kaur. According to the leaflet accompanying the series of exhibitions, Kaur's immediate point of departure was the warrior tradition of the Sikhs and their continuing struggle for independence. In one part of her show, many small figures of dolls resembling warriors were pinned with long poles to the walls of the gallery, like a defeated army. The figures were faceless, though the artist has stated that their struggle is more personal than political.

A particularly impressive contribution to the group of exhibitions was the multimedia installation on the partition by Pervaiz Khan and Felix de Rooy which was shown in Leeds. A computer-generated video projection on two cotton screens (referring to the British destruction of the Indian textile industry), and onto a bed of salt on the floor (alluding to the salt taxes, and the British monopoly of the salt trade, which was challenged by Mahatma Gandhi and his followers), brought together sound and visual effects in a stunning montage of film clips and images relating to the partition. Extracts from the 1937 film *Clive of India*, and *Bhowani Junction* (1956) mingle with reaching hands, changing psychedelic colours, a Muslim woman in a veil, a Hindu man in a turban, scenes of work, speeches, drums, mesmerising images and sounds of flux and indeterminacy repeated over and over again with hypnotic effect.

Other shows used family photographs to show personal histories of displacement, identity and social being, as in Nudrat Afza's exhibition at Bradford University, entitled *Midnight Hour*, after Nehru's speech on the threshold of independence: 'At the stroke of the midnight hour, when the world sleeps, India will awake to life and freedom ... the past is over and it is the future that beckons to us now.'[67] The visitors' book was filled with instructive comments for the cultural historian. While some hailed the visual material as inspired and were gratified that histories and identities like their own were regarded as worthy of public exhibition, others dismissed the show as private, personal and not art: 'Completely inspiring! I recognise these images as part of my own life. These pictures are full of identity and belonging. Brilliant!' (Farah Shaheen). 'Most of the photographs should be confined to the Family Album rather than be regarded as a work of art!' (T.R.Pope)

A work I want to look at in more detail is *Raising the Flag* (1997) by Juginder Lamba (plates 28 and 29), exhibited in Birmingham and Coventry. This elaborate sculpture-based mixed media installation was thematically complex, embodying many ideas already discussed in this book. It was exhibited alongside some of the photographs by Surjit

plate 28 *Juginder Lamba, Raising the Flag, detail, 1997, mixed media installation. Courtesy of the artist.*

plate 29 *Juginder Lamba, Raising the Flag, detail, 1997, mixed media installation. Courtesy of the artist.*

Simplay discussed previously, and documentary works by photographer Sunil Janah from the 1940s, showing powerful images of revolt and oppression from the last few years of the struggle for Indian independence.

The recent rise to power of the Hindu nationalist BJP (Indian People's Party) brought to an end the long period of rule by the Congress Party, one of the main organizations which fought for independence. Although India is a secular state, religion plays an important role in political life. Communalism has intensified as the ranks of the educated, but unemployed, middle classes swell, and people look to members of their caste, family or religious community to help them gain posts in government and elsewhere. Although India has a high illiteracy rate, higher education was relatively well developed under British rule, as the colonizers wanted to create a bureaucracy of 'natives' to run the country under British supervision. Britain legalized religious politics in the 1935 Government of India Act, in which separate elections for Sikhs, Hindus and Muslims were stipulated. As part of her strategy of colonial dominance, Britain sought to ruin the Indian textile industry by prohibiting the sale of Indian goods in Britain, and by selling cotton goods produced in Britain to Indian consumers. One of the effective strategies of the independence campaigners was to boycott British and buy Indian goods. Over many decades, opposition to British rule led to massive strikes, demonstrations (where many hundreds were killed by police and army repression), and Mahatma Ghandi's non-violent campaigns against British goods and the salt monopoly. In March and April 1930, Ghandi led a 'salt march' to the coast where he and his followers illegally collected sea salt. However, Ghandi insisted on non-violent, non-cooperation and he and the Congress movement shied away from violent uprisings and mass strikes; at crucial moments, such as those where violence threatened, they tried to call off protests to negotiate with the British. However, in February 1946 a naval mutiny, followed by riots and the threat of a Hindu-Muslim civil war showed that violence was very close to the surface. Congress leaders, fully backed by the Communist Party of India, supported Ghandi when he called the mutineers 'thoughtless and ignorant'. The British, who had fostered communalism with their policy of 'divide and rule', were obliged to partition the sub-continent between the Muslims in Pakistan and the Hindus in India, and departed in 1947, leaving their former colonial subjects to sort out the bloody aftermath of resettlement which left over one million people dead.

India had been the much-vaunted 'jewel in the crown' of the British Empire, but for financial reasons, the British were not entirely sorry to relinquish it. Earlier in the century, India had served as a useful milch-cow for Britain. For instance, the colony's exports to the USA and Europe

helped to settle about two-fifths of Britain's balance of payments between 1870 and 1914, and a British government minister observed that 'we may draw as many troops as we wish (from India) without paying for them'[68] But once India became a financial burden to Britain (Britain owed debts to India by the end of the Second World War), the imperialist power was in a hurry to leave and rethink its economic relationship with its former colony.

After independence, India became a basically capitalist state, as the government tried to build up the economy in the interests of self-sufficiency. Recently, however, liberalization and privatization driven by Indian capitalists and the international banks have further intensified the gap between rich and poor, who include five million bonded labourers and twenty million child workers. The external debt in 1992 was the fourth highest in the world at over $70 billion. Under new trade agreements which the imperialist countries in GATT want to force on India, seeds, animals and plants would be patented, as well as intellectual property. This would mean that medicines, currently produced cheaply in India, would rise massively in price. As has been pointed out, the countries which now wish to force semi-colonial India into the global liberalization of free trade did not hesitate to protect their own markets from Indian commodities in earlier times.[69]

In many of the art works remembering the struggle for independence and the ensuing partition and migrations, materials and substances such as salt and textiles are important, and in *Raising the Flag*, Juginder Lamba uses saffron, beans and millet to mark out on the floor the colours of Congress and the Indian flag in yellow, white and green. The installation is very complex and elaborate, and, here, I am not able to discuss all its meanings in detail. However Lamba has provided very useful comments on his work to help the viewer understand some of its themes. The installation was in a dimly lit, quiet space, which had the feel of some kind of shrine or tomb that was being excavated. This was very effective, especially since in a nearby room, I had just seen photographs of people gunned down by police in the struggle for Indian independence. Lamba wanted the work to deal with the notion of 'Independence' in a general way, as well as look at the suppressed histories and cultures which need to be reinstated after the demise of colonialism. The personal, the colonial and the political are intertwined. From a ten feet high structure, a lifting platform or a gallows, a cage-like object is suspended. A series of wooden constructions and clay figures are shown ambivalently either rising out of, or being buried in, sand. Rusty metal

and chains are also present. (plate 28) Is this an archaeological site being excavated, or histories being buried and forgotten? The wood in the sculptures comes from ancient timbers: slave ships recycled into barns and industrial buildings. All these are examples of the way labour transforms materials, making culture, society and history. These materials of the past co-exist with our present and help create our environment; they are not dead. Lamba also speaks of the politics and economics of globalization, of agency, independence and determination. He links these questions to displacement and migration, and in the centre of the installation we see on the floor a small bedroll with an old passport, photos and a child's jacket near a battered suitcase. (plate 29) Is this the artist's personal history, made part of a larger archaeological discovery or suppression? The work encompasses many themes from Lamba's creative output over the years, for example the marginalization of the non-European and 'primitive' art forms akin to the powerful heads and bodies sculpturally represented here. Lamba is concerned with the national and the international, and the way in which they interact in contemporary India and Pakistan. The real aims of the independence struggle were not achieved, he states.[70] All these ideas, suggestions and resonances, and more, are represented in this powerful work where the real force of visual and material culture to evoke as much, indeed more, than words, is evident.

The final work I want to discuss is by Karun Thakar. (plate 30) This was not exhibited as part of the *Independent Thoughts* series of shows, but is nonetheless a powerful articulation of themes combining national and family histories, spanning several generations. *Untitled* (1998) is a shirt made of heavy, unbleached cotton, sewn up the front and with sleeves almost five meters long. The shirt has been sewn by the artist, who was helped to cut out the pattern by his mother. The cotton dates from the 1940s and was found in a market in Manchester. The significance of this material relates to the destruction of the Indian textile manufacture by the British in order to build up their own industries in the north of England. This heavy cotton is stitched simply, like institutional clothing, and recalls a straitjacket. This is not a real shirt, but a shirt as 'sign', and is hung when exhibited on an ordinary wire hanger with the sleeves extended to their full length stretching out across the gallery floor to the spectator. For the purposes of the photograph illustrated here, the sleeves of the shirt were folded.

Karun Thakar's family history is important in understanding the resonances of this work. When she was about fourteen, Thakar's mother's

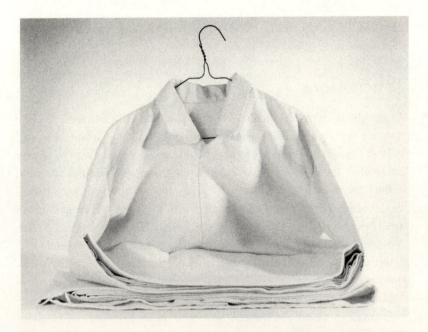

plate 30 *Karun Thakar, Untitled, 1998, wire coathanger and unbleached cotton shirt, sleeve length 500 cms. Collection of the artist. Photo Mike Simmons.*

family had to flee to India from Pakistan during partition, carrying only a few possessions in cloth bundles. His father went to Africa working for the railways; from there, he married his wife who then joined him in Nairobi. The family returned to India where, as a youth, the artist learned to sew, and trained as a tailor. His mother, meanwhile, had set up a clothing shop; this was something of an achievement, since she was one of the very few women running shops in their locality. When the artist was fourteen, he came to England, where his mother had to work as a machinist in a factory.

Recently, the artist's brother who was suffering from mental illness, died after drowning himself in a suicide attempt. The shirt is associated with his brother's arms stretching from the canal as a gesture for help, reaching out, and also as a gesture of compassion for someone suffering from mental illness. When exhibited, the shirt is intended to create a kind of 'aura' or ritual space where the visitor can walk around in meditation and remembrance. In this work, the artist utilizes personal and family experiences in his art practice. Readings in history and cultural theory interact with the art practice and working of materials, so that the work is placed in a wider cultural and psychic context, and the

personal exists and interacts with wider social, cultural and historical concerns.

CONCLUSIONS

Although the terms 'postcolonial' and 'postmodern' overlap, I feel the two are not equivalent, especially when we consider actual artworks. While in many cases the works deal with what might appear to be clearly articulated themes of postcoloniality, for example hybridity, fluidity, ambiguity, in-betweeness and so on, they do not necessarily do this is in the same way as the theories might lead us to expect. In fact, many artworks, even from the Renaissance period, embody contradictions, indeterminacy and other supposedly postmodern and postcolonial characteristics. One of the things that changes in art history is *how* the works do this.

Much postcolonial critical theory crosses over different disciplines – economics, politics and culture, psychoanalysis, the study of language as a signifying system and so on, though often little attention is paid to economics, and at times politics is conflated with culture. The term 'postcolonial' obscures, rather than clarifies, the relative weight accorded to economics, politics and culture in the critical writings of writers such as Said, Hall and Bhabha, to take just a few examples. At its best, critical theory should indeed be interdisciplinary, but the disciplines studied should be examined within a securely materialist framework which enables us to understand why certain things occurred rather than others, and also the ways in which they occurred. We need to know about discourse, signification, representation, identities, but we need to know where they are grounded and why. There is no reason why indeterminacy and ambiguity cannot be understood and valued within a materialist theoretical framework which incorporates dialectics – the means to grasp living change itself.

Art can often be motivated by personal experience which it articulates in a complex and ambiguous way, usually by non-verbal means. In comparison, the postcolonial cultural critic uses words, sometimes in a very difficult manner, in a way which falls between the use of language perceived as a transparent means of communication of ideas, and a literary style of writing, which is aware of language as a self-referential cultural medium. Complexity, ambiguity, hybridity and contradiction can work well in artworks, but can often be off-putting and obscuring in written essays. As a materialization of thought, art imagery works

differently from academic writing, and putting the works and written theories together sometimes brings out more weaknesses in the writing than might be suspected. Sometimes, especially in the writings of Bhabha, for example, the intentions (or pretensions) of the writers simply result in difficult and obscure pieces, which are unsatisfactory as vehicles for the transmission of theories. Hall, on the other hand, writes much more as a communicator, who wants to make it easy for his readers to follow his arguments.

Many postcolonial cultural critics do not discuss artworks very closely. Hall for example, often fails to analyse in detail any examples of culture in his essays and articles, preferring to elaborate his theories with a broadly sweeping brush, an approach which in many cases can be fruitful and suggestive. This poses the question of what is the actual relationship of theory to practice in postcolonial culture. Is the practice the writing of theory, or is it the elaboration of ideas and analysis in relation to cultural productions? Does the discourse of theory create its own objects? Given that postmodernist and postcolonial theoreticians believe that discourse creates both subjects and objects, these questions should not surprise us. Zarina Bhimji, as we have seen, has sought out relevant postcolonial reading to inform her art works. This is all well and good, but isn't there a danger that artists are directed to a small number of the 'correct' theorists at the expense of others who are now considered old-fashioned, modernist or purveyors of master narratives? It is not clear to me how Said's theory of orientalism, for example, is *not* a master narrative, though of course he himself has denied any wish to construct such an over-arching theoretical basis for cultural study. There is also the issue that discourse (the immaterial) is seen as creating the object of study/cultural work (the material), and thus theoretical discourse is privileged over the objects about which it theorizes. What does this imply for the maker of the cultural objects? It seems to me that many of the most interesting artworks made by black artists in contemporary Britain engage with themes of difference, mixing of cultures, fluidity, and ambiguity, but this is probably just as much to do with the ways in which any interesting and meaningful art is produced, as with postcolonial cultural theories. Artists who are unaware of the theories of Hall, Bhabha and Spivak, for example, also produce significant work concerned with similar issues primarily developed from thinking about their own experience as gendered, classed or ethnically situated subjects. While theory is important, and the closer the interaction between theory and practice the better, perhaps theories which do not

sufficiently engage with practice in the first place are less successfully appropriated by producers of visual and other culture.

In conclusion, I feel that there are certain suggestive concepts used by postcolonial theorists, for example indeterminacy or mimicry, which can be of use in analysing examples of visual and other culture or indeed, in making art works. However in my own studies of works by black artists, I have found it more fruitful to incorporate the more useful concepts from postcolonial theory into a rather different overall framework from that of the majority of postcolonial critics. My own view is that notions of ambiguity, fluidity, in-betweeness and so on, are better understood within a materialist framework which attempts to understand both theory and artworks as being rooted in their economic, historical and social context. However, ideas and cultural artifacts do not simply reflect this context, but have a more complex, sometimes contradictory, relationship to it. Understanding these complexities means realizing that the relationship of culture to its economic and social context is not a static, but a changing and unstable one; one that needs to be understood dialectically. What seems to have happened in much postcolonial criticism is that the laudable desire to disturb fixed ways of conceptualizing society and culture which were perceived as belonging to the colonial era has resulted in a glorification of indeterminacy, impermanence and flux, which may indeed be dialectical in some ways, but has lost any materialist basis which would stop it drifting off like a ship that has lost its rudder. However, rather than see this as a cause for concern, the crew rejoice in this directionless escape from a dictatorial colonialist captain and his master narrative.

Postcolonialism itself has to be understood as an object of study, rather than as an overarching theory for understanding the state of culture and society in the late twentieth century. I am reluctant to dismiss postcolonial (and postmodern) theory entirely, since they contain real insights into developments in contemporary culture. For me though, suggestive aspects of postcolonial and postmodernist theory are more usefully applied as part of a different theoretical framework. The best way to test out theory is to apply it in practice, while continuing to refine it, and I recommend this to my readers as a method for evaluating postcolonial theory for themselves, and also for evaluating my own theoretical arguments in this book.

NOTES

1 There are a large number of books for readers who want to read more on the postcolonial. I have found the following useful. I.Adam and H.Tiffin eds, *Past the last post: Theorizing Post-Colonialism and Post-modernism*, (Harvester Wheatsheaf, New York and London, 1991), L.Chrisman and P.Williams eds, *Colonial Discourse and Post-colonial theory:A Reader*, (Harvester Wheatsheaf, New York and London, 1993), B.Ashcroft, G.Griffiths and H.Tiffin eds, *A Post-colonial Studies Reader*, (Routledge, London, 1995), B.Ashcroft, G.Griffiths and H.Tiffin eds, *Key Concepts in Post-colonial Studies*, (Routledge, London and New York, 1998). For an example of the application of postmodern and postcolonial theories to contemporary culture see Z.Sardar, *Postmodernism and the Other: The New Imperialism of Western Culture*, (Pluto Press, London, 1998). Most useful as a general introduction is the clear and well-written book by A.Loomba, *Colonialism/Postcolonialism*, (Routledge, London and New York, 1998).

2 All quotes from Said, *Orientalism*, (Penguin, Harmondsworth, 1978), pp 203–4.

3 '*Interview with Edward Said*' in M.Sprinkler ed., *Edward Said: A Critical Reader*, (Blackwell, Oxford, 1992), p 259. Said's view of Marxism as totally Eurocentric and without evidence of organization, theory and discourse relevant to the Middle East, ignores attempts by Marxists to organize alternatives to petty bourgeois nationalism, Stalinism and fundamentalism in, for example, Iran. Typically, Said fails to distinguish between Stalinism and Marxism.

4 Ibid., p 241.

5 Ibid., pp 247–8.

6 T.Eagleton, F.Jameson, E.W.Said, *Nationalism, Colonialism and Literature*, (University of Minnesota Press, Minneapolis, 1990), pp 72–3.

7 For excellent comments on postcolonialism see A.Ahmad, '*Orientalism and After: Ambivalence and Metropolitan Location in the Work of Edward Said*', in Ahmad, *In Theory: Classes, Nations, Literatures*, chapter 5, (Verso, London 1994.) See also the interviews with Ahmad in E.M.Wood and J.B.Foster eds, *In Defence of History*.

8 Ibid., p 197.

9 G.C.Spivak, '*Can the subaltern speak?*' in C.Nelson and L.Grossberg eds, *Marxism and the Interpretation of Culture*, (University of Illinois Press, Chicago, 1988). For a development of Spivak's argument which argues that if we accept that the subaltern cannot speak, we collude in the erasure of women from history, see L.Mani, '*Cultural Theory, Colonial Texts: Reading Eyewitness accounts of widow burning*', chapter 22 in L.Grossberg, C.Nelson, P.Treichler eds., *Cultural Studies*, (Routledge, London and New York, 1992).

10 See the comments and critiques of Spivak's positions in B.Parry, '*Problems in Current theories of colonial discourse*', *Oxford Literary Review*, vol.9, part 9, (1987), pp 35–6.

11 H.Bannerji, *Thinking through: Essays on Feminism, Marxism, and Anti-Racism*, (Women's Press, Toronto, 1995). Bannerji acknowledges her debt to Marxism, Fanon and others in her book. It is her continued interest in Marxism as a relevant body of theory which can still be developed which differentiates her from most other writers on 'race', gender and class in the so-called postcolonial period.

12 ibid., p 36.

13 Bhabha, '*Postmodernism/Postcolonialism*', in R.S.Nelson and R.Shiff eds,

Critical Terms for Art History, (University of Chicago Press, Chicago and London, 1996), p 311, quoted from Bhabha's earlier book *The Location of Culture*, 1994.

14 '*The postcolonial and the postmodern: The Question of Agency*', in *The Location of Culture*, (Routledge, London and New York, 1994), pp 171,173. Hybrid, a noun and an adjective, is defined in the dictionary as a cross-breed, mongrel, offspring of two different species, or a person of mixed nationality. Bhabha seeks to turn around the pejorative connotations of the term to make the work signify empowering multiple identities existing in spaces which are not circumscribed, but fluid and changing.

15 Bhabha, *The Location of Culture*, p 29.

16 D.Morley and K-H Chen eds, *Stuart Hall: Critical Dialogues in Cultural Studies*, (Routledge, London and New York, 1996), p 429.

17 '*Postmodernism/Postcolonialism*', chapter 22 in R.S.Nelson and R.Shiff eds, *Critical Terms for Art History*.

18 H.K.Bhabha, '*The Other Question . . .* ', *Screen*, vol.24, no 6, November-December, 1983, pp 18–36. Interestingly, Bhabha acknowledges the 'tentative' nature of this essay by admitting that he needs to work out the theoretical implications of gender and class for colonialism more thoroughly and discuss them more fully. This tone is quite different from some of his other writings, where there is no suggestion of questioning any of his views. He stops trying to argue his points, and merely makes statements. For an interesting attempt to relate Bhabha's notion of hybridity to actual artworks, see J.Purdom, '*Mapping Difference*', *Third Text*, 32, Autumn, 1995, pp 19–32.

19 Ahmad, pp 67–8.

20 Parry, p 43. Another article by Parry, '*Signs of our Times: Discussion of Homi Bhabha's The Location of Culture*', *Third Text*, 28/29, Autumn/Winter 1994, pp 5–24. gives a really excellent critique of Bhabha's theoretical positions, relating them to those of other postcolonial scholars such as Paul Gilroy and Stuart Hall. She proposes 'that Bhabha's many fecund insights into cultural processes are paradoxically denatured by the theoretical modes which inform his work', a view with which I heartily concur.

21 McClintock, *Imperial Leather*, pp 62–5.

22 See '*The Angel of Progress: Pitfalls of the Term "Post-colonialism"*', chapter 16 in P.Williams and L.Chrisman eds, *Colonial Discourse and Post-Colonial Theory: A Reader*, (Macmillan, Basingstoke, 1994).

23 Ahmad, p 205. For example, Fanon rejects colonialism, though he is not writing in a postcolonial period.

24 A.Dirlik, '*The postcolonial Aura: Third World Criticism in the Age of global capitalism*', *Critical Inquiry*, Winter, 1994, p 343.

25 Ibid., p 352

26 Ibid., p 356. Dirlik notes on p 333 that Bhabha 'has proven himself to be something of a master of political mystification and theoretical obfuscation, of a reduction of social and political problems to psychological ones, and of the substitution of poststructuralist linguistic manipulation for historical and social explanation – all of which show up in much postcolonial writing, but rarely with the same virtuosity (and incomprehensibility) that he brings to it'.

27 '*When was "the Post-colonial"? Thinking at the Limit*', chapter 20 in I.Chambers, L.Curti eds, *The Post-colonial question: Common Skies. Divided Horizons*, (Routledge, London and New York, 1966), p 259.

28 Ibid., p 244

29 For example, the Second World War was pretty complicated, with imperialist forces on both sides (Germany and Britain), the former using more vicious methods than the other, while victims fleeing these vicious methods were refused refuge in the 'democratic' imperialist country. In addition, the Stalinized but post-capitalist Soviet Union aligned itself first with Hitler and then with his opponents when attacked by Germany in 1941. Many socialists called for support for the USSR while still criticising the murderous methods of Stalinism. This is hardly a simplistic scenario of 'goodies and baddies', and there are many other conflicts of the 'modernist' era which could provide similar examples.

30 Ibid., p 247

31 Ibid., p 250

32 Interview with Surjit Simplay, leaflet to accompany exhibition at The Drum, Birmingham.

33 Of course, work has been done on this by women scholars since the publication of Said's book. See for example, R.Lewis, *Gendering Orientalism: Race, Femininity and Representation*, (Routledge, London and New York, 1996) and especially M.Yeğenoğlu, *Colonial Fantasies: Towards a feminist reading of Orientalism*, (Cambridge University Press, Cambridge and New York, 1998), especially chapter 3.

34 Letter to the author, 1997

35 Interview with Zarina Bhmji in *The Impossible Science of Being*, (Photographers' Gallery, London, 1995), pp 25–7.

36 *Zarina Bhmji: I will always be here*, (Ikon Gallery, Birmingham, 1992), interview, no pagination. For more on the difficulties and lack of role models and sympathetic tutors see Juliette Jarrett,'*Creative Space?: the experience of Black women in British art schools*', chapter 6 in D.Jarrett-Macauley ed., *Reconstructing Womanhood, Reconstructing Feminism: Writings on Black Women*, (Routledge, London and New York, 1996).

37 From leaflet to accompany exhibition.

38 *Mirage: Enigmas of Race, Difference and Desire*, (Institute of Contemporary Arts, London, 1995), p 19. The title *Mirage* was chosen as a reference to Fanon's particular development of Lacan's theory of the mirror stage, when the subject differentiates him/herself from the totality of the surrounding world and tries to identify with a coherent image of the self in the mirror. For Fanon, the black subject is doubly troubled in this attempted identification, because he looks in the mirror and sees a white person as his ideal self. As Vergès puts it: 'But to Fanon, the Antillean Negro remained imprisoned in the mirror stage, in the mirage of the imaginary 'other'. The Antillean Negro is forever captured in this mirage.'. See F.Vergès, 'Creole Skin, Black Mask: Fanon and Disavowal' in *Critical Inquiry*, Spring, vol. 23, no 3, (1997) p 59. Vergès also contributed to the useful special issue of *Radical Philosophy*, no 95, May/June 1999, on race and ethnicity.

39 A.Read ed., *The fact of Blackness: Franz Fanon and Visual Representation*, (Institute of Contemporary Arts, London and Bay Press, Seattle, 1996), pp 24–5. 'The fact of blackness' is actually a misleading translation of the title of chapter 5 of Fanon's book, which should really be translated as 'the lived experience of the black man' ('l'expérience vécue du Noir').

40 Ibid., p 35. Members of the audience were not so convinced. During one of the debates recorded later in the book, p 159, a member of the audience says:'Homi Bhabha says that Fanon would be proud of this looking back to the past and referring to the archive. I think Fanon would be turning in his grave.'

41 Introduction of L.R.Gordon, T.Denean Sharpley-Whiting and R.T.White eds., *Fanon: A Critical Reader*, (Blackwell, Oxford, 1996), pp 6–7.

42 Ibid. p 7

43 Fanon: *A Critical Reader*, ibid. p 208

44 *Black Skin, White Masks* (Pluto Press, London 1986) p. xiii

45 Ibid., p xvi

46 Ibid., pp xix-xx. Bhabha excludes from his discussion of Fanon everything that is alien to his own interests. For example 'when Bhabha presents a Lacanian Fanon – ahistorical and well-suited to contemporary postmodern cultural studies – he interestingly excludes discussion of Fanon's *rejection* of Lacanian psychoanalysis in his discussion of psychopathology in *Peau Noire, Masques Blancs*'. L.R.Gordon, *Her Majesty's other Children: Sketches of Racism from a Neocolonial Age*, (Rouman and Littlefield, Boulder, New York, Oxford, 1997), p 258.

47 See the views of C.Robinson (rejected explicitly by Hall) in '*The appropriation of Frantz Fanon*' in *Race and Class*, vol.35, no 1, July/Sept., (1993).

48 The Communist Party's excuse was that once the French government was in a position of power, it would be more able to negotiate. J-P. Brunet, *Histoire du P.C.F.*, (Presses Universitaires de France, Paris, 1982), p 95. For comments on Fanon's politics and his disillusion with the leaders of the French workers' movements see R.Brenner, '*Every brother on a rooftop can quote . . . Fanon*', *Workers Power*, no 185, Jan. (1995), p 14.

49 See C-R.Ageron, *Modern Algeria: A history from 1830 to the present*, (Hurst, London, 1964), part IV for details of the war of liberation and its aftermath.

50 '*The pitfalls of national consciousness*' (first published 1961) in Fanon, *The Wretched of the Earth*, (Penguin, Harmondsworth, 1990), p 140.

51 Ibid. p 163

52 Quote on p 16 of E.Gallet, '*The menace of Islamic fundamentalism*' in *Trotskyist International*, no 9, Sept/Dec (1992) pp 12–20. This article also points out that the fundamentalists seek to attack and overturn the basic democratic achievements of the Enlightenment, which are also seen as suspect by many postmodern scholars. An interesting article by B.Tibi also shows how Islamic fundamentalism seeks to disprove Enlightenment concepts of truth, reason and the ability to scientifically investigate the world. See '*Culture and knowledge: The politics of Islamization of knowledge as a postmodern project? The fundamentalist claim to de-westernization*', *Theory, Culture and Society*, vol.12, (1995), pp 1–24.This sounds similar to much supposedly radical postmodern theorizing. For more on the situation in Algeria see *The Guardian*, education section 14 November 1995, and more recent current press reports.

53 C.Lloyd, '*Struggles in Algeria*', *Women Against Fundamentalism*, no.6, (1995), pp 44–5.

54 F.Vergès, '*To cure and to free: The Fanonian project of "Decolonized Psychiatry"*', in *Fanon: A critical reader*, pp 94–5, and the excellent '*Chains of Madness, chains of Colonialism: Fanon and Freedom*' in *The fact of blackness*, pp 47–75.

55 '*On National Culture*' (1959) in *Wretched of the Earth*. p. 188

56 *Black Skin, White Masks*, p. 230

57 *Wretched of the Earth*, p. 189

58 While I agree with many points made about the film by L.R.Gordon, especially his comments about the talking head 'cultural critics', I feel he overstates the depoliticization of Fanon. 'Sexual identity politics have subordinated radical revolutionary politics. Fanon's revolutionary praxis

having been occluded, the only criteria of assessment remaining are his stands on gender and sexual orientation.' *Her Majesty's Other children*, p 254. This is true more of what the 'cultural critics' say in the film, for example Vergès and Hall, than of Julien's stance as filmmaker, seeking to integrate Fanon's political, medical and cultural achievements.

59 See the essays by N.Elia, E.Souffrant and D.T.Goldberg in *Fanon: A critical reader*. Fanon's essay is available in English in *A Dying Colonialism*, (Monthly Review Press, New York, 1967) and later editions.

60 For an illustration see *Ten.8 Critical Decade*, p 100.

61 See chapter 3 of *A Dying Colonialism*.

62 See the very useful article *"Unveiling Algeria"* by W.Woodhull, *Genders*, no 10, Spring, 1991, pp 114–5.

63 See for example M.Alloula, *The Colonial Harem*, Manchester UP, Manchester, 1987, K.Dennis, *"Ethno-Pornography: Veiling the dark Continent"*, *History of Photography*, vol. 18 no 1, Spring, 1994, pp 22–28, and Woodhull's *"Unveiling Algeria"*. see also D.Prochaska, *"The archive of Algérie Imaginaire"*, *History and Anthropology*, 1990. vol. 4, pp 373–420, and chapter 5 of my book *Women and Visual Culture in France 1800–1852*, Leicester University Press.

64 Dennis, p 26 referring to Fatrima Mernissi, *Beyond the Veil*, Bloomington, Indiana UP, 1987.

65 S.Graham-Brown, *Images of Women: The Portrayal of Women in Photoraphy of the Middle East 1860–1950*, Quartet, London, 1988, p 250. This excellent book has much valuable written and pictorial research on women, society and politics in the Middle East.

66 A recent exhibiton at the 198 gallery, South London, 'Concealed Visions – Veiled Sisters' by Sabera Bham, projected slides onto materials hanging from the gallery roof. Music and voices of women who 'have chosen to wear the veil' are heard and the artist thus seeks to 'allow the veil wearers to be able to express themselves.' The forthcoming issue 4 of *The International Journal of Postcolonial Studies* is to be devoted to '*The veil: Postcolonialism and the Politics of Dress.*'

67 Quoted in R.Brenner, *"Congress and the Birth of India: Midnight's Harvest"*, *Workers Power*, no 213, July/August, 1997, p 8.

68 R.Chandavarkar,*"'Strangers in the Land': India and the British since the late nineteenth Century"*, in C.A.Bayly ed. *The Raj: India and the British 1600–1947*, National Portrait Gallery, London, 1990, p 369. I have used this essay and another in the same catalogue by F.Robinson *"The Raj and the Nationalist Movements 1911–1947"*, as well as Brenner, *"Congress and the Birth of India: Midnight's havest"*, and notes on Indian History provided by Leeds Metroplitan University's Art Gallery for details of Indian history and politics before Independence. For some critical perspectives on the writing of Indian history and theories of postcoloniality see A.Loomba and S.Kaul eds., *On India: Writing history culture post-coloniality*, special issue of *The Oxford Literary Review*, vol. 16, nos 1–2, 1994.

69 For these examples and more see J.Seabrook, *"The reconquest of India: the victory of International Monetary Fundamentalism"*, *Race and Class*, vol. 34, no 1, 1992, pp 1–16.

70 See the useful inteview with Lamba by Pervaiz Khan in a leaflet to accompany his exhibition at The Drum, Birmingham.

CONCLUDING REMARKS

At the end of the twentieth century, black visual culture is seen by some cultural critics and historians as something which took place in the 1980s. Reviewing Keith Piper's exhibition *Relocating the Remains*, an unsympathetic Rachel Withers remarked: 'Piper is of a generation of political artists whose uncompromising polemics on race first attracted attention in the early 1980s. Then, "aesthetics" was a dirty word . . . Cultural politics have moved on.'[1] Since then, a new generation of young black artists has become visible on the British art scene. This was not something which happened by chance; it was the result of hard work and persistent effort to gain access to colleges of art, art institutions and the art press. This energy and application, and the hard-hitting nature of some of the themes embodied in the art works, are now viewed by critics such as Mercer and Hall as part of a development which is definitively past. Now, black culture has become the culture of discourses of hybridity, of ethnicity, or identities.[2]

However, it is quite true that there never was a single black culture. Class, sexuality and gender cross over notions of black communities and are factors in the consumption and production of culture made and enjoyed by black, as well as white, British audiences. In addition, notions of black culture come into being in the context of particular configurations of economics, politics and culture and these are different now from what they were in the late 1970s and 1980s. References to black culture in the work of Chris Ofili, for example, are playful, sacrilegious and flirtatious, rather than politically serious or confrontational. As I write this, Ofili is currently 7–4 favourite to win the prestigious Turner Prize, and has been nominated for the lesser known but more lucrative Jerwood Prize.[3] Yet many of the issues which concerned black artists and were represented in black visual culture during the 1980s have not gone away – prejudice, access to culture, educational opportunities, racist murders, state harassment, restrictions on movement in immigration and deportation, objectification of the black body, sexuality, identity and history. Of course, some of these themes also relate to the work of white artists,

but not all, and when they appear, they tend to be treated rather differently, as we saw in looking at the work of Mapplethorpe. Nor are the themes absent from the concerns of the now fashionable Ofili: 'One painting I'm working on, which won't be ready for the Serpentine show, is a portrait, based on the life of Stephen Lawrence and a Bob Marley song. They come together from different times.'[4] Ofili deals with black culture, oppression and survival in different ways from many of the black artists who came to prominence in the 1980s, and it is significant that he is basically a painter, rather than an artist working with computers or installation pieces. Yet, despite the changes of emphasis in the work of many black artists in the 1990s, I feel that it would be wrong to write the notion of black art out of existence just yet.

Directly political representations are now frowned upon in some quarters, as some postmodern and poststructuralist theoreticians query or even deny the existence of reality, truth, and the possibility of engagement with society and its inequalities, either through cultural production or by other means. Black culture is now seen by some cultural theorists as an outmoded and rather unsubtle concept, to be replaced by indeterminacies and in-betweenness as multiple discourses position us fluidly in ethnicities and even in our richly modulated consumer choices. All the old-fashioned master narratives got it wrong ... but it is peculiar that racial discrimination hasn't gone away ...

Black cultures have not gone away either, and I am reminded of Fanon's points on the subject, referred to above. In his view, the need to value and create specifically black cultural works diminishes as the power of the oppressors and exploiters diminishes, along with the designation of some people as 'black'. This is also why black identities and histories, understood in various aspects, are still powerful creative and thematic elements in the work of many black artists working in Britain today. For some successful black artists, being seen as black rather than just an artist is frustrating and limiting. This is understandable. However there are still many areas of education where the making and understanding of visual culture is taught without reference either to named black artists or the issues addressed in their work. Thus, it is important in some contexts to make it clear that certain artists are black.

Much of the best art currently produced unites subtlety, density and depth with attention to issues of 'race', identity, histories and sexuality, but represents these in different ways from earlier black art. I do not see this as a break from the modern to the postmodern, however. Many artists such as Keith Piper, Juginder Lamba, Roshini Kempadoo, for

example, incorporate themes and actual parts of their earlier work into their current projects. The use of computer technology allows this to be done in a particularly effective way. Thus, their work embodies living processes, rather than a series of discrete historical and artistic moments.

It is interesting to me to see how many of the works appear to articulate and embody similar themes and awareness of the meanings of the materials used, whether or not the artists are aware of postmodern, poststructuralist or postcolonial theories. This suggests to me that, not surprisingly, personal and family histories and experiences are particularly strong in motivating the production of artworks by black British artists. Confirmation of ideas is then sought, perhaps in theoretical and critical writings, or is suggested to the artists by tutors or friends. I feel it is unfortunate that experience has been so strongly devalued and questioned by many recent theoretical approaches, which belittle the notions of consciousness and agency. Key to this, of course, is a rejection of materialism and of Marxism by many postmodern and postcolonial scholars, entailing a crucial dismissal of any notions of consciousness and ideology. Without theories which help to understand how experience relates to ideology, the placing of the self in particular social configurations, and the way in which individual and collective experience and thought relates to consciousness, much recent poststructuralist writing has collapsed into a kaleidoscopic idealist proliferation of discourse theory. Theory and practice in relation to one another are crucial. However in considering producers of visual culture, my aim has been to emphasize the material presence of the works as active creations of people's labour, and the works' ability to embody and materialize ideas and theory, rather than give pride of place to the theories as more important and influential than the art practice itself. I hope I have managed to get this relationship about right, while trying to extract what I feel is most useful at the core of the theoretical writings relating to the works. My own view, as stated in Chapter five, is that suggestive concepts from postcolonial and postmodern critical writings, such as hybridity, indeterminacy and in-betweenness should be incorporated into a theoretical framework which situates them materially in their economic and social context, and understands them dialectically in all their inter-related contradictions and tensions. I have tried to apply this method in my analysis of works of visual culture, showing how the works are related to, and grounded in, specific economic, social and cultural configurations, but also how the works are not reflections of their material grounding,

but related to it and acting upon it in complex ways which are not static but evolving and interactive.

What I have found important in studying the works of black British artists and other examples of visual culture representing black people, is the importance of history. Without a knowledge of history and histories, we would find it hard to appreciate the full meanings of these works, the best of which, such as those by Keith Piper, weave an intricate tapestry of historical and visual allusions, inviting us to understand the past, situate ourselves in the present and speculate on the future. There is little more one could ask of visual culture, than to attempt, and succeed in, these hugely ambitious aims.

Shortly before his suicide in 1940, Walter Benjamin wrote his *'Theses on the Philosophy of History'*. As a Jewish refugee cultural theorist with revolutionary sympathies, Benjamin mused on the understanding of history, and how a historical materialist (or revolutionary Marxist) might practice historical study. In Thesis IV Benjamin writes:

'The class struggle, which is always present to a historian influenced by Marx, is a fight for the crude and material things without which no refined and spiritual things could exist. Nevertheless, it is not in the form of the spoils which fall to the victor that the latter make their presence felt in the class struggle. They manifest themselves in this struggle as courage, humour, cunning and fortitude'. [5]

These qualities which Benjamin discerned in 'spiritual things' can be found in abundance in the works of black artists of our historical time.

NOTES

1 Rachel Withers, *'Slave to Dogma'*, *The Guardian*, review section, 5 August 1997, p 11.
2 It is important to point out that Hall, Mercer and Gilroy do not offer destructive criticisms of black artists and writers. Rachel Withers, however, castigates Piper in her review of his exhibition, wishes he would forget polemics and become more 'complex', condemning his 'didacticism', 'insensitive' use of objects, and the 'disastrous effect' of his show. She concludes:'It's miserable to come away from a show feeling so negative. If there's a consolation it is that a younger generation of black artists are disdaining heavy posturing while making work of real political complexity. Piper should look sharp.' *The Guardian*, 5 August, 1997, p 11.
3 M.Coomer interview with Chris Ofili, *'The Boy Dung Good'*, *Time Out*, September 30–October 7, 1998, pp 14–5. Ofili duly won the Turner Prize.
4 ibid., p 15. Stephen Lawrence was a young black student murdered by racists in South London in 1993. No one has been convicted of the killing

due, allegedly, to racist incompetence on the part of the investigating police officers, who were more interested in questioning Stephen's family and friends about possible criminal involvement by Stephen at the time of the killing. Despite the continuing efforts of Stephen's parents, his murderers remain unconvicted and no police officers have yet been disciplined or sacked. Key figures involved in the incompetently led murder enquiry were allowed to take early retirement with full pension rights.

5 W.Benjamin, *Illuminations: Essays and Reflections*, (Jonathan Cape, London, 1970), pp 256–7.

RESOURCES AND ORGANIZATIONS

African and Asian Visual Artists Archive,
University of East London,
Greengate St.,
London E13 0BG.

Autograph (A.B.P)
5 Hoxton Square,
London N1 6NU.

Institute of International Visual Arts (inIVA)
Kirkman House,
12/14 Whitfield St.,
London W1P 5RD.

Panchayat Archive,
IRS Centre,
University of Westminster,
Harrow Campus,
Watford Rd.,
Northwick Park,
Harrow HA1 3TP.

For more information about the archive contact
Shaheen Merali,
29B Talbot Rd.,
London W2 5JG.

SELECT BIBLIOGRAPHY

An essential tool for the study of contemporary black British artists' work is:

Keen, Melanie and Ward, Elizabeth, *Recordings: A Select Bibliography of Contemporary African, Afro-Caribbean and Asian British Art*, (inIVA and Chelsea College of Art and Design, London, 1996)

Additional publications

Abelove, Henry, Barale, Michèle Aina, Halperin, David M. eds, *The Lesbian and Gay Studies Reader*, (Routledge, London and New York, 1993)

Adams, Michael V., *'Race', Color, and the Unconscious*, (Routledge, London and New York, 1996)

Ahmad, Aijaz, *In Theory: Classes, Nations, Literatures*, (Verso, London and New York, 1992)

Ajamu, *Black Bodyscapes – Photographs by Ajamu*, (David A.Bailey, London, 1994)

Araeen, Rasheed, *The Other Story: Afro-Asian Artists in Post-war Britain*, (Hayward Gallery, Arts Council of Great Britain, London, 1989)

Araeen, Rasheed, Kingston, Angela and Payne, Antonia, eds, *From Modernism to Postmodernism: Rasheed Araeen a Retrospective: 1959–1987*, (Ikon Gallery, Birmingham, 1987)

Autograph, *Party-Line*, CD-rom, (Autograph, 1997)

Baker, Houston A.Jr., Diawara, Manthia, and Lindeborg, Ruth H. eds, *Black British Cultural Studies: A Reader*, (University of Chicago Press, Chicago, 1996)

Bannerji, Himani, *Thinking Through: Essays on Feminism, Marxism and Anti-Racism*, (Women's Press, Toronto, 1995)

Bayly, Christopher A. ed., *The Raj: India and the British 1600–1947*, (National Portrait Gallery, London, 1990)

Beauchamp-Byrd, Mora and Sirmans, M.Franklin eds, *Transforming the Crown: African, Asian and Caribbean Artists in Britain 1966–1996*, (Franklin H.Williams Caribbean Cultural Centre/African Diaspora Institute, New York, 1997)

Bhabha, Homi K., *The Location of Culture* (Routledge, London and New York, 1994)

Bleys, Rudi, C., *The Geography of Perversion: Male to Male Sexual Behaviour outside the West and the Ethnographic Imagination 1750–1918*, (Cassell, London, 1996)

Boffin, Tessa, and Gupta, Sunil eds, *Ecstatic Antibodies: Resisting the AIDS Mythology*, (Rivers Oram Press, London, 1990)

Boime, Alfred, *The Art of Exclusion: Representing Blacks in the Nineteenth Century*, (Thames and Hudson, London, 1990)

Brah, Avtar, *Cartographies of Diaspora: Contesting Identities*, (Routledge, London and New York, 1996)

Bright, Deborah, ed., *The Passionate Camera: Photography and Bodies of Desire*, (Routledge, London and New York, 1998)

Brown, Ruth, 'Racism and immigration in Britain', *International Socialism*, no.68, Autumn, (1995) pp 3–35

Butler, Judith, *Bodies that Matter: On the Discursive Limits of 'sex'*, (Routledge, New York and London, 1993)

Chambers, Eddie, with Tam Joseph and Juginda Lamba, *The Artpack: A History of Black Artists in Britain*, (Haringey Arts Council, London, 1988)

Chambers, Eddie, 'Eddie Chambers. An Interview with Petrine Archer-Straw', *Art and Design*, vol.10, 3/4, March/April, (1995), pp 49–57

Chambers, Eddie, ed., *Frank Bowling: Bowling on through the Century*, (Eddie Chambers, Bristol, 1996)

Chambers, Eddie, ed., *Tam Joseph: This is History*, (Eddie Chambers, Bristol, 1998)

Chandler, David ed., *Keith Piper: Relocating the Remains*, (inIVA, London, 1997)

Commission for Racial Equality, *Roots of the Future: Ethnic Diversity in the Making of Britain*, (Commission for Racial Equality, London, 1996)

Coombes, Annie E., and Edwards, Steve, 'Site unseen: Photography in the colonial Empire: Images of subconscious eroticism', *Art History*, vol.12, no.4, (1989) pp 510–516

Corrin, Lisa G., Snoddy, Stephen, and Worsdale, Godfrey, eds., *Chris Ofili*, (Southampton City Art Gallery, Southampton, 1998)

Critical Decade: Black British Photography in the 80s, Ten: 8, vol.2 no. 3, (1992)

Dennis, Kelly, 'Ethno-Pornography: Veiling the Dark Continent', *History of Photography*, vol.18, no.1, (1994) pp 22–28

Dent, Gina, ed., *Black Popular Culture*, (Bay Press, Seattle, 1992)

deSouza, Allan, '*The Flight of/from the Primitive*', *Third Text*, no.38, Spring (1997) pp 65–79

Dirlik, Arif, '*The Postcolonial Aura: Third World Criticism in the Age of Global Capitalism*', *Critical Inquiry*, 20, Winter (1994) pp 328–356

Doy, Gen, *Seeing and Consciousness: Women, Class and Representation*, (Berg, Oxford and Washington D.C., 1995)

Doy, Gen, *Materializing Art History*, (Berg, Oxford and New York, 1998)

Driskell, David C.ed., *African American Visual Aesthetics: A Postmodern View*, (Smithsonian Institution Press, Washington and London, 1995)

Dyer, Richard, *White*, (Routledge, London and New York, 1997)

Edwards, Elizabeth ed., *Anthropology and Photography 1860–1920*, (Yale University Press, New Haven and London, 1992)

Eze, Emmanuel C., ed., *Race and the Enlightenment: A Reader*, (Blackwell, Oxford and Cambridge Mass., 1997)

Fanon, Frantz, *Black Skin,White Masks*, (Pluto Press, London, 1986)

Farr, Ragnar, ed., *Mirage: Enigmas of Race, Difference and Desire*, (Institute of Contemporary Arts and inIVA, London, 1995)

Fisher, Jean ed., *Global Visions: Towards a new Internationalism in the Visual Arts*, (Kala Press in association with inIVA, London, 1994)

Foster, Hal, *The Return of the Real: The Avant-Garde at the end of the Century*, (MIT Press, Cambridge Mass. and London, 1996)

Fryer, Peter, *Staying Power: The History of Black People in Britain*, (Pluto Press, London, 1984)

Gabriel, John, *Racism, Culture, Markets*, (Routledge, London and New York, 1994)

Gilman, Sander L., *Freud, Race and Gender*, (Princeton University Press, Princeton , New Jersey, 1993)

Gilroy, Paul, '*There ain't no black in the Union Jack': The Cultural Politics of Race and Nation*, (Hutchinson, London, 1987)

Gilroy, Paul, *Small Acts: Thoughts on the Politics of Black Cultures*, (Serpents Tail, London and New York, 1993)

Givanni, June, ed., *Remote Control: Dilemmas of Black Intervention in British Film and TV*, (British Film Institute, London, 1995)

Golden, Thelma, *Black Male: Representations of Masculinity in Contemporary American Art*, (Whitney Museum of American Art, Abrams, New York, 1994)

Gordon, Lewis R., Sharpley-Whiting, Tracy D., White, Renée T., eds, *Fanon:A Critical Reader*, (Blackwell, Oxford, 1996)

Graham-Brown, Sarah, *Images of Women: The Portrayal of Women in Photography of the Middle East 1860–1950*, (Quartet, London, 1988)

Guillaumin, Colette, *Racism, Sexism, Power and Ideology*, (Routledge, London and New York, 1995)

Gupta, Sunil ed., *Disrupted Borders: An Intervention in Definitions of Boundaries*, (Rivers Oram Press, London, 1993)

Hall, Stuart, ed., *Representation: Cultural Representations and Signifying Practices*, (Open University and Sage, London, 1997)

Harris, Michael D., '*Resonance, Transformation, and Rhyme: The Art of Renée Stout*' in *Astonishment and Power*, (National Museum of African Art, Smithsonian Institution Press, Washington and London, 1993) pp 104–55

Hiro, Dilip, *Black British, White British: A History of Race Relations in Britain*, (Paladin, London, 1992)

Honour, Hugh, *The Image of the Black in Western Art*, vol.4, parts 1 and 2, (Harvard University Press, Cambridge, Mass., 1989)

Iles, Chrissie and Roberts, Russell, eds, *In Visible Light: Photography and Classification in Art, Science and the Everyday*, (Museum of Modern Art, Oxford, 1997)

Julien, Isaac, and McCabe, Colin, *Diary of a Young Soul Rebel*, (British Film Institute, London, 1991)

Kohn, Marek, *The Race Gallery: The Return of Racial Science*, (Vintage, London, 1996)

Lewis, Dave, *Dave Lewis: Monograph*, (Autograph, London, no date)

Lloyd, Colin, '*Marxism versus Postmodernism*', *Trotskyist International*, no.21, Jan-June (1997), pp 38–48

Loomba, Ania, *Colonialism/Postcolonialism*, (Routledge, New York and London, 1998)

Malik, Kenan, *The Meaning of Race: Race, History and Culture in Western Society*, (Macmillan, Basingstoke, 1996)

McClintock, Anne, *Imperial Leather: Race, Gender and Sexuality in the Colonial Contest*, (Routledge, London and New York, 1995)

Mercer, Kobena, *Welcome to the Jungle: New Positions in Black Cultural Studies*, (Routledge, London and New York, 1994)

Morley, David, and Chen, Kuan-Hsing, eds, *Stuart Hall: Critical Dialogues in Cultural Studies*, (Routledge, London and New York, 1996)

O'Grady, Lorraine, '*Olympia's Maid: Reclaiming black female subjectivity*', *Afterimage*, Summer (1992), pp 14,15,23

Owusu, Kwesi, *Storms of the Heart: An Anthology of Black Arts and Culture*, (Camden Press, London, 1988)

Parry, Benita, '*Problems in Current Theories of Colonial Discourse*', *Oxford Literary Review*, vol.9, part 9, (1987) pp 27–58

Parry, Benita, '*Signs of our times: Discussion of Homi Bhabha's The Location of Culture*', *Third Text*, 28/9, Autumn/Winter (1994) pp 5–24.

Perchuk, Andrew and Posner, Helaine eds, *The Masculine Masquerade: Masculinity and Representation*, (MIT Press, Cambridge, Mass., and London, 1995)

Photographers' Gallery, London, *The Impossible Science of Being: Dialogues between Anthropology and Photography*, (Photographers' Gallery, London, 1995)

Pieterse, Jan N. and Parekh, Bikhu, *The Decolonization of Imagination: Culture, Knowledge and Power*, (Zed Books, London and New Jersey, 1995)

Pietz, William, 'Fetish', in Nelson, Robert S., and Shiff, Richard eds, *Critical Terms for Art History* (University of Chicago Press, Chicago and London, 1996) pp 197–207

Pinney, Christopher, *Camera Indica: The Social Life of Indian Photographs*, (Reaktion Books, London, 1997)

Piper, Keith, *Step into the Arena: Notes on Black Masculinity and the Contest of Territory*, (Rochdale Art Gallery, Rochdale, 1992)

Powell, Richard J., *Black Art and Culture in the 20th Century*, (Thames and Hudson, London, 1997)

Radical Philosophy, no 95 May/June 1999, special issue on race and ethnicity

Ramamurthy, Anandi, '*Constructions of illusion: Photography and Commodity Culture*', in Wells, Liz, ed., *Photography: A Critical Introduction*, (Routledge, London and New York, 1997) pp 151–198

Read, Alan, ed., *The Fact of Blackness: Franz Fanon and Visual Representation*, (Institute of Contemporary Arts, London and Bay Press, Seattle, 1995)

Reeves, Michelle, and Hammond, Jenny, eds, *Looking beyond the Frame: Racism, Representation and Resistance*, (Links publications, Oxford, 1989)

Rigby, Peter, *African Images: Racism and the end of Anthropology*, (Berg, Oxford and Washington D.C., 1996)

Robinson, Cedric, '*The appropriation of Frantz Fanon*', *Race and Class*, vol.35, no.1,(1993) pp 79–91

Rotimi Fani-Kayode and Alex Hirst: Photographs, (Autograph and Editions Revue Noire, London and Paris, 1996)

Robinson, Cedric J., *Black Marxism: The Making of the Black Radical Tradition*, (Zed Press, London, 1983)

Rowling, Nick, *Commodities: How the World was taken to Market*, (Free Association Books, London, 1987)

Ryan, James R., *Picturing Empire: Photography and the Visualization of the British Empire*, (Reaktion Books, London, 1997)

Sekula, Allan, '*The Body and the Archive*', *October*, 39, (1986), pp 3–64 *Radical Philosophy*, no 95 May/June 1999, special issue on race and ethnicity

Shelton, Anthony, ed., *Fetishism: Visualizing Power and Desire*, (South Bank Centre and Lund Humphries, London, 1995)

Shohat, Ella and Stam, Robert, '*The Politics of Multiculturalism in the Postmodern Age*', *Art and Design*, vol.10, (July/August 1995)

Sivanandan, Ambalavaner, '*All that melts into air is solid: The hokum of New Times*', *Race and Class*, vol.31, no.3, (1989), pp 1–30

Socialism and Black Liberation: The Revolutionary Struggle against Racism, (Workers Power, London, 1995)

Sulter, Maud, '*Maud Sulter: An interview*' with Mark Haworth-Booth, *History of Photography*, vol. 16, no. 3, Autumn, (1992) pp 263–6

Sulter, Maud, Himid, Lubaina and Barlow, Martin, *Syrcas: Maud Sulter*, (Wrexham Library Arts Centre, Wrexham, 1994)

Tibi, Bassam, '*Culture and Knowledge: The Politics of Islamization of Knowledge as a Postmodern Project? The Fundamentalist Claim to De-Westernization*', *Theory, Culture and Society*, vol.12, (1995) pp 1–24

Trophies of Empire, (Bluecoat Gallery and Liverpool John Moore's University, Liverpool, 1994)

Ugwu, Catherine, ed., *Let's Get it on: The Politics of Black Performance*, (Institute of Contemporary Arts, London and Bay Press, Seattle, 1995)

Veneciano, Jorge G., '*Invisible Men: Race, Representation and Exhibition(ism)*', *Afterimage*, Sept-Oct (1995) pp 12–15

Walmsley, Anne, *The Caribbean Artists' Movement, 1966–1972: A Literary and Cultural History*, (New Beacon Books, London and Port of Spain, 1992)

Wood, Ellen M., and Foster, John B. eds, *In Defence of History: Marxism and the Postmodern Agenda*, (Monthly Review Press, New York, 1997)

Woodhull, Winifred, '*Unveiling Algeria*', *Genders*, no.10, Spring (1991) pp 112–131

Yeğenoğlu, Meyda, *Colonial Fantasies: Towards a feminist reading of Orientalism*, (Cambridge University Press, Cambridge and New York, 1998)

Young, Lola, '*Where do we go from here? Musing on "The Other Story"*', *The Oxford Art Journal*, vol.13, no.2, (1990) pp 51–4

Zavarzadeh, Mas'ud, Ebert, Teresa L., and Morton, Donald eds, *Postality: Marxism and Postmodernism*, special issue of *Transformation: Marxist Boundary Work in Theory, Economics, Politics and Culture*, no.1, (Maisonneuve Press, Washington D.C., 1995)

INDEX